"As I progressed in my studies... I stumbled upon an important

epiphany: culture has nothing to do with race." —AKIL DASAN, pg.200

"I realized I didn't know who I was. The barriers were down, and I didn't have

any restrictions. After I got out of character, I could be anybody."—ROSARIO DAWSON, pg. 186

"There's nothing wrong with being a butch dyke. I have friends who are. But

I'm just not a lesbian. I'm not even very butch!"—ETHAN, pg. 132

"Excuse me, brother, may I take your picture? Because I see this uniqueness

that's inside you—something powerful about you."—JAMEL SHABAZZ, pg. 138

"Well, hello there, Ms. Brazil—do you know where my sister went? She's a brown girl from

Harlem, like me, but I don't see her anywhere."—DJASSI DACOSTA JOHNSON, pg. 204

TM**transcul**

how the world is

turalism

coming together

™ transculturalism
how the world is coming together

essays, analyses, personal tales

and optimistic views of the future

by **claude grunitzky**

with trace magazine contributors

a **TRUE** agency **publication**

distributed by powerHouse Cultural Entertainment, Inc.

First Edition, 2004
First published in the United States of America in
2004 by TRUE Agency, Inc.
476 Broome Street, New York, New York 10013
Copyright © 2004 TRUE Agency, Inc.

Inquiries should be sent to TRUE Agency, Inc.

Library of Congress Card Catalogue Number: 2003114937
ISBN: 1-57687-218-1

Editors: Claude Grunitzky with Steve Greco,
Anicée Gaddis and Peter Lucas
Design: Frenel Morris
Project Coordinator: Angela Cravens
Development Coordinator: Rajiah Williams
Pre-Press and Reprographics: Abysses, Paris
Production Director: Romain Atohoun (the best!)
Printed and bound in Italy

TRUE Agency is a full service transcultural
advertising and marketing shop, partnered with
Omnicom's TBWA\Worldwide
Principals are: Claude Grunitzky (Chairman),
Richard Wayner (President/CEO), Christopher Davis (Executive
Creative Director) and Valencia Gayles (Chief Operating Officer).

**Readers are welcome to post their own transcultural
experiences on www.transculturalism.com**

For Otto, Franz and Cropper

CONTENTS

CULTURE SHOCK 28

HYBRID IDENTITIES 72

CONTENTS

RANDOM ENERGY 162

LIVE TO TELL

TRUE INTELLIGENCE 238

"Turned out Clem and a buncha other white kids were heavily into soul music and pop rock—

Temptations to Beach Boys—just like me and my crew was."—TOM TERRELL, pg.66

castorama

IKEA

"Transculturalists lead unusual lives"

INTRODUCTION

BY **CLAUDE GRUNITZKY**

The word "transculturalism" first came to my attention in the New York City spring of 2002. I had been working day and night, with a small team of grossly underpaid yet highly motivated collaborators, trying to set up a boutique advertising agency out of the one sunny corner in TRACE magazine's SoHo loft. During one of our ad hoc working sessions, Christopher Davis, the man who would become the creative director of our (now successful) agency, pulled out a graph where he outlined a new definition for a word that had been quietly circulating in academic and underground marketing circles. From that moment on, the word "transculturalism" took on a new meaning for the assembled TRUE Agency team. It defined what we were about, how we wanted to communicate with—and be viewed by—the outside world. Post 9-11, it explained who we were, and how we saw the changing world. Transculturalism soon became our new agency's philosophical lifeline, because in that word we knew we'd found a convenient, one-word summary of our aspirations. Now, the hard part was defending that precious word—our turf—without diluting it. Hence the idea of this book, which should be read and understood as nothing more than an exploration of certain progressive world views and experiences.

This book is about identity, and the modern quest for belonging. Still, it's not about conforming. At its core, we will explore how certain curious, open-minded people manage, through perseverance and affinity, to adapt to new, alien cultures. The basic premise of this book, is that some individuals find ways to transcend their initial culture, in order to explore, examine and infiltrate foreign cultures. These people are "transculturalists" and their experiences—not to mention the results of the 2000 census—show that in the future it will become increasingly difficult to identify and separate people according to previously accepted delineations. In essence, we are saying that transculturalism defies race, reli-

gion, sexuality, class and every sort of classification known to sociologists and marketers. Transculturalists lead unusual lives, and some people continue to call them heretics. They date and marry outside of their race or religion; they date and marry inside of their gender; they travel on a whim and venture into faraway lands; they dress unconventionally, and customize new dress codes regularly; they live in areas their parents were once barred from, and take jobs previously considered outside of their leagues; they listen to, and create and criticize music they are not supposed to listen to; they display high levels of creativity in the arts and other progressive disciplines.

I am a transculturalist. In my case, transculturalism can be traced back to my initial transatlantic journey from the sandy streets of Lomé, Togo, to the curvy tree-lined roads of Washington D.C.'s Rock Creek Park neighborhood. This journey, which took place in the permissive Jimmy Carter late '70s, followed the itinerary of the eighteenth-century slaves, but in lieu of a plantation, my siblings and I landed in the official residence of the Togolese ambassador, who happened to be my father. Every weekday, we were driven to the French lycée in Bethesda, Maryland, and early on we learned to play, argue and compete with children—mostly diplomatic offspring like ourselves—from all over the world. With the help of bratty cartoons and beloved television shows like "The Jeffersons", "Good Times" and "Charlie's Angels", we mastered the American-English language (and Dy-no-mite Afro-jive) within a few months. On weekends, we were driven to other African embassies in a merry-go-round of African civility, but I was always asking for permission to sleep over at the house of my school friends Rodrigo Herrera-Vegas (from Argentina), Anthony O'Sullivan (from Ireland) and Amadou Thiam (from Senegal).

A model student, I knew that I longed for nothing more than to discover the world. One can only imagine how so very excited I was when I learned, in the early summer of 1983, that I'd be sent off to a Catholic boarding school outside Paris. The College de Juilly was a turning point, because all of a sudden I found myself one of a handful of black kids in a Franco-French establishment that prided itself on counting the great writer Montesquieu amongst its most celebrated alumni. At the cafeteria, older students would ask if they could land their palms on my nappy "carpet" and feel what a baby afro felt like. They would ask me whether we ate French fries and drank hot chocolate in my part of Africa. I was no longer in an environment where my fellow pupils were well traveled and educated on the cultures of the world. I had to adapt to a new, self-centered, self-serving mentality where every conversation had to do with the greatness of French culture, and the greatness of France's role within the world.

Little did it matter that few of these adolescent philosophers had ever ventured outside the comfort of their Parisian or provincial bourgeois homes. I soon found out that these kids were just repeating their parents' dinner table conversations, as adapted to the "histoire-géographie" lessons we were being taught in class. I felt somewhat ostracized until I met a French language teacher called Jean Ferret. Ferret became my first mentor as he opened my mind to those great French writers— Voltaire, Hugo, Baudelaire, Malraux—who understood and explained how one's life could get richer through the discovery of foreign cultures. By the time I got to college in Paris I had become a total hip hop head, and I'd learned to dissect the street teachings of A Tribe Called Quest, Slick Rick and Boogie Down Productions through the universal thinking of philosophers like Rousseau, Marx and Nietzsche. A political science student, I was also becoming increasingly disillusioned with the polarizations within President Mitterrand's French society and the rise of the far-right leader Jean-Marie Le Pen.

The first Gulf War ended on February 28th, 1991, my twentieth birthday. Pretty soon I would be on my way to London, where the Bristol band Massive Attack—then known as Massive because they had temporarily changed their name in a refusal to condone the war vernacular—had just released the album "Blue Lines". I was fascinated by the

atmospheric, cinematic sound and in-your-face hip hop attitude of this multi-racial collective, which was blending the hardcore beats and laid-back rapping I lived for, with the incredible old soul and jazz stylings they had somehow managed to fuse into new ska and electro mixes from ancestral Jamaica. In London, university classes were somewhat trite and not so time-consuming, so I pursued my real passion and became the budding music writer who could easily gravitate between the disparate worlds of Jewish Swiss Cottage, Jamaican Brixton, posh Mayfair and trendy Notting Hill. In 1995, I started a hip hop and street fashion magazine, called TRUE, out of the converted Old Street warehouse of my then-employer, the nascent style magazine Dazed & Confused, which was then led by its (appropriately named) editor Jefferson Hack. By the time the first issue of TRUE came out, I had met and hung out with the boys from Massive Attack, I had interviewed young British actresses like Rachel Weisz and Kate Beckinsale, and I had sat down with the rising artist Damien Hirst for an unforgettable "chat" at the celebrated Groucho club.

Now the young husband of a Jewish French-African 19-year-old, I started feeling like I knew everyone I needed to know, and that the challenge was to turn the magazine—now called TRACE and published out the loft where my wife and I lived down the road from the Dazed offices in Clerkenwell—into a creative space where my personal experiences and strange journeys could meet my friends and newfound collaborators' personal experiences and strange journeys. The backdrop to these transcultural voices of expression and self-reinvention was a publication devoted to music, art, fashion and global youth culture, but the mission could have been summarized in the prophetic title of a Tribe Called Quest album: People's Instinctive Travels in the Paths of Rhythm.

In 1998, the rent on our Clerkenwell Road loft was tripled when our lease was up, London got expensive and pretentious, and I found myself escaping to New York City on a Virgin Atlantic flight. Before our readers knew

it, TRACE had relocated to 476 Broome Street. Now, we are publishing TRACE magazine in American, British and French editions. In the Spring of 2003, we even launched the TRACE television network in France, Africa and the Caribbean, but we now also run the TRUE Agency think tank (called TRUE Intelligence) out of the same, expanded Broome Street loft. Rather than isolate our accumulated TRACE editorial expertise from the non-traditional marketing programs we are constantly asked to implement for our TRUE Agency clients, we decided to select the most relevant TRACE magazine articles from the last few years, and commission some new essays, analyses and relevant first-person writings for this book, which should be read not literally or linearly but laterally as an honest, earnest attempt to decipher and understand a new process of humanist thinking. In our instinctive travels, we have found that human beings from seemingly opposed cultures are much more similar in behavior than the media propaganda would have you believe. Reading between the lines, some optimists will see in this book on transculturalism a new roadmap for peace.

"The very street life of these areas is changing"

NEW YORK CITY NOW

BY **PETER LUCAS**

New York, in 2003, is possibly the most confident yet insecure Western city. After terrorism and recession has left its mark on the city, it stands at a political and economic crossroads, something that for the last 15 years had seemed unimaginable. With 250,000 jobs lost and a local government debt of some $5 billion, New York is seeking a new consensus, a communality of responsibility and understanding, within and outside the city's borders. Call it the "We Are All New Yonkers Now" ethos. Urban culture-wise, it could already be true.

Culturally, the seismic shifts have been less apparent, or less newsworthy, yet they are (constantly) happening. A new downtown-meets-Brooklyn music scene has emerged, staking a claim to NYE illustrious lineage; nightclubs have closed, often victims to extreme cabaret/dancing laws enacted by Giuliani, now enforced by Bloomberg; the recent smoking ban in bars and clubs also seems set to be a player in the nightlife's culture and economy. Hip hop, created in the outer boroughs, still thrives, but its economic contribution in NYC is small compared to its cultural importance as a NYC original export.

Alongside this flux, in neighborhoods from Harlem to Bed-Stuy, gentrification of formerly run-down black and white neighborhoods is continuing. The newcomers, coming from many different cultural backgrounds, bring new avenues of exploitation and communication with them to add to each neighborhood's culture, and with more people, working or not, in New York's 24-hour ecosystem, with time on their hands to mingle and explore these possibilities, the very street life of these areas is changing. Fort Greene, for example, in Brooklyn; formerly a black middle-class neighborhood, then a place of black flight, has been re-gentrified by both black and white couples and hipsters. Similarly, the "new" Harlem proclaimed by many. Although, surely, the only thing that can be new about Harlem is a reconnection and understanding of how "old" it is.

As possibly the most multicultural city in the world, certainly the Western world, New York City lays claim to many myths. Seemingly, it can only be the endurance of these myths that brings people, daily, to its collection of islands huddled in the Lower Hudson Bay. For on arrival, unless you were to spend all day staring at the vistas of steel and water, there is all too much reality in New York to deal with. The myriad of nationalities crammed onto any given city block or any given subway car represent a victory, of sorts, for the American Dream. Well, they got here. But, what do they make of it?

Atomisation seems part and parcel in NYC. A version of the attitude that both propels every-

one and keeps the city together, in its place. If it broke apart, or in other words, if different nationalities really started communicating, speaking their shared lingua franca—English—then things would get even more interesting. In my neighborhood, which depending on who you ask is classified as either Boerum Hill, Cobble Hill, Carroll Gardens or even Downtown Brooklyn, the urban mix of African-Americans, Puerto Ricans, Dominicans and Italians—the old-school neighborhood—mixes with the professional 30-something couples and the 20-something post-college professionals and hipster/slackers. It's an interesting, if not entirely unusual, mix in many parts of Brooklyn, which itself has undergone big demographic shifts in the last 5 years. Years ago, visiting NYC and staying with a friend in the East Village, the merest mention of Brooklyn would cause many to raise eyebrows, laugh hilariously or nervously. This year, at work, when asked to comment on the sex appeal of a model for a magazine cover, I remarked: "She looks like she could come from Brooklyn." Translation: Real, from the streets and no more or less ethnic than anyone else. The Editor-in-Chief of the magazine stopped and looked amazed, until another editor, a born-and-raised Manhattanite explained: "It's all about Brooklyn. We don't even know." Well, quite.

So how did fashionista magazine editors get wrong-footed? And, a lot more importantly, is the new gentrification and relocation (shift in the cultural balance) going to help or hinder New York's reality check which has been the last two years: economically and socially. Having lived around in the newly gentrified Brooklyn for four years, observing the shifts in all the demographics, it seems that like many things in New York these days, things have reached a peak of sorts: unemployment, taxes, subway fares, yet in this city, frustration probably remains the same, just a part of the everyday mix. Hope and the promise of eternal flux is the real arbiter of change in New York City. Not anything singularly concrete.

In the 2000 census, it was shown that immigration into NYC is at its highest levels now since 1910. It's a testament to the enduring reality of the city as a capitalist utopia, but surely something more. A city where everyone from dis-affected runaways to established families can come and find some common ground or a chance to start again.

And, in 2003, it's the starting again, collectively, that is where New York is at. Maybe it's just a mental process, but nobody who walked the streets, smelt the air and looked upon the faces here will forget their senses in the days and weeks after the events of September 11, 2001. Two years on, the cost, financially and otherwise, has been more completely calculated. The city is back in the mire of the dysfunctional economics of the 1970s and 1980s. The days before recycling, low crime and the new Brooklyn and Harlem renaissance.

Of course, those who have been here all along, which doesn't include me, a long-term visitor and now resident of 5 years, know very well the city isn't about this. A few months back, in Tower Records downtown, perusing a copy of Time Out New York, I was struck by the comments of two guys walking through the store. On seeing the cover of the latest issue: "The Harlem Renaissance", they laughed. "Yeah, sure. But no one can afford that shit."

So, in the aftermath of both the attacks and the late '90s boom and now bust in the city, what will provide a well-rounded renaissance for as many as possible? Even just on the surface. There seems no doubt that the culture of the city itself, the living organism that draws and keeps people plays the vital role here. The greatest thing in New York's favor, particularly as it tries to emerge from its current, and unexpected, notoriety is its social and cultural infrastructure. Politics, too, always a true dogfight in this town, provides a continuity. It seems hard to imagine a New Yorker who regards the President as having more daily control over their lives as does the Mayor. Daily commenting on every aspect of people's lives. Interfering, and unnecessary, yes, but probably also, some kind of lesson in true civics.

But it's the culture, economic and social, for those from here, and those that came, that provides the route forward. This is a city not just of the usual movement: cars, taxis, subways, foot traffic, but of all the people, goods and services. It's all sold, legally or otherwise, in the streets or

over the phone in New York. From the African watch sellers by South Street Seaport to Chinese salesmen on Canal Street to the bootleg DVD sellers in Downtown Brooklyn, they're all there. It's just the tip of the iceberg. Surely, if someone calculated the black, or even grey, economy of the city and added it to the regular economic flow, there'd never be a problem of revenue again.

It's all in the exchange here. Of money. Of time. Of business and commerce. But in all this, the cultural connections continue also. It's observed and understood by the locals, as well as visitors, who buy these goods on the streets, and by any one who goes into a deli or corner store and sees who is serving behind the counter. In this city, every day, most people encounter and have exchanges with several, sometimes many, people who are not native English speakers, but who know the basics because that's how they live.

Perhaps, I've often thought, the functional nature of language and commerce here, so intertwined, is the sophisticated heart of what makes the city tick. On the surface, a basic, almost brutalist, rude and noisy (see: the subway) exchange and environment for communication and exchange. But with all these languages and cultures both flowing freely yet being "forced" into an American identity, albeit for the hours of business, you begin to wonder how much decoding is going on here.

On the subway, where I've witnessed some of the crudest examples of people's behavior to each other, and some of the most heartbreaking examples of human tragedy, often on the same ride—all too often—it leads largely (you can see it on many people's faces) to a wry smile; some understanding, some empathy. In these instances, New Yonkers may decide to keep it to themselves, that's all. Or, because it is New York, they'll just turn to you to share it—straight away.

In such a commercially zoned and racially mixed yet separated city, it's fascinating to study the subways and streets as much as the bars and nightclubs. I don't see as many different races in the bars I go to (maybe it's my fault), but would prefer if the bars looked like the streets. But I have found something like a shared space of relaxation and casual mixing in Fort Greene. It's

called Frank's Lounge. A place I hadn't found before in New York; one that reminded me of bars in Oakland years ago, and to a degree the South London of my upbringing. It's not the entertainment—there's always something or someone different singing, djing or performing on the small stage—but the local flavor. One that is equal parts static and renaissance in this neighborhood. As Frank himself once told my friend: "I've been here 29 years, and I've made all my money in the last 3."

There may be no justice in the world, or in this city, but there are tales and realities. These are just a few thoughts on a few observations over a few years. Frank's observation is but one tale of the city, but I can well imagine the reality, wryness and sophisticated understanding behind his comment. I can't think of one thing that New York, this city of motion, expectations and business—all in the broadest sense—is more about than communication. The gentrification exists; it did before. Maybe if it's not just understood, but talked about, in the way that most things are here, it will make more sense. It might even work out.

People need a place: to live, to come, to exchange. In the United States, New York, probably, still, after all that has happened in recent years, offers that best. Or, if it's all about simple quality of life issues, then you shouldn't be here. The average wage in this city is around $30,000. That tells you more about most people at the bottom end of the economic spectrum than at the top. Most, in this city, being about 80% or so, probably. Yet still they come, from everywhere, and they stay. It seems that they must know and understand the deal, something that people outside the city, or maybe people in the four corners of the earth know. This is a city of Transculturalism. And of Transculturalists.

It might not be easy, but it is real. For now, all things taken into account. It might still be enough to get people through.

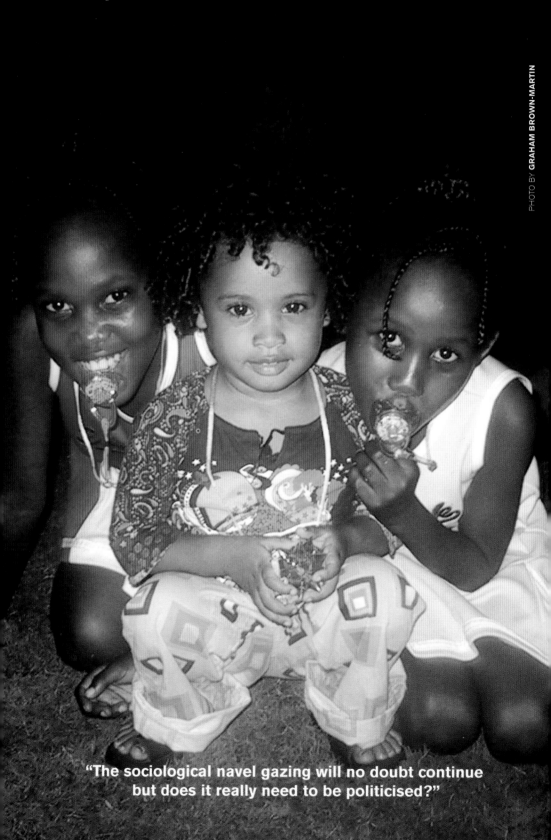

"The sociological navel gazing will no doubt continue but does it really need to be politicised?"

THE RISE OF THE MIXED RACE MAJORITY

BY **GRAHAM BROWN-MARTIN**

During the last general election in the UK, John Townend, at the time a representative of the Conservative party, suggested that Britain was "in danger of becoming a mongrel nation". A nail in the coffin for the party during that election at least. By his comments he was implying that Britain's "homogeneous Anglo-Saxon" society was being undermined by immigration. A typical hue and cry ensued, the MP fired and the party lost the election.

Around the same time, UK black-orientated radio station Choice FM along with various print media such as Pride and the Voice ran their frequently mono-cultural angle on the perils of dating outside your "race" with all the usual arguments about cultural identity issues and blah blah blah...

However, walk around a park or even a supermarket in South London, and you will see the shifting visual demographic that offers a window to the future of urban cities, not just in the U.K. but potentially everywhere. Within half an hour during a mid-week shop, I lost count of the many mixed couples, most with children. Practically every variety was to be seen in this Benettonesque landscape, West Indian with Chinese, white British with African, Pakistani with Jamaican, Indian with white French and so on. The notion and history of mixed race is a long and complex one, an entire book in itself. But even the term 'mixed race' is a dubious one given that practically everyone is, certainly the

British who have such mixed ancestry as well as being responsible for much of the mixing during the colonial times. So the term is often used as a code for a black/white relationship.

So perplexing, in fact, was the notion that up until 35 years ago, it was not permitted for 'blacks' to marry 'whites' in the U.S., although there has never been such legislation in the U.K. During the British colonial period, white men had sexual relationships with black women. In relationship to the African diaspora, these women were often slaves, although in India it was not uncommon for senior white officers to live openly with a concubinage of long standing with Indian women.

Even in the 21st century, the discussion of mixed relationships draws an equally mixed range of opinions. At a party in New York, I had the pleasure of meeting a mid-30's guy of Dominican descent who described himself as African-American. He gave me a rundown of what he considered to be the issues regarding mixed relationships in the U.S. It was a Rubik's cube of logic that effectively assigned status to race like it was cultural pokemon. The logic explained why a black guy would date a white woman, but not why a white guy would date a black woman. Such a guy would be deemed as being 'experimental' in the U.S. Well, it was late, and we'd been drinking, but I think I caught the gist and both of us agreed it was toss.

But it does illustrate the sort of absurd attempts to identify the 'reasons' for transracial dating and marriage. Few of them mention love, however. Amongst the most ridiculous are the suggestions made by a minority of black men, who argue that black women are dominating, too independent, with a gold digger mentality. White women, therefore, are regarded as submissive by comparison. As a white man, divorced from a white woman and now married to a black woman, I would like to take issue with this.

Independency is not a genetic trait; it is something that is socially imposed. One could argue that, in certain circumstances, black women have had no choice but to be independent often because of economic factors.

The debates go on, an article by Ekua Intsiful suggests that black women, perhaps in a playground battle, are dating white men because so many black men are dating white women. If you flick around the television channels, you'll eventually find a chat show hosted by Queen Latifah, Ricki Lake, Oprah, etc that debates this 'phenomenon'.

It seems that among the younger generation of Americans, dating outside your race is no big deal. I spoke to Scott, a 17-year-old black guy living in Michigan who dates a white girl. He really didn't see it as an issue and certainly wasn't pondering on the political nuances of such a relationship other than her grandfather wasn't best pleased. However, on further discussion, it turns out that the grandfather's fears were fed by the portrayal of black men by the media.

The sociological navel gazing will no doubt continue, but it just could have something to do with common interest, lifestyle, culture, outlook and all the usual things that draw two people together. Does it really need to be politicised? It's inevitable that as cultures and people converge, they will mix.

Here are some figures from the U.K., which has one of the largest number of interracial marriages in the western world.

50% of black children born in the U.K. have one white parent. One can argue over the term 'black', but that's western society for you.

In a study published by the Observer newspaper, it was reported that 54% of people interviewed (from a cross-section of British society) would consider marriage with someone of a different colour. In the same report, it was shown that 18% of people had been or were in a mixed marriage, and that 53% would consider having sex with someone "outside their race".

Despite the fears of "mass racial interbreeding" voiced by racists (from various cultural groups) during the 1950's, Britain now has the highest number of racially mixed relationships in Europe. Today, one in eight children under 5, born in Britain, are of mixed race. Given the cosmopolitan nature of London, where according to the National Office for Statistics, 47% of Britain's ethnic minorities (!) live, one can confidently expect a brown-skinned majority in the not-too-distant future.

So what does this mean, apart from great looking kids with difficult to manage hair?

Well, one can hope for a more tolerant society, but let's leave that for the political pages. In many ways, the U.K. has already seen the benefit of a multicultural society. The rebirth of London cool and the political notion of "Cool Britannia" had more to do with the fusion of ideas and experiences from the many cultures represented there. The style, music, design, art and modes of expression emerging from London and other urban centers in the U.K. have clearly demonstrated an amazing cross-pollination of talent.

Whereas, for example, New York's urban culture might be identified through hip hop or R&B, London might be identified thru drum and bass, UK garage or ragga. In the U.S., the word "urban" seems to be a code word for "black", but in the U.K. it tends to have a different interpretation, more inclusive of the cultures it represents. Proper UK garage or drum and bass can't really be described as music of any particular colour or race.

Looking at London, it's clear that the influence of a mixed-race society is being felt on the shop floor of retail. The notion of beauty and how it is represented is challenged by the population it's aimed at—as are the range of product offerings. It would be wrong to assume that

the U.K., or London specifically, is a jewel in the crown of racial harmony. The far-right British National Party scored a higher than expected number of votes in government elections, and there have been many atrocious incidents of racial violence. With the western political world's preoccupation with right wing politics who knows what might happen in coming years?

One might hope that the influence of cultural convergence occurring in London and other urban centres will serve to make the world a better, more stimulating, place. To paraphrase a mobile phone companies slogan: the future's bright, the future's brown.

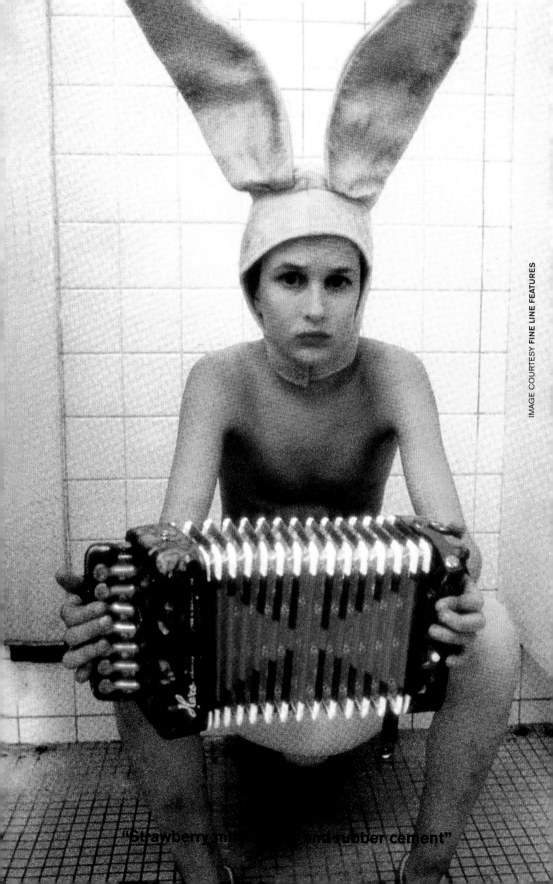

"Strawberry milkshakes and rubber cement"

NEW AMERICANA

BY **ANICEE GADDIS**

Nostalgic postwar America as Dystopia.

I grew up in Atlanta in the 1970s, during a decade when the pulse of the city eddied between post-Civil Rights activism and bohemian counterculture revivalism. I was born in 1971, the year the Blaxploitation films "Sweet Sweetback's Baadasssss Song" (Melvin Van Peebles), and "Shaft" (Gordon Parks) revolutionized the look and feel of popular black culture. A year later, Parks's enduring hit "Superfly" was released on the wings of its forerunners. Curtis Mayfield's ingenious and paradoxical soundtrack–at once a celebration and a critique of the film's "gangsters rule" conceit–continues to populate my imagination with images of femme fatales and fly young bonhommes. Like "Sweet Sweetback's" and "Shaft," "Superfly" foretold a dynamic, if short-lived, new wave in cinema: an unapologetic homage to emerging post-Civil Rights blackness.

In 1973, the photographer Walker Evans published "Polaroids", a book of images taken with the then technologically progressive SX-70 instant camera. "Polaroids" was his second major work after 1941's "Let Us Now Praise Famous Men", an arid memoir of utopian nostalgia for the post-pioneer days of the American south, with text by the Pulitzer Prize winning journalist James Agee. (The postscript to "Famous Men" might be Sergio Leone's 1983 "Once Upon a Time in America", a film that captured New York's Lower East Side gangster culture–portraying an even darker side of the American dream–and drew inspira-

tion for the photographs of Jacob Riis.) If "Men" focused on the plight of poor Alabaman tenant farmers–via the predominately Irish, Italian, German and French immigrant make-up of the time–"Polaroids" removed the face and concentrated instead on the language of America, through vernacular architecture, shovels, kitchen spatulas, blueberry pies and roadside signage. Rumor has it that Evans conceived of "Polaroids" a few months shy of his seventieth birthday, while visiting a friend in Atlanta. The dueling imagery of "Superfly" and "Polaroids"–pre-ghetto fabulous versus post-Depression melancholia–would provide the visual scrapbook of my childhood. Alongside the Bollywood movies I watched at the local theater after ballet classes, these two gazes would also provide my earliest working definition of America.

It wasn't until I went to boarding school in a Mid-Western city, located on the fault line dividing Indiana from Illinois, that my world expanded beyond what I considered to be the rich funk of Atlanta. At age 12, I was sharing classrooms and dormitory suites with Caribbean Americans, Latin Americans, Mexicans and Texans, not to mention transplants from Saudi Arabia, Israel, the Dominican Republic and a token exchange student from Tokyo. Although the cultural shift was mind-bending, I was too young and unformed to fully process my rapidly changing world. I learned bits of Spanish and Arabic. I discovered the history of Chihuahua, Mexico and the sonic subculture of Tokyo, thanks to

my roommate and her boyfriend. When I reported back to my mother, she looked askance at me. She had come from a small farming town in Indiana (the same as cornfed rocker John Cougar Mellencamp, who coincidentally was her second cousin). With each visit home, my enthusiasm to shed the old and embrace the new increased. To her credit, my mother was willing to accept the inevitable; she began to experience my wonderment vicariously.

At age 13, I discovered New York. In my mother's overzealous attempt to make up for lost time, we visited night clubs like the Roxy, the Limelight, the World and Save the Robots. We also visited Bloomingdales and Central Park, outings which paled in comparison to the ebullient underground '80s culture. Needless to say, my head was turned around for the second time. By the time I returned to New York for college, I was rabid for newness, and absorbed each experience with greedy abandon.

The final stepping stone during those formative years, and what turned out to be my great leap forward, was my discovery of Europe, and specifically France. If the journey from the Mecca of the South to the Mid-Western heartland to East Coast urbania was eye-opening, Paris was another universe, another paradigm entirely. It was also my first view of America from an outsider's perspective. As I would come to understand, the French were equal parts watchful critic and reluctant voyeur of my distant shore; the new empire was teeming with sexual energy, cultural diversity and a kind of gauche-glam pop-culture aesthetic all its own. Overall though, they tended to view North America as a grand social experiment gone awry; "Americana" was a quaint paraphrase for a Depression-era nostalgia quickly becoming passé. I would also learn that the French gaze of fixation on America was nothing new. Johnny Halliday, the '60s French rock idol, who was, and still is, celebrated for his reinterpretation of the Elvis persona, à la française, remains a popular icon. But even before that, as early as 1835, the political theorist Alexis de Tocqueville wrote "Democracy in America", a socio-political treatise that would predict with remarkable

insight the future trends of the promised land. Of the immigrant population, he noted: "They had not been obliged by necessity to leave their country; the social position they abandoned was one to be regretted, and their means of subsistence were certain… In facing the inevitable sufferings of exile, their object was the triumph of an idea."

Indeed the concept of the "idea", of an original thought born of multiple influences, has always been one of the saving graces of the American vantage point. If England had capital and France politics and culture, and both a history of colonial imperialism, the new country—a kind of bastard spawn—had historical and intellectual freedom. After shamefully and impetuously cleansing their new home of its indigenous Native-American population, and thereby creating a cultural desert, the early settlers literally started from scratch. A new constitution, a new class structure, a new "American" dialect and dialectic were given birth; originality and invention became the necessary tools for survival. It follows that the new country proved a fertile testing ground for unorthodox, at times outlandish behavior patterns, clothing styles and modes of governance; the idea of a self-governing democracy was regarded with a mixture of cynicism, curiosity and thunderous amusement. Nonetheless, there was an undeniable sense of potentiality associated with the new world. Uninhibited by the shackles of cultural sovereignty, the pioneers would gradually pull apart and remake old world customs and rituals into a new hybrid cornucopia. It was another Frenchman, philosopher Jacques Derrida, who made the memorable declaration "America is deconstruction".

Upon my return to America and New York, I began to see my homeland with new eyes. I began to appreciate it as a creative forum, and the birthplace of the extraordinary: our track record included jazz, the hula hoop, baseball, the atomic bomb, graffiti culture, the vaccine for polio. We were the first country to put a man on the moon. We were the first to invent and promote the worldwide phenomenon of hip hop. I also began to understand the postwar timeline of '50s Puritanism, followed by the '60s Civil

Rights movement, the rise of social consciousness in the '70s and the conspicuous consumption backlash of the '80s. What other country has undergone so many radical ideological shifts in such a brief period of pre-millennial tension? For the first time I began to understand why the rest of the world had mixed feelings about us.

One of the most revelatory portraits of the current state of the union is Harmony Korine's brilliant, incisive and fearless film "Gummo". Released in 1997, it is Korine's follow-up to "Kids", 1995, a controversial documentary expression of urban youth culture, co-written with filmmaker Larry Clark. If "Kids" is abrasive and provocative, "Gummo" offers a more intimate and quietly subversive take on American youth. Set in the no-man's-land of Xenia, Ohio, it is at once a glorification and an unveiling; it is "white trash" idyll: a pastiche of rural Americana raised to the sublime. In the opening scene, Gummo, the protagonist, and his friend Dilmore kill cats with b.b. guns, which they then sell for cash to a black vendor who pawns them off to a Chinese restaurant. The boys spend their booty on strawberry milkshakes and rubber cement glue, the two escapist elixirs of choice. A few scenes later, we see snapshots of Dilmore posing and preening to a voiceover: "He's got what it takes to be a legend. He's got a marvelous persona." In the next frame, we learn that he's on his way to an insane asylum, where he intends to find himself "a raving beauty". What follows is an uneasy joyride through a backwater panorama of freaks and angels. The beauty of "Gummo" is its treatment of the typically American constructs of Metallica, obesity, social alienation, pet abuse, Pamela Anderson and Patrick Swayze, tap dancing and arm wrestling in unprecedented and haunting ways. There is a dreamlike sequence in the movie, where a mentally retarded woman shaves her eyebrows with an infectious, unadulterated joie de vivre, followed by a young boy playing an accordion in an empty toilet wearing bunny ears. The sequence closes with a sign stuck under the windshield of a parked car announcing a missing cat. If that isn't a true-to-life portrait of quintessential small-town America, I

don't know what is. The apex arrives in the form of a plaintive observation made by the anti-hero cum local legend Dilmore: "Without wood there'd be no America: no ships to bring the pilgrims across the ocean, no log cabins, no school houses, no churches, no covered wagons, no railroad ties, no cigar store Indians, no nothin'." The film draws to a close with footage of the tornado that originally destroyed the town, set to Roy Orbison's anthemic "Cryin'", and topped off by the boy with the bunny ears holding up a dead cat. It is a moving portrait, a mixed bag of survivalism and quackery passed down through the ages, as well as a loaded statement: the nostalgic utopia of postwar America is ultimately a Dystopia. It is also evidence of the challenge implicit in the idea of self-claimed freedom.

All of which is to say that Americana, more than material reflective of America, is the look and feel of the country: from the Appalachian trail to New York's concrete jungle to the Nevada desert; the sound: from Johnny Cash to John Coltrane; even the smell: from Detroit's factory exhaust fumes to Georgia's dogwood blossoms. It is low rent camp and high brow art. In the twenty first century, the concept of Americana has gone even further, becoming a kind of transferable marketing phenomenon. Evidence of this arrives via Danish filmmaker Lars von Trier, whose work "Dogville", filmed on a soundstage in Sweden, aims to capture the mood of a tiny Depression-era town in the Rocky Mountains. Master theorist of the Dogme 95 film movement, von Trier, who has never visited the States, succeeds in rendering an emotional canvas. The ultimate proof is when he shifts from his abstract Rocky Mountain landscape to the failed American dreamscape of poverty, euphemized as welfare, captured by America's own photographers, including Walker Evans. The irony is that in recreating his own fictionalized America, von Trier succeeds in portraying a reality that is arguably more resonant than the actual model.

In 2002, the British filmmaker Isaac Julien released "BaadAsssss Cinema: A Bold Look at '70s Blaxploitation Films", a documentary which revisited the socio-political backdrop of the rise

and decline of the movement and its abandoned place in film history. While rewatching the films of my childhood, I realized they were without a doubt more viscerally engaging and baldly politically taboo than the steamiest action thrillers of today. On the other hand, the polarization of "bad ass" black superheroes against "bad" (as in evil) white cops felt, heavy-handed, even taking into account the superreal context. As a child I had not registered this, had moved comfortably between race and class lines, and even ethnic and religious sub-cultures. If America truly is the libertarian melt-ing pot it purports to be, shouldn't tolerance, curiosity and even natural fusion—a kind of national transculturalism within the continental arena—be the dictum of the day? At a Harvard Symposium on the future of African-American Art, scholar Henry Louis Gates, Jr., declared the presumption of "cultural sovereignty" to be ultimately futile, primarily because we live in a country where demographics are changing too radically to adhere to an outdated agenda of Thurmond-esque segregationist politics. Were Walker Evans to reshoot his "Famous Men" today, or even the more generic "Polaroids", the results would be as physically opposite as day and night. The opening "rave" scene of the Wachowski Brothers' "The Matrix Reloaded", 2003, is an ambitious effort to portray a futuris-tic transcultural society (in this case "Zion", the last free city on earth), where color, religion and ethnicity are fused into one grandly and chaotically unified tableau, that coincidentally faces extinction from automated enemy forces. Although it is a Hollywood spin-off, there is an important underlying observation; the changing landscape, the shifting demographics, invite new possibilities coupled with new dilemmas.

In the end, whether we are talking about America or the broader global family, we all share at the same table; our lives are the same stories retold and divided often by a mere hair's breadth. The attitude that will see us through to the future must be a bold, empa-thetic approach to life, in all its diversity.

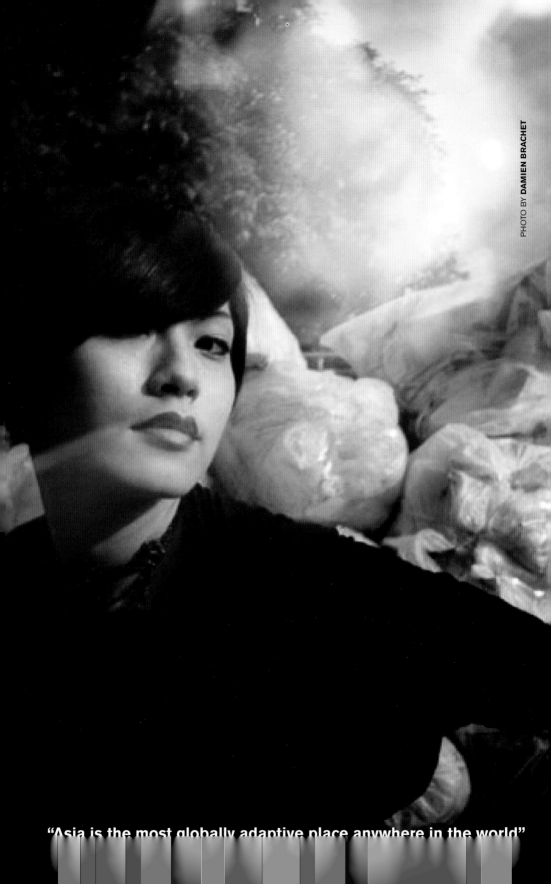

"Asia is the most globally adaptive place anywhere in the world"

EAST-WEST

BY **DAMIEN BRACHET**

The flight from Taipei to Paris, via Hong Kong, was full, noisy and nobody wore masks. Transit in Hong Kong Airport: clean looking, safe, it could have been anywhere in the world. Sleek ceilings, thick grey carpet, piano jazz soundtrack, a vast designer hospital. The surprisingly soft chatter of the duty free bazaar is initially welcome, as if it were a strictly "no Cantonese area". People of every origin floating in a trance, lounging in a Prozac state of partial high, under the spell of soothing mantras: electronic, architectural, linguistic. Clutters of Asians sipping their convivial soup one hour before departure... We are far from the extravagant medinas of mainland airports, in Bombay or Guangzhou. Hong Kong's never been so quiet, it's creepy. Only a trio of vague Commonwealth louts dare disturb the grey-greenish peace. But every face turns back with an indifferent shrug, busy sipping Starbucks coffee, reading Cosmo, shopping for LV, Marlboros, J&Bs and American car magazines. This is modern Asia as first enforced in Singapore and Japan, and now standard goal anywhere along the bustling Far East Coast. It's modern Asia under the patronage of the West for a complex protection fee, also measured as "added value", under negotiation within the W.T.O. A modern world fantasized by Europeans and Americans according to their tastes and education, manufactured in Asia and re-exported with a hefty designer fee.

Changes. But not changing together... Shouldn't Western-style modernization be creating more ruckus and chaos in continental proportions? The answer is always: that's no excuse to draw attention! Don't rock the boat. At the risk of unfair generalizations, let's enjoy the amplitude of sliding, sweeping statements since we're a little early for transit: Asians, Africans, Europeans, Americans, Oceanians, rainbow people of the same biosphere. So, Asians never raise hell in public. They deal through life's tests with patience and agility, persevering stubbornly for the big pay-off some time somewhere, preserving and duplicating riches, to in the end inescapably squander it all away... And even then, still no sign of anarchy, coming from such tribal hordes of exuberant, loud spirits. Because thousands of years of inequality, suffering and catas-

trophes, and a history far from resolved, have taught the Asian brothers and sisters a deeper wisdom: self discovery, inner bliss, warm rice and a roof. The sharing of Love and Happiness in a higher state of consciousness, an all-encircling "Om" in glowing neon, approximately half a pitch higher on the treble dial. That's what Westerners call Asian spirituality, and flock to spas, resorts, treks and full moon parties to partake in. A transcendent grin. Why make trouble, why worry? Whether building families, empires along the Far East coast, eating or singing and drinking, Asians are far beyond such primal emotions as anger or vanity. These are the attributes of short-sighted, prejudiced, naive Westerners or excitable, cynical Africans. These same lowly trappings have cost dynasties their posterity.

So Asians keep to themselves, wrapped up in traditional garbs: shawls and robes, jeans, T-shirts and windbreakers, coordinated pantsuits, nodding quietly, instantly reinterpreting the world around in traditional, simplified, phonetic, iconographic, digital and now abbreviated Roman signs: Asia's consuming so much of the West, it's started to produce it. Giant, sprawling, interconnected malls in every language, driven forth by dreams of fortune and ladders of delusion. East, West, ginger steak, lemon chicken, who knows who's who anyhow? Gap has sprouted dozens of multimillion dollar competitors. Giordano in Hong Kong, Naturally Jojo in Taiwan. Fashion, pop, action movies, television... A global culture indeed, looking strangely like a commercial/residential community anywhere in Suburbia. Safe, easily accessible, recognizable, resellable. One look at modern apartments anywhere along the Far East Coast reveals the same symptoms of Western aspirations: the living room has re-centered around a huge TV/karaoke set, away from the even more cumbersome altar. Framed pictures of graduation, diplomas, babies and pets, holidays through airports and coffee shops. Cupboard shelves display not books but bottles of VSOP. The television is perma-

nently on, spewing daytime local series, gory news and celebrity game shows.

There is no question that every urban population across the planet now is severely Americanized, whether they like it or not. It was a running joke in Paris's literary circles, referring to the century-old flow of Chinese artists seeking refuge, that one week on the Left Bank was enough to close a chapter of 10,000 years of civilization. But, back home in Asia, the throngs of emerging middle classes all celebrate fantasies of American success: from fashion to diet, entertainment, "business spirit", language, lifestyle goals and female beauty standards. Plastic surgery has boomed since the '80s for double eyelids and breast implants, producing a whole generation of mothers looking like Joan Collins. The Westernization of the East had started with a first wave of Europeanization with electricity, social dancing, recorded music and pictures, three piece suits, drugs and Communism, and was overrun by the Second World War Americanization of the entire "Free World", Europe and Asia alike: from MacArthur's new Constitution in Japan, to American forces and dollars in South East Asia, the "Voice of America", comics, movies and rock and roll... Not only was Asia waking up from centuries of obscurity or colonial domination, to the individualistic tones of freedom and short skirts, its urban boom brought to action its formidable, historical adaptability. Never mind the prude rebuttals of "white demon" culture by stubborn parents against their daughters' emancipation. The merchant elite and families who had saved all their lives sent their children to predominantly North American education, counseled by Baptist or Methodist or computer nerds. Call it well invested anti-Communism. The '70s were topsy-turvy, and their growing pains are far from over. Let's not stop at skinny Asians in bell bottoms: at least men had as their (only) role model Bruce Lee, while their wives fought widespread macho barbarism, armed with education and big hair. The '80s generation of ABCs

(American Born Chinese) was a square, scary set. Buttoned up, quiet, disciplined, hard working or discreetly goofing off, staring into space eyes half-opened, looking enigmatic while plotting for global takeover, taking jobs and money with a gentlemanly smile, learning fast, reinvesting, building forts, territories. To that effect, Asians abroad know how to use the minority report card as a simple, "gweilo-friendly" ("foreigner friendly" in Cantonese), zen social interaction. Forget the bravado of Africans or Latinos. Behind the pleasant, innocuous fence, is the sound of a gentle brook, whispering softly, the flowing trade of money, economics rising like waves…

A sea of change to surf for eternity, for a while… Not like white surf dudes turning death-defying tricks, but standing abreast, highest dolphin among highest kites, pulling a dragon constellation of family and friends, spinning orbital destinies, entangled in life or death, in presence or absence, all reflected as complementary projections of each other. Out there, the blinking charms and chants of happiness, fortune, health, luck, prosperity, are more than cultural folklore: they serve as calling cards in the confusing cycle of life. And now that folks got Internet, the world is theirs for the taking! Cousins in far off mountains are catching up with a year of night classes: an ancient survival instinct has taught every sacrificing mother the fruits of education. It was confronted to foreign lands, danger, fear of the unknown, as such not unlike young Americans, with all the genocides and wars, that Asians have grown and built civilizations more advanced then our present Western one on many levels: medicine, science, arts and a complex wisdom made of stubbornness and coolness, simplicity and superstition, a certain working familiarity with absurdity. All Asia needs to conquer is ignorance. It is very slowly rising to dominate the world, in economic and cultural power. For good or evil, it could reign supreme by its sheer progress and scale. Indeed current trends seem to be appropriately twisting to fit a fabulous melt-down, hailing perhaps the self-destruction of Capitalism at its extreme expression in Asia. Scruffy old Asia might very well surprise everyone and mess it all up faster than the West… One elegant way out would be the future coming together of the East and West, but through the back door seas, extending the Pacific's bicoastal grip on half the planet: with the ocean acting as a gigantic hotpot of natural resources, Asians from both sides of the steamboat are manufacturing, designing, programming, cooking and consuming the rest of the world. And visiting Europe for tourism. It would close an extreme generation gap that holds the promise of a long forgotten kin, echoing the "Indian" civilizations long before European colonization. Formidable jumps in human knowledge, through adaptation and death, pioneering rebirths of the ancient into the young. Seen on a large scale, or from outer space, human progress could be assimilated to disparate, self-regenerating growths on the surface of the Earth: black, white, yellow, red, brown… Fighting for space and resources, we curb and mutate our material world to accommodate asymtotic population changes, just as a feisty predator, a viral strain, or other prolific varieties of moss on planet Mars. We reinvent ourselves and adapt to our position in the food chain, gliding across the globe like fantastic cloud formations or climactic cycles or so many anti-cyclones of inspiration, production and desire. Dream and fantasy, moving rapidly across the lands and seas, along skylines and populations, rising chains and bursting synapses, crops of megapoles growing and dying. The fun part with humans is it makes for good stories to tell, for a species so unadapted naturally to change, and so ensconced with fanciful memories.

So now it is time for Asia to show off, because it is the most globally adaptive place anywhere in the world. It is perhaps the strange, not apparently useful wisdom of having partied for thousands of years, improvising drunken poems to the Moon, songs which would outlast wars and emper-

ors. Likewise, Europe's epicurian "art de vivre" may be heavy on the taxes now, but it is raking in some profits: tourism and locking a position in the world's memory, for eternal posterity. A formidable feat in just 2,000 years! And how will Asia fare in the 21st century, under the dollar whore? Will it not become a massive manufacturer and consumer of Western products, a gigantic pulsating, digesting, secreting pump supporting the lifestyle of an aging G8 minority? Just as inequalities grow, the world's middle classes are rushing to the upper deck of the boat, forking over their past and baggage for the big transcultural couch in the sky: discount bin lifestyle designer good, DIY, deliverable. Paris, New York, London, Rome, Rio, Tokyo, Shanghai, are all available in a special box set. A lounge music compilation, a fashion magazine feature, a restaurant menu, a costume party, a theme park, it's all an international fiesta of style.

It is finally time, after much democratic toil and bubble, to enjoy the revolutionary Western invention: the personal credit card. The booming Asian rush for middle-class affluence, initially propelled by Western-style liberalism and the (basic) rule of law, is now contentedly satisfied with a yearly group tour through Europe or Canada— check the photo albums. All one needs is a few night classes of conversational English ("You can do it!", "Give me Five!!!!!", "Oh yeah!"), a disposable collection of pirate video discs, regular updates on what's being sold at fashion trap boutiques. What were once emblems of the West, are now international franchises: McDonald's, Louis Vuitton, Chanel, Coca Cola, Harry Potter, Eminem, all digested as local, integral status symbols. Ostentatious Western influence is no more limited to university literati in turtlenecks and berets (typical Taiwanese art scene), or Tokyo's specialized connoisseur press and otaku collectors on TV; gone is the conscious "foreign" affiliation with all the disgrace attached to such marginal behaviour, the modernist act of rebellion polluted by the progressive illusions of a childish Western world. In our time's distribution networks, eBay, Warner Village, HMV, Costco, Ikea, any smidgen of White Devil social smut is immediately vacuum pressed and logo-doggy-bagged for premium card members. Today's youths all flash J-Lo navels and Ben Affleck casuals, but it epitomizes the successful marketing of personal brand value, more than the triumph of the West. The West is an expensive, taxing dream, for overweight Asians, soulless, money grabbing whores of the Golden Calf. It is to be consumed with moderation, one holiday package at a time, or to extol the follies of youth in grad school. Now the East is completely self-sufficient, all absorbent, but not shock resistant: mother Nature's always stronger. It is a new Renaissance, millions of lives toil and die as slaves, or as tycoons with a private bottle in every piano bar. The West, the funny neighbour across the street, is a big junk dispenser, gadgetizable ad nauseam for an average trial period of six months. And even then, the East has become an early adopter of mass consumer practices long before the West, as in take away food, pagers, mobile phones, karaoke, reality TV…

Seen from the East, the (Far) West is so "over" it's "VER" (super magazine from Thailand). While the "free world" gobs up Justin Timberlake and Craig Davis, Asia's been taking Western artistic forms further: Yellow Magic Orchestra's techno pop in the '80s, Cui Jian or the Fly (Beijing), Lin Jiang (Taipei) or Ua (Osaka)'s raw underground rock put Morphine and the whole Limpish Bizkits and Lilith Fair to shame, Towa Tei and Mondo Grosso are up there with Masters at Work or King Britt. The axis of births and deaths has repositioned to the Pacific Mediterranean, a repository sea cap nurturing the rest of the whole world's crawling and reproducing amoeba. It is heating and boiling with the agglutinate, sucking vacuums of almost half the world's population. Its cancerous explosions glow as bright and red as the megawatt flares of

sun storms and starbursts. Speed building megapoles of industry, standardized housing developments covered in bathroom tiles, regional commuting and entertainment. Small trades are quickly replaced by centralized manufacturing and distribution chains, whose hygiene and safety standards will take generations to fine-tune. Hence the cholera, SARS or chicken/pork/beef/seafood flues, as so many natural self-regulation checks. In the midst of these ant mills sprouting and reproducing in a Babylon frenzy, along with the collective gas emissions of millions, will any real prophet stand up?

Asian wisdom calls for each one to be their own prophet, to seek the truth within, but society is quick to slap out any trace of individualism other than personal lunch boxes. A role model, a hero, a politician to move the masses, a senatorial academic, a "nouveau riche" mechanic turned sponsor of the arts? Where are the uncles and aunties of yore, looking down from their misty mountains? Playing mahjong in their private tea rooms, down at the races with their young lovers/personal assistants, wives shopping and husbands playing golf. It's up to the young generation then. But they've already been broken in and tamed into career machines, emulating a superficial Western lifestyle made of club memberships, video games, car upgrades, plastic surgery and all night binges. The junior generation perhaps, then? Locked on MTV, dressed in gangsta rap attire, or preppy urban Polo Jeans, they are not much better off. It's a terrifying Vanilla Ice syndrome. From Hong Kong to Malaysia, Philippines, Korea, Japan, Taiwan, hip hop culture has eradicated all alternatives to being cool, so much so that one needs to be either geek, retro punk or outcast: kilos of piercings and messy ghost hair, i.e. the homeless look from Gobi desert.

Such "acculturation"—the loss or renouncement of one's culture(s)—should be blamed on the lack of any valid local proposition. One must understand that the very term "local" is derogatory, condescendent and only sometimes endearing because one's parents or childhood friends remain rooted in the mother soil. There lies the ruddy rub: in a massive rush for modernization and productivity-led education, all notions of regional History, dialects, cultural pride, were castrated and mashed in a bastardized post-colonial propaganda grub, where the American/English language—taught by whatever stoner on a sabbatical world tour—became the key to salvation. As a result, societies have split into two defiant halves, ignorant of each other: local blue collar, down and dirty, and Westernized white collar, with blinkers. And there specifically lies the East's new dawn! The larger societies stretch, noses grown dangerously long in the collective lie of national growth, industries relocalizing incessantly to New Territories of cheaper labour, masses converging to border town workshops mushroomed into cities of the Future, such as Shenzhen (in China's Special Economic Zone of Guang Dong), the more people caught in between will fall off, take the jump and refute such a deceitful choice: artists, designers, up to now caught in the daily grind of short term, narrow minded production companies or agencies, slaving away for conservative and volatile clients, producing crass imitations of Western or Japanese work. Even bankers and lawyers and investors and consultants, tired of meaningless speculative politics and inhumane careerism, hurt bad enough by five years of rippling recession, are taking leave. They are saying no to wages and rental of their life. These disenfranchised youths, in their twenties, thirties and forties, are creating their own little firms, from design.

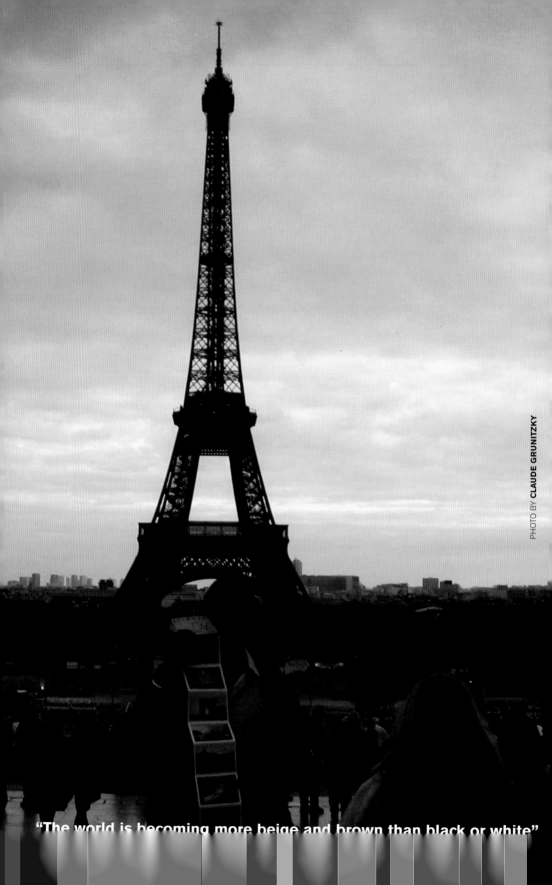

"The world is becoming more beige and brown than black or white"

THE NEW WORLD

BY **RICHARD WAYNER**

February 6, 2003. Paris, France. A Peace of Transculturalism, Part I

Culturally, and racially, segregated society is D.E.A.D. Long live society! Likewise, culturally, and racially, segregated communication is dead. Long live communication! In fact, racially segregated communication has been dying for a long time now. Satchmo mastered a White instrument. Elvis Presley played Black music. Jimi Hendrix is Rock and Roll. And Basquiat conquered a White art world. Just as Fidel Castro won hearts in Harlem, Bill Clinton called himself the first Black president and got 80% or 90% of the votes, every time. Jazz became the great American music not just because of brown faces in New Orleans and Chicago, but because of white faces in Paris and Berlin, too. More dark-skinned nannies and nurses cried when JFK died than cream-colored debutantes. Some people don't know the words to salsa, but they still dance. Some people don't know the words to rap, but they still dance. Few people north of Jamaica understand the words to reggae, so they sing the wrong words, and they dance like crazy. People dance. People travel. People date. People mate, and not just with themselves anymore. Whether you like it or not, it is happening, everywhere. The world is becoming more beige and brown than black or white, every day. Boxes are breaking and stereotypes are getting old, very old. This is what we've been waiting for! And this is what some people are very, very afraid of. This is when the potential of different people from different parts of the world may finally be realized, in concert, for the good. This is when we can share knowledge, share ideas, share genius from every corner of this planet. This is when we can stamp out ignorance because the biggest threat to mankind is mankind… and closed minds. Closed minds caused World War I, closed minds caused World War II, and closed minds can definitely cause World War III! But if we stay open (and some of us need to "get open") and if we share, then maybe we can make things "OK" for everyone, with extra left-over for extra terrestrials whenever they show up. There's nothing to be afraid of, and there is nothing progressive about segregated thought. So instead of "your side" versus "my side", crawling into a corner only to come back dictating one-sided dogma across each other, let's just meet each other in the center, to share and to grow. (We're not going anywhere and there's no known way to run off the planet.) That's how real quantum leaps can be born. That is where people full of wonder are going. And that is where all the fun will be. See you there…

"Not bad meaning bad but bad meaning good"

VOODOO RAY

BY **DEBBIE RIGAUD**

People of African descent have long held an affinity for audacious personalities. Unconventional individuals who especially challenge the status quo may easily earn the respect of this community. Political and social militants often become urban heroes with which African-Americans strongly identify. Young men proudly wear Malcolm X's piercing, no-nonsense glare across their chests like a warrior's shield. Women sometimes inexplicably find themselves attracted to even recklessly bold characters like rapper 50 Cent.

Huey Newton. Bob Marley. Harriet Tubman. Muhammad Ali. Tupac Shakur. Maroons. Whether they espouse their beliefs in a pulpit, from a jungle or on wax, it makes no difference. Their message runs more or less along the same solid lines: Revolution! No justice, no peace. By any means necessary. Not bad meaning bad, but bad meaning good. Suffice it to say, machismo is to Latin culture as what being one bad motherfu**er is to African-Americans.

But if rising against oppressors is praiseworthy, why then isn't Toussaint Louverture, Boukman, Jean-Jacques Dessalines or Haitian people in general acknowledged? Why do most street copies of the revolution handbook make little mention of these heroes? The answer is simple. Haiti has been slapped with the titles, "poorest country in the Western hemisphere" or "land of voodoo". Courtesy of the media, these labels have been drilled into the public psyche until such associations with Haiti are transfixed and many forget those other titles Haiti holds: the first black republic in the Western Hemisphere; the country second only to the USA in gaining independence in the New World.

The year 2004 marks Haiti's bicentennial, a tremendous milestone that commemorates the spectacular uprising undertaken by Creole slaves to oust their French colonists. But sadly, it is only within the last decade that many

Haitian-Americans released themselves from the shame that kept them from openly admitting their heritage. In a country where Chuck D stirred urban youth to "fight the powers that be", the descendents of self-liberators, warriors who sacrificed their lives and the riches of their land for the freedom of black people everywhere, hung their heads. After all, Haitian-American youth who grew up in the '80s and '90s have forged their identities in the age of the AIDS outbreak being blamed on Haitians, the influx of "boat people" arriving on Florida shores, Baby Doc Duvalier's exile and the resurgence of Tonton Macoutes. It's no wonder why, at the time, many Haitian-American children would ask their parents not to speak Creole in front of their school friends. After working so hard to hide the truth, kids were afraid of being found out. They feared the public humiliation.

Still, other Haitian-American youth latched on to other cultures—West Indian, Latin, African-American, or any other which was deemed more socially acceptable—and tried to assimilate. A number of them opted to keep merengue or hip hop music blasting from their speakers rather than compas. Thinking back to my own grade school years, I can recall how my relatives and I tried to guess which one of our classmates were "undercover Haitians". Usually, the visible after-shower talcum powder on their collarbones, or the colorful ribbons in their neatly-braided hair would give some away. And for others, it was that unmistakable Haitian brand of irreverent humor that tipped us off to them. But we respected their wish for privacy and didn't confront them about it. After all, my sisters, cousins and I lived according to that same don't-ask-don't-tell code.

But when people did ask, I had to brace myself for their ignorant, uncensored reactions. Most of the time, I was told, "You don't look Haitian!" (Translation: Haitians are terribly unattractive.) Others asked, "Do you practice voodoo?" I had to learn to exercise a great deal of restraint when I wanted to vociferously accuse them of the highest of spirit-trouncing treasons. And these responses not only came from school children. Most of them came from adults. Only very recently, a man and a woman—

of Caribbean heritage, no less-jokingly asked, "Did your family get here by boat?" It boils my blood that this is the legacy being formulated for Haiti.

I wanted to tell those adults that not only am I Haitian, but I am from the place where the impossible happened; a place where the determination of black people's spirit culminated into an unprecedented feat. The Haitian uprising against France, and also British regiments sent to the island, contributed to England and eventually other colonial powers' decision to abolish slavery in the region. After Creole slaves defeated Napoleon's army, which was sent to quell the uprisings in Haiti, France's military force in Europe was weakened. Not coincidentally, France soon afterward sold their major plot of land in the US, leading to the infamous Louisiana Purchase. And as a result, the United States now spanned from sea to shining sea. I wanted to tell them this, but their stubborn opinions about Haiti had already been formed.

After a while, I went from feeling offended, to being angry to acting righteous. People looked at me and wondered, if all those great things did happen, why is Haiti in such a poor state? But growing up black in America has taught me that it sometimes takes hundreds of years to reverse damages. Being the first black Republic in a part of the world governed by exploitative white oppressors—who thought of African people as pagan savages fit only for slavery—is a scary thought. In its first century, Haiti felt political isolation in a society that wouldn't recognize its government. Haiti's first rulers lived under constant peril of being invaded by hostile neighbors. And when the borders between Haiti and the rest of the world came down, the black republic became vulnerable to financial, moral and spiritual exploitation. From dealing with France's extortionist tactics to tax its former colony in exchange for a no-invasion agreement, to coping with a long list of greedy, corrupt Haitian leaders, the Republic has been repeatedly raped.

But regardless of the state of Haiti today, the greatness of its beginning cannot be denied. When Jean-Jacques Dessalines led a

fearless army to claim their freedom, Saint Domingue was proudly renamed Haiti, an indigenous term meaning "mountainous land". And on January 1, 1804, after 12 years of numerous fierce battles, the Proclamation of Independence was read to Haiti's victorious citizens. The defiant message to the world was unflinching: "Swear to the whole world, to posterity, to ourselves, to...die rather than live under domination. Swear to fight until the last breath for the independence of our country."

Today the fight is for dignity. And Haitians' dignity is redeeming itself every time Wyclef Jean howls "Sak pass" into his mic, and every time Edwidge Danticat brandishes her mighty pen. Thanks in part to valiant individuals like them, Haitian-Americans' pride in their heritage has grown to a level worthy of matching the fervor met at the black republic's bicentennial celebrations. Now that's what I call bad to the bone.

"It's about empowerment"

gradual change

OKWUI ENWEZOR

BY **CLAUDE GRUNITZKY**

"Nigeria's president Olusegun Obasanjo, who ended 15 years of military rule in 1999, accused politicians of orchestrating ethnic and religious violence. 2002 Ethnic riots in Lagos left 100 people dead, while 10 were reported killed and scores injured in a local political struggle in the southeast. Many fear local conflicts and violence will escalate as next year's elections approach. Nigeria has never staged consecutive presidential elections successfully. Mr Obasanjo said recently that 'Nigerians are praying' that pre-election preparations and violence 'do not tear our nation apart.'"

–The Wall Street Journal, Tuesday, February 12, 2002.

"When Okwui Enwezor arrived in the United States from Nigeria 20 years ago, he was a political science major at Jersey City State College who wrote poetry on the side. Now, at 38, he has become an internationally known curator who will cap his career in June as artistic director of Documenta 11, an international exhibition that is to contemporary art what the Olympics are to sports. Last weekend at P.S. 1 Contemporary Art Center in Long Island City, Queens, Mr. Enwezor made his first major New York debut with "The Short Century: Independence and Liberation Movements in Africa 1945-1994", an ambitious overview of the cultural transformations that have taken place across postcolonial Africa."

–The New York Times, Tuesday, February 12, 2002.

The Sunday before The New York Times article was published on the front page of the "Arts" section, this issue's editor, Carmen Zita, and I attended a dinner reception at SetteMoMA, the trendy art-and-fashion haunt of a restaurant, which is adjacent to the Museum of Modern Art. Contemporary art superstars like Maurizio Cattelan and Jessica Craig-Martin could be spotted mingling with the MoMA trustees. Enwezor gave a beautiful speech about hope for Africa in the millennium, but unfortunately there were very few actual Africans in attendance. The reception had followed that afternoon's successful opening of "The Short Century" at P.S. 1, which is part of the extended MoMA organization. Tony Guerrero, P.S. 1's affable director of operations, had just informed Carmen and I that P.S. 1 is one of the largest contemporary art spaces in the world, with over 140,000 square feet of exhibition space, and it was quite breathtaking to see the entire building devoted to the single subject of Africa and its most prominent artists.

The show is so comprehensive that every individual piece on display has to be viewed within the specific historical context of its creation. In that respect, you could call "The Short Century" Enwezor's moment of truth. The exhibition is Enwezor's pacifist response to the Western world's brutal assessment of Africa's slide into oblivion. But make no mistake: this response was dictated by the resilience of

rebels like the late musician Fela (whose inter-views and songs are looped on a series of video screens) and political thinkers like Ngugi Wa Thiong'O and the recently deceased Léopold Sédar Senghor. At P.S. 1, original edi-tions of masterpieces by writers like Amos Tutuola ("The Palm Wine Drinkard") and Chinua Achebe ("Things Fall Apart") sit on tables next to the room that contains framed covers of the trend-setting '50s magazine Drum and Marc Riboud's famed black-and-white Algerian war-period prints.

From North Africa (Le Corbusier's initial sketches for Alger's architecture to the new Egyptian artist Ghada Amer), to images of Soweto township residents, to paintings depict-ing the Lumumba/Kasavubu feud in the Congo, to pictures of the Ethiopian Emperor Haile Selassie standing next to Ghanaian president Kwame Nkrumah, to the official African visits of Charles de Gaulle and Queen Elizabeth, the political statement is all but spelled out in the curatorial process. I have known Okwui Enwezor since 1988, and I have witnessed his gradual transformation over the last 14 years from a quiet critic of short-lived literary phenom-ena to a committed socio-political pundit. Enwezor is still a quiet literary type, but as a leading practitioner in the very guarded world of art, he has become vocal through the radical political views that are expressed in the art he trumpets. When I met him for lunch at the SoHo restaurant Jerry's the day after the SetteMoMA dinner event, Okwui Enwezor struck me as a man on a mission, a man in his prime who acts confidently with the protection of a serenity that comes from walking that fine line between acceptance and rejection.

TRACE: How do you feel about Africa now?

Okwui Enwezor: I feel like the global insti-tutions have undermined Africa; it's not just the governments. It's reached a point where we now have a lost generation in Africa who have no possibility of getting a proper education. What solutions do you see? Before we even discuss solutions, two things are central to the African situation today and need to be under-stood. First, the world is obsessed with the idea of Africa's collapse. So many people are shocked that African people are still able to produce new ideas. For instance, Fespaco in Burkina Faso is showing the possibilities of what a film festival can be. Fespaco is an impor-tant showcase for new African filmmakers from Africa and the diaspora. I've traveled extensively throughout Africa and I cannot be a pessimist. What is happening today for African artists could not have happened 10 years ago. Now, many African artists have transcended the dire conditions and are enjoying international visibili-ty. Artists like Pascale Martine Tayou, Chris Ofili, Malick Sidibé and Mary Evans. So it's a very wide framework, because they're working across different media, even though most start-ed out in traditional painting. The second phe-nomenon comes from the rise of the African artists who are reworking the female narrative of suppression. There are now many possibilities, so I have very little patience for Afro-pessimism.

What role do politics play in this new artistic creation?

OE: Politics can play a very important role. Take South Africa, for instance. Even within Apartheid, political repression energized artists and intellectuals. This exhibition, "The Short Century", is the first time that three generations of African artists have been brought together. The exhibit is not meant to be encyclopedic, but rather an avenue to opening new spaces to think about Africa. The Short Century is one of the most emotional shows I've organized. It's about empowerment; it's about our generation. Our generation could do nothing wrong and was supposed to reinvent Pan-Africanism. Bringing all this art together allows us to imag-ine Africa beyond the pathology of chaos, and violence, and obsolescence, and decay. It allows us to think beyond CNN, and to think carefully about proper African achievement. Africa does not need pity; Africa needs new partners. This show is a historical attempt to write a new visual text about Africa.

Who can these new partners for Africa be?

OE: In the '60s, one of the most important achievements was the scholarship system, and it wasn't just about vaccination of malaria,

which is charity. We know that many Africans would not survive without the extended social network, which is part of the tradition. That being said, African governments need to do more to bring African talent back to the African continent. They need to rely less on administration, so that the social-political-economic base can be reconstructed. The problem today is an over-reliance on mediocrity in government. It's the lack of recognition of new ideas. Still, Africa's problems are solvable. The health (AIDS) crisis is a global crisis, and must be treated as such. The AIDS pandemic must be addressed as a global crisis, and not an African crisis. That's what I call the need for a new partnership. I am not in a state of denial, but the limitations of charity work have become very obvious. The problem of Africa is not the lack of help; it's the plague of NGOs (Non Governmental Organizations). It's reached a point where more money goes into servicing their four-wheel-drive than anything else. Take Nigeria, for instance. Nigeria has a huge film and video industry that is waiting to be recognized. Granted, the quality of some of these films may be questionable, but there is clearly a desire to create. But because the West has retained its power on all matters creative, the Nigerian film industry is finding it hard to be recognized. The good news is: the war in Sierra Leone is finally over; the war in Congo may finally be coming to an end; the Asians are finally returning to Uganda. There is a movement to rethink Africa, and we should give it a chance to succeed. We have to reform our institutions.

You've been living in the United States for 20 years. Is there a larger ignorance of African and other cultural matters in the US than elsewhere?

OE: In Europe, with the exception of Britain, where it's pretty much all there already, there has always been a genuine interest in other cultures. In Munich, at the Museum Villa Struck (where "The Short Century" was first shown last year), there were more than 100 major journalists (from television, newspapers and so on) who came in from Germany, Austria and all over Europe for this African opening. This would never happen in the United States. Having said that, I was impressed by the turnout at the P.S. 1 opening yesterday. I spoke to journalists, gallery owners and collectors who'd come in from across town and seemed enthusiastic. I think the discrepancy between Europe and America comes from the role of the media. In Europe, newspapers and magazines have always been public spheres of discussion, whereas in the United States, information (news or art) is considered a commodity that serves to generate profit. I think it's quite amusing that they even have a new word for it now, the word "content".

So how do you deal with these dual roles of art and commerce?

OE: The conflict between the patron and the producer is as old as time. I've never done any project where my ideas have been compromised by the ideas of the sponsor. In Europe, art institutions are generally public and not dependent on sponsorship money. In the US, however, they are completely privately funded and dependent on the money of these corporations. Still, there are a few examples that show that not everything is black-and-white. In Spain, each time there is a new administration everyone gets fired, because they have this tradition where art institutions must be aligned with the administration in place. That goes to show that the art system—the galleries, the collections, the museums, the foundations, the corporations—is a complex world. This network of actors represents, to my thinking, the reality of the process that these actions are embedded in. There is a responsibility, and there is a space that needs to be respected; that space is "Not For Sale". More often than not, sponsors do not have as much influence as we think.

What can we expect from Documenta 11?

OE: The truth is, Documenta 11 started about a year ago. The process of diffusion and dissemination is already underway, because we are trying to create a constellation of communities, to address the serious issues of our time. We needed not just an exhibition, but a series of intelligences. Documenta 11 exceeds the borders of the exhibition itself, because it's

happening on so many different platforms. It's about transparent research. Documenta actually started in Vienna in March 2001. For six weeks we invited philosophers, writers, activists, architects and artists to collaborate with the Academy of Fine Art in Vienna. We got students involved, and the project was called "Democracy Unrealized". Linked to "Democracy Unrealized" was a workshop called "Theory Unrealized", which lasted for four weeks in Vienna. Vienna was linked to events in Berlin, where people like [Nobel Literature Laureate] Wole Soyinka spoke. Then, we did a project in New Delhi, then Saint Lucia [with another Nobel prizewinner, the poet] Derek Wolcott and in March we're doing events in Lagos. The fifth and final step will be the exhibition in Kassel in June. We're actually building a new space, which is appropriate for the transnational nature of Documenta 11. When you consider that we've approved more than 40 commissions, including a book by anthropologists and urbanists in Bogota, you can see why we've been so busy.

ORIGINALLY PUBLISHED IN TRACE #36, 2002

"I thought it was experimental, futurist, avant-garde music"

GREIL MARCUS

BY **PETER LUCAS**

Music critics can offer helpful references and topical observations, but it's rare that such information becomes essential. To actually document aspects of a culture to the point of devotion and obsession takes time and such attention to detail that few casual readers can be drawn in beyond the opening page.

San Francisco-born Greil Marcus can claim the honour of critic/writer/thinker at large across such a broad musical spectrum, that his work could easily be regarded as an alternative (or real) history of a culture as significant as any over the last 50 years.

Starting with his seminal "Mystery Train", published in 1975, where Marcus laid out and deconstructed the reality and mythology of such iconic figures as Elvis, Robert Johnson and Sly Stone, to his recently published opus, "Invisible Republic: Bob Dylan, The Basement Tapes", he tells the story we all presumed was there–the real one.

The social and cultural background to Marcus' work is so essential that I felt compelled to ask him for his views on the current state of contemporary black music. "Well, you definitely need a context!" is his first riposte. "Otherwise, it becomes completely self-referential. After all, the context of early '60s soul music was the Civil Rights movement. But now it does seem that the context is one of no context. There's no active grass roots movement. So, instead, you have this enormously creative, active, commercially dominant black music taking place against the context of no black community whatsoever. It's pretty weird."

So what has happened to create this situation over the past 20 years? "A lot of things. It's sick the way that pop music devours those it creates. Look at someone like Hammer. He just wanted to do a minstrel act, just like it had been done over the past 100-150 years. He did a great act and the country (America) loved it. But against the harder edged stuff from New York and Los Angeles he was revealed a fraud, but he wasn't really, he was just doing something different. Hip hop was like punk rock at its most intolerant, it had to root out the weakest link."

Ironic when, back in its heartland, white America steals all the best moves from hip hop. For every Hammer, there are many more wannabe Vanilla Ices and Marky Marks. "Absolutely. There's no question that the lingua franca of white teenagers in the US is black hip hop. Don't forget also that more than 50% of black men in the US are in the criminal justice system. What kind of society is that?" Marcus leans closer to add. "You notice that I'm not saying that this music is in any way responsible for all this."

So whereas the arbiters of the moral-outrage-formerly-known-as-hip-hop are condemned from both sides, Marcus casts a more considered eye over the situation. "I'd say there is definitely a squeeze going on. It could also be seen as a recipe for intellectual bankruptcy and cultural confusion. Where does this go? For me, it collapses into The Fugees–a total zero. I find the whole situation appalling. Who knows what it's about? Y'know, Tupac was a pretty intelligent and thoughtful person, and may even have become a great movie actor. When I look at Tupac or Ice Cube, I definitely see smart people."

But pausing to reflect on recent events, Marcus' intellectual guise gives way to more human concerns. "There's a situation in black music that is utterly bizarre and totally split. In Gangsta Rap, the notion of street credibility has gone so far beyond the bound of any sense that there is such a thing as life, that the only way to validate your art is to get shot. I thought that the first time Tupac got shot it would be enough. It's like watching 'Blade Runner'."

But does this situation prove that the work left behind is less important, or merely that the manner of the artists' passing was notorious? "It does definitely lead to an astonishing over-valuing of the work being made. Although Tupac did make some great records: "To Live and Die In LA" was just waiting to be made. But I think back to The Geto Boys scenario. Even with all the madness surrounding Bushwick Bill's shooting, and with them putting that image on the sleeve of "My Mind's Playing Tricks On Me", the song still manages to question all the assumptions of the attitude, the pose and the life."

But, way back, at the turn of the '70s, when Marcus' NY friends played him The Furious Five's early recordings, the options seemed wide open. "I thought it was experimental, futurist, avant-garde music, and not the type you have to go to a music school to learn about. It was clearly influenced by dub, too. When New York started making hip hop they were behind Jamaica in the technology stakes, although hip hop was more playful and expansive.

"Then came 'The Message'–the roots of Gangsta Rap. However, the point of that record was to keep from giving in to that vortex of chaos." So, even if to Marcus, the message seems to be shrinking in its scope, what about the methods employed? "No change! Production and sampling in hip hop is breath-taking. But it all takes place in the service of 'look what a tough motherfucker I am'–and at the root of it, that's not that interesting, really. In the '50s it employed a lot of coded language, which made it more interesting. But it's very complex. Freedom gives us all things we don't like."

Given that the social and cultural conditions in the UK are different, how do you see the development of black music in that country? "It always seems that black music in the UK defines itself in terms of aesthetics. Experimentation is seen as good in itself. I don't know what the drug situation is here, but there's no question that the world of crack is one that hip hop addresses and gets sucked back into. That's not conducive to a situation where an individual can develop a highly personal style, and not: a) be mocked by their peers as a weak link; or b) be scorned as someone out of touch with the street. There's no figure like Tricky in the US; someone who indulges in such formal experimentation. If there was, they'd have to hide it."

ORIGINALLY PUBLISHED IN TRACE #9, 1997

"All this fuckery got homeboy fired up"

BABA OLATUNJI

BY **TOM TERRELL**

**"Out of one, many come." …
Mutabaruka**

When I think about Babatunde Olatunji–his life, his socio-political-cultural legacy–the above words spoken to me some 22 years ago come to mind. I mean, that's Baba in a Cliff Notes stylee: Born in 1927 in a Nigerian fishing village. Founded African drum & dance ensemble at Morehouse College in '52. His '60 debut release "Drums Of Passion" is the seminal influence on NY salsa, Latin rock, JA reggae, American and Afro-Cuban jazz, DC Go-Go and Brazilian samba/batucada. Passed away in 2003.

trans–prefix: on or to the other side of: across: beyond culture: the customary beliefs, social forms, and material traits of a racial, religious, or social group.
-Webster's New Collegiate Dictionary

transculturalist: "The Motherland's spirit-cosmic essence–the eternal rhythms of the drum–flows through every living soul on the planet. Any musician who is down enough can tap into it, but black cats, because we live in three worlds–spirit-our-white–are the prime keepers-translators-innovators-conduits of the spirit-cosmic. And the deepest bloods like Trane, Miles and Olatunji are so dead on the Universal One that their spirit-cosmic oeuvres be fuckin' with music-people-culture in places that never heard of 'em."
-Jimmy "Black Fire" Gray

All my life I've been fascinated/affected by those Afro-American transcultural iconoclasts like Gordon Parks, James Brown, Pam Grier, Michael Jackson and Jordan, Oprah, Russell Simmons and Hype Williams. Fiercely creative savants whose god-like six-degrees-of inspiration/influence has traversed time and space to color my world, your world, their world and other folks' world all over the world. Think about what they set off: European all stars in the NBA, Bollywood flicks shot like extended rap videos, Phat Farm sold in Bahrain boutiques, party girls from Bahia to Beijing flossing "Coffy"-era 'Fro-bells-pumps-'tude, Oprah reruns in the UK, Koreans flexing R&B falsettos, Aussies playing funk and Chow Yun Fat is Shaft.

Though Baba Olatunji's legacy is in every sense as transculturally six-degrees-of-influential, his reach and impact has been even

greater, 'cause it played out in relative obscurity. Five decades the hard way, teaching African drum and dance coast to coast, touring the world, mentoring jazzbos, influencing pop musicians and DJs via one-on-one, example and word of mouth.

The first time I heard Olatunji (though I didn't know it was him) was around '63. Legendary NYC radio jock Murray the K always opened his daily show—"Murray the K and His Swinging' Soiree" with a stirring African call-and-response chant ("Ah-bey! Whoah! Ah-bey! Whoah! Cumah-saba-sabeyyy! Whooaahhh!"). Dunno what they were saying, but it moved me like I really knew, y'know? Matter of fact, all us black teenage fans of "Swinging' Soiree" living in the NYC-Newark-Elizabeth-Plainfield metro area tripped out on "Ah-bey!" Turned it into a racially bonding "freak-the-white-kids-out-in-the-school-yard-hall-cafeteria" psyche out, football cheer and a window-to-the-wall-amping Saturday house party chant.

For me, "Ah-bey!" was a self-esteem booster kinda thing. See, at Union High (Ray Liotta and Robert Wuhl were classmates), the designated 'cool' brothas high-fived "Ah-beys!" but they never even heard of Murray the K. But me and many of the other 'corny' checked him religiously. One day I was talking "Mea-surray" (the K's version of pig Latin) to Russell in wood shop. Clem—the toughest white dude in school—walked over and said "Ah-bey! Whoah!" I answered back. First time I bonded with a white boy since 6th grade. Turned out Clem and a buncha other white kids were heavily into soul music and pop rock—Temptations to Beach Boys—just like me and my crew was. In this microcosm, we were the real cool jerks 'cause we heard "Ah-bey!" and a whole lotta kick ass Black and White tunes on the Soiree first—long before they filtered down to the so-called hip poppas. "Ah-bey!" was our secret handshake, our gang sign and our dapp.

A decade later, my main man George Birchette played an LP. Flash bulb! That's "Ah-bey!" The LP was "More Drums Of Passion". George put on "Drums Of Passion" next. Revelation Time: Baba Olatunji wrote and recorded the original Afro-American African drum and dance songbook. G. drops Santana's "Jingo". Fierce, no?: Afro-Cuban tribalistic thunk-a-dunk funk 'n chant, swinging madly on an irresistible seething organ/raving guitar blooz-rock pop hook-tip. Rocked the Woodstock Nation and pop, rock and R&B radio stations nationwide. Coup de grace: rewind of Drums Of Passion's "Gin-Go-Lo-Ba." Talkin' Six-Degrees-Of-Olatunji epiphany:

Dig: Olatunji's Afro-American-jazzed version of a native folk song ("Gin-Go-Lo-Ba") released in 1960 inspires an expatriate Afro-Cuban conguero innovator to write and a tenor sax godhead to record the best Latin jazz joint of all time, "Afro Blue". Mongo/Trane addict Carlos Santana goes back to the source and blows "Jingo", the first proper Latin-rock single. Grateful Dead drummer and future Olatunji uber disciple Mickey Hart pummels out "quintessential Afro-listic acid-rock jam "Dark Star". Three decades later, a Lebanese-Colombian pop star named Shakira releases "Whenever, Wherever". The Andean pan piping, rock-reggae percussive homage to "Jingo" cops platinum all over the world.

Smell that? OK, now taste the rhythm divine essences of Iron Butterfly, Fela Kuti, Osibisa, '70s fusion jazz and Nuyorican salsa, Black Ark-era Lee Perry, Allman Brothers, Chuck Brown-Trouble Funk-EU, Ralph MacDonald, Kid Creole, Strafe ("Set it Off"), Jungle Brothers, Malcolm McLaren, Nellee Hooper, Sly & Robbie, Joe Claussell, Timbaland and Punjabi MC. Different but same thing still. Rewind, Selector! Dubwize…

Born 76 years ago in Ajido, Nigeria, Michael Babatunde Olatunji was the son of a fisherman. An irrepressibly precocious child, he was "adopted" by the Village's elder drummers. Before reaching puberty, Michael was the youngest player in ritual drum circles. Poppa O. knew his no. 1 son's true destiny lay not in the old ways. So in 1950, he sent Baba to Atlanta's Morehouse College. Today, a political science student, tomorrow, Michael Babatunde Olatunji, Esq., distinguished barrister to the Nigerian High Court. Reality had a whole different scenario in store for the ebony Clarence Darrow.

Atlanta was seriously Jim Crow back then. Two worlds separate and unequal. Morehouse College was all black, all male. Imagine a utopian academic environment where the President, administrative and medical staffs, professors, visiting lecturers and coaches are black just like you. Think of the soul-searching going down with a poor fisherman's son who finds himself accepted as an equal by Afro-American undergrads from the same socio-economic class that had always blocked his kind from attending university back home. Trip out on what kinda head trips a 23-year-old smart country boy from Nigeria was on when he learned the real truth about the British Empire, the Middle Passage and slave trade. When he discovered DuBois, Harlem Renaissance, Negritude, pan-Africanism, Paul Robeson, blues and jazz. What did you do the first time you realized that everything you knew was wrong?

OK, now imagine Baba walking through downtown Atlanta in native drapes. Ugly signs –"No Colored Allowed", "No Niggers and Dogs", "White Only"–on café-bar-store windows, well-dressed black folk dispiritedly walking on the inside lane of the sidewalk with their heads down, overheard white folk calling grown black men "boy" or "Nigra." Even more bizarre, Baba's exotic foreignness–traditional clothing, tribal scars, and speech–gets him special social interaction treatment from the local white folk. All this fuckery got homeboy fired up.

Around '52, Olatunji founded the first ever African cultural workshop at a southern black college. His goals: 1) Teach a collective of American and African m/f undergrads and community youth the traditional music and dances of Nigeria. 2) Transform that experience into a racial pride motivator and African Diaspora unifier. 3) Take it on the road. Bingo! Over the next two years, Olatunji's workshop hit black colleges, churches and public schools throughout the South.

In '54, Baba relocated to NYC to attend NYU's Graduate School of Public Administration. A few months later, he formed a new drum and dance ensemble. Overnight sensation. Popular enough to gig regularly in all the boroughs. Heavy enough to collaborate with

jazzbos, poets and salseros. In '57, A&R legend John Hammond (Lady Day, Count Basie, Dylan, Aretha, Springsteen) 'discovered' Olatunji and co. working out with a 66-piece orchestra at Radio City Music Hall. Signed him to Columbia Records as a solo artist. Three years later, Columbia released "Drums Of Passion". History-making: The first album of authentic traditional African music to be recorded in the New World. The biggest selling world music album of all time (certified five million in America alone).

Baba could have really cashed in; did Vegas to death, hung with Topo Gigio on Ed Sullivan, rocked a beach flick or three or maybe even made it to Carnegie Hall or the White House lawn. But he never sniffed his own vapors. His sense of purpose, his calling was coming from a higher place. America's fame was a false path, Africa's spirit-cosmic rhythm was the Divine Way. So Baba never corrupted his vision, compromised his m.o. or sold out. Instead, 43 years of keeping the spirits alive and passing on his/their legacy to newer generations. Even when his body began to fail him in the final years of his life (diabetes, arthritis, stroke, semi-blindness), Baba always found the strength to continue the mission.

The last time I saw him was at NY nightclub SOB's in September of 2002. A bandmember walked him to the stage. The band was kicking "Gin-Go-Lo-Ba." Baba weakly tapped his conga with a stick. He did it again a little harder. He leaned closer, struck again and smiled. He unleashed a flurry of strikes. "Ratta-ratta-batta-ratta-batta-batta-tatta!" No more ghost walking. This man was alive and virile, changing the beat, swinging the flow, building the vibe. For 25 minutes, it was real time "Drums Of Passion" déjà vu all over again. Magic, considering most of the multi-culti crowd wasn't even born the first or second time around.

Michael Babatunde Olatunji is gone but his legacy is everywhere. In a Santana concert encore, in multiracial/cultural traditional African ensembles from Berlin to Tokyo, on a Joe Claussell or Frederic Galliano 12" remix, in a TV commercial, a Hong Kong film noir or a teenage Philly brother rocking a silver-brocaded blue velvet kofi. That's transculturalism, son.

Post-script: In April of '02, I wrote the liner notes for Sony Legacy's reissue of "Drums Of Passion". Five months later, I was hanging with Baba in the SOB's dressing room. I told him that I was the cat who wrote the essay. Baba nodded and said, "Wait a minute, brother." He left the room. I started to sweat. A coupla minutes later, Baba returned—with the whole fuckin' band. Now, I was really sweating. Pointing straight at my head, he intoned, "My brothers, this is the man who wrote the liner notes we were talking about yesterday." Uh-oh, I feel an anxiety attack comin' on. Two more excruciatingly long seconds later, Baba winks, smiles and exults, "Thank you, thank you, You understand where I'm coming from!" Then he hugged me.

We talked about collaborating on a long-overdue autobiography. It was not to be. Six-degrees-of-Olatunji synchronicity again: Baba ascended on April 6, 2003; on that day a year before, I completed the final draft of the "Drums of Passion" liner notes. In a sense, those notes and this piece form the synopsis of the autobiography that coulda-woulda-shoulda been.

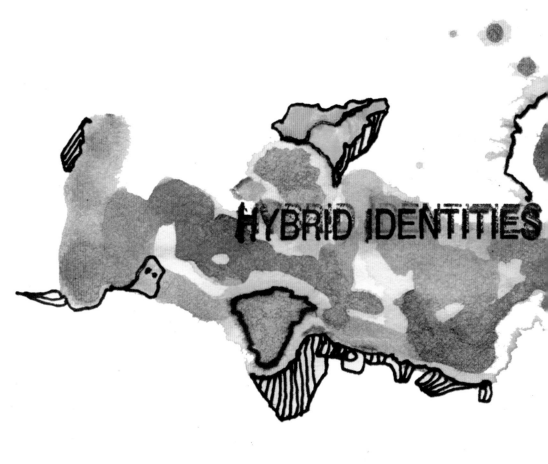

HYBRID IDENTITIES

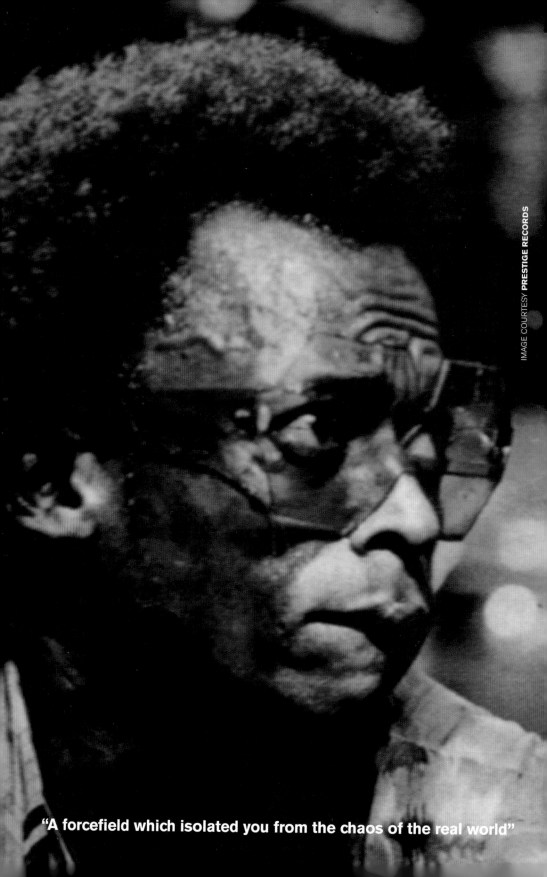

"A forcefield which isolated you from the chaos of the real world"

WHAT IS COOL?

BY **ALIX SHARKEY**

What is 'cool'? The question is as old as the adjective itself, in common use for over half a century. And yet it remains unresolved.

A few years ago, I was startled to hear a Parisian market trader tell a complaining customer that she was 'pas cool'. Until then, I had always thought cool a particularly anglophone concept. But today, cool is an international buzzword, dropped casually into French, German, Japanese, Russian and Swahili to describe anything from pop music to architecture, sports cars to computers, trainers to sunglasses. It is so widespread that we no longer register it. Schoolchildren say their favorite computer games or boy bands are cool—as in cute, agreeable, or at best, exciting. The word has almost been stripped of all meaning.

But this long-devalued honorific was not always so easily conferred. We seem to have forgotten how terrifyingly cool this tiny word once was. There was a time when cool had power, when it was not uttered lightly. You had to be cool even to mention it; only the coolest could pronounce something or somebody else cool. The uncool user of the term invited scorn and ridicule.

Even the sound of the word, its pronunciation, has been modified over the years. Nowadays it is spoken with gushing enthusiasm, in a jaunty kind of buy-me way. But when beatniks began to popularize it in the '50s and early '60s, it was spoken like a mantra, the soothing, husky, double vowel sound drawn out in a low, breathy tone, like the Sanskrit Ur-word 'Om'. Just to pronounce it was to invoke tranquility, equanimity, a quasi-religious state of awareness, a dark, priestly knowledge that only came from being totally 'hip' to what was 'going down'.

Nowadays, we have an archeology of cool. When we look at photographs of old-school rappers and breakdancers, in their Cazals and Adidas and Kangols, we say they are cool. We know it, even though it's hard to say exactly why. It wouldn't be cool to dress just like them, but we can see that it was at the time. Their coolness resides somewhere between their look and their attitude: even 20 years later, there is still a certain joie de vivre, an indefinable spunkiness about them.

Perhaps cool is a word that, by definition, resists definition. If we could define cool, surely it wouldn't be cool anymore: it would be something else. Of course, we could list all those qualities which are undeniably cool—but then we often find the same is true of their opposites.

Examples? To be young is cool. To be sexy is cool. Trying to look young and sexy is decidedly uncool. In fact, trying to do anything—as in noticeably making an effort or striving for an effect—is almost always uncool. Therefore, it stands to reason that not trying can be even cooler than not trying.

Dancing well is cool. Ergo, dancing badly is uncool. But if you dance badly consciously—that is, not trying to dance well—then your bad dancing can be ultra cool, because it makes all the people who are dancing well look as if they are trying. And that, as we have said, is very uncool.

Violence is definitely uncool. But cowardice is even worse, particularly if a weaker third party is being bullied—so perhaps we should never rule out violence completely. It's probably not very cool to say so, but perhaps just a hint—let's say a soupçon—of explosive potential will always have its place in the cool tool kit. But only when morally justified.

What is cool? That will always depend on the era, the circumstances, the individuals concerned. In the early '80s, hip hop was just emerging. A brash new musical form produced by a vibrant but largely unknown suburban club culture, it was both futuristic and yet clearly of the moment. The rapper's accents, the lyrical references to everyday life and TV shows, the technological advances that allowed DJ-producers to sample certain '70s funk and disco records, all were unmistakably of a certain time—the present—and a certain place—the New York borough called The Bronx. And yet the resulting sound was profoundly avant-garde. Is this the definition of cool: the ability to be ahead of the times yet completely in tune with them? To be simultaneously suburban and cutting edge?

Talking about Club 371 in the South Bronx in the early '80s, Nelson George observed that: "A terrible school system, an addictive welfare system and a government that lets drugs pour into the community have, along with twin turntables, somehow conspired to make these young people come up with their own distinctive brand of entertainment. All in all, the situation doesn't differ greatly from the one that sparked England's punk rock movement. Lower class kids have always wanted and created their own insular thing. London youths of the mid-'70s plugged in their guitars, just as the generation before had, but said something different this time. Meanwhile, in Harlem the plastic disco of Studio 54 was ignored, and the music was transformed into a uniquely black and streetwise form closer to home."

Back in 1972, British pop kids had fallen in love with Kraftwerk's "Autobahn" single. It wasn't until the decade's end—when we heard Bronx DJ legend Afrika Bambaataa using Kraftwerk's "Trans-Europe Express" as the lynchpin of his live hip hop sets—that we realized how clever, how arty, how conceptual Ralf and Florian had been. We had thought them merely a pop band. Now we realized they had minimalist art theories, too. And a jolly good sense of futuristic dance rhythms. Then in the mid-'90s a German-speaker told me that a layer of irony had passed me by. Apparently, "Autobahn"'s vocals were delivered in a heavy suburban working-class accent, as if a bunch of Dusseldorf factory workers were reciting the lyric. I don't know if it's true, but the myth is too cool not to repeat.

Certainly, hip hop was the coolest sound of its era, and the clothes that went with it were, by definition, the coolest fashions. Fashion is important to cool, though nothing is less cool than slavishly following fashion, which merely makes you a 'fashion victim'. One of the coolest things anyone can do is to start a trend, especially if that trend flies in the face of convention, even more so if it takes a style or garment considered gauche or ugly and recontextualises it, changing its significance in order to make it desirable. "To achieve harmony in bad taste," said Jean Genet, "is the height of elegance."

In the late '80s hip hop fashions appropriated the logos of high fashion Parisian labels like Chanel and Louis Vuitton and turned them into ghetto chic, enlarging them, making them even more ostentatiously vulgar, stripping them off handbags and wearing them as medallions, oversized earrings and belt buckles, pasting them over tracksuits, T-shirts, rucksacks, baseball

caps and miniskirts. This was considered so cool—so suburban, so avant-garde—that designers like Chanel's Karl Lagerfeld were obliged to copy the pirates and produce upmarket versions of these counterfeit styles, which sold at upmarket prices to trophy wives of the Left Bank and Upper West Side. Perhaps an updated version of Genet's dictum would read: "To achieve social equality in bad taste is unbelievably cool."

But, to get back to the point... where did this notion of cool come from? Why has it become so threadbare over the years? And does it have a future?

As early as 1857, cool was used to signify a dignified calm and level-headedness in the title of an American play called "Cool As A Cucumber"—a simile still in use today, though it sounds increasingly quaint to English-speakers. But this is not the usage we are more accustomed to, which means 'admirably hip' or 'stylishly appropriate'. According to the Random House Historical Dictionary of American Slang, cool as a term of approbation entered the English language via black American slang in the mid-'30s. Almost certainly it was popularized by black jazz and blues musicians. In those days it had a very distinctive meaning: that which was cool was not hot—as in stolen, illegal or in trouble with the police. By way of comparison, American gangsters of the '30s talked of 'packing heat', meaning to carry a gun. In other words, to be cool was to be free of troubles and legitimate—which for a black American in the mid-'30s was no mean feat.

World War II threw black and white servicemen together and naturally they exchanged linguistic tics. By 1944, cool had become military slang for 'very good' or 'fine', and was popularized to a limited extent among Britons, particularly Londoners, by American GIs stationed in the UK. If you were cool in the '40s, it meant you couldn't be upset, unbalanced, frightened or disoriented—again, not easy at the time. And once you experienced that

condition, you wanted to signify it, which of course reinforced your coolness, since others then treated you accordingly, as a cool guy. In July 1948, The New Yorker magazine noted that, 'The bebop people have a language of their own. Their expressions of approval include 'cool'!'

However, cool only really attained widespread usage after 1949, when jazz trumpeter Miles Davis repopularised [and to an extent reinvented] the term with his "Birth Of The Cool" album, which broke away from the fiery, dazzling bop of Ornithology-era Charlie Parker, replacing it with a more somber, studied sound. This was where cool took on its hipster definition and came to mean 'relaxed', 'contemplative' and 'emotionally restrained'—in stark contrast with the frantic Parker-inspired bebop style. Davis' new sound caught on quickly, and cool became distinctly cooler than it had ever been before.

In fact, it was almost icy in its saturnine impenetrability. Cool became a haze, a force field which isolated you from the messy chaos of the real world. It was no coincidence that Miles Davis was addicted to heroin—a drug which creates a sense of insularity and distance from external phenomena and emotions, and which reduces appetite—and thus body heat and mobility. Gerry Mulligan, Chet Baker and countless white jazz musicians followed in Davis' footsteps, and soon the Cool Jazz movement had largely replaced its bebop predecessors.

And so a new and darker kind of cool reigned supreme, and this is when the word 'uncool' seemingly first surfaced. The Oxford English Dictionary traces its earliest use to 1953, in William S. Burroughs' first book, "Junkie": "I learned the new hipster vocabulary...'cool', an all-purpose word indicating anything you like or any situation that is not hot with the law. Conversely, anything you don't like is 'uncool'."

Curiously, though, not everybody who was 'hip' thought cool was a desirable quality. The first indication of it being used negatively appears around the same time. It

was Burroughs' friend and fellow beat writer, Jack Kerouac, who inverted the word. In his seminal beat Novel, "On The Road", published in 1957, he describes witnessing jazz pianist George Shearing perform a frantic set in a jazz club, after which:

'Shearing rose from the piano, dripping with sweat; these were his great 1949 days before he became cool and commercial.'

Kerouac notwithstanding, cool was the underground term of ultimate approval. Yet less than five years after Burroughs had felt compelled to explain this arcane 'hipster' slang, used primarily by jazzmen, blacks, beats and junkies, it had spread from sophisticated and racially mixed urban New York to predominantly white—and relatively prudish—Middle America. The popularizing factor this time was a smash hit Broadway musical which became a record-breaking movie. One of its more upbeat numbers was a song called "Cool":

Boy, boy, crazy boy!
Stay loose, boy!
Breeze it, buzz it, easy does it.
Turn off the juice, boy!
Go man, go,
But not like a yo-yo schoolboy.
Just play it cool, boy,
Real cool!
—"Cool" from "West Side Story"

Thus, in 1957, the young lyricist Stephen Sondheim spread the notion of cool to suburban America via Leonard Bernstein's "West Side Story", and since then no word has better expressed our contemporary aspirations. Suddenly it was not enough to be clever, rich, glamorous or beautiful. But if you had cool—that mysterious, powerful je ne sais quoi—then nothing could stand in your way.

If the word had entered the vernacular, it was still largely reserved for a certain class: those whose high social standing led them to believe they were cool enough to say what was cool. For the most part these were the 'beatniks' or 'hipsters' of

the late '50s. In "The Holy Barbarians" (New York, Julian Messner, 1959), Lawrence Lipton defines cool thus:

'Cool: said of anything that sends you, whether cool jazz or a cool chick, unless you like 'em hot (see Hot).'

'Hot: said of anything that sends you whether a hot lick (jazz) or a hot chick, unless you're a cool cat.'

'Cat: The swinging, sex-free, footloose, nocturnal, uninhibited, non-conformist genius of the human race.'

Lipton also stressed the importance of another neologism, 'hip':

'Hip: to know, in the sense of having experienced something. A hip cat has experiential knowledge. A 'square' has merely heard or read about it.'

'Hipster: one who is in the know. A cool cat.'

Within five years, the teenage proto-hippy Beach Boys were boasting about how cool they were in "I Get Around" (1964):

"I'm a real cool head
Get around round round I get around
I'm makin' real good bread"

Once associated with good old-fashioned capitalist values, cool quickly became advertising shorthand for 'young and up-to-date' and was snapped up by Hollywood as a youth marketing device. Although the buzzword had appeared as early as 1953 with "The Cool Hot Rod", it really took off in 1958 with "Keep It Cool" and "The Cool and The Crazy", before exploding in the early '60s with "Some Like It Cool" (1961), "Cool Cat Blues" (1962), "The Cool Mikado" (1962), "Play It Cool" (1962), "The Cool World" (1963), "Johnny Cool" (1963) and going on to show up in "Cool Cat" (1967), "The Cool Ones" (aka "Cool Baby, Cool") (1967), "Keep the Cool Baby" (1968), "Medium Cool" (1969) and "Only The Cool" (1969). There was even a children's cartoon TV series in 1966, about a secret agent, called "Cool McCool".

By 1966, 'hipster' had been modified to 'hippy' and a new wave of the counter-cul-

ture was emerging, one that would be far more influential than the beat movement that spawned it—thanks mainly to rock music, which became the dominant popular artform during an era of unprecedented expansion in communications technology. Rock music allowed everyone to own a little piece of cool, a circular slice of black vinyl which could conjure up the presence of pop stars—the new cool royalty—in even the most banal domestic setting. Cool went from slang to cultural theory, with academic media theorists like Marshall McLuhan bending it to their own uses: television, he famously remarked in 1967, was a 'cool medium' which allowed the viewer a greater flexibility of response to its imagery than, say, cinema.

The hippies differed greatly from the beatniks and Hipsters—or at least the media interpretation of Them—in their definition of cool. Initially it was synonymous with 'laid-back', as in 'informal' or 'relaxed'. But hippies thought the world too restrained, too conservative and 'uptight', and the last thing it needed was more reserve, more cool. An early hippy slogan was 'Let it all hang out'. The new counter-culture urged us to accept and openly express our neuroses, fears, desires, dreams, anger. It wanted an end to the repressive, rigid conformity of 'straight' society. In this light, cool was not necessarily a desirable quality—as The Beatles said in "Hey Jude" (1968):

"'Cos don't you know that it's a fool
Who plays it cool
While making the word a little colder."

Meanwhile, black America was still using the term in its earlier sense, meaning 'stylish, hip and sleek', as in The Capitols 1966 dance-craze hit, "Cool Jerk". For black urban youth, cool was still a path to freedom, a way of avoiding the social constraints imposed on their parents. And the English working class, black and white alike, agreed wholeheartedly with this definition. So while more affluent white American teenagers began to 'drop out', their British working-class counterparts were instinctively in tune with young black America's upward aspirations, and its Motown soundtrack. Cool was a Mod word, and Mods were decidedly cool.

Two disparate social groups, divided by an ocean and joined at the hip: young black Americans used cool to counter racism; English working class youths, already wearing similar clothes, appropriated their dance music and speech patterns to transcend a rigid British class system which labeled them from birth as factory fodder. And so began a one-sided love affair that endures to this day.

'Nowhere in the world is black American dancing music more cherished than in England,' wrote style guru Peter York in his classic "Modern Times" (1984). 'Since Frankie Lymon and the Teenagers in 1956, since Motown started filtering over here in 1962, there's been this white working-class soulie tradition, bigger, more rooted than anything you ever heard about Swinging London... in the hardcore soulie's clubs Up West and in the London hinterland, black and white kids always mixed for the Life... these white kids are from the same backgrounds as the black ones, the same streets, the same schools, soul brothers, so to speak, sharp-faced, sharp-dressed white working class kids who simply knew the black kids and liked the same music, the clothes and the dancing... blacks aren't Another Country, they're next door.'

Cool was dead by the mid-'70s. Or at least it smelt funny, it reeked of the hippy era and was therefore anathema to the punks. It was one of the words they despised, along with 'love' and 'peace'. It seems to have become unfashionable too among black Americans, though it surfaced occasionally in blaxploitation movies like "Cool Breeze" (1972). Even the advertising industry realized that the concept was ridiculously outdated.

But then a curious thing happened. Cool

encountered irony in a hit TV comedy series called "Happy Days". A nostalgic evocation of '50s Americana, it featured a bunch of clean-cut college kids who were in awe of The Fonz, a cartoon rocker with leather jacket and jeans, whose catchphrase was 'Cool!' The irony was lost on a large part of its audience; "Happy Days" was a family show and children don't get irony, especially when it's wrapped in nostalgia. And so a generation of American kids grew up thinking it cool—or at least amusing—to shout 'Cool!' By the time they were old enough to be nostalgic themselves—in the mid-'80s—this new and terribly uncool version of cool was common parlance among them.

Their ironic use of the word would eventually resurface in "Wayne's World", a Saturday Night Live sketch that grew into a worldwide hit film. Based on the idea of two nerdy, slacker friends in the American Midwest who make their own public-access TV show, the movie of "Wayne's World" (1992) wallowed in ironic nostalgia, and it's no coincidence that creators Mike Myers and Dana Carvey belong to the generation that grew up loving The Fonz. And that, right there, is how cool—the word itself—was stripped of its original power.

What is cool? Well, despite everything cool remains somehow... cool. So far nothing has emerged to replace it. No other term quite articulates the same idea: a kind of fashionable, sophisticated avant-garde attitude and appearance. Actually, the word may change—recently it has been 'hip' or 'stylish'—but the essence remains the same, and if you can locate it, you can make a lot of money. Nightclub promoter Michael Alig did exactly that in New York when he recognized a certain life cycle of cool: "I had this idea that we could corner the club market by having four clubs and rotating them," he told Details magazine in 1997. Every year for four years, he would move the rating of each club down a notch, and shunt a new crowd in, until it became so uncool that it was cool. Or as he said: "It would go: hip, B-crowd, C-crowd, black. Because that's how it realistically works, and then once you're black you can go hip again."

The same principle has now been applied on an industrial level. Having started as an exclusive, underground and, frankly, elitist taste, a new trend—in fashion, music, drug consumption, speech or behavior—is swiftly adopted by the second wave, and then a third, from whence it proceeds directly to mainstream acceptance—which, as we all know, is synonymous with being unfashionable. At which point, the cycle, now complete, can begin again.

Which is why today, in London, Paris, Tokyo, LA and New York, there are a handful of trendy little companies known to the advertising trade as 'Cool Hunters.' Getting it right has never been more vital. International advertising agency McCann-Erickson estimates the world's annual advertising budget at over £250 billion—the bulk of which is directed at the under-35s, who have significantly more disposable income than older demographic groups. Small wonder, then, that the last five years have seen trend prediction—or 'cool hunting'—develop into a multi-million dollar industry, as leading drinks, fashion, fragrance and sportswear brands struggle to devise ever-sharper marketing strategies to reach an increasingly savvy youth culture: even pre-teen consumers are now keenly aware of a leading brand's status, of the company behind it, and the values that it supposedly represents.

Picture an equilateral triangle with five horizontal sections. At the top of this triangle are the Opinion Formers, under them are the Early Adopters, followed by the Late Adopters and then the Mainstream. Finally, under all these, at the base, are the Laggards—those who can't be bothered to get involved in youth culture at all, but adopt fashions by default when they're everywhere—and therefore just becoming unfashionable. So the Cool Hunters concentrate on identifying, hanging out with and questioning (they call it 'creative

lounging') the Opinion Formers, who are vital for predicting trends.

The Cool Hunters go back to ad agencies and tell them what the Opinion Formers are saying. The ad agencies tell the Late Adopters what the Early Adopters are already wearing, listening to or saying. Once the Late Adopters are up to speed, the Mainstream will catch on. By which time, of course, the Opinion Formers will have disappeared over the horizon, blazing countless new trails as they go.

They won't be satisfied until they reach the cool blue horizon of the Next Big Thing.

They don't have a clue what they're looking for.

But they'll know it when they find it.

Because they instinctively know the answer to that perennial question: What Is Cool?

"People have made their own reality"

LOVERS ROCK

BY **PETER LUCAS**

It doesn't all begin and end in Brixton, but it's a good place to start. Since H.M.S. Windrush brought that first boatload of Caribbean immigrants over to the so-called "Mother Country" in 1948, lots of things have changed. And stayed the same. On both sides. Colonialism, the factor that led to post-war immigration to Britain, is over, officially, anyway.

So, where is Britain located now? Two generations plus on from the pyrrhic victory of WWII, and the economic and political consequences that led to Britain "giving up" its empire—very much at the United States' encouragement. Seemingly perched forever between its historic alliance with the United States and its shared history with the near Continent, Britain exists, with increasing uncertainty, between the U.S. and the rest of Europe. Increasingly, though, many former immigrants in Britain are forging their own third way, taking no cues from Blair, Clinton or Chirac. Culturally, however, urban Britain is its own force. With a

social and cultural scene the envy of the rest of Europe, and a keener eye on class than race (compared to the U.S.), it's at street level, in British cities, that transculturalism has been forged. Making great strides from the era of attempts at mere assimilation and acceptance. After all, in England, as in France, a non-white immigrant can never truly be English or French, given all the historical meaning of those two terms. So, people have made their own reality. Where did this come from? To look forward, it's always useful to look back a little for context.

West Indian and South Asian communities in Britain first brought, then developed, and have now mutated their native culture into the fabric of the culture in their adopted homeland. This was the beginnings of transculturalism in action in Britain. From the former colonies, and colonized, came the seeds of non-whiteness in England. However, the immigrant population, despite economic and social prejudice, have integrated their culture into British culture, over

40 years, effortlessly, and almost, invisibly. A short list might help here: reggae; curry; white rastas; bhangra; even an increased understanding of social injustice.

Why? Firstly, and crucially, an understanding of their "adopted" culture was profoundly felt within the immigrants of the mid-late years of 20th-century Europe. Clearly, initially, transculturalism was not a two-way street and, interestingly, it is the immigrants who had a better, more innate, understanding of it. The colonialists, after all, were "in residence" in their former colonies for up to 200 years in some cases: being observed, albeit silently, perhaps, but observed nonetheless. Upon arrival, and within just a generation, immigrants had already proved themselves more than culturally adept at transculturalism. During the first generation/phase there was simply a quiet attempt at assimilation. The socialized British system and the economic situation of the '50s, '60s and '70s enabled immigrants' homes, jobs and education alongside the urban British population they lived amongst. However, the overwhelmingly English cultural template of that era was both familiar yet foreign to the immigrants whose own culture gradually took hold in the neighborhoods they lived in. In London, areas like Brixton, Ladbroke Grove and Harlesden became synonymous with West Indians, predominantly Jamaicans; while Southall, Tooting and, later, Brick Lane, became associated with South Asians. Meanwhile in
· Birmingham, Manchester, Liverpool, Leeds and Bristol, the strong West Indian neighborhoods there became vital enclaves for an immigrant community who felt little in common, initially, with their surroundings.

Interestingly, the political and economic orthodoxy in Britain was breaking down in the '70s, just as the evidence of these further cultural inroads by immigrants was making itself known. West Indians introduced reggae, marijuana and Rasta militancy, linking themselves with the punk and protest movements of the late '70s and early '80s. This mixing and blending, as I heard it so often called growing up in the '70s and early '80s, sowed many transcultural seeds.

For example, in the very late '70s, an offshoot of reggae, infused with a very British pop sensibility, known as Lovers Rock, became the sound of every party in South London. This, at a time when the right-leaning London newspaper, Evening Standard, looked askance at every gathering of black kids on a street corner, particularly the wildly popular Notting Hill Carnival—Europe's largest street festival. At parties, which were always mixed, the night was not complete without an hour or two—usually near the end—of Lovers, as it was always referred to. Its moment in the sun was probably Janet Kay's number one hit in 1979, "Silly Games", remarkable only really for its cultural import at the time. Lovers came and went as many British musical fads do, but, like punk, another contemporary touchstone and mixed celebration of outsider status, it made a mark on those whose idea of social interaction wasn't defined by an evening in front of television.

Those years, as much fuelled by the smooch of Lovers as the fury of the 1981 inner-city riots across Britain, which played out to the sound of The Specials' "Ghost Town" in July 1981, were balanced between the furious misunderstanding and prejudice from the government, police and sections of the population toward the black community. However, in a place like Brixton, already home to a small, but locally and culturally influential cabal of punks, rastas, squatters and the disenfranchised, combined with the economically mixed population of English and Irish white working class, West Indians and Nigerians, it was fuel to the mix, and a sign to continue the social experiment people were embarked upon by mere fact of all being lumped into the same area.

Tested to the limit in Thatcher's own '80s urban experiment in Britain, and pushed further to the political and economic margin, this social class, however, provided the real urban opposition to this era, which was typically aimed at and celebrated by "Middle England". Indeed, ironically, it was this constant social opposition—culminating in the 1990 Poll Tax Riots—which alerted the establishment to the huge liability of

Thatcher's social cost to many sections of the population, despite three successive election victories, later that year she was deposed by her own party, without a vote being cast. Another pyrrhic victory.

By the '90s, the cultural scene had been changed by the arrival and domination of dance music. A different mixing and blending had occurred; out of the cramped, dimly lit basements and blues parties of a decade earlier, and into the empty fields that ring London like a silent partner. Soon, thousands of urban and suburban kids were dancing to house music on Ecstasy. At the same time, behind reinforced steel doors, using basic stereo equipment, black kids on London council estates were forging the sound of "Jungle", replete with a playful spirit and a serious dose of darkness.

Into this evolving cultural brew, was added the new and significant contribution of the self-styled "Second Generation"–British Asians whose cultural awareness and confidence had risen to the point where Jamaicans had been a decade or more earlier. Fusing Punjabi music with house and hip hop-based rhythms, they created Bhangra. I remember walking down Tooting High St, in south west London, sometime in 1992, past the old cinema, now renamed the Classic Club. Being the only place open at the not-so-late hour of just past midnight we were amazed. Inside, the pumping reggae-like sound system was throbbing to the neighborhood sounds of Bhangra. It was like a wonderful secret discovery; back to the late '70s reggae parties. Full circle. Confirmation. Transculturalism was alive and reaching ever further in the new British consciousness.

So, in this last, most mixed-up decade, transculturalism has broken the bonds of back street parties in Brixton and clubs in Tooting, it is fully on display on the streets of London. The old monoculturalism of England, that became the multicultural London of my adolescence, has become the European nexus. A city as full of Italians as it is Jamaicans. A place where mobility, and mobile phones, dominate. London is the de facto capital of the new EU, an area that includes millionaires and refugees; fashionistas and beggars; all roaming the urban streets.

The desire to be at the centre of the English-speaking European world, which in itself provides massive opportunities for those on the streets, from the streets and those who leave them behind for far-flung places–the U.S., for example–as well as the benefits of the British socialized health, housing and social security system prove too tempting for those who flock to London these days.

From the Balkan refugees who haunted the underground tube network in the mid-'90s to the Italians and Russians that gather, seemingly everywhere these days, London has been transformed by the forced influx of people, and their shared desire to be somewhere where it's at in Europe: music, fashion, big business, the English language, a social system to benefit from or to defraud, the list is long, and for those coming from all the countries across the "New Europe", all well worth it.

As Britain, particularly London, becomes ever more European, due to the evolving nature of the EU "project", with growing numbers of Europeans of all stripes living and working there, London seems set to move onto its next phase: a multicultural and transcultural European nexus, closer to Los Angeles in spirit and texture. While, these days, you can be not just English and British, but "European" and a citizen of 15 countries, thanks to the current state of the EU, Britain's historical ambivalence about their European neighbors seems to linger (France is just 25 miles away and linked by a tunnel), although the British are learning/being forced to overcome this. With the initial immigrant population having claimed the terms "Black British" and "Second Generation" for themselves, tired of waiting for official sanction, their "Britishness" is a natural hybrid, looser yet fundamental to the whole culture now. Transculturalism in London, it seems, started from a historical deficit and is leading to a cultural advantage.

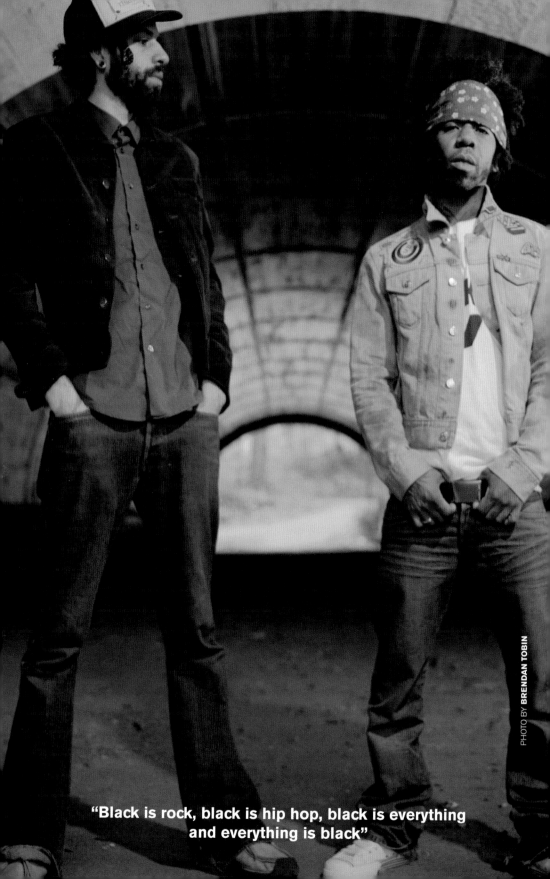

"Black is rock, black is hip hop, black is everything and everything is black"

RAW POWER

BY **ALEXANDER BARNES**

This is an ironic yet valid question from one of New York's preeminent promoters, whose professional fluidity has led him from the house music scene of his native Chicago to New York's downtown underground. Christian Alexander is a man of many outfits—his work as a promoter, DJ, producer and creative director has resulted in an impressive resume that includes collaborations with a wide range of artists, from Frankie Knuckles in Chicago to Apollo Heights, Kelis, Mos Def and his latest gig promoting a monthly party for Star Trak, the new label founded by tastemakers du jour the Neptunes, in New York.

"The Neptunes produce everyone in the industry. The grimiest, most gangsta' hip hop artists in the world need them; they cannot put an album out without the first single being a Neptunes track. But the Neptunes aren't gangstas themselves, they're skaters," said Alexander.

The ever present duality of the Neptunes—their hip hop street credibility versus their skateboarding roots—has been as perplexing as it has been fascinating for those both inside and on the sidelines of the hip hop community. Ever since the Neptunes' eclectic blend of hip hop production took hold, there has been a watershed of artists who have "crossed over" into supposedly uncharted musical territories.

While some of these changes in artists' repertoires have been as blandly revolutionary as adding a live guitar player with beefed-up distortion, the result has often been engaging and interesting.

An outpouring of thoughtful production should always evoke a thoughtful response from listeners, media and industry alike. Unfortunately this has not always been the case.

It has been written, rhymed, spoken and sung past the point of cliché that folks are becoming disillusioned with hip hop in its present state. Yet there is neither rhyme nor reason for the language that has been used to describe the so-called rediscovery of rock and roll by black people.

"Black is rock, black is hip hop, black is everything and everything is black. This is not something we can move into or out of because it is an acknowledgement of what we are; of the resources that are within us," said Alexander.

The fact is that the so-called new black rock revolution is neither new nor revolutionary.

For starters, there is the obvious fact that black people invented rock and roll music. Even deeper than this argument lies the problem with assuming that rock and roll has made a resurgence in the black community because of a total rejection of hip hop. As if it is a clear cut choice: either you dig rap or you dig rock. And up until now it has been widely assumed that if you're black (unless there is something wrong with you) you most definitely dig only rap. This assumption has created a divide so deep within our contemporary culture that it runs from high school lunch tables to corporate marketing departments.

While the polymorphic stylings of white youth have been discussed at length (the suburban rap-rock renaissance, for example, the acknowledgement that black kids too can have cross-genre tastes has been much quieter. Yet over the same 25 years that hip hop has been synonymous with young, urban and black culture, cable television, MTV, the Internet and mall-sized record stores have been appearing in every city and in every home infusing black youth with sounds, images and ideas from all over the world. Why then is there talk of a black rock revolution when this culture was created by our own people?

Tamar-Kali The very nature of Tamar-Kali's musical endeavors make categorization rather difficult. Her connection to Africa is apparent and finds a natural manifestation in punk. Her family's roots in South Carolina are deeply entrenched in Gullah culture where West African customs and languages have been passed down from generation to generation through slavery to the present day.

"My mother's side of the family is from St. Helena Island, South Carolina. When I went down south, I was staying on my family's land. I saw my family growing food; my aunt kept that tradition going. So I felt like I really belonged somewhere—I wasn't just sprouted out of this concrete."

"I started listening to new wave and then got progressively into harder stuff," said Tamar-Kali.

"My love for hardcore coincided with me coming to political awareness as an African-American girl. There is a certain rage that goes along with finding out your own culture and your history, and hardcore really suited that emotion."

Watching Tamar-Kali perform is an intense experience. Her aesthetic is a stimulating blend of skin, studded belts, cowrie shells and body piercing, wrapped up in a body that rocks harder and funkier and sexier than you thought possible. Born and raised in Brooklyn, Tamar-Kali's roots run deep in both the city and country.

Tamar-Kali began performing in the East Village hardcore punk scene in the early '90s, with bands like Funkface and Song of Seven. A deep connection began to form with other black people around her as she became more and more involved with the scene. "I had a very unique experience being in New York in the early '90s. There were a lot of black kids in the hardcore scene. I basically went from being the only one, to having a crew made up of people who knew the same things that I knew—that the first skinheads were black working class Jamaicans in England. And we could build upon those facts. This is what we clung to. There was a real euphoria of having this community where you could express yourself."

After years of heading various hardcore groups, Tamar-Kali branched out and began creating her own groups, first incorporating her written material into a straight ahead five-piece rock group. As she developed as a writer, Tamar-Kali's musical sensibilities continued to expand, allowing her to bring new concepts into her repertoire.

"I came up with the Psychochamber Ensemble because I've always loved strings and in the music I listened to as a kid—Stevie [Nicks], the Beatles, Prince—strings are very present. So I decided I wanted just a string project with all female instrumentalists. Then I started composing some stuff specifically for that project."

After forming the Psychochamber Ensemble, Tamar-Kali began crafting songs for yet another project, Pseudoacoustic, which blends the powerful rock vocals of the five-piece group with the deep emotion of the Pychochamber.

Though Tamar-Kali performs each project independently, the full scope and evolution of her musical capabilities are on full display when all three projects are on stage together. The instrumental depth behind Tamar-Kali's voice is astonishing; a cohesive soundclash that takes place within each song.

"I have an outlet for all types of expressions; now I have a mouthpiece for every single mood."

While being grouped together with others is not an immediately negative experience, her main point of contention lies with the motivation behind such categorizations.

"I believe that the 'black rock' label is another obstacle for artists like myself. For all intents and purposes it continues to marginalize black artists to a group defined by race as opposed to genre."

Afro-Punk: The Rock & Roll Nigger Experience James Spooner, equipped with a video camera and his own memories of dealing with racial identity within the punk subculture, set out on a cross-country trip in search of black folks in various punk scenes in America. The result is the documentary "Afro-Punk: The Rock and Roll Nigger Experience", which delves into the ambitiously complex world of race and rock and roll.

"People had different reactions [to my film]. Most people were like 'Oh that sounds cool,' but some people were like 'No… I'm not interested at all.' That wasn't really shocking, but those were the people I wanted to talk to the most," Spooner recalled.

"Once the interviewing started going down, people were blown away–no one had ever asked them these questions before. And they weren't really tough questions, just things like 'What do you think when you see another black person at a show? What do you think when you are the only black person at a show?' And some people really freaked out."

I asked James why he thought that was. Perhaps we have reached a point where black people can in fact find themselves in a scene where race is not the definitive element of all experiences.

"I think that for most black people, who are into alternative scenes, when they come in contact with other black people, it's very confrontational. It's like 'Why are you trying to be white?' And I was basically asking them the same kinds of questions, but only from their side, and I wasn't confrontational. And when I put it to them like that, they really had to think about it when previously they had put a lot of energy into not thinking about it."

The final touches of "Afro Punk" have been made and Spooner is now looking to get the documentary distributed. In conjunction with the film's release, Spooner is also building what he hopes will be something of a forum for black kids to come together to discuss and address their experiences with punk. His website, Afropunk.com, will serve as one manifestation of this forum. Another is the concerts he promotes, the "Double Consciousness Rock Series", which features bands with all or mostly black members. Spooner understands that the building of this community is not automatic.

"I'm trying to do things that are empowering to black people, but I don't just big up any black artist. You have to be good. If you're just some jackass with a guitar, you're just a jackass with a guitar."

The eventual outcome of the "Double Consciousness Rock" shows has yet to be determined. Its ultimate success will hinge upon whether the bands who perform feel that their individual aesthetic is respected, not molded to fit the confines of racial categorizations.

Apollo Heights "I was playing a show with Greg Tate once," said Micah Gaugh of Apollo Heights. "And someone came up to me and said 'So you're a part of the Black Rock Coalition.' I said, 'I am?'"

To set the record straight: Apollo Heights sound like no other band around right now. Their aesthetic has sent writers and promoters scrambling for new terms–"negroclash," "avant-pop," "black futurist," "blacktronica"– terms that the group appreciate but do not get caught up in.

"People try to come up with all these terms for us, to try and get us, but we just get on stage, play and go home," claimed Danny

Chavis, co-founder of the group with his twin brother Daniel.

The twins hail from North Carolina, from a mostly black housing development called Apollo Heights, and named after the late '60s NASA space mission. Maybe it's from growing up around streets with names like Solar Drive that the group derives some of its not-yet-on-this-planet sound.

Danny and Daniel were previously in a band called the Veldt, who moved over to England to record with the Cocteau Twins. Things didn't quite work out with the record label and the group next found themselves in New York, where they linked up saxophonist and vocalist Micah Gaugh and bass player Hayato Nakao from Japan. In Apollo Heights, one can hear a composite of wide ranging musical influences, from soul to avant garde to electronic music. The opening string sequence of the ultra catchy single "Disco Light" is derived from a Japanese folk song. With a rhythmic background of electronic beats and synth-infused keyboards, Apollo Heights' sound is built on tidbits picked up from around the musical stratosphere.

"When we first came out, the press had a field day. They compared us to every black group. They compared us to Living Colour to Fishbone. I said what!?!? We don't sound anything like Fishbone! It's all ignorance. You don't compare one white group to another white group because they're white. That's why I don't necessarily agree with the whole black rock thing, because it's corny. And now you've got guys who start dressing really rock, but they don't even sound like rock!"

Kali Hawk While Apollo Heights circulate above and beyond existing definitions of music, Kali Hawk is looking to put a black face on the pop rock world. "Kali Hawk is the future," predicted Christian Alexander. "A year from when she hits the streets, every little girl is going to want to be Kali Hawk." After losing her job as a waitress, the native New Yorker went out on a limb and used her rent money to buy her first guitar. She managed to teach herself to play, and began writing songs that are deeply personal and emotional. Coming from a mixed

African/Native-American family, Kali presents you with a bubbly blend of rock and roll grittiness, augmented by an impressive amount of confidence, beauty and intelligence.

"My look is rock and roll. People see it, but what I do is still a little unexpected. When people hear my CD and then meet me in person they never think that that voice came out of me."

Kali's look is certainly rock and roll, but don't let the pop sensibilities confuse you; her music is genuinely entrenched in a rock and roll aesthetic. "A lot of other black female artists who come out doing pop rock music attack it vocally from an R&B standpoint, so you can usually tell where their influences lie. But when people hear me sing they usually can't tell where I'm coming from."

Her first single, "Pintak", is a heaping load of raw emotion laid out with distorted vocals and driving guitar backing. The video, directed by Emory Wells (which can be viewed online at stormwaveent.com), is equally provocative—a trait which can be traced back to her musical influences, such as Guns-N-Roses, Ani di Franco and PJ Harvey. Kali Hawk's goal of achieving pop success is in part driven by an awareness of her own individuality within the scope of music history. "The most important thing about what I'm doing now is that—in all of recent rock and roll history—there's never been a black girl who plays a guitar and has mainstream success."

Kali Hawk's self-awareness as a black female musician delving into a musical world where "what people see is not necessarily what they will get" nips at the heart of what all of the artists in this article are dealing with. Misinterpretation seems to go hand in hand with making innovative music. The industry is just not adequately built to accommodate artists whose music does not fall into pre-existing categories. Categories can be packaged; packages can be marketed and sold. The maxim is generations old: the abstract ideas and emotions that go into creating good music are rarely a perfect fit with the commercial enterprises aimed at marketing them.

Black musicians are more often likely to be categorized by their racial identity than by the

music they make. The sad results are awkwardly pasted together "movements" based on paper-thin ideas with little relevance to the music in question. This is what these artists are fighting against; it is the heart of the double-consciousness that comes with the territory of being utterly committed to your own independence in an industry that is not ready to comprehend you. Yet by pushing the boundaries, these artists are also setting themselves up to make musical milestones. We wait with baited breath.

ORIGINALLY PUBLISHED IN TRACE #44, 2003

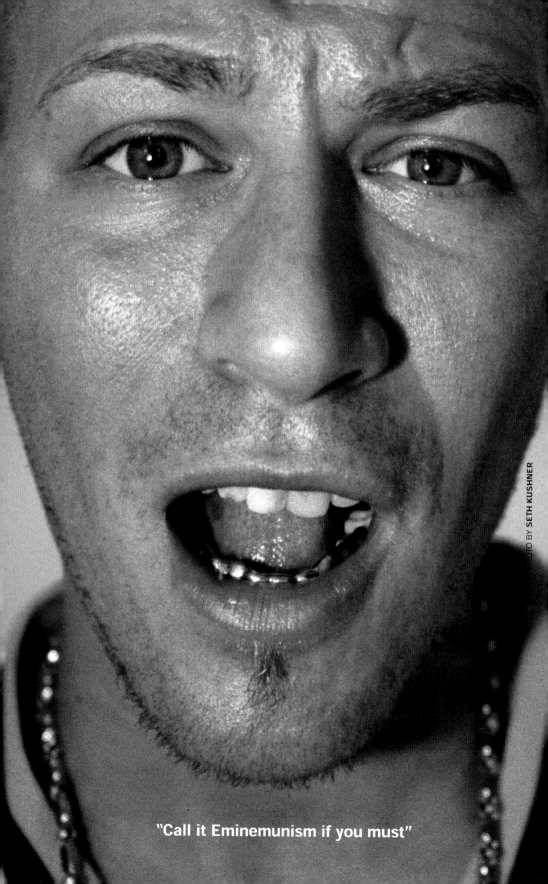

"Call it Eminemunism if you must"

FOLLOW THE LEADER

BY **STEVE MASCATELLO**

I had a dream: of shucking off the vestments of my suburban life's history; of abandoning my old soul, my essence, my—for lack of a better phrase—middle-class quiddity; of winning battles over rappers who spit prattle and becoming a hip hop celebrity.

In this dream, my name was Jon Henree, and just like that steel-driving man, I proved to all the haters that no machine—the Government, the Industry, the SP 1200, whatever—could ever match the power of a man and his art. Imagine, then, my shock, my unmitigated awe, when I turned on BET recently only to see the latest video, "Roll Wit MVP", by a fellow caucasian calling himself Stagga Lee. Apparently, this gentleman had beaten me to the punch(line).

Fans of the 1959 Lloyd Price hit "Stagger Lee" know the story of an 1895 St. Louis barroom dispute: 'Stag' Lee Sheldon (variously referred to as Stagolee, Stag-O-Lee, Stackolee, or Stack-A-Lee) and Billy Lyons, "two men who were gamblin' in the dark", their blood angried up by liquor and competitive spirit, began to argue about politics. Lyons snatched Sheldon's brand new Stetson hat, and the rest is pop culture history. Stagger Lee shot Billy; shot that poor boy so bad. The story of Stagger Lee became myth as it traveled‹by word of mouth, of course—to the South; it became the stuff of rock and roll legend when Price introduced it to white America 64 years later. As each storyteller embellished the tale, bits and pieces of other stories and apocrypha were inserted into the blueprint. Literally hundreds of lyrics detailing the crime of Stagger Lee were being told up and down the Mississippi River by the time Price's version reached America at large. In short, "Stagger Lee" became something of a musical institution. And with all institutionalization come equal portions of gain and loss; in this case, the legend gained national exposure as it lost its local specificity.

These days, few would deny that no musical genre (with the exception, perhaps, of country) receives more national exposure than hip hop. In the video for "Roll Wit MVP", Stagga Lee, a young white male, wakes up on his lawn in suburbia after a night of partying. His friends, a

mixed group of decidedly non-white young men, meet him to plan a pool party. Beautiful young women of all ethnicities arrive literally by the truckload, and the fun commences; more than mere eye candy, the beauties also chirp part of the hook, an extrapolation of Minnie Ripperton's "Lovin' You". As Stagga lounges poolside like Caligula, the young ladies set it off like Vivica. It is an intriguing image, because it somehow manages to make the most familiar aspects of hip hop iconography seem utterly alien. While this video teems with the sort of Dionysian obviousness found in so many others, Stagga himself fails to establish any persona of his own, I suspect, in part because he and his comrades deliberately ignore his whiteness. Indeed, it is an odd hybrid of nearly outdated visual styling and unintentionally progressive racial politics. The end result is a product that fairly reeks of the desire for hip hop acceptance, and that, appropriately enough, has been blanched of color entirely. The self-proclaimed MVP is deraced to the point of anonymity.

While some may view the recent proliferation of white rappers like Stagga as a positive sign of a truly syncretic mass culture, others may just as easily see it as a far more insidious phenomenon. The former point of view holds that whites embracing black culture is a harmonious union, but the latter deems the white mainstream institutionalization of African American traditions a kind of cultural appropriation tantamount to theft. Simply put, hip hop is black music. It is a form of "musicking", to borrow ethnomusicologist Kyra Gaunt's term, necessarily born of and rooted in a legacy African American folk traditions—the oral transmission of ideas and stories through kinesic expression set to the most vital of rhythms. Many critics have argued correctly that hip hop grew from a certain shared cultural memory, and that an Africanist presence permeates every act of African American musicking even now, generations removed from the continent.

Toni Morrison has written of a similar process of "rememory", an act of almost involuntary expression that conflates personal and cultural history in synchronic experience rather than linear reconstruction (i.e. what we know

traditionally as "memory". Many critics use this last point to conclude incorrectly that hip hop does not and cannot belong to whites. The classification of hip hop as black music must be made only as it pertains to the music's origins, not as a means of creating ethnic barriers to entry. To say that all things are equal, and hip hop belongs to one race, is as ludicrous as to say that historically non-literate cultures have a diminished claim to the written word once it has been introduced to them.

As much criticism as hip hop has taken from mainstream media (a trend that seems to be dying down), there is a lingering question of ownership that can polarize both local and regional geographies. Though the Bronx and Queens may argue about where hip hop began, that beef disappears when the East/West coast battle lines are drawn. Similar alliances have surfaced in relation to a certain specter haunting America—no, not the specter of Communism—though Marx's dialectic of the bourgeoisie and proletariat certainly has interesting applications to the majority of the hip hop community's unflagging allegiance to materialism. The specter—call it Eminemunism if you must—has driven many rappers and CEOs (and let us not forget the rapper/CEOs) to deride a man who is both arguably one of the most important voices in the history of popular music, and one of hip hop's fiercest defenders. Eminem is an anomaly not only because of his race and extraordinary talent, but also because of his indefatigable respect for and knowledge of his art and its masters. That rappers like Benzino and Ja Rule would accuse him of stealing hip hop from its supposed rightful owners and hogging the market (thereby denying more deserving black artists record sales) is as laughable as their respective attempts to defend against his excoriating musical assaults. The irony of one rapper blaming his inability to stay relevant on another's race rather than his own mediocrity must have eluded them both.

Throughout "8 Mile", Eminem's Rabbit is forced to atone constantly for his whiteness‹as though the condition of being white is anathema to hip hop. Specifically, masculinity and its supposed manifestations are characteristics

prized in hip hop culture, not coincidentally, as they are commonly attributed to African American males. In this way, we might view Eminem's highly publicized misogynistic and homophobic lyrics not as hyperbolic self-indictment, but as an execrable, albeit shrewd, attempt to establish complicity with the ruling majority of the hip hop community. The implication is that attacking, thus proving himself tougher than, those labeled "other" is penance for his own other-ly qualities. And so we discover the fundamental iniquity: whiteness is considered a bad trait. While the criticism "He sounds too white" is generally accepted, to describe an artist as "too black" surely would not be tolerated. This variable spectrum of whiteness was evident in P. Diddy and MTV's most recent installment of "Making the Band". Diddy cut a young white rapper from the competition with the explanation that "he tries too hard". Effort, as we have learned from James Dean and those hyper-educated, hypo-motivated Gen X slackers, is totally uncool. I, however, have my own theory. Prior to the cut, another feisty competitor, a young black female, had called the rapper a "white devil". In response, he wept. On one level, then, he proved to be too white—er, weak—to be a hip hop artist; crying simply is not allowed in a game that worships effortlessly masculine brio.

ORIGINALLY PUBLISHED IN TRACE #44, 2003

"Filmmaking is a slice of life–it goes on"

THROUGH A GLASS SHARPLY

BY **OMAR "CALABASH" DUBOIS**

Overview: The world has never been the same since the Monkees' Michael Nesmith suggested to John Lack (then visionary executive at the Warner Satellite Company) that he launch a whole network dedicated to music. Not unlike radio, it would basically tread the song after song format. Radical this certainly was. For, since its inception, television had stuck to its comfortable blueprint of regularly scheduled 30-, 60- and 90-minute shows. Picture opens (35 mm, color): Well, on August 1, 1981, at 12:01a.m., MTV was born. Its first cry? "Video Killed the Radio Star" by the British band Buggles. From then on, it was a wrap: the music and television industry were altered for good!

Cut to: It's an unquestionable truism that over the last two decades popular music at large has been irrevocably altered by the introduction of the music video. Indeed, over this period of time, music video has managed to transcend its original commercial role to attain the sovereign status of "art".

Cut to my P.O.V.: Even if you had a fully loaded Desert Eagle shoved down your throat, implying the immediate threat of a long kiss goodnight, you'd be hard-pressed to think of a more progressive, influential visual artform, over the last 20 years or so.

Cut back: Music videos have nursed their own aesthetics, genres and visual language. And if palatability is the key word of the new millennium, is there anything as appetizing or toothsome as a music video? It's terse, attention-grabbing and disposable (in a good way!). Isn't this what true pop culture is about? Plus, it speaks in a tongue everyone can comprehend.

Cut to my P.O.V.: Even the most short-changed dunce can on some level appreciate an esoteric video by, say, Tool or Radiohead. Furthermore, people in distant arenas such as Chad or Kuala Lumpur eat up music videos with relish, without the slightest hint of choking!

Fade to black. Fade up: It's a given fact that music video has altered the movie-making process like nothing before it: the rapid cuts, tele-ciné choices, jerky camera movements, etc. Perhaps we're not so far off from the day of "Video Killed the Movie Star"! With the amount of rappers/musicians (Will Smith, Courtney Love, Ice Cube, Joey Fatone, Queen Latifah, among others) that pervade films today, and the number of video directors (David Fincher, F. Gary Gray, Spike Jonze, Brett Ratner, Mark Romanek, etc.) who have gone on to direct successful motion pictures to date, it

doesn't seem far-fetched. Intercut: And as for the reins of commercials, they practically reside in the capable palms of current practitioners, or alumni of "The Music Video Shooters Association!" Wipe transition to: Michael Jackson and Madonna (Ciccone). Please marinate these two names for at least 19 seconds. Now, what do you see? I'll bet my last yen that if your marinating process was devoid of malice, you probably saw something connected to a music video in some form or fashion. Michael and Madonna are primarily defined by their music videos—they are video artists!

Cut to my P.O.V.: Regarding the former, anyone who was alive in 1983 didn't really experience it if they didn't catch the epic debut of "Thriller" on MTV! Plus, you were a sucker if you didn't have the "Making of Thriller" video tape (good lookin' Aunt Vilma). It certainly kept me very distracted from doing my first grade homework—(Mathers' style) I'm sorry mama!

Cut back: The marriage between Jackson and Ciccone, and MTV respectively, has been hugely beneficial to both parties in that it helped the former redefine themselves, reach a varied and bountiful audience, and simultaneously cement themselves in the history books. It also gave MTV a whole lot of influence, clout and, of course, paper. Today, video artists are more or less the norm. Can you possibly fathom the thought of Busta Rhymes and Missy Elliott being on the map, without their groundbreaking Hype Williams videos? Or even the prospect of Eminem, Justin Timberlake, Britney Spears or even Shakira, existing without music video? Nonaffirmative? Exactly.

Cut to my P.O.V.: Even D'Angelo, on a good day, would admit he owed his last Billboard triangle for "Voodoo" to the Paul Hunter-helmed, "Untitled"! Cutback: Perhaps the most bizarre element concerning music video appreciation itself is the lack of appreciation for the directors. Granted, MTV's "Making the Video", and BET's "Access Granted", have afforded some directors the shine they deserve; but, at best it's still marginal. If video play is undoubtedly as crucial to an artist's success as radio, then why is it that Dr. Dre, Timbaland, The Neptunes or Jimmy Jam & Terry Lewis are so celebrated for

the sound-scapes they compose, while the auteurs who construct the videos for the same artists go largely unnoticed? Surely, these videos that we so relish owe their very existence to the resourcefulness and ingenuity of their "auteurs". Fade to black. Fade up: It is only right then that we rightfully acknowledge a few choice directors who have been responsible for some of the most diverse and exquisite videos we've witnessed in recent times: Diane Martel, Andrew Dosunmu, Sanji, Nzingha Stewart and Francis Lawrence—the true stars! Respect is also due to the pioneers who paved the way: Bob Giraldi, Russell Mulcahy, Steve Barron, Godley & Creme and David Fincher. Freeze frame. The End.

It's peculiarly interesting, and indeed amazing, how much an individual's work can be so characterized by his personality, or even manner of speech. Case in point: our ethereal protagonist (the self-taught auteur behind such envelope-pushing eye caviar as Lauryn Hill's "Everything is Everything", Maxwell's "This Woman's Work", and most recently Tori Amos' "A Sorta' Fairytale", among others) comes across as pensive, self-assured and emotionally earnest (in a metaphysical sort of way). Like many a genius, **Sanji** (Senaka), born to Sri-Lankan parents (in Hollywood of all places), is quite instrumental (i.e. more self-interest than melody); and it's quite fascinating how that seeps into the meticulously poetic way he expresses himself. If ever there was a Stanley Kubrick of music video, it'd have to be Sanji. He approaches his work fastidiously; admits to not being the easiest person to work with; and has done only 10 music videos in as many years! However, if the reclusive Kubrick's sparse output was due to neurosis, and a quest for immaculacy, Sanji's is simply due to the fact that his main goal in life has always been to make feature films. Translation: he was reluctantly pulled into the music video arena. Well, thank goodness for that default!

TRACE: The first video that really gave us a glimpse of your very unique style was Johnny Gill's "I Got You" (1993). How did it come together?

Sanji: There's something a little vanguard about that whole project. I used Jeff Cronenberg as my DP; he actually went on to become Fincher's DP on "Fight Club". And bear in mind that this was pre-Hype Williams; way before Paul Hunter and any of those cats. Anyway, the dark brown tones hadn't been used; even the way we manipulated the choco-late/tobacco filtration and different lighting to get this chocolate look on the skin. It was so groundbreaking, that Malik Sayeed, [Cinematographer of several Spike Lee films], prior to shooting "Clockers", called Jeff to ask him how he got the look!

TRACE: Like ODB, there seems to be no father to your style! How was it born?

Sanji: Well, Pharcyde's "Passin' Me By" was my first video. After that, I was invited to join Propaganda. And I think what was interest-ing to them was that all my ideas came from the universe and God, or whatever. Because I never went to film school in that capacity, I did-n't reference photographers or anything like that. As far as I know, all my ideas are mine; there's no other place of origin but me. And my execution was done in that very beautiful style that a lot of people weren't doing; apart from Fincher. I mean, Michael Bay was attempting it, but he was just a Fincher rip-off! Basically, I've always been in the vein of original thinking. Like with the Pharcyde video, I actually dropped my pencil when I was thinking up the treatment, so when I bent down to pick it up, I got the idea to flip the camera upside down!

TRACE: When did it wholly impact you, that filmmaking was your true calling?

Sanji: Oh, it was the first time I held an 8mm camera and started filming! I knew it right away, because something felt amazingly familiar and real about it! I mean, we've all had delu-sions, and things we've put up against our-selves, etc., but the one thing I can say has been totally real is everything I've done with film. And that level of honesty has not only kept me alive, but kept my feet on the planet while I fly.

TRACE: Do you think you approach music videos with the same intensity you'd accord a feature?

Sanji: Absolutely... I've always tried to put filmmaking into my videos. There's always a beginning, middle and end. Take Mary J's "No More Drama", it was really about the quality of the performance, even though I didn't have the luxury of rehearsal time. I didn't want a "video" performance, you know: the whole "arguing" thing. I wanted people's souls to be captivated for the four or five minutes; and go on a journey with these three people and Mary. I just try to tell a story; try to put as much film into the video format as I can. Sometimes, it's not even a traditional narrative; it may be more metaphor-ical, but the objective is still evident. For exam-ple, the Maxwell video was very metaphorical, but you can tell the video is about a guy's pain. At the same time, I wanted it to look languid and dreamy—like a liquid painting come to life!

TRACE: Masterpiece—Lauryn's "Everything is Everything"! Care to expound?

Sanji: Well, she sought me out after she saw Raphael Saadiq's "Get Involved". With "Everything is Everything", I thought: 'the world is a record; life is a song; the record has to get played; you can only play your record if you allow your needle to stay in the groove, and not skip or get scratched. You have to stay on your groove, i.e. your path, to ultimately hear the beauty and finality of what your song's about.' "Everything is Everything": the world spins; everything IS everything.

Nzingha Stewart couldn't possibly be happy! Why not, you ask? Well, she's sumptu-ously pretty, fluently erudite and rather deft at her chosen profession (who do you think brought you Common's "The Light", Sunshine Anderson's "Heard It All Before", Eve's "Satisfaction" and Freeway's "What We Do", huh?). Dare you imagine a state of elation fac-toring into the aforementioned burdens? Nzingha was born to Jamaican parents in the city Sinatra couldn't stop singing about, was raised in Atlanta and then returned to her birth-place to attend NYU. Considering this informa-

tion, and the conversations I've had with her, it is somewhat safe to say that her breeding and mother wit are responsible for the air of regal, solipsistic cool she so effortlessly exudes. She's indeed a joy to watch and listen to: for one, she could easily pass for one of the models in the splendid video she shot for Bilal ("Soul Sista"); but at the same time, she's so mentally captivating, that the consequent dilemma becomes unbearable: do I fixate visually, do I fixate aurally? Alas, Mr. Pragmatic and Ms. Prudence get the best of me—I select the latter option! At this pretty low-key spot in Brooklyn, I get to chop it up with the ever-polite Miss Stewart about an array of topics, including Picasso, "text-book" culture, black folk, music (Tribe, and even Too $hort), "Daughters of the Dust" and mo' better shit. True to her craft, she was ever the director, in that she was very comfortable being on the listening end, thus rendering me the "performer!" (Note that most interviewees constantly and calculatedly sell themselves to the interviewer.) It's no secret that going for self is the order of the day. Well, not this lady. In truth, it's slightly offsetting. But do not fret: I managed to extract some valuable ear candy.

TRACE: You're blazing a nice trail as a music video director, but I'm quite fascinated by the fact that you majored in Philosophy and Black Studies at college, instead of doing the expected: majoring in film. Has this been an asset or an impediment?

Stewart: On my first visit to NYU, people told me something that stuck with me: "If you really want to learn about film, work on the set; and then study what you're really interested in. I'm kinda' glad that I did, for I noticed that a lot of my friends who went to film school were kinda' stuck in what so and so did in this movie, whereas a lot of my friends who studied philosophy, just spoke about ideas, and what motivates them. And that makes a difference in how your work comes out.

TRACE: Interestingly enough, when you graduated, you started off as a treatment writer for cats like Brett Ratner, Hype Williams and Steve Carr. Did that experience impact your direction in any way?

Stewart: Actually… no. The treatment thing is something I just did to pay the bills; and learning to be a director, was learning what I liked. Being a director is about knowing solidly what you like, and expressing it. And with those treatments, I didn't like all the songs or artists I was writing for. But I suppose I learned how to write within the confines of a budget, if anything.

TRACE: Well, now that you're in the driver's seat, how do you approach your own treatments?

Stewart: Life to me is essentially about love, and not necessarily man/woman love—just love. As in what do I love to see, what do I love to feel and when I get a song to write to, I think, "What would I want to happen to me?" I put myself into a situation and think, "What would I want to experience here?" Like with Common's "The Light" video, I wanted to experience a man I loved just watching me; or say, with Bilal's "Soul Sista", I wanted to experience being put on a pedestal. So, all the women in that video were put on pedestals. It's also about how much I love black people. Like with the Memphis Bleek video ["Got my Mind Right"], I'm looking at him, and I want him to be shoving me [camera] around, but still in doing that to me, I love him so much. (Laughs) I still look at him, no matter what he's doing to me. I guess, in a way, it's symbolic of black people in general—I still love them, no matter what we're doing in the world.

TRACE: How do you select your specific subject matter; and what you're going to make a priority, or rather not?

Stewart: My approach is this: If you gave me a camera, I can make a video about anything in this room. Because I realize that everything I see is as important as anybody or anything else. So, if I made a close-up of this glass, or candle even, it has meaning! So I guess that might be connected to my philosophy background, which advocates that one thing is as important as the other.

Cali-raised **Francis Lawrence**–responsible for Aerosmith's "Jaded"; Britney Spears' "Slave for You"; Shakira's "Whenever, Wherever"; and Jennifer Lopez's "Jenny from the Block"–is surprisingly modest. Eloquent and dry-humored, he barely hypes his upcoming, generously budgeted, full-length feature starring Keanu Reeves. Lawrence's pilgrimage to the crest wasn't overnight: after witnessing Scorsese's "After Hours" and the Coen Brothers' "Raising Arizona", he was immediately convinced his role in life was to be a filmmaker. So, he headed to film school, where, like all students, short films were the term paper. Upon graduation, Lawrence paid his dues by interning at production houses, neck deep in the film crew process, and finally earned the opportunity to direct some low-budget music vids. He's been on the rise ever since. Our discussion was certainly one for the TRACE eye; his random fascination with animals (take a closer look at most of his videos) and his birth in Vienna set on the pages…

TRACE: The music video game is reasonably polluted by more than a few "kindergarten-directors"–everybody's got a camera nowadays. What gives you your edge?

Lawrence: Direction. I talk to them; I have them perform. It's true… everybody's got a camera. But it's where you put the camera; what you have the person doing; the speed; where they look; how they move; the colors; is the camera close up, or is it far away? What lens do I choose? There are so many choices you can make to change the way something feels. Even a simple thing–if a camera moves or not–can change things significantly. It's a combination of all that. And you learn through time how to manipulate all those choices into creating something that feels the way you want it to feel.

TRACE: There's a certain rhythm to your work that makes me assume that you're a big music fan. Is that a fair assumption?

Lawrence: Actually, I've never really been a collector of music. I'm more of a casual listener. Typically, I don't listen to lyrics of songs unless they're very, very obvious. I think of the music more as a score. In general, I think of the tone: how the music makes me feel rather than what the person's singing about.

TRACE: How do you achieve the medium between the concept and the performer?

Lawrence: My early videos, before DNA, were based on the idea and not the artist. (Laughs) I didn't give a shit about the artist! I just thought it was someone who was annoying–who wanted to talk to you on the phone about stuff–and wanted to be in it! So, I actually got into trouble with this early in my career… not showing enough of the band, and just going for the story. I learned that, if you're not just sticking an artist in your world, but rather creating a world around them, they're down with it!

TRACE: Your latest, Justin's "Cry Me A River", is just one in a series of your astounding videos; what's the scoop?

Lawrence: Well, the song is basically a kiss-off song. I've had this idea of a girl stalking somebody, being outside their house, breaking through a window and creeping about their home for a while now. I had actually given it to a bunch of people who never gave me the job. So, when Justin came to me and told me he didn't want to do a big dance video, but wanted to do something different, I just changed the idea a little bit, and made it fit the song. I then tried to make it work–emotionally and tonally. The thing is, if you can capture the way a song sounds, either visually or through performance, it makes a huge difference. A lot of people think that if you edit a video really quick, or if things happen on beat with the music, that it works. But that's like the biggest gimmick of all time in music video, right? It's bigger than that: making a connection to the song on all levels–that's the key! Has your upbringing in any way affected how your work looks? As far as, say, the aesthetic, ideas or sensibilities in any way? I don't really know, but I do imagine it all has an effect in some way. I mean, the only thing I can say is that I try to make things have multiple layers, but I don't know where that comes from. And I think when I succeed, I succeed on a visual level, a storytelling level, an emotional level and

then on various subtle layers as well. The fact is: videos are played, let's say, 50 times. Therefore, there's the possibility of any viewer seeing your video about 50 times! So, hopefully, it's not ruined the first time they see it.

To paraphrase Rashid Lynn: If revolution was a movie, **Andrew Dosunmu** would be its theme music. A reactionary by nature, Dosunmu instinctively thinks outside the box, and is intensely passionate about shaking things up to present an alternative picture. Indeed, a true "renegade". One can only assume that this amiable six-footer's make-up has as much to do with nature as it has to do with nurture. For the man, behind diverse videos for artists ranging from Maxwell to Morcheeba to Les Nubians and the Manic Street Preachers, had a richly cosmopolitan upbringing. Andrew Dosunmu, blessed son of Lagos, has also had the privilege of living in Paris and London. Now residing in the city that never sleeps, this self-described nomad also doubles as a photographer. Over several cups of coffee and Spanish food, Andrew and I discuss life; his heroes—Malick Sidibé and Seydou Keïta; and of course, music video.

TRACE: Like the late Herb Ritts, you made the transition from still photography to filmmaking. How did that come about? Did you go to film school?

Dosunmu: Actually I didn't. I did do the art school thing, and my little running around. But technically, I never studied film. I come from a different background, and it isn't like I had someone in my family, or knew somebody who was a filmmaker. There's nothing like that! It was just an interest I pursued myself. I bought a Super-8 camera, and I shot everything I possibly could. And I learned firsthand from my mistakes.

TRACE: Isaac Hayes' "Funky Drummer" was the first video you shot, right? Has your approach changed a lot since then?

Dosunmu: Well, I shot that video like I did my stills. It was so raw! You know how there's something so organic about first things? There are so many things in there that I'd never do

again, because you learn. But what I really want to keep is that naive quality I had. If I can keep that naivety in time, it'd be perfect.

TRACE: What's your personal best (video) to date; and why so?

Dosunmu: Probably my Manic Street Preachers video. I thought it transcended well emotionally. In that, it wasn't about acting or rigid choreography, it was about these little girls doing what they do, and in the process, little interesting things unfold. I'm intrigued by just getting reactions from little moments, rather than leading things in a particular direction. That's why I resent it when commissioners always ask me what the end to a video is! Why does something always have to have an end? Filmmaking is a slice of life—it goes on. The depiction itself should be enough!

TRACE: So, have video commissioners in any way influenced how you approach your treatments; and are all your treatments yours?

Dosunmu: Definitely… my ideas are all mine, because I know what I want to do. But most of the time, when I put it down on paper for the commissioners, they find it too raw! They want someone who'd say, "The girl looked beautiful and sophisticated in whatever shoe and a pretty Chanel dress driving her Cadillac!" They always want to hear how nice an artist would look. A lot of them want cheesy writing! Come on… it's my job to make an artist look gorgeous and beautiful. I think artists should have a bigger say in how they're presented. I noticed that you were featured on the album cover of Common's new album. I'm assuming you're friends; is that how you connected for what I think is one of your best videos to date, "The Sixth Sense"? Common is a friend of mine, and we have a mutual respect for each other, so it was definitely a good start. What happened was, once I got the track, and we discussed ideas, he came over to my crib, and I told him what I wanted to do: to base it on the Watts riots, and vintage Life magazine photos. He dug the vibe, so we went on and collaborated. The personal touch I think is so much better. Whereas with Angie Stone's "No More Rain" video, for example, it was completely dif-

ferent, in that it was track; write, "like it"–do the video! I mean, it was a good video, but it could have been better.

TRACE: How involved are you in the entire video-making process?

Dosunmu: Very involved. From the treatment, to editing and post. I also work very closely with my DPs. And because I come from a very visual background, I come with layers of references, colors, palettes, lens choices, art direction, etc. All these things matter to me; it's like the domino effect. But what I love about filmmaking is that it's a collaborative effort. It's not a one man show at all.

If words such as "grimy," "gutter" and "dungeon" are perceived as representative of excellence in hip hop culture, then **Diane Martel** a.k.a. Bucky Chrome, video veteran of 10 years, is the undisputed basement fiend. Plain and simple: her work is gangsta! Not to say her work with Mariah (about five videos), Christina Aguilera, and most recently Justin Timberlake, doesn't hold weight. Far from that! But it's just that when it comes to tapping into those murky zones beneath the surface, Bucky's your girl. Peep this: She popped her (directorial) cherry with ONYX's uncompromising "Throw your Guns" in 1992; and then went on to direct Method Man's "Bring the Pain", Mobb Deep's "Burn" and The Clipse's "Grindin". Curiously, like Scorsese and Tarantino, this Park Slope, Brooklyn-born, professional film student (as she refers to herself), is not quite as "homicidal" as her videos. Sure, she's stubborn; strong-willed; has witnessed a few things in her lifetime; and is very much a hustler to the core. But she also grew up on a steady diet of theater (courtesy of her renowned uncle, Joseph Papp); was a dance choreographer; and has a cat named Twinkle! Rakim Allah was right: It ain't where you from, it's where you at. Ladies, gentlemen and lowlifes [free Slick Rick!], I present to you a few snippets of my peek into Martel's world.

TRACE: There seems to be a keen photographic sensibility that pervades a lot of your work. The underrated "Focus" video for Erick Sermon comes to mind. Care to comment?

Martel: I take a lot of time with that. Like, I'd often go and shoot stills before the video, and figure out what lenses I want to use. I've been using these super speed close focus lenses lately; I really like those. And when I work with Malik Sayeed, we always try something new. But the look of Erick's video, which is mostly about the lighting, comes from Matthew Rolston, who I think created the blueprint for beauty lighting.

TRACE: Your casting seems very deliberate. Even your video girls always have something "extra" about them. Do you have a hand in it?

Martel: I do work with great girls. We find them everywhere: at Foot Locker, the Beverly Center, wherever, and make them stars. I do my own casting. I actually used to do casting for other directors in the beginning of my career. The casting for the Clipse's "When was the Last Time" was crazy! We had to audition girls in the parking lots of clubs in Virginia Beach! I'm pretty picky about casting. Actually, I just got to use Brad Renfro, in the "Provider" video for NERD–he was amazing. I got to use the awesome Randy Quaid in "Rockstar". I also just worked with Tommy Davidson on Snoop's new one. I definitely want to work with more actors; it's good for me.

TRACE: Are you big on prepping for your videos, or do you have a more nonchalant approach?

Martel: I don't really think about it too much. When I do work and it's good, it's because I wasn't thinking about it too hard. But I do prep my jobs very heavily. Once you are at the shoot, you've gotta' go with it–be it an 18-hour day, or two 18-hour days. Take yesterday: I had two full crews; two separate DPs; and two separate ADs working at the same time. It was hectic, because it was a 14-hour day! But basically, you get there in the morning and you leave at the end of the night, and you have what you have. All the planning in the world could either have made it much easier, or done nothing, because things go wrong every five minutes on a shoot. It's really about your flow.

I'm still working on how to prep—filmmaking is very much about shrewd planning.

TRACE: Am I justified in saying that you're quite adept at extracting performances from your protagonists?

Martel: Well, some people you direct a lot; and some you put in a situation where they've gotta' perform. It really depends on the individual. Most rappers' characters are instilled in them. You put the camera on them, and they're totally dynamic. A lot of singers aren't necessarily characters; they're vocalists, and I'd say perhaps they need more direction, if anything. But it's a case by case thing. I've been really lucky with the characters I've gotten to work with: Snoop is incredible; Busta is amazing; and Method Man is a genius on camera to me. Anything he does is captivating. If you put the camera on him the right way, he's fuckin' magic! He's really subtle, and really connects to the camera in this really intense way. I owe a lot to him. I definitely learned a lot from him.

TRACE: Do you find that the music video world mirrors society itself, in that it's sexist by order? What has your experience been like?

Martel: It's definitely sexist; it might even be worse. I think I'm a much better director than a lot of male directors, who actually make more money than me! But hey, there's nothing I can do about it—I've got titties! (Laughs) I definitely think that if I was a man I would have gotten a lot farther; faster. Hello?

ORIGINALLY PUBLISHED TRACE #42, 2003

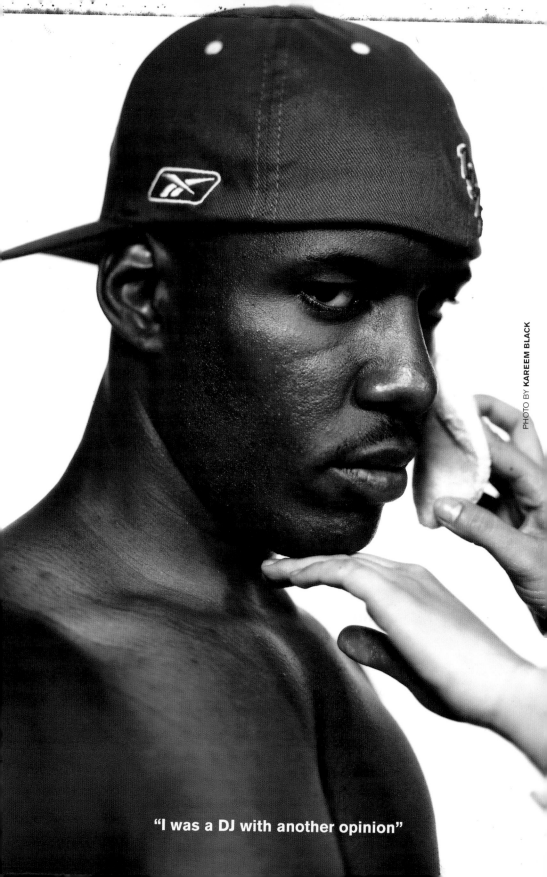

"I was a DJ with another opinion"

FAST FORWARD

BY **OMAR "CALABASH" DUBOIS**

Play: if for a brief second you thought that the hip hop game had totally divorced itself from Mrs. Streets—its ever loyal spouse, and settled for its newfound bitch—Madame Commercial, I implore you to revise your thoughts. Especially over the last three years or so, any hip hop fiend worth their weight in gold would tell you that mixtapes have been the providers of that fix that was so missing from the hip hop pharmacy. They simply cut out the shady bureaucracy and the "bottom line" avarice that's plaguing hip hop and deterring creativity, and put the power in the hands of the people that truly mattered—the dee-jays and the fans.

Rewind: Don't get it twisted, though, hip hop mixtapes aren't exactly a new phenomenon. The circuit is as old as the music itself. Grandmaster Flash, Kool Herc and Afrika Bambaataa, all at some point in the '70s, had "party tapes" (as they were then called) on the streets. What they managed to achieve was give the party peoples' never-ending thirst for the jam, a quencher in the form of tapes that they made from recordings of their own gigs. Flash actually took it a step further by making customized tapes spanning anywhere from 30 to 120 minutes. A dollar a minute was his basic rate. His angle? He'd compile the coldest joints at the time, and using the old school echoing effect, generously shout out the buyer's name. The irony of this is that the

people who could really afford his tapes were the cats with fat pockets. Translation: The gangstas, dealers, hustlers, etc.

Not unlike Flash, Kid Capri and Brucie B started making their names known within the mixtape circuit in the mid to late '80s by making tapes that brought the party to the whip or the crib. "Back then I never based my angle on 'Exclusives', acknowledged the legendary Capri. "My tapes were more like a party—you felt like you was there when I was making it." Actually, Capri's tapes (which he sold out of a suitcase) were so hot on the streets that Warner Bros. came knocking at his door with a deal, making him the first ever mixtape deejay with a major record deal.

Fast Forward: And then came DJ Clue's. The truth is that the man who also refers to himself as Cluminatti, altered the game like no one before or after him. If Capri's short-lived deal with Warner was the seed, Clue's with Rocafella was the tree. Peep game: When Clue came on the scene, it was a scene dominated by blend tapes—placing R&B acapellas atop hard hip hop beats. Clue didn't really have a pot to piss in, for master-hands like DJ Ron "Youngest in Charge" G and Clue's neighborhood hero, Grandmaster Vick had the game all sewn up. Shrewd as he was, Clue came up with his own modus operandi that would forever recast and metamorpho-

size the mixtape game: landing exclusives and freestyles for his tapes!

A true entrepreneur, Clue simply gave fast-paced hip hop junkies what they craved: new songs at the drop of a hat [actually Clue was the first deejay to break BIG's "Juicy"], and freestyles from their favorite artist over their favorite beat that they couldn't hear elsewhere. In the process, many artists like the Lox and Mase solidified their street credibility on his tapes, while unsigned artists like Fabolous and Joe Budden got record deals off spittin' on Clue tapes. Signed to Rocafella records, both of Clue's self-produced "legal" mixtapes ("The Professional I & II") have gone platinum with no videos.

Flipside: If anyone has really taken Clue's magic baton and is running with it, it's the Haitian boy wonder, DJ Whoo Kid, who in fact also doubles as wonder kid 50 Cent's deejay, and has an album dropping on Capitol Records this Fall. Whoo Kid, who actually got his start making "beef mixtapes," asserted rather humorously that the mixtape game as defined by Clue is very much different from the turntablist game (think Jazzy Jeff, DJ Cash Money or DJ Scratch): "I ain't no cuttin' ass deejay, I cut checks!" He described himself as a "distribution deejay" who does "massive bootlegging promotions" for rappers!

In fact, Whoo Kid was very instrumental in the doctoring of 50's explosion. "50 was really hated, 'cos he dissed everybody on that 'How to Rob' joint," Whoo Kid remembered. "So a lot of deejays wasn't showing him love at all. But I always put 50 first or second, and then Jay-Z would be like number 15 or something. It was like I was a deejay with another opinion."

50 Cent has on countless occasions given mixtapes the credit for an appreciable account of his success. After his fallout with Columbia in 2001, he was forced to hit the streets and make a name for himself. Without the interference of spineless A&R's and the need for generic radio singles, 50 took advantage of this street-driven medium and turned the whole industry on its head.

Another "luxury" the mixtape circuit affords is that of a "Dis Heaven." It seems that every rapper with a grievance—from 50 himself, to Eminem, to Benzino, to Ja Rule, to Jada Kiss, and of course, Jay-Z and Nas—has at some time or another run to get their song on an upcoming mixtape. Pause.

This is where DJ Kay Slay a.k.a The Drama King a.k.a Slap Yo Favorite DJ! comes into the picture. Harlem's own Slay fought his way into the game as an underdog with a point to prove. In his ascent to being considered the deejay most representative of the streets, Slay threw uncompromising darts at DJ Clue, DJ Envy and Whoo Kid. He was also almost solely responsible for nursing the craziest battle in hip hop history—"The Takeover/Ether" battle between Jay and Nas. Of course, Slay isn't all about beef; his tapes are also renowned for putting the spotlight on marginally unsigned or underappreciated rappers.

For the cynical who, like Kid Capri, think that "there are too many tapes out, and too many people doing the same thing," there's DJ Greenlantern. Greenlantern who was personally chosen by Eminem to be his deejay, is somewhat of a throwback meets the future: He mixes the creative turntablism of traditional deejaying with a keen appreciation for the thug factor of today, and comes out with a gumbo that is as refreshing as it is progressive.

Indeed, whatever your craving, feel free to holla your nearest mom and pop store or Senegalese bootlegger and you're sure to be satisfied. As long as hip hop breathes, and the street is the blood that runs in its veins, mixtapes will always thrive. Fat shout to the cats who put it down from day one: DJ Breakout, The Funky Four and DJ Hollywood. Can't forget: Lovebug Starski, Funkmaster Flex, Doo Wop, Sway & Tech and Tony Touch. Stop. Eject.

ORIGINALLY PUBLISHED IN TRACE #45, 2003

"An almost zen-like dissection of the roots of urban music"

LONDON MASSIVE

BY **GRAHAM BROWN-MARTIN**

Drum & bass, originally a London phenomenon, broke onto the club scene in the early '90s. For a while, the style was everywhere—in clubs, on television, on nearly every pirate radio station, even as the soundtrack for a dozen TV commercials—invading the senses. Then all of a sudden the sound went quiet; back underground planning its next assault. When drum & bass resurfaced it was bigger, badder and bolder, with a global twist.

I must confess: I'm a drum & bass-head. When I walked into a dark and impossibly crowded club in the early '90s and heard drum & bass for the first time, It was an epiphany—a revelation; the discovery of the UK's own urban music form. There is a constant debate about what constitutes UK urban music. With its interaction with multiple cultures and inevitable integration, "urban" seems to be as much an aspiration as actual city dwelling. I suppose in a media-saturated culture "Urban" comes pre-packaged in Styrofoam containers sanitized for your protection and ribbed for her pleasure. So what of drum & bass? How does this culture define itself? There are recurring themes: drum & bass, in its original South and East London form, is infused with deep bass forms and percussive references to ragga and dancehall integrated within a sampling and technology culture. Drum & bass has never been preoccupied with the notion of race; it is a transcultural movement.

Drum & Bass: The past 10 years of drum & bass emerged out of the fusion between the

UK dance scene and the South London blues party aficionados. It quickly migrated to Bristol, where the scene cultivated its own dialect, perhaps most notably in the style of artists such as Roni Size, Jumpin' Jack Frost and popsters, Kosheen. As quickly as it emerged, at least from a mass media perspective, it retreated underground. The poster boy for drum & bass, Goldie, went on to seek alternative employment. With a part on a Bond film, a "tuff guy" role on a UK soap and the star of an advertising campaign endorsing crap clothing from high street chain, Burton, it can't be bad (or much worse). But the merest mention of a resurgence of interest in drum & bass to V Recordings boss, Bryan Gee, brings forth an almost convincing denial that drum & bass has been doing nothing but continuing to expand. Bryan Gee is one of the godfathers of drum & bass, a passionate man with straightforward objectives. Whilst conscious of his UK perspective, Gee has been impressed by the output of Brazil and South America, where DJs and producers such as Marky, XRS, Suv and Patife have been imprinting their own sonic experience into the mix. Gee initially gave Sao Paulo-based DJ Marky an early shift at the Movement night at Bar Rumba, where his turntable antics and soulful drops had the audience demanding a peak time shift. So a new chapter in the drum & bass story emerges as practitioners appear from every part of the world. The Germans are doing it, the Japanese, the Americans banged it from New York to San Francisco, but the Brazilians and the Colombians are spanking it, drawing off the warm vibes of bossa nova, salsa and highlife. I asked DJ Marky about the new album he is currently working on with XRS. "We've been working hard on new material, and developing new sounds and flavours. We're also inviting some great vocalists onto the project, such as Vikter Duplaix, and working on a live show to promote the album when we release it later this year," Marky explains. Asked whether he felt any pressure to incorporate sounds from his native Brazil, he tells me, "No, not really… You know I'm 100 percent Brazilian, and so is XRS, but our focus is not only to be inspired by our local music. I guess we get asked this question because we sampled Jorge Ben Jor on LK. But in the very same way, I might look towards US soul or rare groove for inspiration at other points. We only use Brazilian music because it fits, not just because it's Brazilian—that would be too transparent."

Sidestepper I was fortunate to meet up with Richard Blair; fortunate in that I caught him on one of his infrequent stopovers in the UK, his birth place, but not his spiritual home. His home lies in Bogotá, Colombia, and he is about to wed Carolina Lizarazo, a well-known Colombian television actress. Their marriage has a kind of Norman Cook and Zoe Ball gravitas in the homeland; the prospect of the Colombian equivalent of Hello magazine dealing the photo exclusives is daunting to Blair. He is the driving force of the project known as Sidestepper. If you haven't sampled the delights of Sidestepper's EP, "Logozo", then you really haven't experienced ecstasy. It's an intoxicating infusion of drum & bass sensibilities with a booty swaying salsa. Sidestepper is also dropping a new album. I've listened to the album and the word is: don't expect a hardcore drum & bass tip. The album is, however, gorgeous, and certainly deserves to be part of your record collection. It's called "3 AM (In the Beats we Trust)" and it's on the Palm Pictures label. The album reflects an almost zen-like dissection of the roots of urban music; it is reflective not only of the Colombian experience but the indelible effect that the African diaspora has had on musical expression. Talking to Blair, it's clear how his experience of a new culture has affected his embrace of cultural integration. He gained access to Colombian culture as a consequence of working at Peter Gabriel's Real World studio's alongside fellow knob twiddlers Eno and Lanois. As producer and studio wizard, Blair had the chance to work with Colombian artist Toto La Momposina's La Candela Viva. Drawing on the music and dance of the Colombian Caribbean, her work is informed and inspired by a rich cultural mix that combines elements from African, Native Indian and

Spanish traditions. After the recording session, Blair was invited to Colombia, which he initially embarked upon as a vacation experience. After his first visit it was clear that he had found something vital—a new attitude to living that inspired him to make music. It came to him in a blinding flash, captivated by the sounds of London's drum & bass scene and seduced by the Afro-Latin beats of Colombian salsa. The structure fitted perfectly. Like drum & bass, the Colombian vibes were infused by sounds from the Caribbean and storytelling nature of the tunes. The first excursion was "Logozo", followed by the album "More Grip". The new album certainly reflects a more chilled out range of beats.

The Drum & Bass Melting Pot There is certainly an influx of new global flavours and sounds entering the drum & bass melting pot. I asked Marky whether he felt that this was a consequence of cultures converging. "I guess in a sense it is, but that's not its aim," is his view. "Drum & bass is like jazz, it's limitless in many ways, and therefore those that get into it from Brazil to Taiwan invariably use their own senses when it comes to producing. I don't think people set off to become a cultural force, but when you look at the healthy state of drum & bass you see that it has become exactly that." There is an assault of album drops over the coming month. I've been listening to Bryan Gee's new mix album, "The Sound of Movement" (on the Movement label), and it's dope. The album is up front, from an exclusive cut of "Trust Me" by Roni Size to the sublime "Moments of Lust" by Marky & XRS. Definitely worth a spin on your turntable, but be careful with your bass bins. If you're feeling the Brazilian vibe—or simply want to shake your ass—look no further than DJ Patife and Suv with their "Drum & Bass Fiesta" double mix album, on V Recordings. It's been out a while, but it's definitely worth picking up a copy of "The Brazilian Job", mixed by DJ Marky, also on Movement. Another album worth your time is Landslide's appallingly named "Drum & Bossa" (on Hospital Records). This record is certainly better than its title, with a bit of a Cuban feel

on a few tracks. If this vibe continues then the summer is sounding good. We certainly need some invigoration as we re-emerge from winter hibernation and the George and Tony show. Of late, I've noticed that girls are getting into the drum & bass scene, as sounds compel the body to dance. We're not talking about the low impact pogo shuffle in the rammed, smoke-filled clubs of the early '90s, but full-on butt shaking, groin pumping, and that old cliche, fun. Where there are hot and sexy girls, guys will follow. The scene looks set to re-ignite, but not by the directions of an ad man's wet dream, but by the passion of people like Marky, Bryan Gee and Richard Blair. These are people that have a profound vision; one that isn't governed by cultural separatism or homogenization—something that reflects our cultural context. Looking again towards the summer and sunshine, I'm wondering whether Brazil could be the spiritual sunshine retreat for the global drum & bass community, in much the same way the dance movement has Ibiza. I'll leave the final words to our energetic man in Brazil, Marky: "I think it already is, you know almost every week some European people come up to me at my club in Sao Paulo and say, 'Hi... I saw you at the Movement night at Bar Rumba (London) two months ago.' Brazil has that mystery and people want to see it. In April we host the biggest arena at Skolbeats, the biggest dance festival in Latin America for some 45,000 people. All the house boys come in and take a peek and they can't believe it. I know they think 'How did this happen?' Well my guess is it'll happen the world over. Drum & bass isn't here to replace any other genre, but I think finally it's getting the respect for its qualities and its people power. We're no longer a little room in the back and that's a great achievement for all the DJs and producers. All we need now is a little island off the Brazilian coast where we can set up a drum & bass summer season each year!"

ORIGINALLY PUBLISHED IN TRACE # 42, 2002

"Come and see where I'm living"

ECOUTEZ-MOI

BY **CLAUDE GRUNITZKY**

France's musical renaissance has been documented so much recently that you could be forgiven for believing that Daft Punk's techno-ambient meanderings in trendy headphones were a foolproof guide to the cobblestone streets of Paris. There is a revolution going on, but it's not being recorded at 120 bpm.

The sound of Paris–and suburban and provincial France for that matter–is hip hop. More precisely, a hip hop built of French language lyrics laid on top of traditional breakbeats and elaborate samples.

I grew up in mid '80s Paris and witnessed the exponential growth of hip hop from a novelty fad to a viable scene/industry that has all but hijacked French youth culture. A lot of my friends–many of whom would congregate to the weekly Zoopsie night at the Bobino club in Montparnasse–have now become established MCs and producers, and their younger brothers have taken to the mic, too. The stalwarts of the scene have moved on to executive positions within record companies and Cut Killer (the number one DJ) has become something of a figurehead–he is the Funkmaster Flex of Paris and his live cuts double album, "Show", is currently selling out in record stores throughout the country.

I went to Paris to meet the names who are shaping the sounds of the new generation. As I spoke to them one by one, I couldn't help but reminisce over the days when I was excited to hear Afrika Bambaataa preaching his Zulu nation teachings in Paris: when, in 1983, a national television network dedicated a weekly programme called "Hip Hop" to the emerging movement. Even though the show was short-lived, hip hop itself steadily grew into a self-sufficient culture, one in which American attitudes were deemed inappropriate and far removed from French realities. The Rapattitude compilation made waves in the late '80s, and NTM were becoming a household name because the lead rapper looked so very threatening every time he appeared on TV, but it wasn't until 1991 when MC Solaar recorded the anthem "Bouge De La" that hip hop crossed over for good.

Then came a law which made it mandatory for radio stations to play a daily minimum of 40% French language songs. This law changed the face of French popular music–a moribund morass of Gainsbourg reissues–and signaled the birth of a viable national record industry catering to the young kids who were engaging so profoundly with American B-boy culture. MC Solaar released a second album, "Prose

Combat", which went on to sell a million copies, and the rap scene never looked back. (Coincidentally, just as he was paving the way for future MCs, Solaar became the object of ridicule: when news of his liaison to the voluptuous starlet Ophélie Winter leaked in 1996, he lost all remaining credibility.)

Around that time, NTM, the hardrock agitators from the Saint-Denis suburb, received prison sentences for insulting policemen and inciting riots at a concert in the South of France. Even though the judge's decision was later reduced on appeal to non-custodial sentences, the publicity ensured that hip hop was now part of the political—and therefore national—arena. A large proportion of the new rap fans were pre-pubescent teenage girls, and their aesthetic sensibilities and commercial clout meant that rappers were now in danger, not of extinction but of becoming their worst enemy. Doc Gyneco, a cute offspring of the respected Ministere AMER posse, had released an unashamedly commercial (read: soft) rap album that was climbing up the pop charts faster than Oasis' Morning Glory.

Sometime around the beginning of '98, MCs all over the country regrouped and figured out a solution. The saving grace of French hip hop would have to be those lyricists who could inject some much-needed reality into an artform that would not survive if left at the mercy of a handful of overexposed pop darlings. Enter hardcore mercenaries La Cliqua, X-Men and Lunatic, Arsenik, Busta Flex, Oxmo Puccino, 2Bal 2Neg and Les Neg Marrons. The two extremes of French hip hop were apparent, but my mission last month was to find the middle ground wherein the real growth was taking place. During the four days that I spent reporting in France, I listened to the radio constantly (Nova, NRJ and Skyrock mainly), I read all the hip hop magazines (RER, Groove, L'Affiche, Radikal) and spoke to countless record company people.

The first conclusion that I drew from my exchanges was that it is impossible to speak of one unified French hip hop scene. French hip hop is now a hybrid of many different components, which range from the hardcore to the commercial to that middle ground which I set out to identify. Because competition has divided the

scene beyond any readily definable categories, French hip hop can only be approached through carefully selected case studies. The one slogan all French rappers agree on, is man-of-the-moment Passi's "La France Au Rap Français", a witty and provocative take on racist National Front leader Jean-Marie Le Pen's "La France Aux Français" (France should be left to the French). Here then, are three hard-hitting examples of how French rap struck back:

While Passi is running late for our scheduled interview at the newish tenth arrondissement headquarters of V2's year-old French division, Michel Vidal, the affable head of press, shows me Passi's video for the mega-hit "Je Zappe Et Je Mate". I tell him that I think the video is weak, predictable and very badly directed; that a song which recites TV programme titles and aims to make fun of France's soaraway TV culture could, should, have been more tongue-in-cheek; that I don't understand why it is being shown on French TV every hour or so.

The success of "Je Zappe Et Je Mate" and the 300,000 selling (and counting) four-month-old album from which it is drawn, "Les Tentations", is confirmation that Passi's success is nothing short of phenomenal. This is because in his previous incarnation, Passi was one of the most controversial/hardcore rappers in France. A 25-year-old Congolese who moved to France with his family in 1979, Passi is, along with his best friend Stomy (whose solo album is out on Columbia France), the co-founder of Ministere AMER, Ministere AMER is a highly influential crew from the Sarcelles suburb, 15 minutes north of Paris. The Ministere—managed by Kenzy, the mastermind of the crew's ascension through solo deals and a man who has recently been called the RZA of French rap—was later expanded to include Hamed Daye (who is close to being signed to V2), and Doc Gyneco (Stomy's good friend who briefly joined the Ministere before releasing a 700,000-selling debut album on Virgin France).

Shortly after the release of their superb second album "95200" (the postcode for Sarcelles), the Ministere were asked to contribute a song for the soundtrack to Mathieu Kassovitz's 1995 film

"La Haine". On the song, "Sacrifice De Poulets", the Ministere proved to be so vehement in their denunciation of police brutality that they were taken to court by a police association and fined £20,000. This incident contributed to Ministere's elevation to cult status. Their reputation as social commentators and instigators of race debates was given further credibility by the authenticity lent their cause by the nature of their hometown—Sarcelles has the highest proportion of black residents in any French city. The conflicts between the suburb's blacks, Arabs and whites, who live on high-rise estates, are touted as a cry for alarm in virtually every one of Jean-Marie Le Pen's National Front rallies.

But the Passi who finally showed up for the interview, with Ministere co-member Stomy, was definitely a pop star. Although his sudden high profile—the profile that comes with being recognized by six-year-old schoolchildren and septuagenarian grandmothers alike—seemed not to affect him in the least; he still carried himself with the confidence of one who is all too aware that he is the man of the moment. After he sat for the photo shoot, we decided to head down to the Bastille area. V2 had booked a table for us at a North African restaurant called La Casbah but, as I would find out, Passi is not one to concentrate on probing questions, especially when faced with the prospect of bedding lascivious North African waitresses.

How, I asked him, do you deal with your new fan base being so much wider, so much younger than the one you'd built up since 1991 with the Ministere? "After we went through all the aggravation with the Ministere, we decided that the big priority was to get our music heard, to get as many people to listen to our message as we could. The more records you sell, the bigger your potential to reach people. I know that a lot of my new fans are younger because of 'Je Zappe' being such a kid's song, but I've always been into cartoons and I would never pretend to be what I'm not. I will never deny or forget about the things we talked about with the Ministere. We were the first crew to use the term 'Negro' in our lyrics. Me and Stomy and Bruno [Doc Gyneco], we're using all this new media attention to further the Ministere's message; there's going to be

another Ministere album later this year because the one thing we hate is silence. In a way, it's like we're using these radio hits to get people to hear what it is we were saying all along, when no one wanted to listen."

"Je Zappe Et Je Mate" is a truly intoxicating pop song. It displays Passi's virtuosity as a lyricist, especially in the way he moves from the quirky characteristics of one TV show to the next, and makes sense of the links between the programs so that anyone who is even vaguely familiar with French television can memorise the entire song almost instantly. But I can't imagine that many NTM fans would be humming along to it in the metro when someone else can hear them. "You'd be surprised," said Passi, "because a lot of the people who've been requesting autographs recently are older heads who bring all of my CDs with them, even the Ministere ones from the early '90s. I know Gyneco and Stomy have been going through the same thing, because they told me so. You could think we've sold out and that our stuff is commercial now, but there's an element of solidarity in the new French rap game, where hardcore heads will feel a song like 'Je Zappe' because they want the Ministere to succeed, to voice the ultimate 'fuck you' to the racist system."

Although his tone can instantly shift from sweet to aggressive, Passi is currently the main benefactor of the contradiction at the heart of the French rap explosion. Passi's radio-friendly pop tunes are still considered hardcore enough to warrant the support of his homies from Sarcelles: France wants its new rap stars to be all things to all people, and everyone seems satisfied with the compromise. Dominique Ringaud, the head of sales at leading retail chain Fnac says that Passi's audience is difficult to define, because it contains core hip hop fans as well as mainstream buyers: "This is because the album 'Les Tentations' is getting airplay across all the major radio stations in France," she says. "Plus there are two hit singles on the album, which is unusual."

Passi, who read agricultural studies at his university for three years, is an intelligent, aware artist, and his conversation revealed a man who knows exactly how to play the game—when he

needs to. After he admitted that the album title, which means "temptations", alludes to the endless temptations he was faced with when living at home—his parents insisted upon the traditions of an African upbringing, but as soon as he walked out of the family home he'd hang with his homeboys and get into all sorts of trouble—I finally understood how he ended up fitting the bill so perfectly. Passi can be good and Passi can be bad. On his solo album he is good, but on the forthcoming Ministere album, we can expect some more cursing and a lot more cop dissing. Passi: all things to all people but nobody's fool.

An hour after Passi and his crew left us at the restaurant for a late night recording session, we traveled to a club in Bastille where we were due to meet Fabe, who was there to meet friends and hand out flyers for his weekly Tuesday night R&B spot. Despite his reluctance to publicize himself as a rapper, Fabe is one of the most well-known MCs in France. His lyrics have long been championed by local music critics but some people say that he suffers from "an image problem". Fabe is said to be too critical, not only of his fellow MCs but also of those outsiders who ignore hip hop and its potential to become the driving force of youth culture.

Fabe's notoriety dates back to a televised appearance, two years ago, on a top-rated programme called "Taratata". The very nature of the show, where distinguished guests from the worlds of entertainment, literature, sport, politics and science are invited to sit on a couch and discuss current events, without the air of formality normally associated with French talk shows, should have been conducive to an intelligent debate about hip hop and its progress in France.

But, as soon as Nagui started to imitate stereotypical hip hop attitudes, and cracked a few unfunny jokes about the way some rappers love to pose and act hard, Fabe's face turned almost red as he found it increasingly difficult to conceal his fury. As the show's presenter Nagui, and another guest, a popular West Indian ballad singer named Laurent Voulzy, continued to ridicule the culture, Fabe got so offended that he walked off the set. That unexpected move shocked the presenter, the other guests and the millions of viewers who, to this day, are divided as to whether his refusal to collaborate helped or hurt both his career and, more importantly, the progress of hip hop toward mainstream acceptance.

"They were making fun of hip hop," Fabe remembers. "They wanted the TV audience to think hip hop is this stupid game dumb people play, and they wanted me to help them with that. I got upset and left. You know how dangerous media portrayals can be: once people think hip hop has been explained to them, they think they know what the movement is about. I refuse to condone that type of manipulation." Fabe is convinced that rappers are in danger, that hip hop is in danger of extinction, and that as a result the French Republic is also in danger. "In theory, a Republic should be a government that gives power to the people. I see today's French Republic as serving the sole interests of those multinational companies that pay the Republic's bills."

Surely, with France being the second hip hop nation, subordinate only to the US in sales, French rappers must be doing something to redress the balance. "French rap is currently searching for its identity, and independent labels have turned the culture into a force to be reckoned with. There is plenty of money being thrown around, but you know that a lot of that cash is being given to soft MCs and fake-ass gangsters who, collectively, are worth less than two francs. Those clichés have contributed to rap becoming the number one music for young French people… but where is that leading us? I listen to some of these rappers, like Passi, I watch their videos, and I think that they might as well be selling drugs; it would hurt French kids far less than their soft lyrics about TV shows."

At the time of our conversation, Fabe and his protegé Korma, along with a young R&B singer named K Reen, were on heavy rotation on all the major stations with a song called "Mal Partis", a single drawn from Cut Killer's live cut compilation. Such radio attention was unusual fro Fabe, whose sole hit, "Ca Fait Partie De Mon Passé", from the first album was the reason he got invit-

ed to—and banned from—television in the first place. For the most part, his second album, "Le Fond Et La Forme", was a critical success but a financial disaster. His distributor, Shaman, went under just as he was recovering from being ostracised after the "Taratata" debacle, and his own label, Unik Records, was left to fend for itself without a radio plugger in the cut-throat market of French rap.

At the same time, Fabe was in negotiation with several major labels, one of which is Sony Music France subsidiary SMALL, who put together and distributed the Cut Killer compilation his latest hit is extracted from. Philippe des Indes, a veteran of the music industry and the chief executive of SMALL, said to me that he thinks "Fabe is an extremely talented rapper. He is intelligent and articulate, but his problem is, he won't compromise. He shouldn't have dissed Laurent Voulzy like that on TV, because Voulzy is the nicest of guys, with the best of intentions. He didn't mean any harm. I think Fabe has a bit of learning to do about the way this industry works. But I have a lot of respect for him. Fabe is a poet."

MC Solaar, the rapper to whom Fabe is most often compared—not least because their lyrical styles are structured around endless alliterations and metaphors—managed to sell more than a million copies of "Prose Combat". That's a major achievement, especially if judged against the frustrations of the best-known English rappers who, at best, will move 10,000 units of a full-length album. "People used to compare me with Solaar, because they thought my lyrics were on the same level as his, but that's only because I choose as subject matter the topics most French people would rather no one discussed. Solaar is absolutely not a reference point for me. Put it this way, he means so little to me that I haven't even bothered to listen to his latest album [Paradisiaque]."

Still, no matter how his detractors feel about him, Solaar is a poet who can hold his own against acclaimed novelists like Françoise Sagan. (In an Actuel magazine cover story published four years ago, Solaar debated modern issues so intelligently that his "Prose Combat" album was launched with the blessing of France's powerful left-wing intellectual lobby.) And Fabe, whose Le Fond Et La Forme, succeeded in bringing the contradictions of the immigration debate to street kids as well as the deputés of the Assemblée Nationale, is, like Solaar, a natural poet. "The dictionary defines rappers as being poets. I would hate to be presumptuous, but if I can be given credit for pushing the envelope, for forcing the French language to move on with the times, then I think I will have done my job. For now, poet or not, I still have a long way to go."

Studio Mega is located in Suresnes, a middle class suburb situated across the Bois de Boulogne, in Paris' immediate *banlieue ouest*. The friendly staff seem to fit the low-key deco in the reception area. Visitors are immediately put at ease, and in the chill-out rooms, where antique ping pong tables sit comfortably next to hi-tech VCRs, it could be easy not to notice that the walls are lined with platinum and diamond plates for French pop stars such as Mylene Farmer and Jean-Jaques Goldman. In the main studio, Shurik'n, one of Marseilles rap crew IAM's two lead MCs, is putting the finishing touches on his yet-to-be-titled solo debut for Delabel. Delabel, which was founded shortly after the late '80s success of the Rapattitude compilation, is a Virgin subsidiary which has become the leading French rap label. Three albums deep into what is now arguably the most successful career in French rap—from their groundbreaking debut "De la Planete Mars" to last year's award-winning "L'Ecole du Micro D'Argent"—IAM are still Delabel's biggest act. And, given that two band members (Akhénaton and Khéops) have already released successful solo albums for the label, it is quite apparent that, as a collective and as individuals, IAM are a very big deal, not only to Delabel but also to French rap in general.

On this mid-March afternoon, Shurik'n is under a lot of pressure, because the entire Delabel staff is due to come in for a 7pm listening party, where all the rough cuts will be played for label boss Laurence Touitou's approval. Not to mention that he is also scheduled to sit for this oft rescheduled TRACE cover shoot and

interview. The champagne and such are already on the studio table, and Duro, the American engineer who tells me he recently worked with The Firm and Noreaga, is already munching on the goodies. Soon-to-be-rejected bass-heavy instrumentals are playing in the background and, without warning anyone, Shurik'n busts into a chorus verse that proves to be the very last vocal recording for the album.

"Rap in France is still undergoing a real explosion," he says after finishing the chorus. "Even in these confused late '90s. The '90s have been a real test for hip hop, but in the end hip hop came out on top. There was a clear danger, when we first came out at the beginning of the decade, and up until about '95, that hip hop was just a fad. It had become so fashionable for people to listen to hip hop, even though they may not have identified with anything in the culture. But now French hip hop is in its maturity phase." How do you define maturity? "Maturity is in the beats, but in France, where language is the sole parameter you are judged by, it's really about the lyrics. About what we call la plume.

"The way that some people are writing in France now is no joke, and that's why hip hop is winning. Because there are so many talented MCs around, so many gifted kids who want to share their experiences with the world." Some of the kids he is talking about, I suppose, are the Fonky Family crew, whom IAM pretty much discovered and helped to grow into leaders of the new school, but we'll come back to that later. "Another reason hip hop is so big in France now is the relative freedom new artists get when they sign these big record company deals. Artistic freedom has always been a big thing in France, and I think in that respect we're lucky. The way it is here, it's like the [record] company people wouldn't even dare to ask rappers to sound like this or that person. When we signed with Delabel, we made it clear to them that we'd already been doing our thing on our underground label, and that we had a sound they couldn't fuck with."

That is the most interesting thing about the French rap explosion. Once the major labels saw the potential in rap and decided to invest in the sound as a gateway to the culture, they found themselves in a situation where they had no choice but to rely on independent labels and their pool of new talent and ideas. Today, most major labels work in synergy with the many indies, and it is not rare to see a new signing re-release an underground record under a major label. This pragmatic approach to artist development has kept the music close to its roots and allowed an efficient filtering process which, given the number of home-based label/studio set ups, like IAM's own Coté Obscur, now implied that, as in today's independent film circuit, those who end up making it through the studio system can immediately boast a fan base wide enough to recoup on a full length debut album.

On their latest album, "L'Ecole Du Micro D'Argent", which won the French equivalent of the best album Grammy, IAM recorded a song with Wu-Tang affiliates Sunz of Man called "La Saga". In the first of several such high profile collaborations (soon after their receiving prison sentences, NTM released a French version of "Affirmative Action" with Nas and Foxy Brown rhyming their original lyrics on top), IAM wanted to bridge the gap between US and French hip hop affinities, and show their US counterparts that they too have come a long way since the early days of SP 1200s. "I'll be pretentious and admit that I've become very critical of American rap," says Shurik'n, "I'm still listening to the Raekwon album, and that came out in '95, three years ago. Mostly, US stuff is weak, apart from the underground shit, and the stuff that makes it onto mix tapes and bootlegs."

After half an hour spent on debating the reasons why UK hip hoppers seem to be lagging behind their French counterparts and, to some degree, German MCs as well, we attempt to pinpoint the single most important prerequisite for success in hip hop. According to Shurik'n, hip hop is about one thing and one thing only: integrity. "This is how I break it down to myself, when I look at where we started in Marseilles, and where we are now, in the big picture of French music: on top. My only criteria is whether I can look myself in the eye when I'm in front of that mirror in the morning. When I'm in front of that mirror, and getting ready to shave these

whiskers off, I ask myself whether I like that person in the mirror, whether I'd be friends with that person. And the moment I feel like that person isn't down anymore, I can guarantee you that I'll move on to something else, but for the moment IAM is exactly the kind of music I want to be listening to, so that's the kind of music I want to be making." Sure enough, the new album is straight-up bangin'. When the studio fills up with anxious Delabel suits, the first lyrics I hear on the opening track are: "Come and see where I'm living/ With the homies still starving surviving…"

Two days after my late-night talk with Fabe, I flew to Marseilles for a meeting with the much-hyped Fonky Family, a seven-man crew from France's second rap city. Ever since the days of the Roman Empire, when the key trading port was known as Massilia, Marseille has lived up to its reputation as the insubordinate city. The people of this Mediterranean port were once so reluctant to obey the Parisian government's laws that the city center was long sectioned off and barricaded so that outsiders could not gain access to it. Needless to say, the absurd situations depicted in the popular Asterix comic series still ring true to many Marseille residents. Listening to the way their heavily accented speech sing-songs jokes about Parisians' lack of humor into veiled attacks on Paris-centric political hypocrisy, you realize that the Marseillais are proud to be different.

One of the local heroes is the now-deceased Gaston Deferre, a good friend of President Mitterrand, who for several decades up until the '80s was the indefatigable mayor of Marseille. Although his time in office was plagued with financial scandals and accusations relating to his alleged involvement in prostitution rings, most Marseillais continue to speak very highly of him. The phrase you hear most often when his name is mentioned is: "On l'aimait bien, le pere Deferre." (We were fond of good ol' father Deferre.") Today the new heroes, the unofficial leaders of Marseille' disenfranchised youth, are IAM, whose 1991 masterpiece "De La Planete Mars" heralded the birth of the Mars (short for Marseille) hip hop scene of which Fonky Family are the latest emissaries.

The story of the Family's steady march toward supremacy goes something like this. Although they were familiar with Run DMC and Public Enemy's New York style of rap while still in their early teens, it wasn't until after the release of "De La Planete Mars" that they decided to venture into hip hop and rewrite the rules so as to incorporate their own round-the-way Marseille experiences. First, there were two bands, Black White (comprising Le Rat Luciano, Menzo and Laoubi) and Le Rythme Et La Rhyme (Sat, Don Choa, Djel and Pone). In December 1994, they got together on a local stage to support the Swiss crew Sens Unik. Twelve songs deep into their set, they announced that the two bands had merged into a new collective called Fonky Family. Although they were heavily reliant on producer Pone's second-hand W30 for beats, they kept writing rhymes and performing at small venues until a teenage immigrant named Ibrahim Ali was murdered in cold blood by Marseille policemen.

The murder shocked the city, and the local rap community decided to respond by organizing a benefit concert to raise money for Ali's family. After Fonky Family's noted performance at the Café Julien, Akhenaton (aka Chill), one of the lead MCs from IAM, asked them whether they'd be interested in rapping on a song he was working on, "Bad Boys De Marseille", from his upcoming solo album "Métheque Et Mat". The song, which came out as a single in summer 1996, was a nationwide smash. Suddenly, Fonky Family were the new kids on the block, with a street buzz louder than the noise more established groups like Soul Swing and Uptown were making. They signed up to IAM's management company Coté Obscur, and a major label deal was negotiated with SMALL.

I stepped into the Coté Obscur office the day after the Fonky Family's first album, "Si Dieu Veut" [If God Wills, or Insh' Allah], was released. To my great surprise, the band still hadn't seen the final artwork on their own CD. It is difficult to describe the feeling of extreme exhilaration that rushed through their bodies when I pulled out both the CD and the double vinyl with their photos on. The cover displayed a local model named Clara, whom they all secretly lusted after,

but the back of the vinyl showed what seemed to be their entire posse standing proud against a white wall. I asked them whether that was the whole crew and, they laughed: "If we'd been allowed to show the whole crew we would have needed not a double but more like a quadruple vinyl. That's how deep we roll: this album's a dream come true for all our people who've been through the struggle."

What struggle? "It's the struggle of delinquent early mornings," said Djel, the DJ who contributed all the scratches to the album. "It's the struggle of knowing that the metro stops at 9pm, that it costs nine francs anyway, that the buses never run, that the council is not interested in investing in public transportation, that you can't even get back from your grandmother's place after dinner, and that because you're pissed off at seeing how nobody cares you just stay in the streets past 9pm and decide to steal cars, because that's what the system is telling you to do." "It's the struggle of wanting to go to school," continued lead rapper Sat, "but realizing that the headmaster can't find a way to make use of your artistic inclinations. Everybody's dream is to go to work in the morning and get a pay check at the end of the month so they can feed their children. But for us, these things remained a dream and the system never showed us how to turn that dream into a reality."

This seven-man crew is the product of pure working class Marseille, and the multiracial nature of the line-up mirrors the demographics of Marseille's inner-city. Fonky Family come from three neighborhoods known as Le Panier, La Joliette and Belsunce— in short, they come from the cesspool of local crime where the North African population is immediately blamed when violence erupts. Belsunce in particular is right in the city center. Most of the people who live there are second generation immigrants whose parents were brought in after the war while the city was being rebuilt. When the authorities tried to kick them out after purpose-built estates were erected they refused to move. These youngsters' anger at the deep psychological scars of their parents' pain at being robbed of their dignity feed Fonky Family's lyrics.

"La Furie Et La Foi", the first single from the album, is so inspired you'd think they starved for three days before walking into the studio. As they talk about defending Marseille hip hop and their freedom of speech in the name of their forefathers, Fonky Family's lyrical edge cuts like a knife and justifies Fabe's claim that "Si Dieu Veut" is the best debut album ever to have come out of the French rap scene. Such a claim was surprising, especially as the French media played out Paris/Marseille divisions, started by the verbal war between NTM and IAM, to mirror American type east/west conflicts. "That stuff is bullshit," says dancer Laoubi. "We played the Locomotive and the Elysee Montmartre in Paris. Joey Starr [lead rapper of NTM] is the one who greeted us onstage. We've done a track with the X-Men from Paris for this album. I think what the journalists really mean is that because there's a rivalry between PSG and Olympique de Marseille football teams we should be fighting as well."

"We do have plenty of things to fight about," adds Sat, "But it's more things like the Mayor, Jean-Claude Gaudin, saying on national television that he thinks the city center is looking a little too colored these days. It's things like the four cities that surround Marseille [Vitrolles, Marignane, Toulon and Orange] being run by National Front mayors. Things like the 2am curfew on all hip hop events, and having to wait for the first metro at 5am, when ravers can keep on popping ecstacy and dancing all night without the cops giving them a hard time.

With their self-produced album now selling well in the stores, Fonky Family face their biggest challenge yet: they have to prove that they can keep their eyes open and stay true to the rebellious spirit which informed their tales about growing up poor and unequipped for society's idea of success. They have to show older Marseille that hip hop can really be a viable alternative to the dirty politics they love so much.

ORIGINALLY PUBLISHED IN TRACE #15, 1998

"That's not the illusion I want to give"

THE AGGRESSIVES

BY **DANIEL PEDDLE**

It was the summer of 1999, sunset on the Piers at the West Side Highway across from Christopher Street in lower Manhattan. I was cruising on my new Phatboy BMX, paying little attention to the usual banjee queens putting on a spontaneous show by boombox. Their vogueing seemed passé. I wondered just how many times that badly wigged drag queen could lip-synch "I Will Survive". "Paris is Burning" was history; the flaming queers and their strange subculture had long since been exposed and appropriated. Its charms dwindled at dusk, and I steered clear of what I supposed was some final hoorah. Maybe being queer was cool, but being a queen was definitely not. "Yo Danny!" someone shouted from the gaggle. I tried to speed by but it was Kisha, my girl, so I curiously swerved into the shadowed circle and for a moment dropped my guard.

Kisha introduced me around. Fumbling through elaborate handshakes, I slowly realized that what I had presumed was a group of gay boys were actually real girls! They called themselves "Aggressives", and ranged in masculinity from pretty tomboys like Kisha to the very butch. Even though night was nearly upon us, I took out my camera and started taking pictures of Kisha's crew. It was a vision of androgyny that still haunts me, stripped of all device and pretense. These girls weren't playing as boys; they were simply being themselves. The Aggressives had defined themselves outside of society's usual grasp of the feminine. By passing as boys, and enjoying all the freedom associated with their young male urban counterparts, they transcended mere "lesbianism". In effect, they had found a loophole in society's gender tapestry. After four years of exploring the subcultures of NYC, I sensed something authentic, sincere and original about the Aggressive style and presence. I took down names, numbers, and on the spot decided to try and penetrate the scene and find out what it meant to be an Aggressive.

Three years later, after numerous excursions into clubs, cars, bars, buses, bathrooms, bedrooms and backyards, following the six women featured in my documentary on life as an Aggressive, I am still enchanted with their aura, strength, pride, independence, and ultimately, their beauty. I feel fortunate that they have shared their lives with me.

Kisha is a "femme-aggressive". She has

tomboyish ways, and makes an androgynous first impression, but has an unmistakably feminine face. Sometimes she "butches it up", hides her braids under a baseball cap, snaps in her gold fronts that spell DYKE across her generous smile and saddles up her yellow Honda Rebel 450 motorcycle for a ride to the West Village. Her tall lithe frame suddenly transformed into a billowing banjee boy, all swagger and sway.

She always wanted a motorcycle. It is the perfect accessory, cast in masculine mystique. On it she is a rebel, free, speedy and usually alone. She saved her money for years to make the purchase, working as a messenger while moonlighting as a model in hip fashion editorials and sportswear campaigns.

I remember stopping Kisha back in 1997, when I first started scouting models for agencies. She was on her bicycle carrying a messenger bag, with her hair tightly cornrowed. I thought she was a cute boy, maybe even cute enough for pictures. As I made my move he became a she. I was mesmerized. I took a load of polaroids and showed her to some agents. They all thought I was nuts! Well, since then, she's been stopped numerous times. She eventually signed with an agency and has appeared in every trendy magazine out there, but hasn't made the "cross-over" yet and her patience wanes.

Sometimes photographers are challenged by her startling shift from rough-neck to swanneck. Other times, they just need a girl who is comfortable with making moves on another girl for a sexy lesbian shot. Or maybe they just want her to be "real," "street," and try to capture her stylish aggressive ways. Regardless, Kisha shines. Her honesty refreshes. "I used to hate getting my picture taken as a child, but since I got into this business, I love the way I look," she tells me.

As a young girl, she always knew she "liked the ladies". Her family, a close-knit clan from the Dominican Republic and Puerto Rico, doesn't mention the obvious, nor do they meddle. Kisha lives on her own and has since she was 15 years old.

The first time she let me come home with her was two years ago. We braved the Rottweiler in the backyard and descended into the basement of a house in the Bronx. Kisha had made her home in a paneled, closet-sized room. Her unmade mattress lay beneath piles of hip hop gear, sweats and hoodies. On top, a few girlie magazines fell open. A busty calendar shared a corner with dirty socks and lube. A beat-up boombox pumped Lil' Kim. There was a poster of Latrell Sprewell on the wall. It was the perfect picture of a boy's crash pad. "Welcome to the ultimate hide-out for single young fellas like ourselves," Kisha introduced her crib with a laugh. In a few months, she moved. But I still remember the glamour that descended upon her in that tiny room as she dressed to go out and left with her hair still wet.

Kisha insists she's not a player, and that her string of past relationships indicates she hasn't found "the one" yet, by which she means that "real femme" girl who wears eyeliner and skirts but doesn't have an attitude. She would never date anyone more butch than herself. She doesn't "play like that." Sometimes she doubts a girl will ever inspire her to settle down because she's a loner at heart. Regardless, the girls keep calling, blowing up her two-way pager with innuendoes. She laughs at her legacy as a lover. "I'm just beautiful," she says with a boyish sneer. "I'll always be beautiful, 'cause I'm sexy."

It is the kind of beauty that transcends the whims of fashion even as it momentarily transfixes. Although she has walked in some runway shows, Kisha hasn't mastered heels. Her agency stresses a desire to polish Kisha, make her more palpable for the masses. Regardless of her costume, she has a distinctive spirit that cannot be masked. Ultimately Kisha is always herself, always an Aggressive. To make the fabled "cross-over," she might have to handle things her own way, the Aggressive way. It is hard to imagine her somehow slipping in under some veil of bland beauty.

Today, it is snowing. I'm following Kisha around on her messenger run. She works on foot now. She says she hated bicycling in a rush in the city all day. Things have gotten rough since 9/11. Her Honda is in the shop,

and the messenger service has lost a lot of clients. I ask her if she hasn't met anyone through modeling that might have a better hook-up. She hasn't, and besides, she likes the flexibility of her job. She likes staying active and being outdoors.

Her two-way pager buzzes all morning. Girls, stylists, fashion editors, model agents and the messenger service send word; Kisha is a wanted woman. She is thinking of switching agencies. In her bag is a thick stash of magazine tears, the edges slowly growing wet. She says her agent just asked her if she'd like to see some money clients. "Just asked me!" she emphasizes.

I tell her money shouldn't be her motivation and that she should be proud to represent for her people, that the images in her bag are an accomplishment on another level beyond just the personal, that she is an exception and rare. . . but she just gets that far away look in her eyes. Snow flakes catch in her long lashes, so I stop talking and take some more pictures instead.

When RJ, a 29-year-old African-American, first appeared on the Ricki Lake Show, in the spring of 2001, for a special feature on girls who were curious about same-sex relationships, she was one of four women on a panel of possible dates; in other words, the pros of lesbian sex. Not only was RJ chosen by the novice, she was later revealed to be the perfect date, courteous and respectful. The initiate felt that RJ was a terrific mix of female sensitivity and masculine aggressiveness. She felt protected but also understood, giddily announcing her willingness to explore further. The episode sparked a veritable flood of girls interested in RJ's unique blend of gender strengths; they were eager to experiment with a female possessing the personae of a true "gentleman", that dreamy sensitive man who seems forever trapped in romance novels.

RJ, particularly attuned to the needs of women, as well as a missing sensitivity in the current male paradigm, has created a niche for herself. Although she is often mistaken for a man, she shies away from "thug" posturing, and instead has adopted the look of a professional male, dressing in a business suit and tie. She seems accessible and acceptable, cunningly avoiding any threatening street "realness".

RJ used to work in cellular phone sales, a nine-to-five gig which required her to be the professional she dressed as. After the Ricki Lake Show, and an appearance on Maury Povich, she decided to quit and pursue a career in acting. She is undaunted by the task at hand: breaking into an extremely competitive field with minimal opportunities for people of color, and even less for an overtly masculine lesbian. RJ is persistent. She feels her unique gender identity will set her apart from the pack, and that her Aggressive ways will help guide her through obstacles. Perhaps there is a special role surfacing in the media that only an Aggressive like RJ could unearth.

When I met RJ, she had temporarily moved in with her girlfriend Fahtima, a "bi-curious" feminine woman, who wasn't comfortable yet with the gay life. She had only toyed with the lifestyle, mainly through other femme girls who didn't pique society's challenge. With RJ, Fahtima was forced to deal with her evolving sexuality. She could no longer hide behind the façade of two girls just hanging out, exchanging gossip or makeup tricks. With RJ, the sexual dynamic is bold; its homosexual nature can only briefly be hidden as long as RJ "passes". It is a precarious position to operate from publicly, but the risky nature of it only fuels the private sexual charge. Fahtima's femininity becomes exaggerated beside RJ's aggressive desire to fill the man's pants.

By dating a "bi" girl who is not yet out of the closet, however, RJ runs a much greater risk. Should her own masculine traits waiver, she might lose her girl to fear of a homophobic society. Unless Fahtima embraces "the life", their love is simply trapped in the game, and the burden of the player falls entirely on RJ's shoulders.

After a year, the two women decided to redefine their relationship as a platonic one. But lately, every time I meet with RJ, Fahtima is still with her and I begin to wonder. So I ask. Fahtima says they made out two weeks ago. RJ

can't remember. They agree that they're both looking elsewhere for sex and love. Fahtima has returned to the clubs. RJ, who considers the scene an exhausted resource, has started to go out again too. She holds her powder blue cell phone to my ear and lets me hear one of the five girls she's now dating. A voice convincingly coos, "I'm really feeling you baby."

RJ has taken a job as a security guard in the courthouse parking lot. She wears a tie and man's uniform. She stops a few wayward parkers and sends them out with a firm voice. They offer no objection. If they knew she was a woman, would they argue more? It's a long mundane day. Finally, RJ leaves to work her night shift at a warehouse, donning a man's uniform yet again. She's working two full-time jobs to save money for acting school. She's already been accepted, but now has to come up with the hefty tuition. RJ knows she must be more than just a talk-show thrill to make it as an actress. Like Kisha, she must somehow lure the media to look beyond her obvious sexuality into the specific characteristics that define the Aggressive woman, confidence, strength and an unapologetic self.

Marquise, out of all the Aggressives I've followed, has the most developed male persona. Unlike many, she makes an actual effort to exaggerate her manly qualities. She usually straps her chest. For the everyday, she wears an undersized athletic bra, sometimes two. When she walks "balls", a runway competition where her appearance as a man gets judged, she straps with ace bandages or even heavy-duty duct tape, and usually walks in the "butch body" category. Her exercise routine is designed to help her body take on a particularly masculine shape. She speaks with bass in her voice and habitually clenches her teeth to develop a large defined jaw-line. "Basically a lot of work goes into it," she explains. "And not just physical work, but mental work too . . . it's not easy."

Ironically, sexually, Marquise is less rigidly butch, and says she likes to experiment. She's comfortable being a woman who loves women and leaves it at that. Her girlfriend, Aniche, whom she's dated for just over a year, is a gorgeous fresh-faced beauty. They appear to be really in love. A handsome couple by anyone's standards, they always pass as straight. I can tell Marquise gets a thrill by fooling "85 percent" of society, but for her the guise is protective.

"Why would I let my breasts show? That's not the illusion I want to give. Unless you have to deal with me on an everyday basis, you don't need to know I'm a woman." Marquise considers her "realness" to be a matter of pride. In the scene, she is already legendary, even by those who have witnessed her gradual transition. But she wouldn't have a sex change. She doesn't consider herself a man born into a woman's body. Instead, she is comfortable being a woman who has chosen to live life as a man.

At the moment, Marquise is in boot camp. She enlisted in the army with hopes of a better future. Since her living expenses are paid for, she can save her earnings and possibly go to college on a scholarship. In the service, she won't be able to keep her hair cut short. She will have to wear a woman's uniform. Before she leaves New York, I ask her how she feels about being forced to suddenly live as a female. She says she'll still be herself and "that won't ever change."

The evening before her departure, Marquise and Aniche take me to a mutual friend's house in the Bronx. Marquise drinks a few 40s, loosens up and talks about her fears of the future. She says she and Aniche will wait the four years out. She's going to write and visit when she goes on leave. They kiss for a moment and we're all quiet.

Later, I video her leaning in a hallway under some child's art while she free-style rhymes. The flow is great and, as sirens whiz by in the distance, I'm struck by her harshness. She literally seems hardened by life. I wonder how much of her toughness is a front and how much came from growing up in the inner-city. In just a few days, in order to escape the streets, she'll actually be crawling in the trenches. Somehow, I figure she'll be fine. She's already survived one sort of boot camp.

Undoubtedly, the army will only make a better man of her.

Tiffany, a 17-year-old light skinned African-American, is, like Kisha, a "femme-aggressive". She has a baldie and wears baggy sportswear, but doesn't strap her chest down or use the men's room. Sometimes she is mistaken for a male, but usually a gay one, and often gets hit on by young gay men who think she's a pretty boy. She has grown up in the Village, and seems free of sexuality issues; she never came out of the closet because she never went in. The vast sub-cultural landscape of Manhattan's downtown has always been her home; she is still exploring its subtle terrain.

On and off again, for the past two years, Tiffany has been dating Kelly, an 18-year-old Latin transvestite, who has just started female hormone treatment in preparation for an eventual surgical sex change. As a public couple, their combined androgyny creates a veil about them; they seem to vacillate between gender roles while never claiming either the masculine or the feminine. She calls him a her and he calls her a him. But in bed the roles suddenly solidify, and sex the old fashioned way prevails: Kelly penetrates Tiffany. Within the scene, it is a secret which disgusts the older members. But for the youngest, who are mostly teenagers still, this paradigm has gained a fashionable following.

Tiffany and Kelly are pioneers in a new realm of shifting gender and sexual roles. Here in the liberated line between the usual polemics, they can experiment with radical taboos, while enjoying a position of ironic tradition. By claiming so many sexual labels, they have escaped them all. Society, in effect, yields its hold to their clever manipulation.

Tiffany claims to have no sexual attraction to other boys. She doesn't see Kelly as one, even at that crucial moment. The physical facts of her "straight" sex with Kelly do not challenge her social identity as a "femme-aggressive". She chalks it up to the power of true love. Should they still be together after Kelly's operation, she will love her just as much, certainly enough to adjust sexually.

Tiffany says people began to mistake her for a boy when she was 15. It is a common experience amongst Aggressives, femmes and butches alike. But instead of provoking any gender uncertainty, Tiffany, like many Aggressives, was flattered by the uncertainty. She embraced her androgyny and its mysterious power to alter the rules.

What is most disconcerting about Tiffany is that she doesn't model herself on a regular boy, but instead has chosen a "femme queen" personae, or that of a sissy. "I consider myself a faggot," Tiffany explains. Within the scene, Tiffany plays a role usually ascribed to the flamboyant fag; she vogues; she MCs balls; she gossips; she even speaks a queen's slang; and has taken a femme queen's nickname, "Trevon". She delights in the irony of her unique blurring of distinctions in sexuality: "I'm not a lesbian if I date transgendered men and have straight sex with them."

Tiffany has dropped out of high school. Her public education got particularly rocky after puberty, when she boldly announced her sexual preference. After both of her parents died, she was admitted into the Harvey Milk School at the Hetrick Martin Institute for Gay, Lesbian, Bisexual and Transgendered Youth. All went well initially, but soon her life, filled with "drama", proved a distraction. She left to pursue her GED, taking preparation classes at another school like Harvey Milk. She didn't pass the first round of testing. Now she's gearing up for a second run.

Tiffany goes out more than any of the other Aggressives I know. She frequents both Aggressive clubs and some "homothug" spots. She loves being with the boys, especially the few remaining flaming ones. She's attracted to their "female appearance" and their flare for performance. She's even in the gay, not lesbian, House of Latex. She is the only Aggressive who MCs balls like a real queen, obviously trained by the pros.

Tonight, she prepares to call a ball. She dresses in street wear at her best friend's house, a pre-op transsexual. The phone

rings incessantly. She puts on her shades to volley calls and fires into the line, practicing her quick repartee. A young group of her friends, mostly butches, pass blunts and beer around Nintendo.

Eventually, everyone piles onto the subway. Tiffany has become Trevon. She loudly curses and jokes about the long ride from Brooklyn. Strangers scatter as she "kee-kees" and "carries", slang for having fun by stirring up trouble.

As the club fills up, Trevon takes to the stage. Mike in hand, she announces a category, and to the beat of some deep house music, she growls away: "Walk for me! Walk for me!" Suddenly Kelly pops out from the crowd into the aisle and wildly prances. "Livinglike livinglikelivinglikeCUNT!" Trevon sings. As if in a trance, Kelly twists her head and flips backwards onto the floor. "Livinglikelivinglike livinglikeCUNT!" Trevon shouts again. The crowd goes wild. Kelly pulls herself together, and out of the spotlight. It is the beginning of a very long night. When Tiffany finally surrenders the mike, she is nearly hoarse. The crowd thanks her with raucous applause. She has conquered, mastering the ceremony like a true diva. After she finishes, she puts her shades on and, with her entourage still intact, leaves in a flurry.

Flo was born in Hong Kong. Like most traditional Chinese women, her mother hoped for a baby boy. After her birth, Flo contends, her mother dressed her in boy's clothes. When her brother was born, Flo says everything changed. Her mother began treating him like a king, while she and her sister became less important. When the entire family eventually relocated to the West Coast, Flo rebelled and continued to dress as a boy.

When she was nine years old, her parents split up. Flo and her sister moved to the East Coast with their father. Soon, Flo found herself steeped in the young urban ways of inner-city African-Americans and Hispanics; her tomboyish dress and mannerisms flowered and found a home. She loved baggy clothes associated with the hip hop culture. She got a crew cut and came out as an Aggressive butch. "When I was growing up," Flo recalls, "everyone always said, 'You're gonna be a dyke.' And they were right."

In spite of her mother's blatant disapproval of her decision, Flo maintains a closeness with her family, mainly through a tight relationship with her sister, whom she lives with when necessary. Their childhood bond has only grown stronger over the years. Flo can introduce her girlfriends to her sister. In turn, her sister accepts Flo unconditionally and understands her intuitively.

"I'm just like a nigga. I'm just like a man. . . a special kind of man. . . but I don't pretend to be a man. I'm just me that's all," Flo tells me. The last time Flo used a public toilet for women, she got thrown out and nearly arrested. Now she always uses the men's room. No one has questioned her since. To strangers, she appears to be big, rough, even mean. But when she is comfortable, her femaleness prevails; she becomes soft-spoken and sometimes giggles.

Like RJ, she is a rare mix of strength and sensitivity. A critic of butch "realness", she considers her own take to be truly authentic. Even in the scene, she has achieved "judge" status, and sits on the stage at all major balls ranking the contestants.

For the moment, being jobless in NYC has lessened Flo's desire for a relationship. She wants to focus on herself and surviving the present. She has a passion for cooking and submits resumes to local restaurants. But after no response, she considers other schemes. The risks are high since Flo is on probation. She tells me she secretly wishes she could find a woman to take care of her, but as a butch she is expected "to be the man." Flo isn't striving for maleness. It is the ideal she aspires to, the romantic notion of the man as caretaker. She has decided she can't pursue a steady relationship until she has gotten back on her feet.

Octavia has been locked up since 2001, after an arrest on drug related charges. She says she has put on a few pounds since I last saw her. Back then, she proudly proclaimed

her "roughened-up look like a little dude" appearance. To me, she looked like a pretty boy after a long night fight, thin and gangly. I imagine her in solitary confinement from where she writes me now. I've been granted one filmed interview, but she continues to get in trouble and our session is postponed yet again. "These girls in here just won't let a nigga shit!" Octavia explains.

Octavia is 20 years old. She has a 4-year-old son—from when she was still "perpetrating"— who is now being raised by her aunt. Since coming out and meeting Kisha, "her gay father", Octavia considers herself to be a "straight-up-lesbian Aggressive". She hasn't yet taken on the butch label, even though she is strictly "on top" sexually. Unlike RJ, Marquise, and Flo, she is mistaken as a boy but never a man.

Before she went to jail, Octavia was jobless and hung out a lot at the Piers. She told me that being a lesbian was fun and that she'd never go back to men. That she ever had a relationship with a man, even has a child by one, is hard to fathom now. Octavia seems so smitten with all women. Before going to jail, she cruised chat lines and made house calls when invited. She dreamt of settling down one day and honeymooning on the black sands of Hawaii, but until then she was very busy playing the field.

It was nearly impossible for me to keep up with Octavia before she was locked up. She bounced from one date to the next, and was the first same-sex affair for many of her partners. Sometimes, I'd find her back at the Piers, nursing a 40 ounce and a swollen eye. She was quick tempered then, and often summed up the conflict as "those bitches be wil'en out".

As an Aggressive, Octavia stood out to me as perhaps one of the most raw and uninhibited of her kind. She threw herself into the scene with reckless abandon and never looked back. I related to her antics. They recalled my own early days in NYC, when Chelsea was still a cheap neighborhood and the East Village seemed to stretch into eternity. Since then the Piers have been "cleaned up". Little green nooks and shiny new benches have sprung up where dirty old men used to trick.

I write to Octavia that a lot has changed since she got locked up, that the scene is different now. she writes back to say that as soon as she gets out she's smoking a blunt and heading straight to a club. I better be there waiting. In the meantime, she asks, could I send her a couple of copies of "Playboy".

ORIGINALLY PUBLISHED IN TRACE #37, 2002

"Maybe it's just individual character"

TRANSMAN

BY **AINA HUNTER**

Three old college friends sit around a table at a trendy Chelsea restaurant. Garnsey and Theresa look like any pair of hip New York women brunching with their cute gay friend. Ethan, a programming whiz kid for an investment bank, has thick side burns, bright blue eyes and a charming personality that makes him the natural center of attention. But Ethan's not exactly gay, and this is no ordinary brunch. Garnsey hasn't seen Ethan in nearly a decade, when he was called Liz. Back when he was a girl. Now, over omelets and espresso, Garnsey and Theresa are laughing as they talk about the old days. "Back at Wheaton, Liz was BDOC—Big Dyke on Campus! BDOC!" They grin as Ethan covers his face in mock horror.

At the Massachusetts liberal arts college, Ethan and Theresa were on student government together, and because they both ended up in New York after graduating, they've stayed in fairly close contact. It's Garnsey who hasn't seen Ethan in nearly a decade, since he was called Liz. Garnsey was a year ahead, but she knew Liz because Wheaton's a small school, and because, well, everyone knew Liz. Some of Garnsey's friends—straight girls—had not-so-secret crushes, and a running joke would go something like, "You all! I'm so horny, the guys here are losers, and now I'm having Liz Carthaus fantasies—what do you think that means?"

It was all in good, drunken fun, but what it boiled down to is that Liz was considered a good-looking, bad-ass girl. Today, Garnsey peers across the table, looking hard into Ethan's face. Finally she shrugs and picks up her fork. "You look different, but you really haven't changed much," she says.

When most people think of transgendered, they think of men who become women, but clearly this is only half the story. While about three times as many biological men seek sexual reassignment surgery as do women, this statistic should not be taken at face value. Female-to-males are everywhere. They just don't always choose surgery, which is expensive as hell. Some transmen (a preferred term for female-to-male) get by on just testosterone. Hormones are relatively cheap, especially over the Internet.

Testosterone—which transmen usually get by doctor's prescription—affects a guy's body in powerful, visible ways. Genetic differences aside, the average biological woman who injects "T" will experience facial hair, body hair, coarser skin, a redistribution of fat and muscle thickening. In essence, she will look like any other guy. Like Ethan.

On being introduced to Ethan Carter, the first thing you notice is his jubilant confidence; the happy energy he radiates. His chuckle sounds like a cross between a giggle and a chortle—a chorgle. He's like a hunkier version of a Keebler elf. I visit him downtown, in his cubicle at the massive Credit Suisse building. Walking into Credit Suisse is like entering a museum. Stately marble and chrome, everywhere. Security guards block the elevators while your bag is scanned through an x-ray machine. People are expected to move quickly at CSFB, which suits Ethan just fine. When I meet his colleagues, the interpersonal dynamics are easily discernable: Ethan is still one of the popular kids. He greets the tall boss-man with an easy smile and the boss-man jokes back, saying that he's the one to come to "if you want to hear some really good stories about this guy." A few minutes later, Ethan exchanges what smells like flirtation with the sexy public relations chief—the cutest woman on the floor. She keeps her eyes on his face, calling him the "resident HTML genius", as she explains how her office sends him completed web copy to upload.

"Has there ever been anything between the two of you?" I ask him this later, over soft tacos. Ethan chorgles wildly. "Oh no! She has a boyfriend! Does it show? That's not good!"

At quitting time we walk from downtown to Chelsea. Going down 7th Avenue with Ethan is almost like walking with a celebrity. Gay men strain their necks to give him the once-over. Ethan says he's strictly down with the ladies, but he doesn't seem annoyed by the stares. He loves attention. Plus, for a transmen, no matter how straight his preference, being hit on by a gay "bio-man" is the ultimate validation. Certainly, being accepted as a peer by straight bio-guys, like Ethan's boss at Credit Suisse, is high praise for passing. But straight men are not always the most observant creatures. Gay boys are eagle-eyed, so if you're passing in Chelsea you're doing better than good.

We stop by a pharmacy to pick up Ethan's testosterone prescription. I examine the glass vile; tilt it to one side. Every 10 days he injects 200 milligrams of "T" into his thigh. For some reason I expect it to be thick and brownish, but instead it looks like Johnson's Baby Oil. The solution has to be injected deep into the muscle with a wide-gauge needle. So it's painful. But, like most transmen, Ethan looks forward to his bi-weekly infusions. Getting a shot of T isn't quite as dramatic as say, a can of spinach is to Popeye, but if he were to miss a dose, Ethan says he would definitely notice a difference in his energy level and mood.

If Ethan is an elf, his best friend Neil (not his real name) is Batman, moody and reclusive. He lives alone in a one-bedroom condo that's been his for eight years. Neil and Ethan have a lot in common, superficially. They have similar looks—both are an average height for women, but short for men. Both have compact physiques made muscular through regular workouts and regular injections of T. They're both in their early 30's with black hair and blue eyes. They also both work in IT, and they both transitioned from female-to-male on the job. When it comes to personality though, they are pretty much opposites.

Neil is a self-described misanthrope. Married to his career, he says he has little patience for people. He says he will never fall in love again. He was in love once, with a beautiful, intelligent woman. But when he told her he wanted a sex change, she told him she had never wanted a man; that she could never love a man. Neil started hormones anyway, had the top surgery, had the lower surgery, had a hysterectomy, and that was that. He chose transitioning over love. Maybe he thought she'd come around, but she didn't. So, like an injured superhero to his bat cave,

Neil retreated to his condo, emerging, primarily, for work.

Neil was in his mid-twenties when he decided to transition. At the time, he was employed as a programmer for a Manhattan-based corporation in the financial services industry (he asked the name of the company be withheld). He knew that under the Americans With Disabilities Act of 1990, he could not be fired. Like Ethan, Neil had been officially diagnosed with Gender Identity Disorder, a prerequisite for those seeking sexual reassignment surgery. So Neil faced management head on, but not before arming himself to sue his employer if it were to come down to that. Unlike Ethan, Neil is always ready for a good fight. But as it happened, his transition went nearly seamlessly. His dad offered his unconditional support, and his colleagues—jaded, self-absorbed types—seemed mostly indifferent.

"I had to notify people in my building—no, not my neighbors, I don't speak to my neighbors—but the doorman and all. I just said that I'm having my name changed to Neil. They were pretty good about it . . ." The only person who objected, it seems, was the person most important. The woman he'd hoped to marry.

Ethan, always generous with his time, gives me a tour of the Credit Suisse building. The cafeteria is nicer than the restaurants I usually frequent, but more amazing is the gym. At lunchtime, it's packed full of CSFB employees, white, black, Asian. Benetton without the funk. More like the rainbow graphics in a USA Today; all the corporates dressed in identical t-shirts and sweatpants. The whole thing seems kind of Stepford-esque and scary. Talk about pressure. If you're not working out with the gang, everyone probably knows it. If you're not having dinner in the restaurant, everyone knows you're not working late. Seems odd that Ethan is so comfortable here. After all, if you type the word "individualist" into the Microsoft Word thesaurus, Ethan's tattooed, surgically and hormonally altered physique should pop up as a big 3-D graphic.

Unless, of course, you adopt the conservative view held by some gays and lesbians, who think transfolk are the ultimate conformists. This feeling has been at the root of an ongoing debate, particularly within the lesbian feminist community. Instead of helping to change society so that all women are respected and allowed to live free of harassment, they think transmen alter their bodies to suit the status quo.

What was so bad about being a butch dyke anyway?

Ethan finds that question, which he has heard many times, mildly irritating. "There's nothing wrong with being a butch dyke. I have friends who are. But I'm just not a lesbian. I'm not even very butch!" he chortles.

Ethan remains secure in his identity in the face of tepid support from the gay community, and a colleague said that in disclosing his intention to transition, Ethan faced his employer with the same confidence. Ethan first assumed that Credit Suisse (which is currently reworking corporate policy in an effort to be inclusive of sexual minorities), would be responsive to the needs of a productive worker like himself. So about three years ago he went to his boss and said something like, "I'm transgendered. That means I'm going to have a sex change. I've changed my name from Liz to Ethan, so I'm going to need you to speak to HR about new ID's and all. Also, I predict my colleagues are going to need some help making the adjustment, so I'm recommending a diversity trainer to come in and do a half-day group session."

His boss responded positively, and his coworkers attended the group session and learned to adjust. Over the years, the old boss left and a new one came on board, and other faces in the cubicles changed. Ethan says he's pretty sure only a few people on the floor are now aware of his trans-status. And judging by appearances, it does seem likely that Ethan is known simply as the cute, short HTML guy who DJs on the weekends.

In the '70s and '80s, few people would have dared pull an Ethan. Transfolk would quit their jobs, get the surgeries, and move

away to start new lives. Dr James Reardon, a Manhattan plastic surgeon who has performed sexual reassignment surgery for over a decade, usually recommends that people schedule the body-work during a time such a move is possible. "It's not that they should hide away, but in my experience most just want to start over fresh," he said. But people of Ethan's generation and younger are feeling increasingly entitled to demand that society learn about and make room for them.

Neil was similarly proactive when he first transitioned, and his boss and colleagues eventually got used to him. Over time his coworkers came and went until he was no longer the dude-who-used-to-be-a-chick, but just another stiff in a cubicle. But soon he began to sense that he wasn't being paid as much as the other guys, so, strategically, he sent out resumes to competing firms. He went to interviews, without divulging his trans-status, of course, and received offers for more than twice his old salary.

He brought these offers to management and said if they wanted to keep him they'd pay him what he was worth. He got promoted. Neil, who has been a feminist since high school, felt compelled to share his strategy with the women who now worked under him. From his new vantage point, he observed what he considers the passive behaviors that sometimes help keep women from reaching their earning potential. He began to give them free advice on how to bargain for more money. But to his disappointment, his female colleagues were disinterested. He sensed there was an unspoken resentment that had something to do with a man invading their space to tell them how to speak up. "They were like, 'who is this asshole and what does he know about it?'" Neil sighed.

Neil and Ethan sit in Neil's sparsely decorated living room. There are a couple of pictures on the walls—science fiction fantasia. There is a big desk with a computer. Shelves are stuffed with programming manuals and quite a bit of solid, college-issue American literature. Neil rolls a Drum cigarette. Ethan talks a mile a minute.

Ethan remarks that he can't say he's made more money since transitioning. Neil snorts.

"Sure I make more money than I did three years ago," Ethan qualifies, "but who's to say I wouldn't be doing just as well if I hadn't transitioned? And if my higher salary is due to that, it could be not because I'm a guy but because I'm now a happier person. Happy people tend to do well in life."

Neil shrugs.

"Or maybe it's just individual character," Ethan continues. "Maybe you just have to be a person who knows what you're worth and insists on it."

Neil grins. He likes this second possibility. Even Batman will admit he's a happier person now than he was before, when he couldn't call himself a man. He leans back in his chair and grins some more.

"I was just looking for something that was different, distinct and

SPANISH FLY

BY **JAMEL SHABAZZ**

Excuse me brother may I take your picture? Because I see this uniqueness that's inside you—something powerful about you and I know that in time if you allow me to photograph you, it's gonna make history." I grew up in South Brooklyn, in Red Hook, in a community that was basically 60 percent black and 40 percent Latino. As children, we were all one and the same. Other than some language barriers, there was never any real distinction. I thought all Latinos were Puerto Rican. Their cultures were so intertwined. I never knew one from the other. It wasn't until later that I found out this one was Puerto Rican, that one was Dominican and the next from Peru. There were so many similarities stemming from love, common language and a common pride in their flags. I made it a point to take the challenge of photographing them and transcend the word "Latin". I was merely appreciating life. My desire at that time was to connect with those young people. Don't get me wrong, I wore my Adidas, my Kangol and all that! But it was deeper than that. Latinos inspired me. Always have. My best friend Alex, a Cuban brother, was a graffiti artist. He belonged to the graffiti group the X-Vandals, and would go to train yards and paint masterpieces. My

girlfriend at that time, and the first woman I ever loved, Rosie Sanchez, was Mexican. I had a glimpse of Latino life with her. Back in the '70s, a cat by the name of Philipe Luciano, of the Last Poets, introduced me to the Young Lords, a Latin organization preaching love and unity. He took me through the Latin culture. It got to the point where I had to go to all the parades—from the Puerto Rican day parade to the Dominican one. I would go and sit back in amazement at the pride that they had when that time rolled around. It often made me reflect on my childhood days when I'd see the Puerto Rican flag flying high in someone's window. The love they shared with each other always moved me. I was open. And to further understand the culture, I felt I had to go to the land. I found the more you know about the person you're shooting, the more likely you are to open yourself to their world. I had to go to the rainforest. Had to eat food off the land. Had to live in the hills and the mountains. Had to go to the Dominican Republic and spend time in Washington Heights, NYC, to understand their mentality. I even made it over to Mexico—from the poor sections of town to the elegant ones—in order to get a feel for the people and their attach-

ment to their land. I was blown away. It intrigued me to find out what produced that.

I shot what was accessible to me and what I found to be beautiful. It was my goal to capture the street. Back in the day, I would spend time in areas that I called the nucleus. It was a central location where everyone would be traveling to and from. One of my greatest locations was downtown Brooklyn, right in the heart of the shopping district. I would go down there like a fisherman looking for fish. And I would just sit in a main area—maybe in front of the mall—knowing that people would pass by. Or I'd go to 42nd Street on the weekends. That was our Hollywood. Everyone from the five boroughs and New Jersey would pass through there. On Sunday, I'd go to Delancey Street, which was our Bloomingdales—where everyone bought their gear. During the summer, I'd go to Coney Island and just observe. I knew that eventually I'd see those unique individuals.

Sometimes, I couldn't tell if someone was Latino or not. Their skin tones range from the darkest blue to the whitest white. Sometimes, the only way I could tell if someone was Latino was by the music. I admired their music; their drum. I never knew what was being said, but the voices were so rich. Growing up listening to it, I would ask my partners, "What are they saying?" And the songs were always about respect, brotherhood, land, culture and the power of family. Latino musicians motivated me to take interest as well.

However, for me, the first impression was basically the clothing. When I grew up in the '70s, there were three types of sneakers: Converse, Pumas and Adidas. When the '80s came around, fashion was really booming. Nike was introduced. Excessive jewelry was the craze. Gazelle was introduced. Women wore shoes and took greater pride in themselves. Men stayed in the barbershop—they got their hair cut every week. I remember brothers walking around with toothbrushes just to keep their Pumas clean. I mean, fashion was really big and the people were on point. The fresh red and white Pumas, the sheepskins—the spirit of the person, that's what really captured my curiosity. And when people dressed with pride, you could see the

confidence. If I saw a Latin brother that was sharp, I would approach and compliment him. 'Excuse me, brother, may I take your picture?' He'd answer something like, "Why you want my picture?" 'Because I see this uniqueness that's inside you—something powerful about you and I know that in time if you allow me to photograph you, it's gonna make history.'

Basically, I was just looking for something that was different, distinct and positive. It may have been love. For instance, I'd see a couple that loved each other and I'd focus on that bond. I'd try to snap a picture of the essence of their relationship. As I clicked the picture, I would leave them with words of wisdom. Even with the young Latin King on the corner or in front of the bodega, who may look like he's involved with a little negativity—I would take his picture. I would use our meeting as an opportunity to encourage him to think about life. I would try to give him a chance at looking at the present and the future. I was making an investment, not only for myself, but for the future of his people—our people. Or I saw a posse of guys just hanging out, or buggin' out, and I'd try to capture that confidence on film. I found that type of camaraderie in the city back in the days quite admirable.

A young Latino I knew, who grew up in gangs later joined the Zulu Nation, a multicultural organization based in the Bronx and Manhattan to my knowledge. It changed him. Here, you had Blacks and Latinos working side by side for the improvement of mankind. Zulu is a term referring to African warriors, and the Nation represented that. I found the Latinos in this organization to be very powerful, beautiful people with a sense of appreciation for both worlds that created them. These Latinos were unafraid to represent their African roots. They had an understanding that made them feel strong enough to wear the symbol on their clothes or on their bodies (tat-toos). It was amazing. I am glad I was able to photograph them to show their bondage and enduring spirits.

I attribute their work to the brotherhood among blacks and Latinos. It had broken down a lot of doors to racism. This became the begin-ning of the universal family, the metamorphosis. The beginning of hip hop—it was off the hook!

The beginning of hip hop—it was off the hook! Clubs were opening up everywhere. Block parties were all over the place. It changed the music scene. Music and fashion were the prevalent culture and Latinos were definitely apparent. We saw the emergence of Spanish versions of songs, like "Good Times" by Chic. WBLS used to rock the Latin Quarters, a program that came on at 10 every night. They played Latin jazz and introduced us to the Latin cultural perspective. Music by Tito Puente, Joe Batan and Gato Barbieri laid the framework for future artists. One of the first rap songs was by a Latin guy named Joe Petez. He would incorporate the Latin lyrics in his songs to African beats. It was beautiful. It was an artistic, creative time. Even the trains became art galleries.

The '80s were no joke. My focus was capturing all the aspects of that period. When I reflect on my photos from that era, the young people were smiling. I want to remind people how things used to be. I want kids to get an idea of what their mothers and fathers looked like. Everyone looked happier. I want that to be the reality for Latinos—everyone for that matter—today. I want them to see love and unity. I want them to know that I am not just a photographer. I am also a street teacher and a street soldier. My camera has been my tool of communication more than anything. And from my love and observance of this very special culture, I truly feel there is something in Latin culture that we can all learn from.

INTERVIEW BY **AMY ANDRIEUX**
ORIGINALLY PUBLISHED IN TRACE #33, 2001

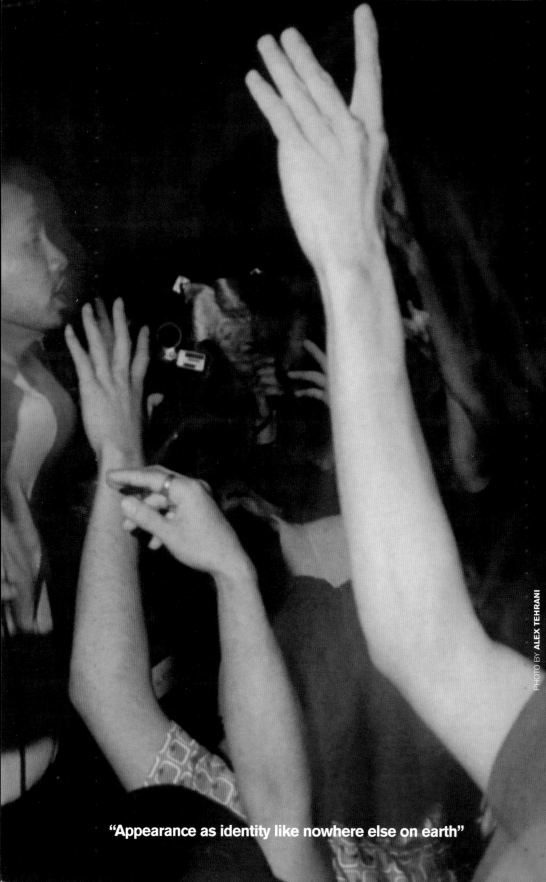

"Appearance as identity like nowhere else on earth"

TOKYO

BY **PATRICK NEATE**

There aren't many occasions when a tiring hip-hop head falls back on the lyrics of PM Dawn. But this is one of them. Walking through Shibuya, looking for Tokyo's premier hip-hop club, Harlem, my eyes are on stalks.

It's the wash of red and yellow lights. From the electronic stores to the gadget stores to the sex stores to the electronic sex gadget stores, this is neon homogeny. It's the restaurants. From the "Mickey D's" to the "American" diner to the "Japanese" noodle bar, you choose your meal that looks like plastic from a photograph of a plastic representation of your food. This is eating as alienation. It's the people. From the Lil' Kim's, eyes manga-wide, in crop tops bearing abstract English phrases ("Sexy Kitty" anyone? Or "Culture Style") to the '80s Goths to the women dressed like schoolgirls to the schoolgirls dressed like hookers, this is appearance as identity like nowhere else on earth. I'm thinking, it's just so fake, so shallow, and I'm beginning to feel claustrophobic and, like, I need to scratch.

My girlfriend, Kanyasu (yeah, yeah... even other Africans think it sounds Japanese), isn't freaked out like me, and she's singing under her breath: "Shibuya! Shi! Shi! Shibuya roll call!"

Shibuya—roll call is right. Roll up, roll up, it's time for every fashionista to get on the bus of their choice; to express every nuance of their unique self through every nuance of their membership of some or other clique.

So turning up Maruyama-cho is a relief. It suddenly feels more... more what? Real. Outside Club Harlem, gaggles of B-boys are fronting with testosterone on tap. They've got corn-rowed hair and thick cigars and Raiders shirts and Fubu jeans and a well-honed B-boy swagger. I like the way they're checking each other out; a raised eyebrow and a slight jerk of the head. I like the way they're checking me out; a high chin and a glance through an imaginary target at the end of the nose. I like the way they're checking Kanyasu out; a brief bob of the neck and a coy sideways scrutiny. On the door, I like the bullshit from the bouncer. He thinks my ballpoint is a knife, and makes me write my name to prove otherwise. I like all this. It has a gritty seaminess that is familiar and welcome, a real antidote to the trendy ephemera that swarms a street or two away.

Inside, Harlem is dark and smoky, and I get that familiar adrenaline rush when I feel the beats. The music is dirty south—not my bag—but, in the half-light, the way people move, the way people are dressed, you could be in any hip hop club in the world. I just need a whiskey to set me up. The bar isn't busy. I assume it's because drinks are so expensive. Only when I turn away, scotch in hand, does Kanyasu point out the orderly queue of Japanese B-boys at the far end. I've just jumped in front and nobody said a word, and my bubble just burst. These aren't like any B-boys I've ever met. Seamy? I've dropped off my niece at playgroups seamier than this. What is hip hop? It's always been a tough question and these days you'll find as many answers as there are artists, critics and heads. Your definition can be narrow

("I am hip hop," says KRS One) or broad ("Hip hop is just black people's creativity," says Chuck D). You can talk up the four elements of hip hop as subversion or hip hop as big business. It's up to you. For me, the one phrase I prefer to all other is hip hop as "keeping it real". It's so flexible as to be almost meaningless, and yet any B-boy knows what it means and knows how it applies to them. It's about depth. It's about where you come from and where you're at. But here in Tokyo's very own Harlem? It's back over to PM Dawn: "Reality used to be a friend of mine."

At Tokyo's annual hip hop festival, B-boy Park in Yoyogi Koen, the Kick the Can Crew exhort the crowd to wave their hands in the air. The crowd respond in metronomically perfect time.

I want to talk to people–to ask questions. I approach a guy with a glorious tattoo on his bicep. An angel is framed by the words "Los Angeles" and "Trust No Man." I ask him if he speaks English and he smiles, "Word up, dog." Cool. Could I ask him about the Tokyo hip hop scene? "Word up, dog." And that's as far as it goes.

On stage, the Kick the Can Crew appear to have been succeeded by DMX. Only he's rapping in Japanese. As I approach the stage, I realize it's the Japanese superstar Zeebra. He just sounds like DMX. Now I come to think of it, the Kick the Can Crew weren't far off Arrested Development.

I finally find a group of fluent English speakers but they're not forthcoming. They explain they're not really into hip hop so they don't want to talk about it. Fair enough. I'm checking out their Ruff Ryders chains, Roc-A-Wear jeans, Sean John jackets and Wu T-shirts…

Back in Harlem, the DJ has launched into his classics set. Tracks by Das EFX, EPMD, Quest and the like are skillfully chopped together. On the dancefloor, there are two apparently African-American men. They are surrounded by about a dozen fawning Japanese girls. Some wear head wraps like Erykah Badu, some have neat dreadlocks (at $1,000 US a time), some have super dark complexions from hours on sunbeds. So I guess these girls are kokujo: women who hit on African-American men. It's a noted phenomenon. Earlier, at the B-boy park, I met a strikingly beautiful teenager called Kioko. She wore her hair in braids and a T-shirt that said "gettoho" (sic). I asked her why she was particularly attracted to black men. She corrected me: "Just black Americans." Because they are, she claims, "more romantic."

As I watch the fawning girls grind against some sturdy African-American thighs, it doesn't look romantic to me. More like ugly. I catch a word with one of these guys later and ask him where he's from. Brooklyn, he says, but I'd put his hometown closer to Accra. In his position I'd probably tell the same lie.

I'm talking to Yuko Asanuma (editor of local hip-hop mag Clue). "Hip hop is often just fashion here," she explains. "A lot of the kids who dress hip hop just put on the clothes. Tomorrow, they might put on other clothes and become goths."

So it's fake?

"Not fake," she shakes her head. "You need to understand that Japanese culture is very orderly, so the way you look is very important. Often dressing in some or other American style is the only way you can identify yourself."

I'm on the dancefloor and my fourth whiskey is kicking in. I'm drinking too quickly because, well, I don't have to queue, right? With my eyes half shut and the Ummah's beats, I could be in any hip hop club in the world and my head is full of a thousand thoughts. So the Japanese B-boys are keeping it real in their own way? Homogenous, alienated and superficial, but real nonetheless.

I watch one of the black guys dancing with one of the Japanese girls and wonder about the exoticization. But I'm confused. Who exactly is exotic? For some reason I find myself thinking of the W.E.B. DuBois idea of double consciousness as the "in but not of" thrusts his pelvis against the "of but not in". For some reason I find myself thinking of the protagonist "The Wind-Up Bird Chronicle" (by cult Japanese novelist Haruki Murakami). He says: "My reality seemed to have left me and now was wandering around nearby." I know how he feels but it's his culture and his reality, so who am I to judge? So I'll stick to Prince Be: "Reality used to be a friend of mine."

ORIGINALLY PUBLISHED IN TRACE #35, 2002

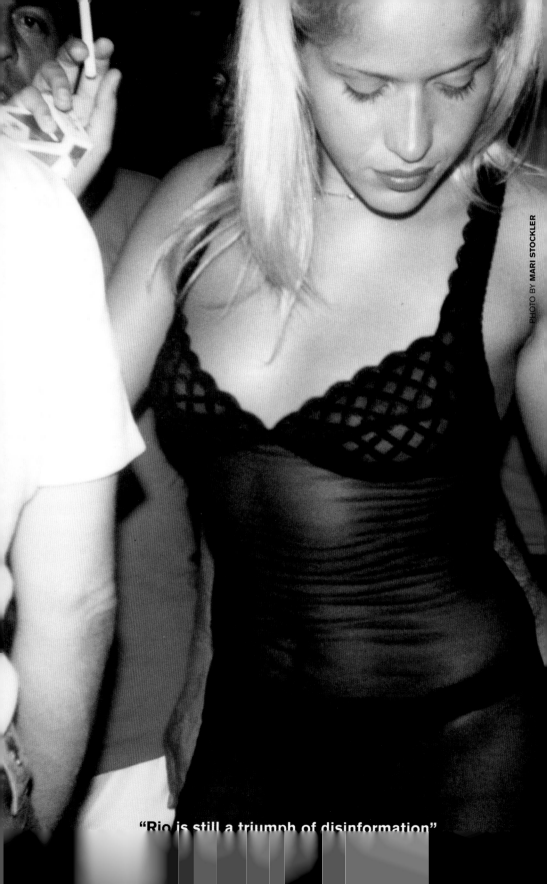

"Rio is still a triumph of disinformation"

RIO DE JANEIRO

BY **CLAUDE GRUNITZKY**

To understand the New Brazilians, you must understand Suzana Alves, a Zorro mask-adorning television "actress" and Playboy centerfold who is better known as Tiazinha. Tiazinha (Little Aunt) was catapulted to fame last year when her regular appearances on Luciano Huck's Letterman-like "H" show became a must-watch for teenagers and married men alike. Standing short at 5 feet 5, with 32-24-36 measurements (more on the importance of these measurements later), Tiazinha, a vampish cartoon character who likes to blurt out grand pronouncements like "I want to conquer the world!," was an instant phenomenon, the product of Brazil's new pop factory. Only Tiazinha's reign ended three months ago. Now, there is a new Tiazinha, and her name is Feiticeira (The Witch). You can see her splashed out on the country's billboards: all lips and Latin blondness in the Antarctica beer ads, in a lascivious pose with a see-through dress and see-through witch mask proudly reinforcing her 'take me now' stare. On her hit show, which draws a huge male and female audience every day, Feiticeira plays and jokes with four male slaves. She must discover which slave is wearing a red swimsuit underneath his

Oriental costume so one of the girls in the audience can undress him and give him a live shower. So this is modern Brazil: blond bombshells and sexual innuendos for free-spirited citizens.

Of course, to most foreigners who read magazines and buy clothes, Brazil 2000 is one 21-year-old supermodel who goes by the Franco-German name Gisele Bundchen. The daughter of a neurosurgeon, Gisele, who was born in a small town called Horizontina but nurtured in John Casablancas' Elite model network through Rio, Sao Paulo, Paris, London, Milan and New York is already, with the possible exception of Claudia Schiffer, the most successful model ever. She may not have yet proven herself with the longevity of a Cindy Crawford or Christy Turlington, but the sheer velocity of her whirlwind ascension, which was sealed with more than 1000 magazine covers and major advertising campaigns ranging from Dior (with photographer Nick Knight) and Dolce & Gabbana (with Steven Meisel) to Celine and Lanvin all the way to the low-end fashion chains Zara (Spain) and H&M (Sweden). Even though the slim but buxom Gisele, who is said by American Vogue editor, Anna Wintour, to be "singlehandedly

reviving the supermodel," is less known in her native country than either Tiazinha or Feiticeira, you can see her all over the Brazilian print media hawking jeans (with Mario Testino for the Brazilian retailer Zoomp), phones (for the telecom concern Intelig) and even Internet services (for national provider IG).

Gisele gets written about regularly in the celebrity gossip magazine Caras, and the episodes relating to her dumping an American model boyfriend named Scott for a rich scion of the Diniz supermarket chain and subsequently dumping him too for Leonardo di Caprio, were well documented in recent issues. (This may, of course, be old news by the time you read this.) Still, right behind Gisele is marching a new model army made up of hundreds of sexy soldiers with names like Fernanda Tavares (Victoria's Secret) and Carolina Ribeiro (Gucci), both of the Marilyn Gauthier agency. (Carolina Ribeiro, who has just shot her second consecutive Gucci campaign, looks like the superelegant '70s Brazilian model Dalma Callado when she swings on the runway.) There is also TRACE veteran Renata (of the Polo Ralph Lauren ads) and Talytha Pugliesi (Plein Sud); there is Isabeli and Mariana Weickert and Ana Claudia and Adriana Lima (our cover star). "When I started with Women four years ago," says Cutibiba-born Vanessa Greca, "I was the only Brazilian girl in the agency. Now, Paul [Rowland, the agency owner] and some of the bookers speak Portuguese. There are so many Brazilian girls working in the circuit today that it's almost become a prerequisite that you have to speak Portuguese to be able to communicate fully."

Yet, if you asked most Brazilian men off the street to choose between Gisele's busty feline figure and Tiazinha's flat-chested, round-butted (32-24-36) physique as an ideal of beauty—an experience I conducted in Rio, Sao Paulo, Fortaleza and Brasilia during two trips to Brazil last March and April—the large majority would not hesitate before selecting the actress. A brunette who sports a natural Latin tan and a genuine "bunda" (butt), Tiazinha would still be the people's choice. Brazil's image in the outside world, Gisele is, on the other hand, a cliché. And most Brazilian women do not necessarily want to look

like her, nor would their husbands or boyfriends instantly drool on her pictures either. Gisele became the ultimate supermodel because she possesses the finest European-style features, and learned how to exploit them fully on European runways and in the pages of the most avant-garde style publications. But without the boost of photographers like Testino (a Brazil lover and the de facto general of this new model army), she may not have been able to unleash her Latin sensuality onto the early pictures and immediately capture the zeitgeist.

When you clock Tiazinha's 36-inch butt in Playboy magazine; when you consider that the best-selling magazine Bundas was created as an antithesis to the previously mentioned Caras, and proudly displays the firmest, roundest, nicest Brazilian derrieres on most of its pages; when you refer back to American Vogue's May issue, which pointed out in the article 'Blame it on Rio' that "There are no busts in Brazil... Brazil is bottoms country... Plastic surgery in Brazil is all about breast reduction, not implants"; when you consider that two years ago, the Bahia dancer-turned-singer Carla Perez became a national pop star despite the well known—and well accepted—fact that she could not really sing, you can begin to understand the enduring appeal of Brazil as the ultimate tourist destination in Latin America. And nowhere is the magic of the bunda more apparent than in Rio de Janeiro and the daily lifestyle of its inhabitants, the Cariocas.

As the tourist is being driven into the city from Antonio Carlos Jobim airport, through the slums in the outskirts with Paul Landowski's Christ the Redeemer hanging supreme on the never distant horizon, the breeze of Ipanema, Copacabana and Leme beaches, with its soothing sight of bikini-sporting, caipirinha-drinking beauties is a friendly reminder that Rio de Janeiro is indeed The City of God. The writer Paulo Lins, who wrote his influential book about Cariocas and titled it The City of God, is a prime documentarian of the contrasts and contradictions which have rendered the presence of God indispensable within the perimeters of Rio. As the tourist takes a walk along Avenida Niemeyer and approaches the Vidigal favela (shantytown) on the hills right behind the luxury Sheraton Hotel with its famous

swimming pool; as the tourist ventures toward Sao Conrado beach and peeks into the exclusive Gavea golf club in the middle of guarded mansions suspended on hills of opulence; as the tourist continues along the beach into the new Barra neighborhood with art galleries and Miami-style villas spread across the riviera; as the tourist gets stuck in traffic with the disillusioned bombeiros–whose motto is "Somos bombeiros, nada do que e humana nos e indiferente" (We are firemen, we are not indifferent to any human beings)–the irony in the City of God becomes all too clear.

And painful. Which is why religion is everywhere. As with many Brazilian films, Walter Salles' award winning feature, "Central Station", contains a strong religious theme, and this theme seems to be the soul of Brazil itself. "The religious scenes were not part of the original screenplay," Salles admits, "but as we were location scouting, we were impressed by how many religious pilgrimages, such as the one which is represented in the film, still exist, and we incorporated them into "Central Station". Religion is fascinating, directly linked to the Brazilian's essential quests." Salles is a carioca. And cariocas need their god hanging above them right in the heart of the city, redeeming their everyday sins because the inequalities are so huge and the divisions so deep within the fragmented fabric of Rio society that religion seems to be the only way out of the pain of everyday existence for some, and out of the guilt of abundance for others. Benedita da Silva is the vice governor of the state of Rio de Janeiro. As a mayoral candidate in Rio's upcoming elections, she has become an outspoken critic of Brazil's race and gender relations. Few can criticize her views with conviction, because she was born 58 years ago in the Praia do Pinto favela, and remains an objective advocate of the faveladas. Because she was a favelada herself. Benedita (as everyday people call her) happens to be the first black woman ever elected to such a high office in Brazil. Her views influence decisionmakers outside the confines of her party, the worker's party (PT). Characteristically, on April 25th, three days after the big 500 years feast, which celebrated the discovery of the country by the Portuguese

explorer Cabral, Benedita was asked about Rio and Brazil's prospects for the next 500 years. Benedita said, without a hint of dogmatism, "I hope that the social exclusion will give way to a complete integration. Brazil is growing up economically, but there are still many things missing from the poor man's table. What is missing is happiness itself. If Brazilian society was born of the mixture of blacks, whites and Indians, the differences must be respected and there must be equality for all." Easier said than done, because Rio is the City where armed gangsters storm into poor people's buses and calmly point their AK 47s into commuters' faces after telling them, "I love to kill, and my friend here loves money." So the faveladas riding the overcrowded bus to work–the median salary in Rio is $197 a month - are forced to scramble for petty cash so their lives can go on for another day. When you find out that some of these gangsters are wealthy sons of the bourgeoisie who just happen to be strung out on drugs; when you find out that the drug dealers themselves have agreed in a concerted effort to keep crack out of the city limits, so as the extract more money out their cocaine-consuming clientele; when you find out that some of the bikini-sporting, caipirinha-drinking beauties on the beach are the $50 teenage prostitutes the term "sexual tourism" was invented for; when you find out that some of these 15-year-old prostitutes have two kids at home and are engaging in anal sex every night with German businessmen; when you realize that some of these prostitutes are university students–call them "escorts"–saving up for their tuition, the magic of Rio is immediately put into perspective as the cariocas' oft-described happiness and samba-fuelled joie de vivre becomes a blurred notion.

For all the attention which was laid upon it recently in style magazines and travel programs, Rio is still a triumph of disinformation. Rio does not end at Copacabana beach. The original Girl from Ipanema, Heloisa Pinheiro, is in her fifties now, and the myths that are being perpetuated in the foreign media relate to Rio in the '60s. Carnaval, samba and bossa nova are still essential elements of Rio's spirit of insouciance, and foreign journalists are legitimate in clinging on to

the '60s carefree approach to life, but the Cariocas do not vacation all year round. Nor do they follow the Carnaval parade every afternoon. Actually, very few of the sexy girls in the tiny bikinis on Copacabana Beach are prostitutes, and when the sun sets they put on their supertight, low waist, stonewashed jeans—the bikini tan is always apparent and some girls prefer to tear the two back pockets off so as to show more of the bunda—and head back to the bus stop. When they ride the bus to the favela, the reality that awaits them is often one of desperation. Even in the Copacabana backstreets, I saw poor black women scrounging through the garbage bags of the Pao de Açucar supermarket (a chain which belongs to the family of Gisele's ex-boyfriend) for leftover slices of pork and fish tails. Their young children were helping them sort through some of the bread bags, and none of the passersby seemed to be surprised that they were doing this without shame and in broad daylight. That is because it hardly mattered that they were black. They were just poor, and it could just easily have been a white family picking food in trash bags. In Brazil, it's not about black and white. It's about rich and poor. It just so happens that most of the rich are white and most of the poor are black.

Even though a black man like me could potentially still get called a "macaco" (monkey) by a racist (or drunk) brasileiro, Brazil is somewhat colorblind because, to some extent, black and white Brazilians are regulated by television culture. And Brazilian TV culture is largely the domain of Globo, a powerful media conglomerate that counts the Globo and Rede Globo TV networks, the daily newspaper O Globo, and the news magazine Veja among its most prized assets. Globo, which, like MTV Brasil, keeps its headquarters in Rio, is known for pushing a Rio lifestyle. So much so that the carioca lifestyle has become the Brazilian lifestyle. Above and beyond Tiazinha, Feiticeira and Gisele, the soap star Maria Fernanda, who stars on the hit show "Terra Nostra", is considered by the general population, by blacks and whites alike, to be the most beautiful woman in Brazil. And this despite the disconcerting fact that 12 months ago, she was just another aspiring novela actress.

The Belgian journalist Christian Dutilleux is the Rio correspondent of the French newspaper Libération. He is married to the singer Daude, a protegée of the producer Caetano Veloso. Dutilleux is white and Daude is black. In the early years of their interracial marriage they would notice the resentment of both blacks and whites, who would blatantly throw glances of disapproval at them. Now, he says, the perceptions are changing everywhere they go. The reason black and native Brazilians are more willing to accept their fellow white citizens—and vice versa—is not because football players like Pele and Ronaldo (Brazilians call him Ronaldinho) are married to white women. Rather, it is because of the clear social mobility Rio is quietly witnessing.

Again, the changes start in the favela. Many children of the favela, whose mothers work as maids in the houses of wealthy families, begin hanging out with the children of the house at a very young age. With their children growing up, these maids tend to spend all their income on their children's education. Those children of the working class see university as the only way out of the favela, and therefore many of them get admitted to college. Once there, they work harder than their fellow students from the bottom of the city and tend to take on part time evening jobs. The work ethic becomes a code of honor for the poorest students, and they end up working day and night so as to escape the trap of poverty. Rio University students are known to be able to fix their own computers—hardware and software—and they do their homework at night after work before heading back to class in the morning. Ironically, when in the '90s inflation eroded the purchasing power of the middle class—the teachers and secretaries and their offspring—many domestics started making more money than qualified professionals. Rio's economic upheaval is at the very root of Brazil's new social mobility.

And this social mobility explains the complex race relations Brazil is known for. First, the military dictators in the '70s played the "racial democracy" card to the hilt. They insist ed on painting the picture of complete racial harmony, and trumpeted the melting pot achievements of those forefathers who conquered Indians and

freed black slaves into society after slavery was abolished in 1888. The generals pushed for bilateral free trade pacts with developing African nations, and the 1970 world cup victor Pele was still the national hero. But the racial integration of this racial democracy was less successful than those who paid lip service to it would have you believe. Black and mixed race people were still poor, and whites continued to dominate the worlds of politics, finance and entertainment.

The recent changes, however, are real because they started with the economic upheaval and spread to politics and entertainment. The ripple effects have led to subtle changes, particularly in the field of advertising, where perceptions of beauty are increasingly being played out in an arena of complete transparence. With the exception of the dark brunettes Fernanda Tavares, Carolina Ribeiro, Renata and Adriana, the overwhelming majority of Brazilian models working overseas are, like Gisele, blue eyed blondes from the south of the country, the states which were largely populated by European immigrants after the first and second world wars. In Brazil, however, some pioneers have taken to changing the politics of beauty. Marcelo Seba is the creative director of Ellus, a leading Brazilian apparel manufacturer which made a lot of noise this past spring with a new ad campaign featuring Mariana Weickert in one ad, and the Sudanese model Alek Wek in another.

Seba, who had previously cast Wek for Ellus' winter 2000 runway show, drew criticism from fashion insiders and even his local newspaper, the Folha Sao Paulo, for exploiting Alek's unusual looks and African heritage for the benefit of sensationalism. "The great challenge of this new campaign," reflects Seba, "was to translate the concept of Ellus' winter collection: Terra. It's hard to find a translation to the word 'terra,' since it has so many meanings in Portuguese. Terra means earth, dust, soil, mother, land, among so many other things. So this was our point of departure, to look out for models who could represent this feeling that we all have concerning our roots, and how impossible it is to run away from who we really are. People stopped on the streets to see Alek's bright smile on the billboards and even wondered if she was Brazilian. The first preoccupation with Mariana was to make sure that her billboard would be in Blumenau, her hometown. The important thing is to realize who we are and where we live."

Could it be that Rio is not really Brazil's epicenter? Could it be that Bahia is really where things start? Surely, if you count the number of pages we devoted to Bahia in this issue, you will grasp the importance of Bahia as Brazil's cultural laboratory. Particularly when it comes to the constant musical experimentation–think Tropicalia and its two main composers, Gilberto Gil and Caetano Veloso–that Brazil has always been known for. It is often stated that 40 percent of Brazilians identify themselves as mulatto. This figure becomes more significant when you study the many musical inclinations of the bahianas. Bahia the state, with Salvador as its capital, is where Cabral, the Portuguese "discoverer", landed 500 years ago. This is where the colonialists set about building a nation from scratch, with a little help from a few thousand slaves who were bought and brought in from Africa.

The proposition is simple enough: if Brazil is music and music starts in Bahia, then one could argue that Brazil is Bahia. In April of 1999, Gerald Marzorati, the editorial director of the New York Times Magazine, wrote an essay for the Sunday supplement which stated that for the tropicalistas, mixing was in the blood. "[Brazil is] a near-numberless variety of regional styles that fuse African tribal musics (the legacy of slaves), Portuguese ballads, Amerindian sounds, a variety of Caribbean styles (themselves hybrids) and the musics of more recently arrived European immigrant groups. In the towns and cities of Bahia in northeast Brazil, where most of the Tropicalistas grew up, the mixing, racial and musical, is especially pronounced, and by the time Gil and Veloso and [Tom] Zé (and Gal Costa, who would later sing many of their songs) met in the early '60s at the University in Salvador, the Bahian capital, they were familiar not only with reigning bossa nova style, which they played on their acoustic guitars and sang with their soft voices, but also with Carnival samba marches and accordion-based

rural dance music and also the many foreign sounds the radio brought: Celia Cruz, Duke Ellington, Elvis." The trajectory was also simple enough: after the bossa nova craze of the '50s faded with the early love songs of Joao Giberto, Tom Jobim and Vinicius de Moraes–think "Desafinado" and "The Girl From Ipanema"–Gil, Veloso, Zé, Costa and the singer Maria Bethania, found their mentor in the Sao Paulo producer Rogerio Duprat, and Tropicalia was born. 1966 was the year and the generals were in power. The songs from that era were overtly political–think Veloso's "Sem Lenco Sem Documento"–in their desire to challenge the generals' status quo, poverty and white supremacy. Gradually, the Tropicalistas, once the rebel's rebels, became stars, and Tropicalismo mutated into MPB (Popular Music of Brazil) when it accepted to fuse samba and bossa nova with pop and rock. Now, the near-numberless variety of regional styles can be said to define the population across geographical lines.

Today, young brasileiro musicians can be spotted on any street corner, strumming along to notes memorized on newsstand partitions, singing every word from current hits like "Ana Julia". But dig deeper into the regional styles and you will spot local devotions to axe (in Salvador), pagode (in Rio), forro (in Fortaleza), mangue beat (in Recife), bumba meuboi (in Belem), hip hop (in Sao Paulo) and sertaneja (in rural areas all over the country), all of which owe a huge debt to Bahia and its tropicalistas. Now, with the fascination for all things Brazilian reaching fever pitch, as evidenced by the success of Putumayo records' "Brasileiro" compilation last year, Marzorati pointed out that "Beck, who perhaps is making the most ingenious American pop at century's end, has a song on his latest album called 'Tropicalia,' which borrows its weird noises and samba grooves from a song by Os Mutantes (the Mutants), an arty Sao Paulo psychedelic band of the late '60s." Even the Racionais MCs, Sao Paulo's resident hip hop revolutionaries, and arguably the most important hip hop group in Brazil, owe a debt to the reactionary songwriting of Gil and Veloso in the late '60s.

This goes a long way toward painting the picture of a modern Brazil where young people are stuck between memories of their parents' glorious legacy, and their own dreams of a modern existence where achievements can be measured on a new global scale. Young brasileiros are rushing to the Internet because the digital challenge seems to open a window to the outside world. In the race to century 21 modernity, Sao Paulo is miles ahead of the rest of the country. If the country looks to Rio for lifestyle and Bahia for musical impetus, Sao Paulo, the richest of all 22 Brazilian states, has taken on the responsibility of pointing the way to the future. Fashion is always an indicator of where a country is headed, and Sao Paulo can now take pride in the presence of avant-garde designers like Alexandre Hercocovitch, Walter Rodrigues, Fause Haten, Tufi Duek, Icarius and Reynaldo Lourenco. Sao Paulo is where Morumbi fashion week has taken place twice a year (in January and June) since 1995, and Sao Paulo is where the MMM (Mercado Mundo Mix) was set up as a fair where young designers can sell their home made designs to assembled clients. The European influence on Sao Paulo's residents, the Paulistas, is obvious. The young photographer Daniel Klajmic, who the British stylist Isabella Blow discovered during a recent trip and took under her wing, was quoted in the May issue of French Vogue (a special Latin issue) saying, "We are constantly in search of new information. Via the Internet, we know the schedule of the MoMA and Tate Gallery. We read Purple, Dazed & Confused, Vogue and The Face. These sources are taken into our culture, which is already based on diversity. We are reducing the gap that separates Brazil from the US and Europe, but we do it differently, with our own ingredients and spices." At the Ann Demeulemeester fashion show in Paris last March, I met the journalist Erika Palomino. Palomino writes about fashion and pop culture for the Folha Sao Paulo newspaper. "You're going to love Sao Paulo," she said to me before I got to her city. "You're going to be impressed by how modern the city is. You won't believe it's a Latin American city."

True. The traffic jam from the airport to our

hotel near the Avenida Paulista was so severe that I finally understood why the wealthiest denizens—and there are many of them—have opted for helicopters as a more convenient mode of transportation. Sao Paulo is all concrete. It is overpopulated with 21 million people, the weather is bad and there is nothing aesthetically appealing about the city. Yet you get the feeling that paulistas are trying to show what Brazil is about, and what the world is expecting from Brazil. This challenge is at the very heart of the workaholic tendencies many paulistas have been recently diagnosed with. Daude had warned me back in Rio: "You're going to Sao Paulo? It's going to be quite a change for you. You won't be hearing so many people saying 'Tudo Bem.' (it's all good)" On a warm April night we went out with Bruno Soares, an ex-model and photographer who now works at the Sao Paulo branch of Next model agency. "We're going to this club called Lov.e," he said. "The DJ is Marky Mark so don't be surprised if we don't leave before 6am." Sure enough, every morning at 6am, Lov.e's owner Angelo Leuzzi serves morning tea to all his guests who have managed to stay up all night. "A lot of these people will go straight to work from my club," said Leuzzi. Leuzzi is a smooth-talking, forty-something stalwart of the Sao Paulo club scene. His girlfriend, who looks about 17, seemed infatuated with his studied nonchalance. Sao Paulo has become a lot like New York. Like New Yorkers, the young paulistas work work work to party party party. Unlike in New York, there is not much of a street life in Sao Paulo; paulistas work during the day and take out the stress during the night, which may explain why drugs have come to play such a central part in many paulistas' lives. (Then again, the previous president, Fernando Collor, was long suspected of being a cokehead, which goes to show that in Brazil, drug matters obey their own law and should be put into perspective.)

While we were in Sao Paulo, the single most common topic of conversation was the mayor. Like Giuliani, Sao Paulo mayor, Celso Pitta, is the subject of constant criticism by his constituents. Unlike Giuliani, he is black. Pitta, the first black man ever elected mayor of Latin America's biggest city, has been in power for four years. He manages a multi-billion dollar budget, but as I write this, he is facing charges and could very well be removed from office before this magazine comes out. The reason? Like many Brazilian politicians, he is being accused of abusing power and taking an illegal loan. Nothing unusual about that—you may recall that President Collor had been impeached for similar reasons—except for the fact that the key witness against Pitta is his own estranged wife. So this is modern Brazil: dumb politicians and black men who beat the odds and still end up blowing it.

The truth is, Brazil 2000 can be seen as a triumph of the New Economy. But this New Economy feeds off Gisele and Tiazinha, as well as DJ Marky and the legacy of Tom Jobim. In Brazil's New Economy, tradition Is reinforced by technology. The Globo conglomerate was quick to add newly created globo.com Internet portal to its list of prized assets, and the early numbers are impressive. New youth culture websites are popping up daily with subtle messages of subversion, but the Diniz family is putting huge resources into amelia.com, a new portal for women, which is being spun off their Pao de Açucar supermarket business. In a twisted take on modernity, amelia.com is being marketed as the site for Brazil's "Amelias," the women who stay home and look after their husband and children when they are not out shopping for groceries at the (Pao de Açucar) supermarket. Brazil 2000 is also a triumph of modern art. For all its recent controversies, the next Sao Paulo biennale (2002) has been endowed with an $8 million budget, and many Brazilian artists are commanding respect on the world stage. The names are Ernesto Neto, Rozangela Renno, Tunga, Cildo Meireles, Beatriz Milhazes, Edgar de Souza and Vik Muniz. Still, when all is said and done, Brazil 2000 will be remembered as the bikini-sporting, caipirinha-drinking beauty on the beach. Like the Girl from Ipanema, this beauty will never go out of style. Nor will she ever miss a beat.

ORIGNALLY PUBLISHED IN TRACE #27, 2000

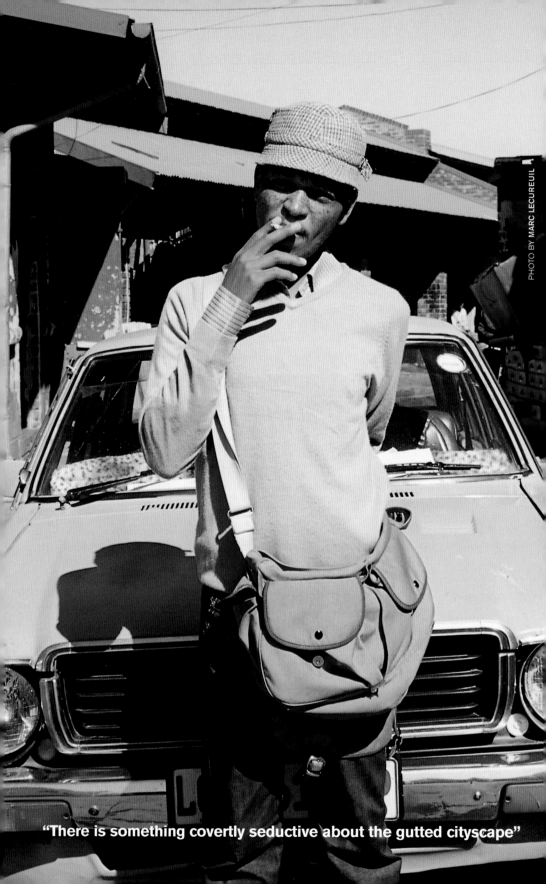

"There is something covertly seductive about the gutted cityscape"

JOHANNESBURG

BY **ANICEE GADDIS**

But the sentiment on the streets these days is less nostalgic than guarded. Eviscerated Art Deco buildings covered with Peter Stuyvesant cigarette ads loom up like tattered beatific beasts. A Vodacom cell phone billboard, featuring one of the top kwaito artists, Mandoza, surveys the ruins from above. Vans carrying convoys of workers and police patrols scrawl through the empty streets below. There is not much loitering—a throwback perhaps to the days when African people of color were not to be seen after dusk. Outside banks and business complexes, sharply dressed employees scurry from the safety of hired cars to the safety of lobbies with armed guards under a stark afternoon sun. I am reminded of an earlier conversation with our driver, Ketlego Seale, or Ket, a 30-year-old Sowetan, who has been carjacked ("with a gun to my head") on more than one occasion. "It's safer now," our guide Tshepo Nkosi, who is a member of the Johannesburg Development Agency, tells us. "It's safer because there are closed circuit cameras on satellite from the tallest building, the Carlton Centre." We are stopped at a "robot" (what Jozis call stoplights). A police van pulls up next to us and a stony-faced officer eyes our mixed crew. I look to Ket who seems both focused and dreamy, as if the watchfulness were

a kind of aphrodisiac. Indeed there is something covertly seductive about the gutted cityscape, with its recent past and unsketched future. But as the drive continues, the southern sun now illuminating the Anglo Gold and Mining Company high rise—a diamond-shaped tower that proves to be one of the flashiest on the horizon—the mood starts to shift. We pass an impromptu sidewalk market populated by street vendors and children. There is music coming from a car radio. The colorful backdrop—the yellow building façade, the motley reds, blues and purples of the vendors' clothing, the crisp blue of the Jozi sky—looks like a model for a still life. The feeling I mistook for imminent peril has more to do with acclimatization. On the next block we pass Gandhi Square, where the peacemaker himself kept offices. "He lived in South Africa for 20 years, 10 of them in Jozi," Tshepo tells us. It is well known that Gandhi was hugely influential on the young Mandela and his Youth League collaborators, he continues. The 1913 passive resistance campaign, in which Gandhi led a tumultuous procession of Indians crossing illegally from Natal to the Transvaal, became a model for the spirit of defiance and radicalism the Youth League would emulate during their own 1952 Defiance Campaign Against Unjust Laws. "We are setting up tours in the

footsteps of Gandhi and Mandela," Tshepo adds as an afterthought. Looking at the historical site now, an empty courtyard presided over by a turn of the century French colonial edifice, you wonder what its honoree would have made of the end of apartheid and the installation of closed circuit surveillance cameras. You wonder if he would have approved.

Tshepo continues to fill us in on the history of Jozi. Each city block contains its own story; a derelict museum, you think, alive with possibilities. Eleven official languages are spoken (including Afrikaans, Zulu, Xhosa, English), with at least one radio station catering exclusively to each; the city itself, entering its 110th year, was discovered for its gold and diamond reserves, some 300 years after the Dutch East India company settled Cape Town; Anglo Gold continues to hold a monopoly on the two markets.

The rest of South Africa's story is world history by now, or if it isn't it should be: the birth of the apartheid government in 1947; the Bantu Education Act of 1955, requiring a separate education system for Africans of color; the 1960 Sharpeville riots, protesting against passbooks; the formation of the South-Western Townships (Soweto) in 1963; the day in 1967 when a young Hector Pieterson was shot during a student demonstration against Afrikaans as the official language of instruction; the voice of Steven Biko and the "Black Consciousness Movement" in the 1970s, which in many ways crystallized the freedom struggle; the rise of the MK (Umkhonto we Sizwe), the armed wing of the African National Congress, symbolized by the "toyi toyi" freedom fighter song and dance, less than a decade later; apartheid's end in 1994 with the election of Mandela.

Taking all of this in, the violence and injustice of 50 years of apartheid rule, the residual polarization of black and white, leaves one with a disturbed conscience and a heavy heart. But seeing the young city for what it is, a spirit of optimism overpowers. The potential for Johannesburg to remake itself, to rise up again and rebuild, seems entirely possible. The question is will Jozi meet broader national and international expectations? Will it one day become the engine that conducts the African continent into the 21st century?

"A phoenix rising from the ashes," Tshepo intones, and there are solemn nods all around. The Johannesburg Development Agency is prepared to help change mass misperceptions of a country and city whose storehouse of culture has surprisingly not been depleted in spite of its unique and unusual history. The specific task of the JDA is to revive the inner-city post capital flight syndrome, during which most of the major corporations relocated to the safer suburban neighborhoods of Sandton and Rosebank. Already the nightlife is being reinvigorated at spaces like 115 Anderson Street, a former artists' loft; the popular Politburo weekly house party has also moved in. The Museum Africa, Market Theatre and Horror Café, as well as the culturally avant-garde French Institute, are thriving. There are still the old strongholds like Kapitan's Indian restaurant on Kort Street, founded in 1887 by Marjorie Kapitan, a native of Sao Paulo, Brazil. It was one of the first and only places for some time where blacks and whites could take a meal together; Mandela lunched at Kapitan's regularly and even had his own table.

As a break from the history lesson, Tshepo suggests a bit of shopping. The Oriental Market, a renown marche aux puces, is a lively spot selling everything from "fong kong" (rip-off label) clothing to medicinal herbs to used vinyl. There is a hustler's energy about the Market, but the overall vibe is that of a quaint hometown hangout. We browse through a rack of used leather coats set up on a sidewalk. Christine de Lassus, TRACE fashion director, is trying on a calf-length white leather gem. One of the men tending holds up his handpicked preferences like a doting clerk at a highend boutique. A decision is made. The price redefines bargain basement.

We return to Ket, who has kept the engine running. He is listening to one of his favorite Mandoza CDs. The sun is casting a golden light. At another robot, we pull up behind a truck with men squatting in the open bed. One of them seems to be recounting a story to the obvious amusement of his colleagues. He pauses, ruffles his hair, his profile a stark outline in the incandescence.

ORIGINALLY PUBLISHED IN TRACE #41, 2002

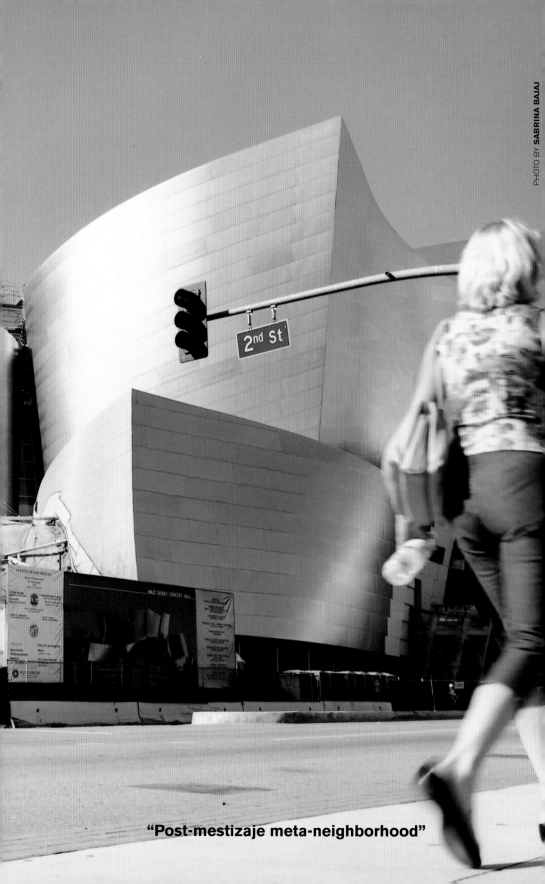

"Post-mestizaje meta-neighborhood"

LOS ANGELES

BY **STEPHEN GRECO**

Is the next Los Angeles already here?

"We are witnessing a transformation of the L.A. basin into the first continental multiracial, multiethnic metropolis in the U.S."
–Kevin McCarthy, Rand Corporation demographer, Wall Street Journal, January 15, 1985

Whether you live in Los Angeles or not, you might try visiting the next LA as soon as you can–the city as it will be known in the year 2020. It exists right now, in downtown LA. We've heard about the previous LA for decades: the little mission that grew into a vast city because of a railroad link, stolen water, waves of immigrants, the movie, and the automobile–the city that is both ecological disaster ("Blade Runner") and golden dream ("Father of the Bride", the Steve Martin version). That LA is part illusion, of course, reflecting the fears and hopes of the rich, unicultural, and largely self-referential enclaves of the city's west side–Hollywood and environs. Downtown was an illusion, too. It boasted a pueblo that was there since the beginning, but not all that influential, historically–in the middle of several nice, little,

sunny settlements that grew and grew, and spread inward, toward the center, in a kind of inverse of urban sprawl. Life always felt elsewhere, even after skyscrapers sprouted around Broadway and Seventh, and the Chandler Pavilion, the Taper Forum, MoCA and the other monuments of LA's pseudo-acropolis were erected on Bunker Hill. But downtown is where the next LA is materializing right now–a real LA. Neither dystopian nor utopian, it includes both the industrious, who lunch on salads in sunny, fountain-graced plazas between the skyscrapers, and the idle, who putz nearby on skateboards in the shadow of freeway on-ramps.

This LA reflects the promise of Simon Rodia's Watts Towers, located some distance away but radiant with a dream of urban transculturalism–that creative expression can lead social change. This LA reflects, but was not caused primarily by, wise civic plans, such as those to expand Metro service and to strip the banks of the Los Angeles River of the concrete straightjackets they have worn for 70 years. This LA doesn't so much supercede the vision of radical juxtaposition that theorists have neoned for decades–"a Neo-Aztec Mansard-Moderne

Moorish-Tudor-Revival car wash!"—as fulfill it. Enclaves have been neatly superceded by today's pueblo—people as demographics, market, audience.

The next LA is a post-mestizaje meta-neighborbood, an amalgam of communities defined by affinity and direction as much as by money and history, including those communities currently growing within a radial embrace of City Hall: the Asian, the Pacific, the Latino, the Black and the European. And you could see this LA both in the audience and onstage last June [2002], in the spectacular, multimedia, site-specific (and all-women!) production of King Lear, directed by Travis Preston and produced by CalArts at the Brewery, a former power plant just minutes from Union Station. The distinguished black actress Fran Bennett was Lear. The mix of human beings who came together in this cavernous space to rethink Shakespeare's elderly king felt excitingly like a new us. For in LA, as in New York and elsewhere, the arts are leading the development of urbanness—helping define what cities are, by determining what influences are attracted to and expressed by their citizens.

The California Institute of the Arts, the forty-year-old school based in Valencia, is one of several forward-thinking arts institutions now active downtown. Joining it there with new facilities, not far from Rafael Moneo's new, much-hyped cathedral and Frank Gehry's new, much-hyped Disney concert hall, are the Colburn School of the Performing Arts and SCI-Arc—the Southern California Institute of Architecture. It's CalArts that has the most glamorous project: REDCAT, the Roy and Edna Disney/CalArts Theater, a $20 million, 266-seat, state-of theater scheduled to open next year. Built right into the Disney concert hall complex (Walt having been one of the founders of CalArts), REDCAT is designed to present the kind of work that both reflects and drives cultural progress, worldwide: interdisciplinary creations that push us forward as forcefully as the Stravinsky-Nijinski Rite of Spring did the world of 1913. Until now, for lack of an appropriate theater, such as New York's Dance Theater Workshop and The Kitchen, LA hasn't

been able to see much of this work. "There had always been a clear perception that there is a gap in the Southern California cultural topography," says Mark Murphy, REDCAT's executive director. "We have opera, we have a symphony, but we didn't necessarily have a venue that was part of the international network of contemporary performance—which was a huge gap, considering what a major city Los Angeles is. I'm very excited about the possibility of bringing cutting-edge, international productions here, and of giving California artists a next step where they can find international audiences. That leads in general to a more sophisticated community." You might define "sophisticated" as anyone who cares about the next enough to shake apart outdated protocols and rituals. There are a lot more of us around now than when the Chandler Pavilion was built, which is possibly why Bunker Hill suddenly feels more like an earthquake—a big one—than an acropolis.

ORIGINALLY PUBLISHED IN TRACE #40, 2002

RANDOM ENERGY

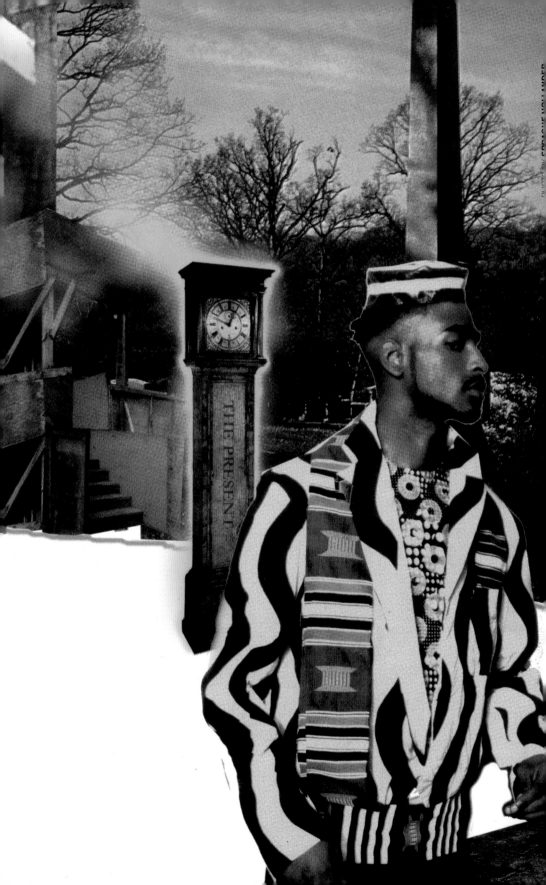

NEW ROLES FOR THE SPECTATOR

BY **CLAUDE GRUNITZKY**

These tongue-in-cheek images were produced at The Office as a sort of entry mode into the new, post 9-11 fantasy city. The Office is a multifaceted collective of ideas spearheaded by Donald Hearn, Sprague Hollander and Jason Farrer. The Office features monthly lectures—some call them "Townhalls"—on such varied topics as "Color Theory Now or Never," "Postmodernism Influx Or Outflux," "Pressing For Success" and "Real Estate Opportunities." These lectures, which are always very lively, have produced some invigorating discourse among some participants.

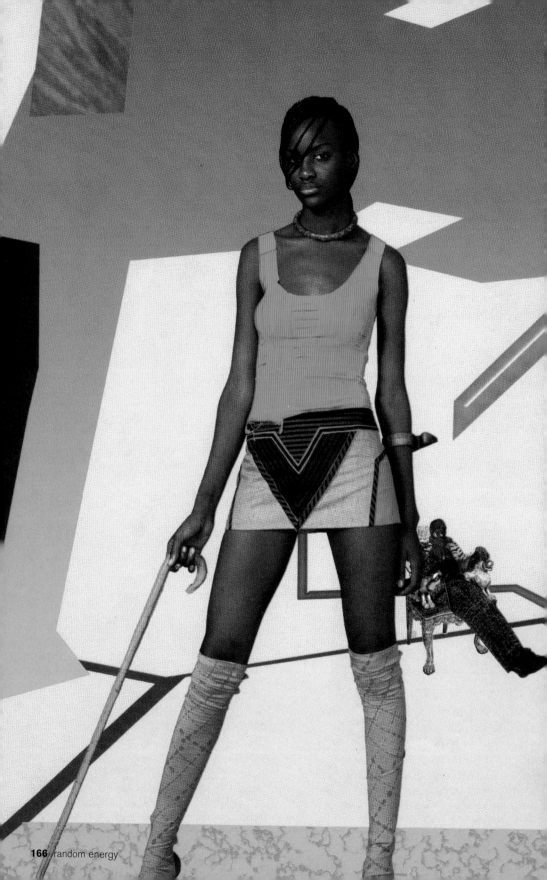

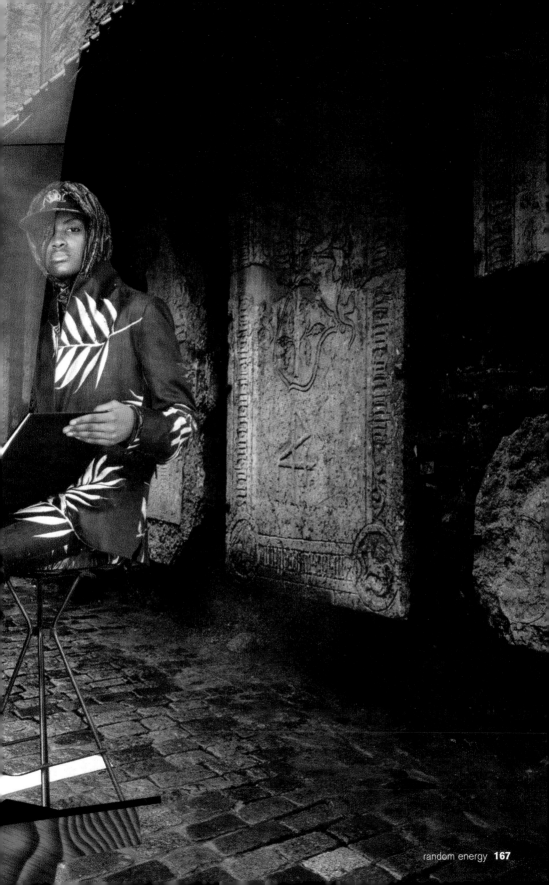

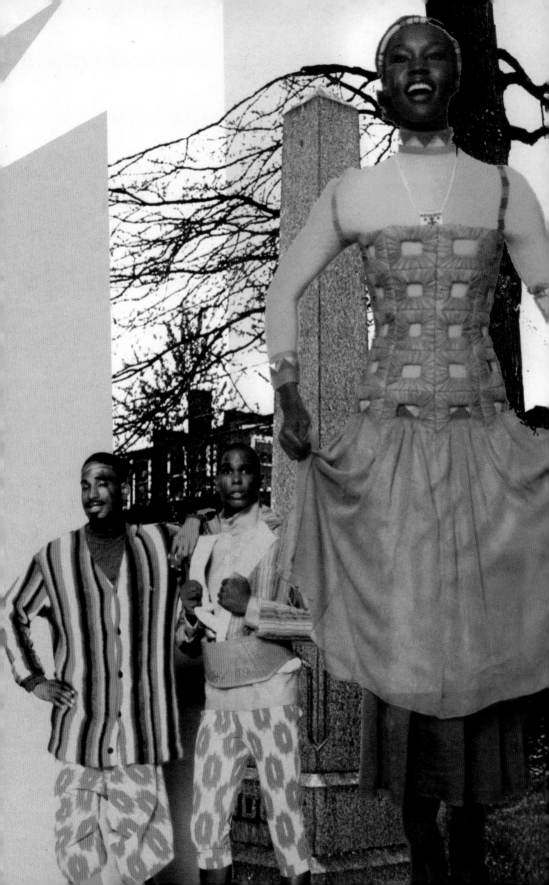

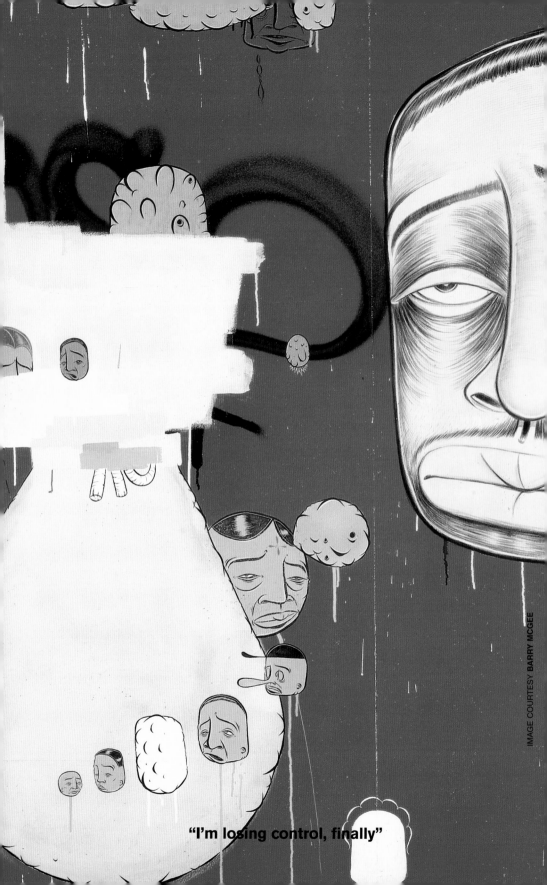

"I'm losing control, finally"

SPACE INVADERS

BY **ANICEE GADDIS** AND **CLAUDE GRUNITZKY**

BARRY MCGEE

Like a generation of writers before him, Twist (a.k.a. Barry McGee) started with a can of spray paint and a taste for late night street runs. Before long, the native San Franciscan was being mentioned alongside mythic scrawlers like Kaws and Espo, among others. But he discovered his true artistic voice through a character—the universal transient streetwalker, with sagging features and a burnt-out regard—and immediately set himself apart.

Much more than a tag, McGee landed on a kind of imagery that directly translated the ills of urban dystopia; his torso-less Depression-era faces and dripped, red-washed canvases address modern-day angst in a language that is completely relevant to the time. The combination of portraiture, coloring and compositional structure (objects such as cigars, neckties or bowling pins appear regularly) evokes a sublime beauty that is difficult to find in such ponderous themes. McGee's final message seems to be one of redemption.

His show at UCLA's prestigious Hammer Museum in the spring of 2000 proved to be a kind of real life reenactment of the proposed "Wild Style" scenario, where art-circle denizens were confronted with the power of street art in a gallery setting. Leaning in for closer inspection, viewers were warned against "disturbing the art"—life mimics fiction… the story continues.

TRACE: What first inspired you about graffiti?

Barry McGee: The ability to offend the public.

You've referred to your work as taking into account the "sensory overload" one experiences in an urban environment. Can you comment on this?

BM: I think I was talking about the bombardment of advertising and whatnot, telling us how we should look, act and feel.

Describe the progression of your can control, in terms of your early work compared to the work you are doing now.

BM: I'm losing control, finally.

Graffiti has always been associated in the public conscience with vandalism. Have you ever been arrested? Do you consider it an act of vandalism in some part against yourself when a piece of your street art gets taken down?

BM: Arrested, yes. No, not an act of vandalism taking it down, only putting it up can be the act. That is the charm of graffiti.

What is the next phase in terms of your art?

BM: Filling a ship with it and sinking it.

BRETT COOK-DIZNEY

Falling somewhere between street archeologist and cultural ethnographer, Brett Cook-Dizney makes animated art. Take one look at his multi-hued, mural-sized portraits of local neighborhood personalities and you get the impression the art is sentient—living, breathing entities, entirely comfortable in their spray-painted skin.

Cook-Dizney's art is about process. Before beginning a portrait, he spends time with his subject, making sketches, conducting interviews, snapping photographs. It is an almost scientific process, which traces back to the fact that he studied science and botany at the University of California at Berkeley. The resulting work conveys a warm, full-bodied feeling. As Cook-Dizney himself puts it: "It's like one soul talking to another."

Cook-Dizney's recent work, "Images of Hip Hop", featured at the Bronx Museum's "One Planet Under a Groove: Hip Hop & Contemporary Art Show", is complemented by autobiographical pieces like "Documentation of a White X-Mas" and "Documentation of Blackness", addressing issues of self-identity and cultural pluralism.

TRACE: You've referred to yourself (or have been referred to) as a "critical ethnographer." You keep notebooks, visual archives and draw from personal history to explore a larger universal history. Can you comment on this?

Brett Cook-Dizney: My work is a document of our existence in literal and figurative ways. I regularly visit different communities, and through qualitative research methods create reflections of the community I am in that are simultaneously parts of all of us. So all the time I try to listen, to recognize what is going on around us, to learn about who we really are.

In my notebooks, I try to document these experiences. Sometimes it is with writing, sometimes drawings. Other times it is with documents—a flyer from a club, a photo from a taqueria (a place where you buy Mexican food, with a particular connotation in California where they define the fast food culture. A burrito from a taqueria is to California what the pizza slice is to New York), a Noam Chomsky E-mail article, a leaf from a maple tree. As much as the leaf may be about my trip to the Northeastern United States, it can be about the degrees we all have lived or imagined the experience we feel in that leaf. Those feelings transcend the object, and transcend any specific community.

Describe the progression of your can control, in terms of your early work compared to the work you are doing now.

BCD: The first time anyone tries to spray paint, they are challenged to paint without drips. From trying not to have the paint drip, one realizes that there is a technique to applying the paint... there is a skill involved. Because graffiti is typically so linear—we outline letters, maybe fill them in, and outline them again—my early work was more about controlling the line.

But painting technically for me became more and more about color and tone. Even though I don't mix my colors, I recognized that the way the paint was applied, in terms of hues, values and layering, could create other energies. Mark making is what I call a vocabulary that extends the subtleties of spray painting's rules for application. My work has been an evolution through subtleties in spray paint's application, to now where each mark is vital to the entire painting itself, as well as what it does to the marks around it—ideally what each mark does to the entire painting.

Graffiti has always been associated in the public consciousness with vandalism. Have you ever been arrested? Do you consider it an act of vandalism in some part against yourself when a piece of your street art gets taken down?

BCD: The exaggeration in our consciousness of graff as destructive goes back to spray painting's origins in the barrios/ghettos of cities all over the world. In most urban locations, graffiti is just one of many urban symbols constructed to malign the places where tagging thrives—and more covertly malign the people that live in them. To a degree, we writers have accepted this deviant image, it is even in the language we use, "let's go bombing," "lets do a burner," like we are actually destroying the business we just painted on, but

we are not.

Just as a subway train is not destroyed by the painting on the side of it, the effect of my paintings are not destroyed by their removal or appropriation… the greater social change of the piece transcends the actual object. And regardless, I will make another one, better, the next time.

You adopted the last name of Dizney. What is the significance of this?

BCD: When I was growing up in San Diego, California, there was no graffiti culture like the global culture that exists now (this is before there was even a hip hop section at the record shop, much less seeing letter styles in print advertising or the side of a store). It was from hearing bits and pieces about graffiti in New York, and seeing the various Chicano gang writings not far from my neighborhood that I got inspired to spray paint the characters I had been drawing in sketchbooks, outside in the middle of the night. By the time I went to Berkeley for college, the culture of hip hop had exploded. Graff was alive in the more metropolitan Bay Area, and I flowed in parts of that culture. It was there that I got a tag, and started to tag. As I had already done a lot of pieces of characters by that time, and my childhood nickname was "mouse," someone said, "You should be Disney, like Walt Disney." I changed the "S" in a youthful attempt to be somehow original, and that became my graff' identity. I thought of changing it, as certainly it isn't the most creative or conceptually deep autograph, and politically I am against Disney and the values they continue to poison the world with. And I haven't changed anything legally. Nevertheless "Dizney" is a part of where I come from, an acknowledgement of my history and the identity of a spray painter.

DAVE KINSEY AND SHEPARD FAIREY

Few would argue against the notion that the essence of street art was born in the South Bronx circa 1970s. One of the original four pillars of what would become the temple of hip hop (including MCing, Breaking and DJing), the graffiti tag provided the wallpaper for the movement that experienced all the growing pains of a precocious urban youth, and yet left its indelible mark after only a few short decades. But historically speaking, graffiti can be traced back to the stone ages;

everything from hand-carved cave scrawl to Egyptian obelisks bearing hieroglyphic exposition to the ubiquitous "Kilroy Was Here" anti-propaganda tag of World War II falls under the umbrella of the ancient art of the tag. Despite its long history, much of graffiti has remained on the periphery of art theory and critique, thereby creating a genre unto itself, and basing its evolution on constant reinvention.

Dave Kinsey and Shepard Fairey weren't born in the South Bronx, and they weren't of age in the '70s to go street crawling. Growing up in the Northeast and South Carolina respectively, they started up their own style based on the influences of hip hop, skateboarding and punk-rock, and the more subliminal inspiration of gothic urban landscapes. Exposure to their counterparts and, in some cases, forerunners, arrived for both writers via roadtrips; in 1986, Kinsey spotted a Serg tag on a Pittsburgh freeway while visiting his father, and in 1989 Fairey glimpsed the NYC canvases coating the Cross Bronx Expressway and West Side Highway. They saw in the artwork a revolution they were determined to keep in motion and morph into something that reflected their own history.

The two followed the traditional rites of passage—battling in the streets, getting arrested, bombing their respective cityscapes with unabatable energy. In 1996, they set up the tag-team enterprise of Blk/Mrkt Inc., an independent artists-in-residence Los Angeles-based firm, where they began applying their art directly to the marketplace.

Urban gothic. Subliminal revolution. Call it what you will. Kinsey's post-millennial portraits give a kind of sublime resonance to Fairey's anti-indoctrination 1950s Soviet constructivist style posters (i.e. "André the Giant has a Posse"). Add to that the "Unlearn" and "Obey" stenciled mantras, and you've got a new level of consciousness in street art. Following are excerpts from a telephone conversation with Kinsey and Fairey.

TRACE: What first intrigued you about graffiti?

Dave Kinsey: I believe it was in the eighth grade, visiting my father in Pittsburgh for the summer, when I had my first experience. We were driving through downtown, and I looked up under

the freeway and there was this big Serg piece. I was totally astonished. I was like 'When did he do this? Why did he do this? How did he do this?' I never really thought of it again until a few years later, when my friend told me Serg got busted in Pittsburgh and slapped with a $100,000 fine. I thought that was so amazing that he got in the newspaper because of something he did in the street.

Shepard Fairey: I was going to the Rhode Island School of Design and I took a road trip to New York. I was driving on the West Side Highway and the Cross Bronx Expressway, and everything from 20 miles from the city on in was just crushed out with pieces, stickers, tags. There was stuff really high up on the walls, where people brought ladders or repelled down or walked on a ledge. It blew me away the extent that people would go to get their names out there. I was really inspired, but I thought I kind of wanted to do something besides just write my name. I had this weird notion from seeing "Beat Street" and things like that that you had to be born into graffiti. You couldn't be somebody from the South and go to New York and front on graffiti culture and be accepted. That's just not gonna happen.

When did you actually start writing?

DK: Back in Atlanta, I met up with Andy Howell. He was a pro-skateboarder and making a decent living at the time. He said, 'You know what, let's just go buy paint and try to get up.' I had always wanted to do graff but never knew the tricks. So we went and got a whole shopping cart full and went for it. Most people steal it, but Andy reluctantly covered the bill. From then on, I started bombing streets, clubs and restaurants using the tag X-Factor.

After a year of battling the true Atlanta graffiti guys in '92, like Sense, Jazz and Chase—who were all against me and Andy because they thought we were suburban white kids coming down to the city to do shit—I changed my tag to Büst after I got my can control down and some bombing experience. Those guys were hardcore writers since the early '80s… OG. ATL. But in Atlanta, me and Andy were on the next wave, doing stuff on a new level in the early '90s with characters. So they didn't really warm up to us so easily. From then on paying our dues would only

help me manifest my style and respect for other writers.

Eventually you both added wordplay—tags like Obey and Unlearn—to augment your imagery.

SF: The "André the Giant" stuff started out as comic relief. It's promoting a dead wrestler who is not threatening in any way, shape or form. But a lot of people were getting really bummed out on it because they were scared it was a cult.

I thought that's really funny, they're not threatened by a lot of this other advertising or manipulative propaganda, whether it's political or just about mass consumption, but they're getting freaked out by my thing. So I decided to do something that's pseudo political, but makes fun of people's obedience and still has a sense of humor. That's how I came up with the Obey thing in '95.

DK: I had this alias Büst on the street, which meant almost nothing to people. I was like, what do I see in my artwork that I can project out there and give some wordplay to to make a little bit of an easier connect? It just kind of hit me one day… Unlearn. I starting putting it out there and it started making more sense. It was the perfect tagline. Büst… Unlearn… that's my message… Reprogram.

What are your thoughts on the transformation of commercial brands into populist street art?

DK: It depends on how you're angling it. [Blk/Mrkt] is not doing stuff for K-Mart. We're doing stuff for big people who understand what we're about and kind of latch on. The whole reason me and Shepard started Blk/Mrkt is because we wanted to cater to our own style, but we wanted to be able to present it on a commercial level for people who could relate to it.

Just because it's being done on a commercial level, doesn't mean that there's no content behind it. Corporate America basically funds us artistically. That to me is the perfect blend.

SF: The basic philosophy is trying to deliver some sort of authenticity that doesn't insult the consumer. When people hire us they usually do it because they feel like they aren't connecting. One of the things we won't do is promote a product we think is substandard or misleading.

For example, we were gonna do some stuff for aluminum skateboards, and when we found out there was nothing any better about them than wooden skateboards, we refused. I think we share the opinion that in a capitalist society people are trying to sell stuff, and if we don't do it for them, someone else will. The best thing that can happen is that you make and market the coolest possible product.

As far as doing stuff for Pepsi and Mountain Dew, it's a soft drink, it's got sugar and caffeine in it. If you have a problem with it, don't buy it. But the cool thing about them is that they sponsor a lot of extreme sports events that up the prize money for sports that in their short histories haven't really had very much prize money. It's like these golfers don't do shit. How come skateboarders don't get paid as much? Part of it is that skateboarders are too cool to be endorsed by big companies.

What do you think about the fusion of graffiti and fashion?

SF: Graffiti in the fashion world is kind of big right now. Futura did some stuff for Levi's. Kaws has done some stuff for Diesel. In Japan, Bathing Ape is bigger than ever with the Pepsi campaign. People are saying Nigo is the next Warhol.

DK: I heard even Maharishi is doing stuff for graffiti artists now.

There is still a public perception of the graffiti artist as vandal.

SF: It always excites me to see people that are willing to take risks for their art. It's just so boring that somebody can put down a couple of grand, and get a billboard and make everybody look at it, when somebody else has to run from the police. It's a big contradiction.

When did you last go out and tag?

SF: I went out last weekend and did two billboards in LA. I put up eight foot paste-ups of mine. One was my re-illustration of George Orwell's Big Brother with the Andre (the Giant) star on the forehead. The other is a mixture of the Misfits theme skull with an original André face. It's kind of this weird punk-rock André morph.

Have you been arrested?

DK: I got arrested twice in Paris last year. One time, I had a small nug I was hauling back from Amsterdam. My friend told me not to bring any

back, and I got arrested for that. A week later, I was out bombing with Space Invader. I was on the side of a second floor building putting up stuff, and then these two guys roll up in this little beat ass car and start yelling at me in French.

They were trying to harass us, because they knew who Space Invader was. They were like, you've been arrested fifteen times, and now we're going to make an example of you for your friend. So they held us there for maybe five hours and when we were released, we went around the corner from the police station and started putting up more stuff to finish off the night.

SF: I've been arrested eight times. I think for me, I've just done so much that the law of averages… I've done over 200 illegal billboards, but I've never been arrested for one of those. It's always street level stuff where I can't get away.

DK: Like putting up a sticker.

SF: Yeah. The cops pull up or somebody writes down my license plate number.

Why do you do it?

SF: It makes me feel vital.

Do you think graffiti is still relevant as a language?

DK: Futura, Twist and Espo have pioneered graffiti in a way. They're saying, we're graffiti artists, but the bottom line of what we're doing is fine art. They're pushing the boundaries of graffiti by not saying, okay, put your shit in galleries and sell out. Those guys are like fuck that. Graffiti is one form of application, canvases is another, directing movies is another.

Twist had a show at the Hammer Museum in L.A. a year ago. You walk into this super legit gallery, and Twist had bombed the whole place. People were standing around in suits and when they got too close to the work, you were told 'please step away from the artwork'. I've been following his work for ten years now. I can't believe it took people that long to associate value in his work above and beyond graffiti.

SF: There are people who still think that if you're not from the ghetto you're not legit. Most of the writers we respect don't have that mentality. But that's part of the graffiti world– the competition. If you're rattled easily, you're not gonna make it. It's good and bad because it weeds out the people that aren't dedicated, but it also intimi-

dates the faint-hearted. I accept the whole thing, the yin and the yang.

ASH, JAY ONE AND SKKI OF BADBC

Here is a three-step guide to producing a BadBC painting. Step one: Walk down any street corner and collect random pieces of discarded cardboard. Step two: Staple and tape these random pieces together on the entire surface of a chosen wall. Step three: Add giant, stylized black letters in a subtle reference to the so-called graffiti style, and send out a message dubbed "Resist" to recall the September 11th events. Then again, "Resist" could be meant to insinuate the continuing resistance of those urban-bred painters who have managed to overcome the critical backlash that comes with being constantly relegated to the somewhat derogatory, all-purpose denomination of street artists.

The particular piece being referred to in this three-step program was unveiled for the first time at fashion designer agnes b.'s Galerie du Jour in Paris last October, and "Resist" can be said to be an adequate summary of the Bad Boy Crew's long road to acceptance in metropolitan art world circles. The Bad Boy Crew collective was formed by the hip hop-loving graffiti artists Ash, Jay One and Skki in 1983 Paris. From day one, the medium being the message, the BadBC opted for the following working tools as their preferred media: spray cans, bare walls, canvases, t-shirts, adhesives, billboards, video screens and even discarded cardboards. BadBC were immediately inspired by everyday fashion images and codes. Not to mention those omnipresent catchy slogans whether advertising or political. The BadBC were always firm believers in the informed viewer's ultimate discerning abilities.

Of course, in this newly crafted cause-and-effect configuration, improvisation was always key to achieving the sort of authenticity that early audiences craved. In a recent installation, at a Tokyo gallery in November, the BadBC collected various found objects and took them out of their initial, intended context. The end result? A cross between Pop Art and Modern Figurative interpretations that shows the BadBC style is in a constant state of flux. Now that the three founders have migrated away from Paris and their native

19th arrondissement, Ash in Copenhagen, Skki spends a lot of time in New York City, and Jay divides his time between Berlin and Paris, it appears that their newer work has less to do with the street perse, and everything to do with adapting to new situations, however physically challenging the creative process may have become. Ultimately, the objective critic could argue that BadBC are on a semi-spiritual mission to reveal the hidden face of cynicism, sexism and all-around stupidity. Had those attributes not become a part of our daily vernacular, the BadBC cause would have gone the way of so many failed manifestos.

TRACE: What is the BadBC concept?

BADBC: There is no specific concept, only a state of mind. Globally, we use all sorts of media to put forth our ideas and approach to life. These ideas keep evolving as we deal with life and go through situations that affect us directly or indirectly. It can be music, and the role music plays in our lives, or it can be financial worries, and how we choose to overcome some difficulties. The main thing is that we always strive to push the boundaries, and achieve more than we would normally be allowed to achieve, given our backgrounds and the socio-economic limitations that come with growing up where we grew up, in the working class. It's about transcending all clichés, and surpassing all expectations.

How do you work as a team?

BADBC: We all work individually on our projects, because we live in different countries now, and we believe that these new individual experiences add a great deal of wealth to the collective. Therefore, when we decide to collaborate on a common project, we exchange stories relating to our latest experiences, and this process always leads to debate. It's not always easy to work as a collective, but at the same time, it's so enriching.

Of course, over the years, we've managed to get to know each other well, and some reactions now just come automatically. It's a little bit like the painters of the old days; they'd meet regularly to exchange ideas and their individual work would evolve as a result of these meetings. We're actually really tough with each other, and the least we could say is that we are critical of each other's work, but it's constructive. That may be the rea-

son why our work may sometimes seem removed from the expectations of our core audience. This audience saw our work change over the years, from basic street creations to the new aesthetic we've developed, which emphasises the point by which visuals are not everything. There are so many images being projected onto our daily life screens nowadays, that artists have to be very careful with the way they use visuals to make a point. And in that respect, we believe it's crucial to leave enough room for spontaneity. There was this Russian filmmaker who said that artistic creation had to be an effortless, spontaneous, fluid process, and that therefore hard work should not be confused with talent.

What are your most recent works?

BADBC: We've just finished a series of exhibitions in Paris, New York and Tokyo. Even though these three shows had nothing in common with each other, we developed and executed one main idea on three different sites. The idea can be found in the execution, where in each site you could find the same types of materials, like cardboard, paper, adhesives, aerosol paint (but very little of it), permanent markers and a choice of sober colors, which essentially become a natural fit for our basic urban environments. The urban environment we're talking about here may not be what most people would think about upon mention of the word "urban".

That is, we're not talking about the concrete buildings or bricks or asphalt. We're not even talking about the harshness of city life, or violence. Rather, we're referring to the simplicity and spontaneity of urban life, the making-ends-meet-by-all-means mentality, the fragile existences many of us lead in the city, the way the world's homeless always find a way to protect themselves and build an inner resistance against aggression. Could it be because they end up becoming an integral part of the outdoor city life? Using cardboard, paper, found materials and various objects that hold no real monetary value. From Paris to Tokyo, we've managed to get closer to the automatic mannerisms of urban life. In Paris, it was at a group show held at agnes b.'s Galerie du Jour, and the theme was graffiti in Paris. Concerning our own work, we just wanted to suggest the essence of graffiti,

which is ephemeral by nature. We didn't want the audience to leave with the sole impression of the type of graffiti they see in the streets. That's one of the reasons we showed a black-and-white video, directed by Skki, dealing with the meaning of tags. It's about how aerosol signatures on certain city walls, or sharpie signatures on different surfaces, can be equated to patterns found in branches of certain trees, in a sort of still life comparison. If you film these still lives and magnify the images on the screen, the tags can end up like the still lives, and you can hardly distinguish between two images. The point we tried to make with that video was that the essence of graffiti could also be found in nature.

Now that we've been using aerosols less, we've had to adapt to new contexts. That attitude is a prerequisite to a balanced urban life, and lately we've had to adapt to new contexts. We've been feeling the need to get closer to nature and all things natural, to the analog, to basic human sensations and how we can master our imperfections and even our flaws.

ORIGINALLY PUBLISHED IN TRACE #36, 2002

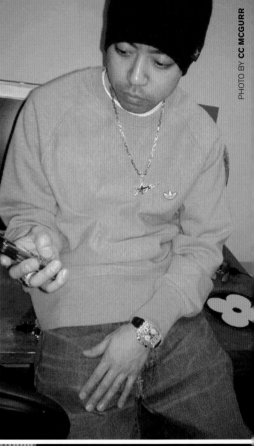

"A multiplex of fashion and cultural projects"

BATHING APE EMPIRE

BY **CC MCGURR**

Built upon the face of a monkey some eight years ago, grandmaster Nigo's hip Bathing Ape label has been defying social and economic gravity as it spiraled into a multiplex of fashion and cultural projects: the original tiny Busy Works boutique has turned into an empire. Prodigal and elusive, the young Nigo san's obsession for pop culture gave life to the label, creating a kind of ironic and iconic fashion force in Japan: the "Ape shall never kill Ape" motto infuses some socio-philosophical theory into the brand bathed in street flavor (lots of ape camouflage and references to the hip-hop culture), and characterized by quality material and love of detail. Exclusively sold in Japan (with the exception of a new store in London and a "by appointment only" boutique in Hong Kong), the hard-to-find brand sells limited quantities of goods in streamlined boutiques (designed by Katayama), and has generated a cult following for all things Bape. (Kids line up outside the stores just to get in.) Initially a tee-shirt line, it is now a full blown lifestyle expenditure: Nowhere Gallery, Bape Café, Bape Cuts, Ape Sounds, Bapy and Bape TV; future projects include a Bape Hotel as well as a New York outpost. Referred to as "the general" by his killer team, Nigo loves to collaborate with cutting-edge artists and musicians (Futura, James Lavelle, Jay Z...), and goes on insane shopping trips collecting toys and luxurious icons. We wish.

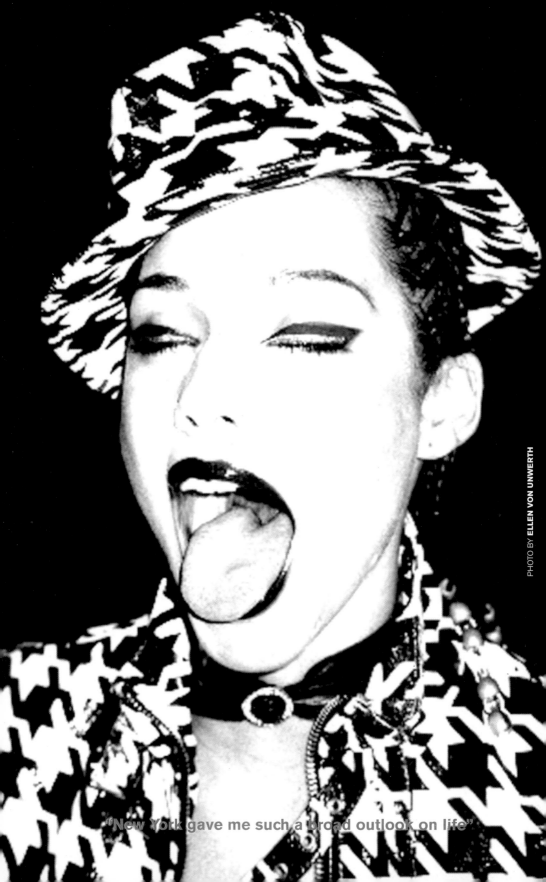

"New York gave me such a broad outlook on life"

ALICIA KEYS

BY **CLAUDE GRUNITZKY**

Either you're the sexiest girl on the block who works hard at perfecting the usage of god-given looks to further the time-tested fantasies of the loneliest round-the-way-homies, or you're the sexiest girl on the block who works even harder at finding newer, better, sweeter, harder ways of exploiting God's gift for the benefit of the collective advancement. If those God-given good looks happen to complement the gift of gab, then we readers and editors can quietly and collectively get that little bit closer to understanding why on that warm, hazy April night at the Bottom Line club in Manhattan's bohemian Greenwich Village, Alicia Keys rocked the house solo nuevo-retro style. There, she almost mistakenly but always instinctively, laid the foundation for a nonstop neo-soul celebration that somehow unexpectedly led to this current TRACE cover.

Alicia Keys is a dream come true, but before that she was just a dream. The kind of dream that only the lonely can dream in Technicolor. In all likelihood, the dream began when this New York City schoolgirl daughter of an actress mother first became a teenager. "For me, it started when I was around 12 or 13," Alicia Keys revealed to me at one of our interview sessions in New York City this past spring. "Me and one of my best friends, we were into the music thing. Her mother had a tape of Marvin Gaye's "What's Goin' On" album. That led me to Donny Hathaway, Nina Simone, and I remembered that my own mom had been playing Billie Holiday when I was very young, so I automatically gravitated toward this music."

"This music" is surely one of the most original emanations of soul music to hit our saturated airwaves this side of the millennial resolutions. This music offers an ultra-feminine take on the new power dynamics that are currently

redefining the big city dating game. Truth be told, this pre-millennial tension really surfaced way back in the late twentieth century, when D'Angelo set it off with the overlooked but now increasingly recognized masterpiece "Voodoo". Then, Def Soul's Musiq Soulchild and Interscope's even more gifted Philadelphia crooner Bilal dropped a couple of nice little jewels which were allowed to be developed into more than worthy debut albums. Now, in the new age double zeros, the feminine mystique has manifested itself in a triple whammy led by the Alicia Keys' double punch. At 20, Our J Records' cover star Keys may be the leader of this new school of soul, but hot on her heels is MCA's Philadelphia songbird Res (pronounced Reese) and Atlantic's Josephine Baker-idolizing chanteuse Lina.

Sunday April 22nd, a brownstone on 122nd Street in Harlem: the location for Alicia Keys' first video shoot is fast becoming the theater of a new kind of Harlem renaissance. For now, call it the theater of the mind. The day before, Alicia had chosen a women's penitentiary in upstate New York as the first background setting for her tough love/distant lover/broken dreams love-gone-wrong narrative that was being woven into the video for her current hit single "Fallin". Visiting one's lover in a state prison can in no way be imagined to be an easy story to portray, not even in a fictional emotional context. "The basic meaning of the prison scene," she would later tell me, "is to just portray the struggle of love, as a woman relating to that, relating to the eternal struggle. I would not allow this video to be anything other than real."

So by that Harlem Sunday, as she kept repeat-singing: "keep on fallin, iiiiin and out of love, with you, sometimes I looooove you" for director Chris Robinson at that living room grand piano, while cameras crews, stylists, makeup artists, hometown homies and plain ol' hangers-on watched her every movement and expression, it was not difficult to notice that Keys had already become a natural at giving the people exactly what they want.

"Give me seven seconds, one roll to the bit, please give me an extra two seconds! Everybody, if you're not with the crew, or J Records, I'm gonna have to kindly ask you to step out of this room! Action! Action!" "Keep on fallin, iiiiin, and out of love, with you, sometimes I looooove you." "Let's do it again! I want George to be there when she starts singing.

Also, tell her to keep her chin down. A-iight guys, you're ready? Everybody move on action."

And so the stylist, Patti Wilson (checking on Keys' choice of a tight-fitting D&G top and urban chic Pepe Jeans denim look), and the director of photography John Perez (checking on the overall mood in the darkish front room), verified a few more details before Keys launched into another chant of "keep on fallin, iiiiin and out of love, with you, sometimes I looooove you". By 2pm, this assorted community—which, incidentally, was growing bigger in size by the minute—still seemed delighted with the repeat performance as Keys continued to sing those few opening notes of her song for what seemed to be the hundredth time. The pace was instantly accelerated when one brave member of the crew shouted the words: "Lunch! One hour!" Down the road at the Pelham Fritz recreation center, the crew and the volunteers rushed to the temporary cafeteria, and I followed Keys to her trailer, where people (all seemingly close friends but none cuter than an eight-year-old special friend named Danielle) were coming to give blessings.

"I said to everyone to come on through,"said Keys. "It was nice to have people around, and I know it's genuine love. People ask if I'm tired. I say no, I'm wired. I feel like I have so many good people around me. When you're with the right team of people it just gels, and it comes together so nicely. I'm just feeling so blessed right now. I feel wonderful." By all accounts, Alicia Keys' ascent to the top has been— excuse the repeated analogy— the stuff that dreams are made of. After a fierce bidding war between most of the major labels in New York, which was sparked by the fact that she's been hard at work on her debut album since the age of 14. In fact, after her friend introduced her to that Marvin Gaye record. She signed to Arista Records in 1998. When Davis was forced out of Arista early last year, Keys followed him to his new company, J Records. Though she was accepted to Columbia University after graduating high school (early) at 16, Keys decided to focus on her music and she now credits "the many important people in my corner" for the exceptional year that 2001 has so far proven to be. Those people she names as being in her corner are her manager Jeff Robinson, her A&R Peter Edge ("He helped me to keep my essence true") and the irrepressible, super-connected svengali Thomas Martin, a sea-

soned J Records executive who has been devoting much of his time to ensuring that all the right moves are made, in the right order.

Keys finished recording her debut album, "Songs in A Minor", earlier this year, but the promotional blitz so far had been, even by Davis' hyperbolic standards, quite dizzying. First, or so it now seems from TRACE's rearview mirror, Davis introduced her to a packed Waldorf-Astoria ballroom on Valentine's Day. Keys sang "Fallin" and the following Friday, Mitchell Fink proclaimed in his Daily News column that Keys has "major star" written all over her. Then, Billboard magazine's 'New & Noteworthy' column compared her to Roberta Flack and Aretha Franklin, and went on to proclaim that she was a star waiting to happen. A little after that, MTV's Kurt Loder noticed her and insisted on a small special segment for her on "You heard it here first." Then, she made a big impression on Soul Train and soon after Rolling Stone magazine (who had caught her first performance at the Bottom Line) published a piece titled: "A star in born".

By the time the buzz became deafening— again in TRACE's rearview mirror, the precise date could be traced back to May 1st—the W hotel chain had invited her to give live renditions of her sensual piano act at some of the more select properties it owned across America. In Keys' own estimation, those W hotel performances were "phenomenal because I was completely getting my feet drenched, not even wet, drenched."

By the time you read this, most of you will have caught the video on MTV. Some of you will have seen Alicia Keys on the Today show, as well as on Oprah, but perhaps it helps to give a little genesis of the song "Fallin", which is the main cause of all this sudden attention. "Actually," Keys reveals, "'Fallin' was created at the end of 1998. It was one of those songs that when people heard it, they liked it. When we were coming back around toward singles, Jeff Robinson, Peter Edge and Ron Gillyard [the head of black music at J records] all suggested that we give it a shot at the different venues. We got an instant reaction, and we all figured, if it's working, it's working. For me, it is the ultimate single because it is just so me."

The remix version of "Fallin", which features labelmate Busta Rhymes on the mic and a lusciously re-recorded hook, is already on heavy rotation in hip hop clubs, thanks, no doubt, to leading DJs like Bobbito who have been pumping it nonstop to receptive audiences. But "Girlfriend", which was co-produced by Jermaine Dupri, and "Rock Wit U" (from the Shaft soundtrack), featuring Isaac Hayes, are set to become crowd favorites precisely because they showcase Keys' incredible versatility, and ability to draw on past references while updating her vocal range to please younger ears accustomed to the hard-edge beats of progressive hip hop. In fact, Alicia Keys' sensibilities are so wide-ranging that one can easily imagine a Lauryn Hill type crossover audience for the "Songs in A Minor" debut.

Most interviewers, this one included, cannot help but ask Keys about her relationship with Davis, the legendary record man who brought the world Carlos Santana and Janis Joplin, before creating the phenomenon called Whitney Houston. Along the way, Davis also nurtured the budding careers of L.A. Reid (the current head of Arista) and a young Sean Combs by agreeing to fund their upstart labels La Face and Bad Boy. Though this information is by now common knowledge in the music industry (and even to some extent the public at large after so many TV specials), the more curious journalists seem to be so fascinated by the Davis method of discovering stars, that Keys may have involuntarily benefited from the aroused curiosity of the many pundits who are watching Davis' every move to see whether he has retained that Midas touch.

"My management brought me to Clive Davis," Keys remembers. "He saw an early BET performance I did and he wanted to meet me immediately. He is such an incredible human. When I saw all those pictures of Earth Wind & Fire and Miles Davis in his office, I fully grasped his love of music. When he encouraged me to be my own artist, I knew we were on to something. There's not a lot of people who will encourage you to be who you're supposed to be, so I couldn't turn him down. What was so different with him was, when he asked 'How do you see yourself as an artist?'".

Alicia Keys grew up in Hell's Kitchen, Manhattan, before moving to Harlem, which, incidentally, is probably why on that particular Sunday she was so ecstatic that the video was being shot right in her old neighborhood. (She now resides in Queens, where she lays down tracks and records vocals right in her own home studio.) Keys has been in groups since she was nine years old, and that early exposure, which was heightened by the life-chang-

ing Marvin Gaye experience, finally ignited her passion for music. "New York is a great place to raise kids," she says, "because of the diversity. That gave me such a broad outlook on life. City life tends to be a little harsher because you grow up more quickly. I love the huge buildings, the streets are always lit, the floors are so hard with the concrete, and it's from that New York electricity, that New York excitement that I got my drive." New York, New York, big city of dreams. Alicia Keys, the world is yours.

ORIGINALLY PUBLISHED IN TRACE #32, 2001

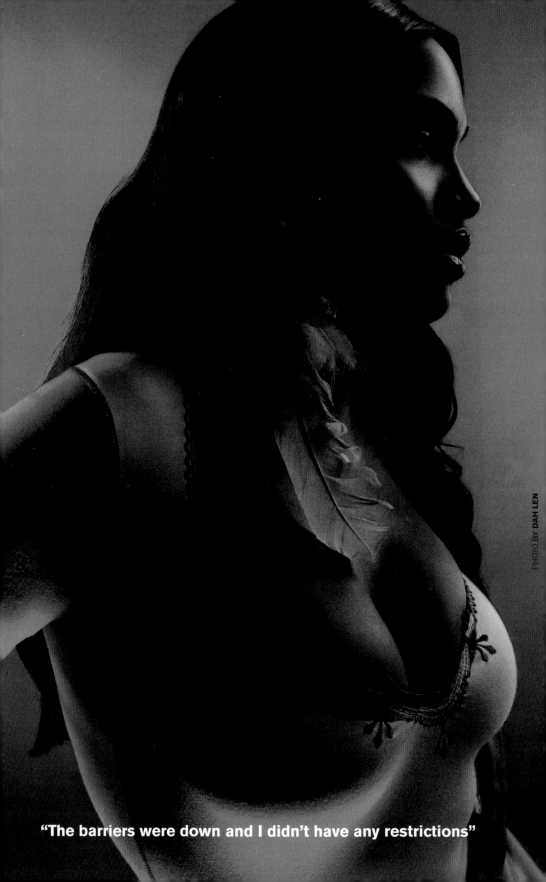

"The barriers were down and I didn't have any restrictions"

ROSARIO DAWSON

BY **CLAUDE GRUNITZKY**

A few Fridays before her 20th birthday, which this year fell on Mother's Day, Rosario Dawson walked into Mrkt, the hip new Belgian restaurant in Manhattan's meat packing district. Fashionably late, she was there to meet some TRACE staffers and one movie person who'd been pursuing her for the past few months. The purpose of the dinner was to get her acquainted with some of the people who possessed inside knowledge of the simple fact that Rosario is about to blow up big. Regardless, the cover pictures she had shot a month earlier were causing a bit of a stir in TRACE's New York headquarters. So it was time to plot the ascension. "You're amazing," I said to her, New York style. "I know, I'm an incredible person," she laughed, barely sifting through the attention.

At these types of dinners, past and future, relevant and not-so-relevant projects are mentioned in concurrent streams of interconnecting conversations, and as everyone gets gradually lost in the comfort of that smooth, ethylic feeling of elation, one tends to let emotions drift into the ease of friendly small talk. The movie person pitched her a story for an upcoming urban-vigilante feature called "Bundy", and she politely said she loved the script when she read it initially. We showed her the pictures and, staring, she said "My father will cry when he sees this. He'll go, 'That's my little baby!'" Then, we discussed her role alongside Valeria Golino in Tony Gerber's upcoming Merchant/Ivory vehicle "Side Streets", which she had promoted in Venice, and she casually mentioned her burning desire to work with the Spanish director

Pedro Almodovar.

So when, inevitably, I quizzed Dawson on the current wave of Latina actresses, Spanish-born Almodovar veteran Penelope Cruz's name was the only one she cared to mention, in a tone that could be deemed aspirational. As I'd suspected from other, Dawson-related conversatons I'd initiated with industry folk, nowhere in the drift was Jennifer Lopez's name mentioned, but more on that later. One thing that was discussed extensively was the future of film, and the void a sexy, young actress like Dawson would eventually fill in the ever-changing world of sexy, young actresses. Hollywood eats its young. That we know. So on the Hollywood treadmill, Rosario Dawson can currently be spotted at the root of the tortuous learning curve.

Last month, Spike Lee, who had cast Dawson as Ray Allen's girlfriend in the basketball flick "He Got Game", wrote an article for The New York Times' special summer blockbuster preview section, denouncing Hollywood's continuing dismissal of people of color. Because the studios have decided to confine black directors and actors to a certain type of film—essentially, the ghetto drive-by drama or the ghetto romantic comedy—Spike pointed out the need for a viable, alternative network devoted to producing films outside the so-called system. By employing more black and Hispanic talent to target these minority audiences, such a network, Spike felt, would broaden the base of films that are actually brought to the screen with minorities in mind.

A month before Spike's article was published, The Wall Street Journal had run a cover story devoted to Hollywood's changing financial landscape. Through a series of eye-opening, behind-the-scenes interviews, the report analyzed the diminishing power of producers, directors and actors who, collectively, have been forced to eat humble pie. Recent big budget fiascos have traumatized the powers-that-be beyond their well-documented scramble to defeat musical chairs. Things have gotten so bad for the major studios and the people that run them, it was stated, that even

established stars are fighting to justify their inflated fees. If Sharon Stone can't get her usual eight figures for a no-brainer like "Basic Instinct 2", then outsiders might legitimately wonder what obstacles some of the more ambitious up-and-comers will be faced with. Especially if they are women. And, even more so, if they are women of color.

Somehow, one gets the feeling that, once the dust settles, a Rachel Weisz, say, or a Catherine Zeta-Jones will be safe on the new Hollywood map. Safer than even an upwardly mobile, post "Beloved", post Vanity Fair cover Thandie Newton. The reason? Weisz is, like Emma Thompson, a well-bred, Cambridge-educated Brit who happens to be a (white) vixen. Zeta-Jones is also a sexy Brit who, because of her dark, moody look, can pass for an exotic Mexican bombshell on any silver screen.

Now consider this: the '90s explosion in urban cinema has produced three semi-bankable Latin starlets. First, Rosie Perez came in through Spike, and created the notion of a Latin leading lady before fading into the B category. Now, she is the 24-hour-woman. Then, Jennifer Lopez made a name for herself by dissing some well-known—and well-liked—actresses in a move that some might equate to calculated controversy. She then went "Out of Sight". Shortly after, Salma Hayek learned some English and capitalized on the new Hollywood need for some hot blood. Some might say that she stalled at the gates of Studio 54. What do these three actresses have in common? The answer is: tits. Or, in the case of Lopez, ass. The point is, Hollywood 2000 wants sex. And in our postmodern daze, sex has been conveniently reduced to tits-and-ass. When I interviewed a then 18-year-old Rosario Dawson one year ago for the June 1998 issue of TRACE, I openly questioned how the trades would respond to a young Latina actress who, even then, was, "to put it mildly, physically endowed with more than a fair share of feminine curves."

My guess was, the industry would find it easy to exploit her physical attributes, so as to

pigeonhole her just like they did Perez, Lopez and Hayek before her. How she would outwit a cash-strapped, racially-biased, openly sexist industry would be anybody's guess. A year later, I found myself again sitting across the table from this teenage actress and the film credits, which started rolling four years ago with a role in Larry Clark's "Kids", were starting to add up. Although Dawson recently shot the Miramax vehicle "Down to You", starring Julia Stiles, this latest conversation would be centered around her role as Stephanie Williams in Fox 2000's "Light It Up", which is slated for a September release.

Stephanie Williams is a serious student at a Chicago high school which is, quite simply, falling apart. Usher is also a student, the good boy who heads the basketball team, whose father was killed by police in an "accidental" shooting, and who wants to "get with" Stephanie. Fredro Starr (Onyx) is a thug student who antagonizes both Forrest Whittaker's cop and Vanessa Williams' negotiator. And Stephanie remains something of an enigma. A prissy, goody-two shoes moralist who wants to be a doctor when she gets older. Her attitude is, basically, 'Don't disturb me from my work.' But, then something happens, and things change for good at that school. Because it depicts a pre-Columbine world of cold classrooms, metal detectors and police officers walking in the school hallway, "Light it Up" will inevitably be hyped as an important social commentary, an insight into the mind of the troubled high school teens who have become America's worst nightmare.

"'Light It Up' was not supposed to be a fun movie," admits Dawson, "but [director] Craig Bolotin did succeed in making it chilly." Because the film was shot in freezing mid-winter Chicago, reports came back that a flu epidemic which affected much of the cast forced production to be halted for a whole week. "It was more difficult shooting in Chicago, away from everybody, and not in Coney Island, like when we did [Spike Lee's] 'He Got Game'. All my family lives there on Coney Island, but in Chicago I realized I didn't know who I was. The barriers were down, and I didn't have any

restrictions. After I got out of character, I could be anybody. It's very strange to feel like you have to express yourself. Strange to see that people have perceptions of you that are limited to the ABC you give them. In a sense, I learned that that's what acting is." That attitude, which expands on the teen's dilemma of having to cope with the pressure of becoming a young adult, explains the ease with which Dawson changed into some of the sexy clothing we chose for the deliberately pin-up-like pictures that accompany this article. Last year, she had told me that "I'm not the kind of girl who will gladly take her clothes off. I'm just turning into a woman, but people are already seeing me as a woman." And the picture reflected that.

So, about the lascivious poses that were required for this photo shoot, she explained the radical transformation. "I jump into character, like in a film. Rosario don't even wear makeup. It's my job. I know the difference. In the end, there's a common thread to everything I play, like I'm definitely not ['He Got Game''s] LaLa, but I'm also definitely LaLa. I wanted to be as honest about my roles as I can. So I put myself on the cover, like I put myself into LaLa's world, with her limited knowledge, knowing that she made these choices. I'm really aware of human beings, and that's what I play into with my characters. It's really about the experience of having met someone like your character. When I was taking classes at Lee Strasberg, it didn't work because they wanted me to tap into my experiences only, and not necessarily others'."

Rosario Dawson was born at 12:17pm on May 9th, 1979, in Coney Island Hospital. Her mother Isabelle remembers that Rosario's birth interrupted the soap "All My Children". For a couple of years, the young family lived among extended relatives in the Coney Island section of Brooklyn, before moving uptown and finally settling in a downtown "squat", on thirteenth street, the semi-permanent address the Dawsons now call home. Still, Isabelle being Puerto-Rican on her mother's side and Cuban on her father's side; and her husband being Irish and Native American, New York City,

though their adopted home, always carried with its frivolity a strange feeling of isolation, of living in what the novelist Salman Rushdie would have called Imaginary Homelands.

Because their family—which in its nuclear core also consists of Dawson's 15-year-old brother Clay—"has a lot of issues with the City," every few years, the Dawsons would make split-second decisions to escape the New York homeland. When Rosario was ten, they took off for San Francisco, and Rosario remembers that year as being "one of the best in my life. Everything came together, because we were once again very family-oriented. We used to go camping, and I remember the wilderness and all these great views of the Golden Gate Bridge. The only downside was school, because it was such a difficult transition. After the West Coast we had to move back to New York again."

When Dawson was 14, she was spotted around the corner from her house by a young screenwriter named Harmony Korine. Korine told her he was shooting a film called "Kids", and that Dawson was just the kind of young teenager the director was looking for. The story would allow her to express herself in a personal way, to put her personal emotions onto a film, so why not try acting? So she shot a few scenes for the film and, soon after, the family decided to take off again, this time for a vacation, a road trip that would take them all the way to a small Texas town called Garland, near Dallas. (Garland is now known to the world as teenager LeAnn Rimes' hometown.)

Dawson was 16 when "Kids" was released. Somehow, the film people managed to track her down in Garland. Inevitably, she moved back to New York, while her family ended up staying in Texas for four years. When "Kids" became an international hit, due in part to the controversial nature of the teenage sex themes it explored—some would say exploited—the press started paying attention to the individual actors' backgrounds. After that film, Chloé Sevigny truly became New York's "It Girl" for a few months, and her then-boyfriend Korine was now perceived as an authentic chronicler of downtown teenagers' late century delinquency. Because "Kids" turned Korine into the new Nan Goldin, "Kids" became a platform for all the beginners who were talked into participating in the experiment.

It's 1999, and there is a buzz on Rosario Dawson. In some New York circles, there are key people, such as this writer, who are silently rooting for this fresh face to live up to the promises that Jennifer Lopez never fulfilled. The Hollywood producer Daniel Bobker, who was introduced to Dawson last year, says "Rosario has the potential to be bigger than Jennifer Lopez. In a strong, sexy, urban, powerful way, she comes off as extremely passionate about what we call "The Story". She's got it. And that's why I'll be curious to see what happens with 'Light It Up', because it's a Babyface film. And everything Babyface does, like 'Soul Food', tends to do very well."

Elena Romero, an editor at the fashion trade publication DNR, met Dawson last year when the magazine decided to put her on the cover of a special issue. "Rosario was so great to work with. Everyone was into her. She knows exactly what she wants, and it's good to see a Latin sister who had such a strong sense of identity. Just don't mention the name Jennifer Lopez when she is around." The reason? Just as one can spot a positive, underdog's buzz on Dawson, many can detect a slight Lopez backlash brewing in these same key circles. And buzzes being known to spread concentrically from key circles, there is reason to believe that Lopez's monopoly on all things cool, sexy and Latin might have been shaken the minute Hot 97 added her wack new single to the playlist. It is also safe to further assume that the cool factor melted for Lopez when she allowed In Style magazine to follow her all the way to the gym for a (very pedestrian) cover pictorial. If Lopez is now comfortable with being the public's property, then the time is right for (someone like) Dawson to step up and step in as a worthy challenger.

Stakes is high. In this writer's case, the rooting can be traced back to the milk-fresh inno-

cence, apparent in Dawson's observations, which led her to elaborate on two significant first encounters. Exhibit One: Denzel Washington. "I never thought Denzel was that good looking, until I met him. He oozes charm and confidence. He makes you feel comfortable around him, and he's got this amazing laugh. I was looking forward to my Denzel scene in 'He Got Game', and it was so beautiful to see Denzel hunched over, and getting into character. There was great chemistry between him and Spike. Like, when you know that Spike pays everyone scale, except Denzel. It was so beautiful to witness Denzel becoming proud of his character. I just had to tap into that energy… and keep up with it."

Exhibit two: The Artist, who had asked her to collaborate on a re-recording of his single "1999". "The Artist is an amazing, talented, curious person. He's very comfortable to be around, extremely sweet and talkative. He's been writing about the coming of 2000 and the spiritual/religious ramifications of that arrival for a long time. He doesn't waste his energy frivolously on trying to sound intelligent because he knows he is and doesn't have to prove it. It's evident in his concerns, and in the brilliance of his music and lyrics. So, in essence, he seemed to me to have a very simple demeanor, which was totally unexpected and extremely appreciated."

All of which leads us to the inescapable, significant fact that, with Dawson, the conversation somehow always seems to flow back to her mother, and the options Isabelle allowed her blossoming daughter. Last year, Dawson had told me of her mom's dreams of becoming a singer. Of her mom's struggle to lose weight. Of her mom's struggle to raise a young woman, when she herself became a woman in a world of prostitution, drugs and single Puerto-Rican women. Lately, Dawson has been saying that she will be forever grateful to her mom for allowing her to be a kid. In short, for creating and providing her with that comfort zone where decisions can be thought out carefully. In Dawson's case, this new freedom has kept her from executing on gut reactions, arbitrarily and out of fear.

"At 15, it was my choice to do "Kids", because they [Harmony Korine and Larry Clark] approached me about documenting my growing up. They said it would be based on my yearbook." When I finally met the two women at an East Village health food store, the initial impression was one of great camaraderie—call it trust—between mother and daughter. So the Mother's Day birthday this year was significant in the rites of passage transition it represented. It was almost like, with the official end of her teenage years, her mom was finally setting Dawson free and giving her the keys to the adult world. All that on her first official day as an adult. The twentieth birthday. Mother's Day. "My mom says, someday, someone at a preview will be saying… 'Rosario Dawson is glowing in this film.' Almost like they'd say that about Juliette Lewis, or someone like that. My Mom is my guiding light."

Last year, Rosario Dawson was, not unlike Star Wars' Natalie Portman, hesitating between college and a budding career in film. This year, she recapped yesteryear's dilemma as "I should be in my third year of college now, as I'd always planned it since I was two. But things didn't turn out that way. I'm ambitious now, but in a film career way. That's the difference between now and the last time you interviewed me. I guess I just wasn't ready at the time." So what about going after Jennifer Lopez's hot seat? "I'm very motivated now, because I see the potential of someone like me in the business. And I don't see why it shouldn't be me."

ORIGINALLY PUBLISHED IN TRACE #23, 2000

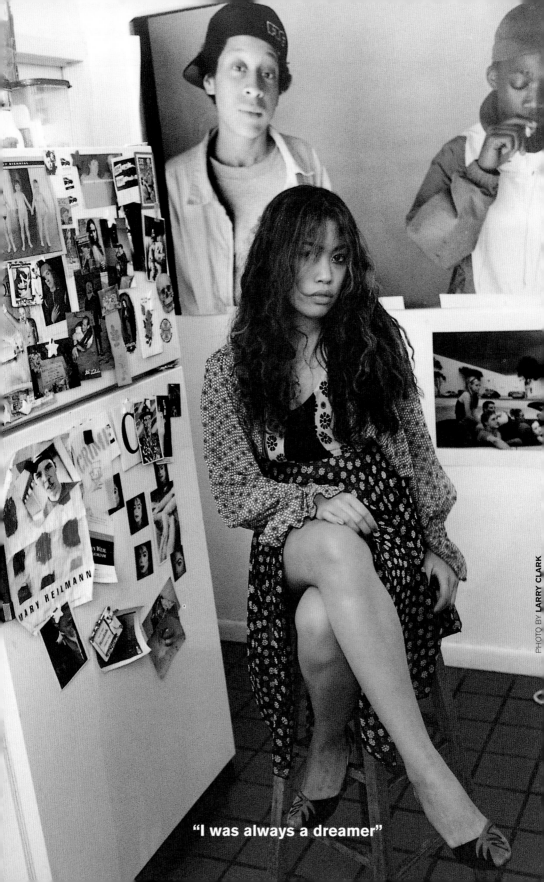

"I was always a dreamer"

PHOTO BY **LARRY CLARK**

TIFFANY LIMOS

BY **CLAUDE GRUNITZKY**

While the New American Nation continues to take pride in its somewhat therapeutic celebrity fixation, by now, it should be no secret that many American teens long for nothing more than to be discovered for their "talent" and become "stars." Hollywood and the various concentric circles around greater Los Angeles are populated with surgically enhanced, overtly lascivious wannabe actresses who make no secret of being down for whatever. The choices that keep leading some of these aspiring movie stars to endless open-call castings and dead-end rehearsals can usually be traced to the Nation's enduring obsession with celebrity, which in turn is fuelled by the youth-celebrating media circus. To protect the myth and allure of celebrity, most pundits never seem to talk about the back-street excursions that force

the majority of aspiring actresses into abandoning their Big American Dream. That is because nobody wants to read about failure or compromise. No one wants to know about the failed actresses who end up as waitresses or trophy wives. Or the ones who choose to turn tricks on Sunset Boulevard or in the porn studios of the San Fernando Valley.

In 1995, certain perceptions of sex, celebrity and stardom were forever altered with the release of the independent feature film "Kids". "Kids", which documented the reckless sexual lifestyles of certain New York City teenagers, was also a breakthrough moment for the then 52-year-old photographer-turned-director Larry Clark. The film resonated with audiences worldwide because the intimate, cinema-verité dia-

logues and interactions provided a rare—and accurate—glimpse into a new kind of youth culture. The fact that Larry Clark had been photographing other types of decadent, underground youths for years, from his hometown in Tulsa, Oklahoma, to early eighties 42nd Street in Manhattan, was lost on the hordes of young fans who saw in his storytelling a new, honest voice that could possibly lead to social dialogue. I know of one teen who brought her mother along to see "Kids", because she saw in the film an opportunity to initiate a difficult conversation about sexuality and morality. When one considers that the inevitable controversy which surrounded "Kids" served as a global launchpad for the film's screenwriter Harmony Korine (now a director in his own right) as well as for the then unknown actresses Rosario Dawson (now a co-star of "Men In Black II" and "The Adventures of Pluto Nash") and the ever stylish Chloé Sevigny (of "Boys Don't Cry" fame) one can understand why Clark's every move ends up being dissected and scrutinized by Hollywood talent scouts and New York City trend-spotters. "Bully", a 2000 release which may be his most accomplished film, was Clark's last foray into the twisted world of disoriented suburban teens. Set in small town Florida, amidst trash-talking, hip hop-blasting scenes of verbal violence and violent intercourse lost in all-too-real scenarios of love, lust and discontent, the film revolved around an ill-conceived assassination plot, and revealed yet another talented young female actress, the rock and roll daughter Bijou Phillips. This fall, fans had better prepare themselves for another moment of controversy and debate, because Larry Clark's new film "Ken Park" is, not unlike the young French director Gaspar Noe's controversial debut feature "Irreversible", just way too shocking for the moral majority. As with "Irreversible", I suspect that many people will walk out of theaters a few minutes into the screening. Clark's many foes and critics, led by Lynne Cheney, the very vocal wife of the Vice-President, will have a field day. Get ready for a sparring match, because judging from my conversations with him over the last few months, Larry Clark, for one, seems prepared for the frenzy, as well as an inevitable backlash which could, quite possibly, lead to his Hollywood ostracism. Says

Clark, "I am just relaxing and enjoying my time because when that shit-storm happens, all hell is going to break loose!"

Ken Park is the story of four very dysfunctional families living in Visalia, a small California town where weird things seem to happen sequentially without anyone wanting to discuss them. In the film's first scene, a young skater, who is later revealed to be called Ken Park, rides his board to a moment of complete elation before pulling out a gun and blowing his own brains out in a surreal moment of catharsis. As far as suicides go, this one is quite unexpected, and the film goes on to reveal a very dark side of America, through some very believable acts of incest, violence and confrontation. The film features a young ensemble of first-time actors—Stephen Jasso, Mike Apauletegui, James Bullard, and James Ransone—who are so convincing in their roles that some scenes seem take on a documentary feel. I saw the film on a rainy New York night in May of 2002, and all I can really remember is walking away in a total daze, but with a clear view that "Ken Park" could possibly be about betrayal and the path to redemption. With the benefit of hindsight, I can now see that "Ken Park" is nothing less than an extremely eloquent statement on the secrets, lies and tragedies that continue to destroy the fabric of American families. In these tragedies, a new generation's sense of confidence is being undermined. "Ken Park" may not be Clark's best film, but it is certainly his most relevant one, and post 9-11-02, it could prove to be his most poignant declaration of love in a time of war, in the same way that "Kids" could be seen as having been about love lost in a time of AIDS.

The Visalia, California world of "Ken Park" is very far from the Hollywood dream machine of fame-seeking aspiring actresses. Audiences will walk out with a strong impression of an innocent character called Peaches De La Cruz. Peaches is a quietly perverted ingénue, a warm and loving daughter who looks as if she has just stepped out of a late 19th Century Gauguin painting. Peaches has a very special relationship with her father, as well as with some other boys in Visalia, and as you see her coming of age, you can experience the pain and hope that comes with being a first generation American. Peaches is portrayed by the

young actress Tiffany Limos, who also happens to be Larry Clark's on again/off again girlfriend in real life.

Three years before she met Larry, and way before Justin Pierce, one of the stars of "Kids" and a good friend of Tiffany's killed himself, Tiffany had noticed a poster photograph of Larry's that was strikingly similar to a photo she herself had taken when she was a kid. The photograph depicted two guys screwing a girl, but Tiffany didn't like the fact that the girl was high. Tiffany had seen Larry around, and they even used to work out at The same gym, but she did not realize he was the author of that photograph. One day, she decided to leave work early and go search for that poster at the art bookstore Printed Matter. When she got to the bookstore, coincidentally, Larry Clark was having an exhibition there, and signing posters in the back. She just went up to him and said "Hi I'm Tiffany, and I'm looking for this poster." They talked a bit, and she thought he was really handsome, and very smart. Still, she didn't really think anything much of the encounter and she left, but then she kept running into him in the street. One day, he invited her to see "Julian Donkey Boy", Harmony Korine's debut movie, and they connected on ideas, but that first date was not without its hiccups.

"He liked the way I think," says Tiffany. "I think what made Larry like me so much was that I told him the truth. I told him that he was sexist and I told him his work sucked, because in 'Kids' the girls keep talking about sucking dick. Why don't the guys ever talk about eating a girl out? I was 19, and Larry was like 'Huh?' No one had ever said anything like that to him before, and I was like "Have you ever thought about that before? Have you ever even eaten a girl out?' Soon after, Larry cast Tiffany as the very sexy but evil Judith in the HBO movie "Teenage Caveman", where she played a vamp alongside the actress/designer Tara Subkoff. The script for "Ken Park", which Larry wrote way before "Kids", had been sitting around for ten years. Having seen the Peaches character in her, he finally showed it to Tiffany and she thought he was so full of shit, because the girl didn't have anything much to say, and "the original plot revolved around this Hispanic/Filipino family that was so racist." Still, he insisted, using

the argument that the other actresses were too Hollywood, or too old, and that he needed someone youthful looking, who understood that 16-year-old character and could bring her to life. Tiffany's first acting role had been Mother Mary in the school Nativity, a part she landed in the second grade at her Catholic elementary school after the other eight year old kids and teachers voted for her. Then, her father bought her a video camera and she used to use it to make her own movies and videos, with her reluctant younger sister Joy as her muse. "Joy did not want to be in my movies," Tiffany says. "She just wanted to drink her Hi-C and watch cartoons. In the fourth grade I became the class writer, producer, and director for the plays. I loved every moment of it. I didn't mind that the other kids were my actors and had it easy, which was what I thought back then. I loved directing them and having total control." When I spoke to Joy, who still lives with their mother in Mesquite Texas, which is a few miles outside of Dallas, the younger sister and erstwhile home video actress said "Tiffany and I are just total opposites."

Tiffany's mother, a softly-spoken former nurse who left her native Philippines for a new life in America in the '70s, told me that when she was only three years old, Tiffany used to walk up to total strangers in restaurants and give them her hand, saying "I am Tiffany, what is your name?" Sure enough, when she was 12, Tiffany, by then a regular at the Jeff Phillips skate park in Dallas, was discovered by a model scout, and she started shooting for the JC Penney's catalogue. At 14, she moved to her uncle's in San Francisco, because most of the skaters she'd met in Dallas lived there, and then a few months later she went on to New York to visit her Godmother in Jackson Heights, Queens. "Then I got to New York, I couldn't believe how dope it was. Growing up in Texas with all that racism, it was interesting to come to a place where you could be gay, straight, black or white, and still be accepted. I could sense that you could become famous and rich in New York without even going to college. I always knew that I had drive and ambition, so I realized that this was the place for me. There was no turning back, and I was ready to do anything to stay in New York."

She begged and begged her parents, and they accepted that she stay in New York with her Godmother. While she continued skateboarding, and made her first appearance in this magazine as a young skater, she got a job assisting a fashion photography producer called Mutale, because she'd gained weight and realized the modeling thing was not for her. She lived in London, worked in restaurants, and at the trendy style magazine Visionaire. Tiffany basically built her now very impressive rolodex, in between appearing on MTV and BET in videos for Lauryn Hill ("Doo Wop"), TLC, and Brandy because of her incredible gregarious nature. She even developed such a solid friendshiop with the late singer Aaliyah that her friends thought she should get with the singer's brother Rashad, marry him, have babies, and live happily ever after. Now, she has lunch with Harvey Weinstein and Jack Nicholson, and she is friends with a supercool fashion set that includes the designers Hedi Slimane and Matthew Williamson, the painter Cecily Brown, the models Sophie Dahl, Karen Olsen and Devon Aoki, the fashion photographer Mario Sorrenti and the actress Rachel Weisz. Tiffany Limos knows everyone, and when she appeared on the front page of the New York Observer newspaper last July, under a headline that read "A Naked Star Is Born", it was clear that she had arrived. Now, she is being featured in British Vogue, Interview and the Face magazines, and "Ken Park" has just been officially selected for the Venice Film Festival, as well as the Toronto and Telluride ones. Another classic New York success story, you could call it. I just call it determination, and the confidence in the old cliché that New York is still the place where dreams can come true. "I did everything, I hustled! You want to talk about a girl who is a hustler? Tiffany Limos is a hustler."

Family

My father was the one to push me to be in the movies. Larry wanted me to do a cameo in "Bully" but I didn't want to. My father told me that I was crazy. My best friend Kathleen said that I should do it. My mother was the one to push me into finishing school and getting straight As. My grade point average is a 4.0. My father wants me

to make it, as he says, "Big" in Hollywood. My mother doesn't like the fact that my body of work, as of right now, is controversial. That is including the photographs of myself, the magazines that I am in, and movies. Not to mention whom I date. My mother always wanted me to finish school and become a doctor. I always knew different, I always knew that I was going to be in the entertainment business. I feel that you have one life to live and no one is going to suffer the repercussions but you, and you can't listen to what other people say because you can't have regrets in life, and it doesn't matter what other people say because they're not living your life, otherwise I wouldn't have gone out with Larry. People would have said he's old and you're young. You know, my adopted sister and her husband —he's 27, and she's 21. They bitched and bitched to me about how when I have kids that Larry is going to die, but guess who died, her, she died in December last year. You can't predict who's going to stay alive or what's going to happen to the world. All you need to worry about is your life, and stop worrying about other people's lives. My adopted sister, she has two kids now that don't have a mother, all the while they were trying to talk me into not being with someone older. I never thought I would fall in love with him, I never knew I would be in this movie.

Ethnicity

It is nice to have Jennifer Lopez and Beyonce Knowles star in commercial movies. It's great just to be in a world where there are more diverse people represented in the media. There isn't an actress at the moment who has my distinct Polynesian features and who is at the same time American, from Mesquite, Texas of all places. Even though there is only myself at the moment, this is a giant leap in the film industry, when you have Latinas with white complexions and African-Americans with white complexions working. You know, I heard someone say this really racist comment and it pissed me off. It was an ex-boyfriend of mine, he said, 'You know the only reason Jennifer Lopez is so popular is because all those Mexicans in Texas and California, and the Puerto Rican and Dominican people in New York and the Cubans in Florida are buying her CD.' I said

'What? Well whatever, man.' Obviously there is a market for her and they like her so what, obviously they can relate to her. They might as well have a role model. I thought it was the most racist comment. I didn't know what he was trying to say. There is definitely a new definition of America, and that's why Jennifer Lopez, Salma Hayek, Michelle Rodriguez and my friend Rosario Dawson are doing so well right now. We are a new breed of people, we were born in America, and that's what mainly my script is about this American dream. Jennifer Lopez always refers to the American dream. It's harder for us because we have to live up to the Filipino communities, we have to live up to the American communities. You know, we're not Filipino enough, we're not American enough, we're not Spanish enough. She is the symbol of an American dream. You can be American and you can believe in your heritage and make it, from nothing. That's exactly the bottom line, and that's exactly where I'm coming from. My mom didn't want to help me at all. I am making it, because I hustled my way.

Stardom

I was in Venice, Italy, last year at the end of August. I had a lot of fun with Brad Renfro and Nick Stahl. I like hanging out with those two because we are all country bumpkins. Brad is from Tennessee and Nick is also from Texas. We went to see movies and hang out. Larry and I went to eat lunch with Martin Scorsese, and the view of where we were eating was amazing! I met so many interesting people there. It was quite an experience. I Also went to the Venice Biennale and I felt so honored to have the experience of seeing everything in the art show. It was so huge! Rachel Miner and I rode on a boat but since she was sick, she stayed to herself.

9/11

I went to Texas on the 9th of September for a family reunion. The following Tuesday, I was watching Good Morning America and the twin towers were on the TV. And they kept saying that there was a bomb explosion, but then that whole chaotic scene with the planes and the people kept repeating. I was in bed for two weeks straight. I was so saddened by that. Everyone at

that time felt helpless. I knew people there and that was just a horrific experience. Then Kathleen passed away eight days before Christmas. I couldn't believe it. I started crying for all of those people lost. I knew some people that worked there and that building falling was just unbelievable. It hardened my heart to see people jumping out of the windows. I was just beside myself. During this year's fourth of July, I went to see the Fireworks on a friend's rooftop. There was a special song set aside for the victims of 9/11 and they had beams of lights where the buildings once stood. Everyone was silent and tearful. It always brings me to tears when I think about them. It is always going to be overwhelming in my mind. I always say a little prayer for them.

Larry

You could say that I am Larry's muse or protege. Larry is an icon, a photographer, filmmaker, a well respected artist. Larry is the most underrated artist of his generation, a legend in his time. Larry is what you would call Rembrandt or Michelangelo in their time, a Master. Larry doesn't compromise for money. He turns down money and would rather be broke than to do work that he doesn't feel. People steal Larry's ideas and claim them as their own. I'll see Larry's influence in movies and photos but then there is Nan Goldin and Bruce Weber, who have acknowledged that without Larry's influence, their work wouldn't exist. You have to give them credit for humble enough to admit that! It is easy to pick at the obvious. Larry isn't obsessed; he missed out on his childhood and most of his work is about relating to the boy or being the boy, through the eyes of the boy, not wanting to hook up with the boy. Most people don't understand that about Larry. It's lame how people don't try and understand. Larry also feels that he doesn't have to explain himself to people. I respect that. People ask me, "Why does Larry make movies about young people and kids?" I wish that they would ask him, first of all. I think that there are many directors out there that are making movies about teenagers, but their ideas of teenagers are all sugar-coated. Larry isn't the only person making movies about teenagers. What about all of those teen movies that come

out every summer? I will always have infinite love for Larry.

Memories

When I was five years-old, my father took me to the bowling rink and I would bowl with all of the little boys. I wanted a little trophy of my own. My father had a whole case full. I felt like I was in the shadow of my father and I wanted to prove to him that I could be as great as he was. My father was so cool, I was competing against ten boys and my dad would just cheer me on! I remember that I had auburn Osh Gosh B-Gosh overalls without a shirt, blue Adidas, and my hair was to my knees and it was in a pony tail. I won a little trophy and the other little boys were sad. My father taught me at a young age that I could become anything that I wanted to be and that being a girl wasn't going to stop me. My father also taught me karate (he is a black belt); he taught me how to play football, gambling and he also taught me about guns. He was a character. I always used to be scared to compete against boys but my father would tell me that I could do it. Then I wouldn't feel so bad. I thought that he wouldn't steer me in the wrong direction.

Inspiration

The most inspiring words came from my sister and best friend, Kathleen Lauder. Last summer, I was hopeless and suffering from a bout of depression. I just wanted to quit the business and I was sick of the people around me. I was truly unhappy with my life. I asked her what she thought I should do and I was dreading her answer because she was never good at giving advice in situations like that. She happened to say something magical. She told me that I should just DREAM. I was on the other line of the phone and I was speechless. Why didn't I think of that? I asked her what she meant by that and she said, "Well, imagine what you want to do, dream about it, and make it happen." I told her that I had a dream in my head and that it was never going to come true and she said that I should still dream even though it seems impossible now, I can make it happen. My whole life I was always a dreamer and I made things happen but when I was weak, I totally forgot about that

and she made me remember. I take her words to heart because shortly after she told me that, she passed away at the age of 21. So every time I feel like giving up, I just dream. That is what motivates me to live and move on.

Patriotism

I love being an American! I love America. I was born here! I have a dislike for Americans who take America for granted. They should see how other countries are doing, especially the Third World countries. We are lucky to have the freedom to be whomever we want to be and to do anything we want to do. I have a dislike for immigrants or foreigners who come here and talk down about America, while they are living here and earning American dollars. That doesn't make sense. They come here to reap the benefits and freedom and then they put Americans down! They should go back to where they came from. America isn't all about fat people, bad music, casual style, and all the stereotypes that come along with America and Americans. You have the freedom here to like or dislike anything!

Dreams

Having my own company or companies. Acting. Writing. Producing. I want to own a house in California and own a nice place in Manhattan. I will probably inherit my parents' house in Texas. It must be so nice to own something. I do not own anything at all, so I want to be secure enough to own everything I have. Still, right now it is hard to have a relationship because I travel so much. I try to get away to Texas as much as possible to see my family. I always try to make time for my sister Joy. We have a lot of fun together. I think that my next venture will be going to California. I have many cousins there, and they live all over California. [The "Kids" actor/skater] Harold Hunter and I are going to go back to Visalia, California to visit our friends from the set.

ORIGINALLY PUBLISHED IN TRACE #39, 2002

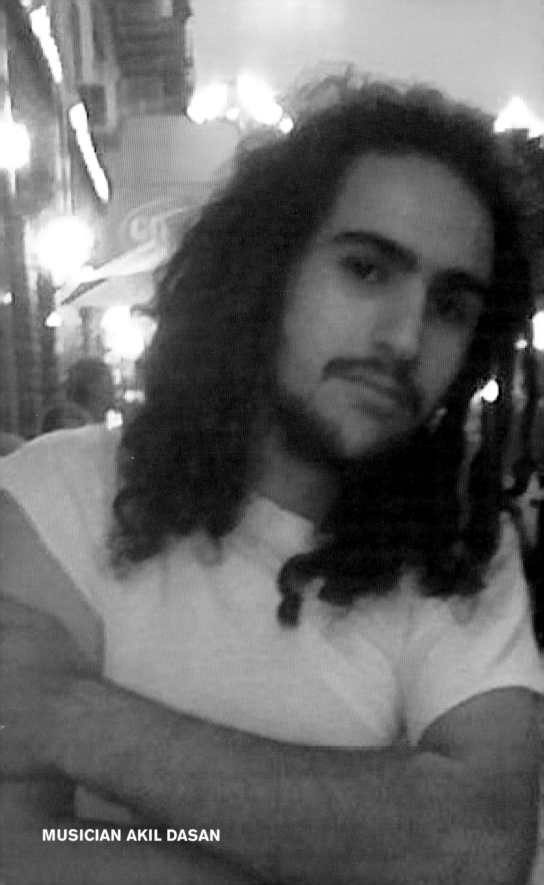
MUSICIAN AKIL DASAN

"RACE DOES NOT EXIST"

Now, my pop, a stocky and tan mulatto with glasses, grew up in the Bronx, but my mother grew up in Queens, raised in a small Jewish family that never went to synagogue or kept kosher. So I guess that makes me a Black Jew, even though my fair complexion can hardly be considered black, and my lack of religious practice alienates me from many in the Jewish community. To top everything off, my Arabic name, which is just a coincidence, further confuses those that attempt to place me in some sort of concrete cultural or racial category. As for myself, I identify with both African-American and Jewish culture while simultaneously transcending them, or in other words, I hold a transcultural perspective.

I grew up in a predominantly African-American neighborhood in Philadelphia called Germantown. I always thought it was funny that I never met one German person when I lived there. It was a nice place to live, my parents took out a loan and bought our two story row-home for around $13,000, and even with the occasional break-ins, my sister and I felt right at home selling lemonade from our stoop and playing with all the kids up and down the block.

While my parents did an excellent job of reminding us of our cultural legacies, frankly discussing slavery, the holocaust, the civil rights movement, sexism, racism and anti-Semitism, my first major confrontation with my personal identity occurred when I was at summer camp one year. I remember getting put in "time out" for asking a counselor whether I was a honky or a nigger. One of my black friends had called me nigger, and I must admit that I was confused, because I knew that my grandfather was black, but since I never met him (he died before I was

born), and since my mother was basically white, I couldn't quite understand where I fell. Besides, up until that point, I had always been told to never use the n-word and if I did, I would have had my mouth washed out with soap (which actually happened once or twice, though not for the n-word). After this incident, I had to reflect for a long time before I could truly find my cultural identity, and when I did, I found it in music.

As I child, I listened to everything. In pre-school, we spent a period each day dancing to James Brown, Aretha Franklin and Otis Redding tunes. At home, I loved listening to all of my pop's old records. He had a nice collection, everything from Gladys Knight and the Pips to Thelonious Monk and John Coltrane. I would breakdance on my friend Gabe's front porch and rap in the school cafeteria. In seventh and eighth grade, I became briefly interested in alternative rock (around the time Nirvana came out), but over time, I began to notice that, with a few exceptions, most of my musical heroes were black. When high school began, I really became interested in learning to play the guitar, and my playing reflected my musical tastes.

At first, I fell in love with the blues, and although nowadays the blues have become a genre supported by a largely white fan base, it's a music dominated by black legends, and it's at the heart of all modern popular music from jazz to funk and rap. As I progressed in my studies, I explored each of these genres as well as Afro-Cuban, Brazilian, classical European and Indian music. After internalizing all of these sounds and conceptions, I stumbled upon an important epiphany: culture has nothing to do with race, and race does not exist.

Culture merely signifies the artistic concepts and traditions of a community of people, which evolves over time as each generation builds upon the aesthetic discoveries of the past. Due to the technological advances of the last century, the music has become a formidable cultural commodity and now, more than any other time in history, people have access to an enormous spectrum of world culture in the form of recorded sounds and images. The information age furnishes us with the tools to import and export cultural commodities to the remotest regions and societies in the world. As a country colonized by numerous intermingling immigrant groups, and saturated with capital to invest in promotion and distribution of culture, the United States, in particular, seems to lead the rest of the globe in the export of new and interesting transcultural combinations, from jazz to hip hop.

As for race, the more that I scrutinize this illusive concept, the more I find it founded on nonsensical generalizations. We must remember that all humans share the same species and the practice of dividing us into phenotypical categories, such as skin color, has no more relevance than any another genetic phenotype such as eye color. Wouldn't it seem absurd to classify people into races such as Puteulanoid for blue eyes, Fronoid for brown eyes, etc. (as opposed to Negroid and Caucasoid)? Besides, people constantly reproduce and create new and beautiful phenotypical combinations. Race has nothing to do with culture.

Recently, I discovered some of the music that my grandfather composed between 1920 and 1970 (he taught piano for a living) tucked away in a cardboard box in my parents' basement. To my surprise, most of it was classical European music, collections of preludes and fugues as well as one jazz-influenced Bach-style choral composed for the text of the socialist poem, "Mourn not the Dead", by Ralph Chaplin. Discovering these works really drove home my conviction about the versatility of culture. When the son of an enslaved African-American can appreciate and master the beauty of European cultural theories, amalgamate these cultural aesthetics with his own experiences and imbue them with his own beliefs, one cannot deny that artistic expression transcends predetermined cultural categories and he or she must recognize that cultural evolution is inevitable. In other words, all culture is transcultural.

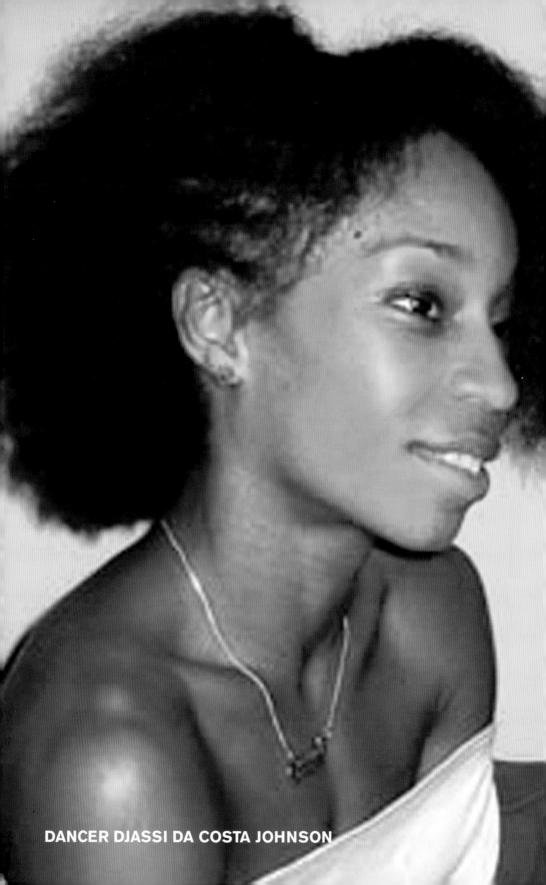

DANCER DJASSI DA COSTA JOHNSON

"DANCING THROUGH THE DAYS IN THE STUDIOS, AND NIGHTS IN LAPA WITH THE REGGAE AND HIP HOP KIDS"

13 Janeiro 2003

It's been a month since I arrived in Rio. I got off the plane, and was met by the divine vision of my sister, Sibongile. Long braids, hot, low, low, low white Brazilian jeans and a tight lil' Lycra shirt—well, hello there Ms. Brazil! Do you know where my sister went? She's a brown girl from Harlem, like me, but I don't see her anywhere. We laughed and hugged and made plans to braid my hair up as soon as possible. "The humidity and beach are hell on the naps, Dja. We'll hook you up—certo." Sibongile had already been in Rio for over six months. She was on an exchange program in her junior year at Brown University. Last year, when looking at my tour schedule, I saw some huge gaps where I wouldn't be working. I was tired of returning back to the city and instead of dancing, struggling to make ends meet, or going on auditions for jobs I didn't even want—just to survive. A light went off in my head and I decided to live a lifelong dream. To not just pass through a city or country for a few weeks—

mostly seeing the theater and the hotel—but to live and immerse myself in a culture. To continue this process of becoming who it is I want to be, while feeling the consistency of who I already am in another time zone, another language.

The timing is perfect. Sibongile just started her 'summer' break and so we have a few months to just chill before she goes back to school. We've spent the last month traveling all the way up north to visit my girl, my sister-friend Elise from college (what are the chances, ten years later, that she would fall in love and move to Brazil in the same time period that I packed up my bags and finally am realizing a long time dream of 'living' here?!) To get up north, to a beautiful place called Jijoca de Jericoacoara in the state of Ceara, we took the bus (60 hours!) from Rio. Splurged on the air-conditioned bus, and did as much crocheting, reading and writing as possible to keep us sane. We chilled at the Pousada that Elise's man has had for 15 years for two weeks—a

beautiful paradise hidden in the brush of 500-year-old trees leading to a lake. Where the jungle meets the desert and dunes line the path to the beach. Where I picked up mangoes on the trail to my room every morning, and tried not to disturb the monkeys having their breakfast of the overripe ones. We ate amazing food and met people vacationing from all over Brazil and a lot of folk from Europe. After New Year's, the three of us passed through Salvador to see "Minha Avo" (our adopted grandmother) and our adopted Brazilian family in Boca do Rio. At least on the way back down south, we broke the trip up in two parts by stopping in Salvador. Stayed 5 days at the cutest Pousada in Praca Castro Alves—right up from Pelourinho—which has become extremely clean and 'touristy' from when I remember it, 10 and even five years ago.

The first two times I had been there, I was "alone". The only non-Brazilian in my world. This time, there was such a serene flow to this trip, as I traveled with my blood sister and my sister-friend because we all have a similar understanding of being a world traveler: When to blend, and when to use the privilege of being "not of here" to move swiftly and make things happen.

It was a beautiful trip. Three brown girls traveling through the land that I will be living in for the next six months. Sibongile's Portuguese is fabulous. We let her do all the negotiating and handle most of the introductory conversations—she was key to our disguise at times. I was so impressed at the way she dealt, and the way people reacted to her based on her confidence and hold on the language.

Now that I'm back in Rio, I'm getting on the ball. She's in school, so she can help me with the grammar, but I'm all in the cheesy TV set every night sounding like a crazy woman, repeating everything I can understand. Rounding my mouth. Raising my intonation. Getting the attitude in my throat that goes with welcoming this beautiful language to roll off my tongue. I have a lot of work to do.

My résumé's out for a teaching job at the English schools in the area. I'm going around to dance schools next week and have some names of friends of friends to connect with. A lot of butterflies in my stomach. Aside from Sibongile, who has her school and her friends and her life here, I am feeling a little displaced—by choice. But I feel blessed that I made this choice, and through my dance and my path, I

have faith in this place and time. Leblon, Rio de Janeiro, with the beach three blocks away and 'white' Brazilian money all around, brown people on the street begging for money, the juxtapositions and the realities. I have faith as I sit on the veranda looking out at Corcovado floating above the clouds and the mountains surrounding the city that I will find my way. And blessed, oh so blessed.

Obrigada pela dia, meu coraçao, e a vida. Thank you for the day, my heart and life, Boa noite, Djassi.

My first trip to Brazil 10 years ago was a gift. One of my father's best friends, who became my brother's godfather and my 'uncle', is from Salvador, Bahia. I had grown up around his dance company, Dance Brazil, which was based in New York in the 1980s. My older brother, Kimathi, had studied Capoiera (an Afro-Brazilian martial art form) with him and accompanied him on trips to Brazil since the age of seven. For my high school graduation, it was my turn. He gave me a ticket on his frequent flyer miles with plans to meet up with me in a week. Business consumed him and he never made it down. I ended up staying with the mother of one of his former dancers. She was a priestess of Candomble. Dona Claudia. Mae-de-Santo (mother of the Orixas) of Oxum, goddess of the rivers, fertility, lover of sweet honey and the god of thunder, Xango. She spoke no English. Eager as I was to learn, I spoke hardly any Portuguese. But for three weeks I was by her side, communicating through eyes, energy and spirit. When I met her at 4a.m., after arriving from my flight, in a dark hallway, she embraced me and spoke: "Bemvindo, filha de Oxum," ("Welcome, daughter of Oxum") I watched her each day, welcoming people into the consulting room in her house, coming for readings, cleansings and giving offerings. And at night, I often accompanied her into the hills and valleys of Salvador's neighborhoods and favelas to different terreiros (spiritual houses). For feasts to Oxala, Iansan, Obatala and various deities she would help other Mae and Pae de Santos in ceremonies. After introducing me to a godchild or two, she would leave me with them as the ceremony got underway. Once, while in possession, while "being ridden" by a saint during a feast for Iansan, The physical body of Dona Claudia came right to me, embraced me in the ceremonial way, blessing me, and while pulling away, held my hands as she began to dance before

finally letting go—eyes rolled back in her head. I couldn't tell if she knew it was me. Later that night, on the way home, she turns to me:

"Voce tem que dancar para os espiritus, minha filha." ("You must dance—for the deities, my daughter")

This introduction to Brazil, this immersion in the very core of a society so colored by its spiritual base, planted something in me, called on me to want to find my own personal relationship with this place that felt like home. Catholicism and African religions, juxtaposed to the point of syncretism were at the heart-beat of daily life. On return to the States, I entered into my first year at Barnard College, in New York. I had worked very hard to get in and receive a number of different scholar-ships to help fund my education, but I was, truthfully, not very clear on why I was going to college. In my heart, I knew that all I wanted to do was continue to train as a dancer. I have always danced and been in and out of training all of my life. From what everyone told me, if I was REALLY serious about dance, why didn't I take my dance school, Alvin Ailey American Dance Center, up on their offer to increase my intensive summer study programs up to a scholarship program and study full time? Now is the time, they said, "you know a dancer's career is only but so long. . ."

I went with my heart and resisted the status quo and now, am so grateful. Now I know, that for me, there was no contradiction in my body wanting to move and my mind wanting to grow. In my growth, I discovered the universality of movement to preserve, celebrate and tran-scend culture. I re-read all of my Katherine Dunham and Zora Neale Hurston books. Struggled through the institutionalized study of "the other" in my intro-anthropology courses. Rushed downtown to dance class as often as possible. By my senior year, I had integrated my thesis process as an undergraduate to include my fascination with all art forms and their role in creating and preserving culture. I finished my last year's course load in the more open, eclectic and contemporary anthropology department at the graduate school of my uni-versity. My dance and my cultural experiences were innately related. Four years after my first trip to Brazil, I wrote my thesis to graduate on "Dance and Music as cultural preservation in African Diasporic Religious Traditions".

As a spirit and as an artist, I knew that I had just touched on the beginning of my under-standing. I knew I still had a more personal journey through my dance. And through the feeling I had of meshing and blending—beyond "participant- observer"—I was. And the journeys began.

I graduated and spent a year training on scholarship at the Ailey school. My 'uncle' came to see me dance in a studio performance at the school and asked me if I wanted to join his company, now based in Salvador, to rehearse for the 20th anniversary season. After my first experience, five years earlier, as well as 'growing up' with the dance company, I saw the dream realized and jumped on the opportu-nity to return to Brazil and work with Dance Brazil.

When I arrived in Salvador, the second time, I realized that my uncle (who was the only one who spoke English) was held up with business again and would not be coming for several weeks. Whatever understanding of Portuguese I thought I had gained five years earlier was lost. My joke to this day is that my affinity, or rather, lack of fear, in learning Portuguese, and any other language, stems from my first moments in rehearsal that day. The rehearsal director never slowed her intonation or babytalked me. Aside from my brain working overtime for the first 30 minutes, half in won-der, half confused, half in awe that I wasn't as lost as I expected to be, I remember the feeling of elation and excitement as I crammed to catch up in learning choreography. Over the next month, I slowly picked up enough Portuguese to communicate, but most of the day, we communicated through the movement. All of my questions were answered through demonstration. I realized that if I thought about it, this was always the case in dance. Dance is its own universal language. It couldn't be intel-lectualized too much, it just is. You follow, inter-pret, move, define space and keep time with the tools we all have that do not need transla-tion—our bodies.

In the years following that first dance experi-ence outside of my own country, I have had the privilege to travel and dance throughout so many beautiful corners of the world. My anthro-pology has become everyday fieldwork. Every city and town I find myself in, I break away from the 'touristic' outings of whatever dance com-pany I am travelling with, and venture off, hun-gry to connect with the space and its ancient stories. With the people and their current ones.

People are so much more receptive and

open to communicating and breaking down cultural or language barriers after seeing one "naked" on stage. We strip bare our physical selves. As performers, we become vulnerable, open to receive and giving all of ourselves in the same infinite moments. I have been touched by so many people as a performer, who, seeing my physical being (which often stands out in a company of "white" dancers—of which they are used to seeing) have a fascination with getting to know "who I am". Who, despite their own social definitions or previous perceptions seem to get a rush out of breaking down these proverbial walls just to "connect". They feel compelled to hug me, cry to me, let me know that they felt my spirit from the stage, they felt closer to me . . .they are going to put their daughters in dance class tomorrow. German mothers thanked me for my dance and my "fire". Japanese girls who had taken my dance classes during a teaching program in Japan approached me one day; "I am like you—we are your fan club. She's #3, she's #2 and I'm #1. . We be like you and dance like you one day." The more I travel with my dance, the more I feel at home in so many spaces and "cultures". The prouder I feel about my career. Which at times, I have felt was too torturous, selfish and narcissistic to commit to. The more my dance took me abroad, the more I began to feel as if I was a dancer in order to understand what it meant to be a diplomat.

Artists allow others to see our humanity and "inter-connectedness". When I perform, I feel my audiences see their reflection in me, and I in them. In those moments I am on stage, I am truly the sum of all of my parts, an unspoken human exchange that is like no other. As back to basics as birth, ancient wedding ceremonies and funeral processions, as real as an auditorium of hearts beating in unison in the deafening silence of one moment—as surreal as life can be.

16 Maio 2003

I just got in from a long day of dance classes, then rushing to Botafogo to teach an English class to my favorite student (Romildo, 60, Journalist, loves to talk, has a crush. . .) and then back to Ipanema to teach to Zdzislaw, my Polish student (living here for two years—speaks hardly any Portuguese but wants to improve his English). But I am still energized off the day. I had so much fun at the studio today.

Alan is one of the scholarship students at Nos da Danca, the amazing dance studio where I've been taking class for two months

now. He is one of about 20 boys who are part of a project called "Homens na Danca", "Men in Dance". He was chosen at an open audition held at the public schools in Rio looking for boys with the talent and drive, but not the opportunity to dance. Not only is he extremely talented and a fierce dancer, but I love his musicality. We have been eyeing each other in the last few weeks when it's time for combinations, to make sure we are in the same group and dancing together. It feels so good to find someone with the same understanding of the movement and rhythm as myself. Dance can be such serious work at times, but classes, for me, especially as I get older, HAVE to be fun as well. I have to enjoy the pain. Be able to laugh. Release. I always have a better class when I'm smiling and Alan is like me. He is confident in his dance and plays comic relief for the class. This is something I really enjoy about studying here as well. The "lightness" and warm social interaction that is characteristically Brazilian permeates the classroom. Back home, it can all be so stoic and serious at times—drive you crazy. Everyone looks scared. Here, each individual is easier to see and performance is happening every moment—freer to be.

Every once in a while, Alan or someone else will say something to me in class and then act so surprised at either my response, or the fact that I understood the gist of what they were saying. ("Listen to her—how does she know our slang?" "Don't mess with Djassi—she'll correct YOUR Portuguese!" Today he goes: "Olha, menina Novaiorquina, onde você aprendeu seu Inglês? Você fala ingles muito bem." "IBEU, claro! Porque é a mais barata" "Ah, IBEU—Eu vou lá amanha!"

Alan had the whole class in stitches. He was alluding to the fact that even though it has only been about 5 months, my Portuguese is so impressive that I must have lied to them all. I'm actually a Brazilian masquerading as a foreigner, and he wanted to know where did I learn to speak English so well? I snapped back that I learned my English at a well-known school in Copacabana—because it was the cheapest. We all had a good laugh for about ten minutes and then started rehearsal.

At this point in my process of learning the language, this whole interaction was the biggest complement. When I first arrived, even asking for directions on the bus it was like an alarm went off, "FOREIGNER IN THE HOUSE, FOREIGNER IN THE HOUSE!" Before answering

me, their first response was, "You aren't from here, are you? Where are you from?" I would sigh, found out. "Nova Iork" "Ah, Americana" "No—Nova Iork, there's a difference."

So that became my nickname at school too. Novaiorquina. But lately, on the buses or in the stores, the best has been that either I don't get any questions or it's an assumption now: "Where are you from, Angola?" and even "Você é Italiana?" I proudly say yes—to it all. Growing up at the tip of Washington Heights, and picking up street Spanish from the Dominican kids my brother and I hung with gave me my base for Romance languages. Then, in the last few years, working with my dance company, MOMIX (we tour in Europe and, especially Italy, often) I have fallen in love with that language too. I guess it all comes out in my Portuguese (which is by far, my favorite, claro!). On face value, almost anyone can be Brazilian—shades are the national race. But open your mouth and they could tell you exactly what state and town you are from in Brazil. The accents vary in the same way as American English from the south and English from the north are detectable. Now, I acknowledge the improvement of my speaking and accent as not necessarily indicative of studying (although Sibongile and I do have to have our sessions for conjugation and tenses from time to time… usually after I see her cringe at a frequent mistake I've made…) but more about my cultural immersion. I've always had this want to become universally nondescript. From all places and none. That's why I make the distinction to let people know that I am from New York. Even my father would joke with us growing up, "I'm an American—I'm from Connecticut. Y'all ain't American—you are New Yorkers."

That's why I love this gift I have been given called dance. Even from the beginning, from the moment I entered the dance studio, it didn't matter so much where I was from or how thick my accent was. It just mattered that I could dance.

As carnival time finally wound down, and Rio opened back up after being basically "shutdown" for two months, I began voraciously looking for the world of dance in Rio. I went around daily to schools with my resume, took a few classes, but nothing pulled me. I was getting out of shape, frustrated and a lil' depressed. Then, at our first little soiree that Sibongile and I threw in the fabulous apartment she snagged for us after she left her host-family's house, the doors began to open. A friend from her school introduced us to a beautiful Cariocan named Junior with "MADE IN BRAZIL" tattooed on his heart. We danced at the party and talked, and he told me that his brother was a "street dancer" and he would introduce us. A few weeks later, I met his brother Hugo, who then introduced me to his teacher, Washington. I took his class and mentioned that I wanted to teach Horton technique and his eyes opened up as he said, "I know where to take you". A week later, he took me to Nos da Danca and introduced me to Regina Sauer, whose school it was. Class was about to start, so I rushed in and at the front of the classroom stood. Regina. Long braids down her back, she reminded me of my Horton teacher, Ms. Forsythe, from my days studying at the Ailey school. With her grace and her subtle eye contact, she welcomed me into the class. As soon as the music started, I felt at home. I breathed deeply, realizing that this was one of those defining moments in life where doors are opened and seeds begin to grow. Flat backs, lateral T's, cocxic balances stag turns. I was floating.

She didn't really say anything to me during class. After the last group went across the floor doing the combination, she walked right up to me. She asked my name again and asked if I would "me faz um favor"—do her a favor and do the combination alone for the class. My palms became waterfalls, and a mixture of excitement and absolute terror came over me. I had been itching to perform. It was three months since I had taken my break from my dance company to come and live here. The music started and 30 seconds in I blanked and froze—had to start over again. "That's OK, don't be nervous, just dance" She said, and started the music again. When I finished, the class cheered and Regina explained that she didn't know me or where I was from but wanted me to show the class what she had seen. The seriousness and clarity of my movement, my performance quality even in class. Where was I from? Who do I dance with? How long was I here? I responded by telling the class about myself and that I had been looking for a school for a while. That I was so happy to be here and that I too, could tell so much about their teacher by just one class. I thanked her for the chance to dance.

Afterwards, we talked and I explained that I would be here for three more months and I

don't have a lot of money to take class but was interested in teaching. She talked to the rest of the faculty, and the next week called and invited me to stay at the school on "scholarship". I could take as many classes as I want in exchange for a 2-week course to share with the other dancers my dance experience and choreography. After that day, Regina and the whole school embraced me without question. Twenty years before, she had taken class at Ailey and because of our shared dance experience, she embraced me like a child into her family. She is beautiful. Every day we have different variations on the exchange of "I'm happy to have you here" and "Thank you so much for letting me be here". Of all of my experiences here so far, I am most grateful for Nòs da Danca. The other amazing dancers there, and the unconditional love and understanding that comes with this art that is my life that is dance. I came as a stranger into a community and through my art—without words or background—was embraced and began an artistic exchange that enlightened me about the beauty of human interaction. Now I have less than a month. I start teaching my workshop next week, and will present my choreography with the students along with the duet I'm working on with a dance partner I met here, Magno. I have never actually been in a collaborative process with one other person before and I'm excited. He has 10 years on me in dance experience, and I know we both feel like we have something to learn from the other, so, we'll see.

And like Alan jokes, instead of being sad that my time here is almost up, I will continue to improve my Portuguese and be "Brazilian". Enjoy the patterns of the day. Taking the kombi (dollar-van) along the beaches of Leblon, Ipanema and Copacabana to ballet class every morning. Dancing through the days in the studios, and nights in Lapa with the hippie, reggae and hip hop kids or at an African party in a Zuki club, dancing with Cape Verdeans and Mozambiquans. Where it doesn't really matter if I'm from Angola, Italy, Bahia or Harlem. This universal language of dance and love and friendship is beautiful. Like the song on the radio these days: "Eu sou de ninguem, Eu sou de tudo mundo, tudo mundo e de mim." ("I am of no one. I am of everyone and everyone is mine too.")

Boa Noite, Djassi

I think we are all given gifts—through our art, our lives or our personal paths. They are meant, not for personal fulfillment of society's definitions of "success" but to bring us closer to knowing ourselves so that it becomes blazingly obvious how connected we all are. This is the responsibility of the traveler versus the tourist. Because of these gifts that I have; being a brown girl of many bloods who 'happened' to be born and raised in New York City. Having revolutionary educators as parents, who gave me the education and options of being both and artist and an intellectual so that I could become a Universalist. Finding peace in my existence in the physical world through the sur-reality of my dance.

Because of these gifts that have allowed me to glimpse into other spaces, towns and cultures, I am beginning to fulfill this need I have to connect to human beings. To realize the continuum of our existence and break down the walls of 'perception' and pre-judgment to get to the purity of emotions and exchange that I have experienced that have no language, no color, no contradictions. Those places where we are essence, and connected, and life. The life essence that is essential to our survival.

WRITER CHRIS LEE

"CAN'T FIGURE OUT WHERE MY GENES ARE FROM?"

There's just something about getting pulled over by the cops. A fuzzy, lactic anxiety makes you feel like a criminal whether you've done anything wrong or not. Growing up in Los Angeles, in the years before Rodney King becomes a household name, I get to know this feeling pretty well. I am 17 years old, my black hair is shorn close to my skull and my skin is a tan brown. On a palm-lined street in Beverly Hills, two friends and I are idling in a black low rider with deeply tinted windows and 20-inch rims. We are in front of my house, nearly at a dead crawl. An LAPD black- and-white glides up behind us and flips on the rollers. My first experience with racial profiling is less than 30 seconds away.

But first, the interminable wait. During traffic stops, no less than five minutes elapse before the Los Angeles police sidle up for license and registration, the operating assumption being that guilty parties will get the jitters, slip up, get busted. But my high school homeys and I haven't so much as smoked a roach. I get out of the car—quickly, but with my hands up—to explain, "I live right here, officers. What's the problem?"

The rear curbside door of the K-9 unit opens suddenly, and I watch the dog hit the ground running. He bounds down the street toward me, covering the two car lengths between us at an alarming clip. My feet feel as though they are stuck in quicksand. I can't believe this is happening, and I am moving too slow, as if in a dream. Not a moment too soon, I am back inside with the door closed and the windows rolled up. The German Shepherd's frenzied barking fogs up the glass. I have a closer familiarity with the vicious dog's dental integrity than I could ever want.

It was a case of mistaken identity, Sergeant Stadenko soon explained. Some 18th Street gangsters, a Mexican gang from East LA, apparently committed a burglary nearby. Though I may be Latino in appearance, I am not Mexican; simply bi-racial... part-Asian, part-white. The cops saw me, and fittingly enough, mistook me for one of the gang members. The surprise isn't that I had been wrongly pigeon-holed, race-wise again. I was thinking: This never would have happened to Emilio Estevez.

Don't cry for me, Argentina. I'm not looking for any sympathy. Given the amorphous nature of identity in the information age, I don't begrudge anyone's racial slip-ups: it happens all the time. Being half-Chinese and half-French Canadian has resulted in my getting pegged for everything from Tibetan to Peruvian, Filipino to Native American. But as a small part of a bigger picture, I feel my experiences are a sign of the times. In an era in which a Caucasian ethnic majority no longer exists in New York, California or Texas (presaging the minority makeover soci-

ologists predict for the rest of the country by 2030), it has become increasingly difficult to accurately profile race. As national borders evaporate and countries in every hemisphere are dragged kicking into the multicultural landscape, situations like mine are much less unusual.

I am part of an encroaching coalition whose race is not obvious from a distance, and for whom identity is then ascribed from the outside in. Can't figure out where my genes are from? Give it your best shot.

If America's brief national flirtation with political correctness taught anyone anything, it is how to be incredibly earnest in the face of potential insensitivity—even if that means behaving like an outrageous cornball in the process. While in college, when my hair was shoulder length, (and more rock 'n' roll than "Dances With Wolves", I thought), one youngish, goateed flight steward on an LA to New York plane approached my seat, kneeled down in the aisle ahead of the impending drinks cart, and gazed intently into my eyes to ask if he could ask me a personal question. With appropriate solemnity, he enquired what "tribe" I was from. I paused, considering China's population of more than one billion people. I replied, "The biggest tribe in the world."

To be fair, the perceptions depend a lot on whether or not my head is shaved, how lavishly I wine and dine, what SPF factor sun block I use, where I am at the time. Popular culture has a funny way of bending expectations. On a good day, I am told I look like Keanu Reeves or Jimmy Smits or Bruce Lee. On a not so good day, Freddie Prinze, Jr. or Lou Diamond Phillips. In the end, I may find small validation in the Rock's racial ambiguity or Tiger Woods' Calibanasian cool. But I remain thoroughly confused by another, bigger star—what the hell race is Vin Diesel, anyway?

Identity politics are perhaps never more in flux than during trips overseas. But to complicate matters, when there, the locals will often confuse me for one of their own: I'm a Carioca in Rio de Janeiro, an over-size Hindu in Bali. Backpacking through tiny islands in the Gulf of Thailand, I was approached by a bedraggled man in a dirty sarong who had made it his mission to get the 411 on my nationality.

"You are Thai," he said firmly. Finding these conversations tiring, not to mention a language barrier and 14 time zones worth of jet lag, I tried to beg off from the conversation. "No.

American."

But sarong man remained firm in his conviction, and I realized my powers of persuasion were waning.

"You are Thai," he insisted. "And you in the Army!"

"Have you by any chance noticed that I am a foot taller than you, and we are speaking in English?"

A similar conversation in Spain years earlier, with a Barcelona native, yielded a pearl of wisdom I have held on to ever since: with my Asiatic and European blood and my new world pedigree, I could be fairly regarded as a Do-It-Yourself Latino.

Casual slurs and racial epithets directed my way are almost inevitably off the mark. Forecasting my race remains an ongoing process. Years and years have been devoted, unintentionally, to my search for self. But like many others in many different situations, the less I look, the more I find out about how I am unique; how my being this way resonates with the rest of the world. While interviewing a 23-year-old Caucasian surf-slacker turned Tibetan monk in Huntington Beach, California, for a magazine article, I was broadsided by the simplest of ideas. Guilelessly, he asked if my interest in Buddhism stemmed from my Tibetan heritage. Again, I explained the racial hullabaloo that has surrounded me; how it has both caused me pain, and made me laugh. I trusted him enough to elaborate beyond my usual company line, spelling out how being biracial, an implacable other, has forced me to try to understand myself from the inside out, while almost everyone else does exactly the opposite. The kid seemed at first taken aback, appraising me with his wide monk eyes. "You know," he began slowly, "You may find it strange, but I think you are incredibly lucky." What for him was surely a throwaway comment, a simple truth, was about to blow my self-conception apart: "To be mistaken for so many different things, you must have incredibly good karma."

ORIGINALLY PUBLISHED IN TRACE #38, 2002

MODEL MEBRAK TAREKE

"GIRLS WHO DIDN'T LIKE A 'MAGGA KOOLIE-HAIRED T'ING' IN THEIR MIDST"

In Tigrina my name means "reconciliation of the east." I was told I was born smiling on a festive January afternoon in a tumultuous Addis Ababa, Ethiopia, where I lived and was totally enamored until the age of five. My family and I then pursued peace and personal passions in Kuwait. For the next eight years, this sweltering desert sprawl would serve as my adoptive homeland. Having only spoken Amharic and some nursery French, I soon learned English and Arabic. I nurtured some friendships and read the Holy Qu'ran amid an Islamic cosmology in which we were one of the few secular East Africans. Life then came to a sudden and irreversible halt on August 2, 1990.

The Gulf War: As Iraqi troops were barricading the outskirts of Kuwait City and taking my father hostage, my mother and I were in utter oblivion—on holiday in London. While my father hastened to escape to Jordan, my mother and I again had to adjust to the norms and constraints of living in yet another new country: England. I have not seen my father since.

The UK, and the oddities at my Suburban Church of England School, took a while to get accustomed to. This was also where I was met with my first encounter of patois speaking, teeth-kissing, West Indian girls who didn't like a "magga koolie-haired t'ing" in their midst. So much for my notions of black unity. It was at a mediocre school fashion show that Davina McCall first spotted my potential as a model. This was followed by the persistent encouragement of people from the fashion industry to "give it a shot", but it wasn't until the summer of my second year at University College London that I visited Select Models. Soon after, I was voted the "Select-Diesel Face of 1998". My first job would have been a main fashion story for The Face

Magazine with Katy England, but I couldn't get to Paris because I was still considered an Ethiopian who had to naturalize first before gaining a right of passage. Still, this was only the beginning of many more opportunities. Often, I would be pleading with brazen immigration officials in the hope that I could fulfill next day options to work with Givenchy in Paris and Jil Sander in Milan.

Life oscillated between modeling for very little money and being a frugal student. I decided to stop modeling at the cusp of my young career in order to continue studying, and to work and travel in Peru. My bookers went "ape shit." As far as they were concerned, it was time to consider quitting school.

Modeling, I was told, was an industry in which I could make lots of "serious dosh." After rallying industry support I finally naturalized as a British citizen, and was able to start making a lot of money. After graduation, the road to unbridled success was nearing. So I thought. My first visit to Paris was met with ambivalence. I decided to migrate to New York—an urban shocker—where black girls apparently "ruled". During the struggles there, I was offered a full scholarship to read Social Anthropology at the London School of Economics and Political Science and put modeling on hold for a year. When I returned to the Big Apple, I eventually attracted the attention of Steven Meisel, Calvin Klein and Ruven Afanador. It has been going well since, and is getting better every day.

Instant fame and success is more apparent than it is real. It takes more time, effort, perseverance and integrity for women of color to brandish their own niche of representation. This is what I still constantly find myself doing day after day.

ORIGINALLY PUBLISHED IN TRACE #43, 2003

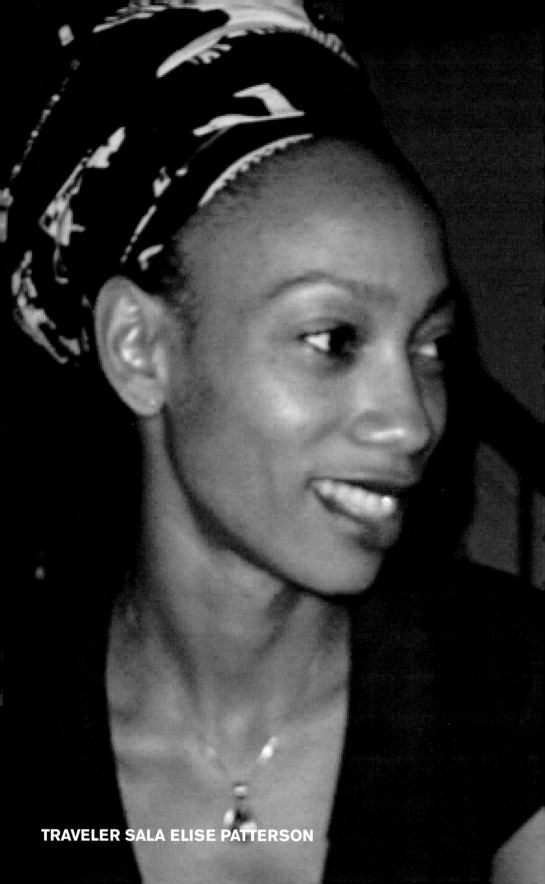

TRAVELER SALA ELISE PATTERSON

"WELL, WHY DO YOU MOVE AROUND SO MUCH?"

As a child, I was always drawn to people who were different. Not always racially or ethnically different but people with some other way of affecting their voices, or preparing chicken, or expressing themselves. I liked the way the French girl in fifth grade barely moved her mouth when she talked, and thought it was so cool that one Thai girl always had pomegranate in her lunch instead of a banana or an apple. Then there was the teacher assistant's son with the caramel-colored face who smelled like curry, or the chubby half-Tunisian half-American girl who just showed up one first day of school, fresh from Tunis. I just remember her seeming like such a bad ass. She taught me about harissa and Cheb Mami, Fa products and couscous. Her mother bleached her moustache and waxed her legs with sugar, lemon and water. I loved going to her house.

I made friends with the Tunisian when I saddled up to her and told her that I had just come back from Tunis. She thought I was lying for about a week, but I had actually just gotten back from my first trip outside of the US at age six. My father's friend was the head of the Peace Corps in Tunisia and invited us for two weeks. My most crisp memories are of blue and white tile, the oasis, the way the city came to a halt seven times a day for prayer, and, my friend.

She was the daughter of a Tunisian Peace Corps colleague and was around my age. She came over the first night with her parents and other siblings, and we all ate fat, roasted green peppers stuffed with spicy meat. Even though we didn't speak the same language, I think we took to each other instantly. She had big round eyes, and short, thick, curly hair cut like a boy. We played and pantomimed our way through the language barrier, and became fast friends during our visit. The day I had to leave, I cried so hard that I think my mother was worried. I was losing this perfect new friend. My father's friend told me that I didn't have to worry because I would carry a part of her with me everywhere, and that anyway, the world was small and we'd see each other again. Traveling, for me, became defined by that friendship, and that beautiful hazy country. So I kind of have Tunisia and a beautiful Tunisian girl to thank for all of this.

I first started really traveling after high school. I went with three girlfriends through six European countries in 30 days. My three traveling companions had summered in Italy since forever and their parents thought nothing of turning them loose on Europe at 18. My mother, even though she spent a year in Paris in college, thought it was ludicrous. My friends and I caucused and plotted, phone calls were made and then a dinner was arranged. Three bourgeois white women had to convince my mother to let me go. Now I

can't believe I never considered how hard it must have been for her to go to the dinner. All I remember is driving home afterwards. My mother was so upset. She parked and she just started crying and she asked me to consider that she had a completely different life than me, let alone my friends' mothers. She reminded me that she grew up in the '50s, in the projects, in Boston. She said, "you have an upper-middle-class reality, Sala," but I do not.

My mother and father let me go in the end, but after that I always felt three things: that I was blessed to be doing something my parents and grandparents could never have done at that age; and that first in wanting to go and then being able to go I was taking advantage of a freedom to explore that they had planned and worked for me to have. Maybe that made me travel to Europe with an added sense of purpose. I wanted to come away with the smells and memories of places in my head. I wanted to exchange. One night on a train, in something like country #6, I wound up separated from my three girlfriends. Walking through the jerky trains, I saw a French guy we had met in the previous station. We started talking, in French, and he invited me to hang out with him and these two guys he'd just met. He then turned to the first guy, and said in Spanish, "I just met her earlier," (I think). Spanish guy introduced himself to me in hesitant English. The last guy was Italian and so he understood Spanish. So we all had, more or less, at least one language in common. We start talking, literally across each other in different languages, and then someone told a joke. We all wanted to know so he translated the joke to someone who then translated it to me and the laughter crescendoed as we got it, one by one. It made me fall in love with languages on the spot. I wanted to learn as many as possible so I could be like that with all kinds of people—and in their language, not mine.

After I graduated from college, I worked with this Morehouse grad who told me that he had just gotten back from Japan. I had never thought much about Japan, much less living

there. But to hear about it from a young black man, who had clearly been touched by his experience, made Japan seem relevant to me. What if that were true of other far-flung places as well? Until then, the global map in my mind's eye was limited to America, Francophone Africa and Europe. Suddenly, I was thinking about other parts of the world. An enormous, panoramic view of the possible spread out before me.

So I decided to go to Japan. I got all kinds of resistance from people around me: "You know they hate black people over there", and "You know they hate women". All from people who had never been anywhere near Japan, mind you. Well, I decided to go anyway. My parents encouraged me as they always do, and that security gave me all the blessing I needed to go without hesitation. It was like when you stay up on a bicycle for the first time: you feel the high of speeding along by yourself, but you keep glancing back at your parents. They are still there cheering, and that gives you the courage to push down on the pedals again. That is what it's like when I live in a foreign country. I feel a sense of freedom from, and at the same time, dependence upon where I have come from. I need to know home is there in order to go away from it.

In Japan, the teaching program I was on placed me in Nishi Aizu, a small town in the mountains near the northeast coast. Behind God's back, one friend used to say. There were 10,000 people—mostly farmers, hundreds of geometric rice paddies and no stop lights. Time had stopped about a hundred years ago in Aizu and nobody was interested in resetting the clock. (I remember once being rung up on a register in a small shop and the woman checking the math on her abacus.) Although at times frustrating, I found so much dignity in the preservation of tradition. Suddenly, so many things that I did without thinking, like making friends or food shopping, took massive amounts of attention: to detail, to custom, to the thousands of tiny symbols on the label to make sure it's baking powder and not baking soda. At first, all I could think

about were immigrants to big cities in the US. How overwhelming it all must be.

People in Nishi Aizu had never seen anything like me in person. They had seen a few foreigners, but I stood taller than every full-grown man, I had seven ear piercings, I did step aerobics in my apartment, I wore makeup (well, mascara) and I was black. They had never seen most of these things, much less in one person. My students loved me and asked me about how I did my hair, and they all wanted to come to see my house. One high school student told me proudly that she turned my color in the summertime. The old folks just looked up at me on the street and smiled, probably thinking, "The aliens have landed." But then what must it be like to live your entire life and never see anyone who has different color eyes and hair and skin and is almost twice your size?

I fell in love with Japanese culture, and I really tried to navigate respectfully through the dizzying amount of custom and tradition. America never seemed so characterless and virgin to me before. I learned to sit on my knees, understand the meaning of a tea ceremony, perform the long bathing ritual before entering the public baths, and to sing—with a smile—Carpenters' songs on the karaoke box for colleagues at office parties. I hid my cigarette smoking from everyone because young teachers don't do things like that, but drew the line at things like not drinking a glass of wine in public. I tested the limits of the situation and myself, and discovered that they are not nearly as narrow as I had thought.

My grandfather died in Boston on my birthday, two months after my arrival in Japan. I went into work the next day and told my boss at the Board of Education, and then went out to teach at my schools. I came back in the afternoon and he handed me an envelope and said, "For Sala-san to go home." I opened the envelope and in it were other tiny colored envelopes with the names of each of my three schools and some teachers with whom I had just started to work. Each had given me money to pay for my ticket home for the funeral. I had never seen such a graceful extension

of support and goodness. It was as if the community felt it their duty to communicate and support my filial responsibility to go home and say goodbye to my grandfather.

But, at times, I felt like an outsider and that was painful. Surrounded by people, as I constantly was, I felt so alone knowing that I was layers away from fading undetected into Japanese society. It wasn't because I was black, or American, even. It was just that I wasn't Japanese and that fact gave me limited access, an objectified existence. I could only get so close to even my closest friends. It was a completely new experience for me. To move from New York, where I was surrounded by friends, to living on my own in Japan I had to rely on myself for the first time. That meant teaching myself about myself. I wrote a lot and reread what I wrote frequently. It was the next best thing to conversation. Japan would make me grow and, after living there, I felt that I could manage anywhere in the world.

On my way back home, I spent one month traveling in Thailand, China and Vietnam. China overwhelmed me (the Great Wall left me speechless), Thailand fascinated and Vietnam felt—go figure—like home. When I got home, I discovered that I had an offer to participate in an experimental English teaching and curriculum development program in Benin for an American-based NGO. I had been waitlisted for the program the year before and my application had been accepted at the last minute for that Fall. I accepted the job, unpacked from Japan and repacked for Benin in one month. I got seven shots, started anti-malarial drugs and arrived tired but excited in Cotonou, the dusty, surreal village/capital city. Lots of French expatriates, American NGOS and Lebanese businessmen.

Poorly planned, our education program failed miserably but I had a marvelous time in the classroom. I have never had a group of students so eager to learn. In one school I had 40 plus kids. The school was in a field of sand in five small wooden buildings with poured concrete floors. The teacher, who was paid $40 a month and hadn't received a

check in three months, somehow made every child feel special and capable. You could see it in the way they spoke to him. He encouraged me to push them and make them concentrate. Those kids learned like their lives depended on it. And for many of them, their families did depend on it. Parents often had to choose one child to send to school, to buy books, pencils, notebooks and a uniform for. They usually sent the child with the most promise, and while she or he went to school their siblings worked. Most of my students spoke at least three of the following: French, Fon, Gon or Yoruba. So their minds were ripe for language acquisition. I rarely had to teach anything twice. I used to leave an hour lesson dripping with sweat, exhausted. To give that much and get that much more from children was wonderful.

I passed almost all of my free time with a crazy middle-aged Italian/Eritrean engineer. We met in our hotel lobby my first week in Cotonou. Tall and thick, he came bounding in on crutches screaming, in Italianized English, "I want a room right now. And I want a room with the bathroom inside the room." We both liked to dance but as a woman I couldn't go by myself. The only women in Beninois clubs were hookers. So we would go to dinner and then dancing at a club called New York New York. By last call, the dance floor used to be littered with strips of hair weave and lost extensions. I met Beninois friends for drinks at night at buvettes, bars that become informal clubs at night. The tiny dance floor was always packed with men dancing with one another hunched over, hands on hips popping up and down to the zoukous. I had never seen men dance together like that showing off, sparring in rhythm, smiling and sweating. One night, I was walking home from a buvette with two other Americans and two Beninois. We were tired, and no one was speaking, so we heard it all together. It sounded like faint sleigh bells or rattles marking out a steady beat. We stopped as the sound got closer, and from around the corner, dead ahead of us, came a procession of men chanting and carrying idols, drums and wearing masks.

There was one man way in front, whose job it must have been to clear the way, because he ran straight up to the Beninois and told them to get out of there. Benin is the birthplace of Voodoo and its practice thrives there today. There was a religious ceremony in progress and outsiders could not witness it. I was in awe of the power that the group of men generated, but I knew that I had no business trying to watch.

My favorite thing to do in Cotonou was go to the Sunday market. I did the weekly food shopping for the house where I lived with two other black American women. I used to spend all morning there. I'd get up early and walk past women sweeping the dirt clean in front of their home, and across the train tracks to our local market. I went to certain women for certain things. One for the eggs and condensed milk. Another for tomatoes and onions and so on. I had to win over their confidence, pay a little bit more the first few visits, and learn how to haggle with a smile. But there was a sense of familiarity, some women would keep me for a quick chat or make a big show of throwing an extra tomato in my bag. Almost everyone is a woman or a child. That's why I liked to go. You never saw women out socializing apart from church. So it was the one place where I could be around women and watch them mingle. Geleés bobbing around under umbrellas, teeth sucking, unrolling and rerolling the lapas as a nervous habit. Laughing. Many of them, I found out were doctors or lawyers, but there was no work for highly educated professionals. Others were elderly women who'd always worked the market. Many, I gathered had come from upland with their children and grandchildren. They haggled the best through a school-aged grandchild who would translate prices from an indigenous language to French for the expatriates.

Dating under globe-trotting circumstances has proved a delightful experiment. Paris, junior year abroad, was the beginning. At one point, I was seeing a Yugoslavian who sold Levi's and hashish, a German/Turkish male

model and a German homeopathic doctor/drummer—concurrently—in Paris. Each relationship had something comically absurd about it: the model's hodgepodge accent, the Yugoslavian's odd hours, the doctor/drummer's blonde dreadlocks. But it was the first time I really dated without restraint, getting guys' phone numbers, meeting them for drinks or walks. No one was around to tell me what they thought of this one, or to give me advice, so I just bluffed my way through it all and tried not to get caught dating all three.

But I really fell in love for the first time with an Italian, while I was on vacation in Thailand after my year in Japan. During my time in Benin he and I did the long distance thing, and then six months after I arrived in Benin, I decided to move to Rome and live with him indefinitely. I hadn't liked Rome the first time I went after high school. But I went for him, and of course, it came to be my favorite city in the world. Whatever may have been the case in the past, Italy doesn't really advance today as much as it just coasts along. People are too busy enjoying. Everything still shuts down at noon and people rarely talk about work. It somehow always feels like you are on vacation. That space of the day between the end of work and bedtime feels longer in Italy than anywhere else. The evening gets stretched out over huge meals, bottles of wine and talk, and so you feel like you have come down before you have to wake up and go again. Rome was a wonderful place to make friends because the culture encourages people to commune. You never planned to see people weeks in advance. Like magic, everyone wound up in one of a few places, night after night. I learned that running into a friend, even at 11 AM, was a good enough excuse to have a glass of wine. That you ate because it is one of the greatest pleasures. I remember my boyfriend offering me a piece of something and I said, "No thanks, I'm not hungry." He gave me this look like, "silly woman" and said, "You don't eat because you are hungry, you eat because it's enjoyable." So I broke with my eating obsessions

and stopped counting grams of fat, ordered the whole milk latte and learned to work through a wedge of cheese on my own. I had no idea what I was missing.

I saw all of Sicily, which is more a piece of Arab North Africa floating in the Mediterranean than Italy. My boyfriend and I criss-crossed the island on the back of a motorbike and strolled through Greek temples that were so old that they make you tremble. I saw Naples in 48 hours with a strawberry-blonde American woman and two Napolitano club crawlers we met. They walked us up into the hilly city lecturing on Napolitano traffic laws, mafia enclaves and Naples' underground scene until 6 AM. Italy was the first place I ever felt sorry to leave.

I am just back from almost a year living in northeast Brazil. That means that since I graduated from college seven years ago, I have lived on five continents. Rented an apartment, held down a job, started friendships, made nice with the new neighbors, five different times. People at home are always asking me "Well, why do you move around so much?" And I think what they are really asking me is, "how have you had a relationship with life and the world—economically, emotionally, logistically—that lets you pick up and go live in country after country after country?" One answer is that I am open to it. There is a short list of things I don't do well without: friends, work, restaurants, books and music. But I'd go anywhere in the world where I can find these things.

The other answer is that traveling and living abroad has become my journey into me. All kinds of people and places have left me with pieces of what, I discovered, I need in order to be me. I hope that I reciprocate. I need to experience that connection both with people at home and with people all around the globe. Both to have a more holistic view of the world and myself, but also because the variety of ways people eat, work, worship, suffer and love, inspire and fascinate me.

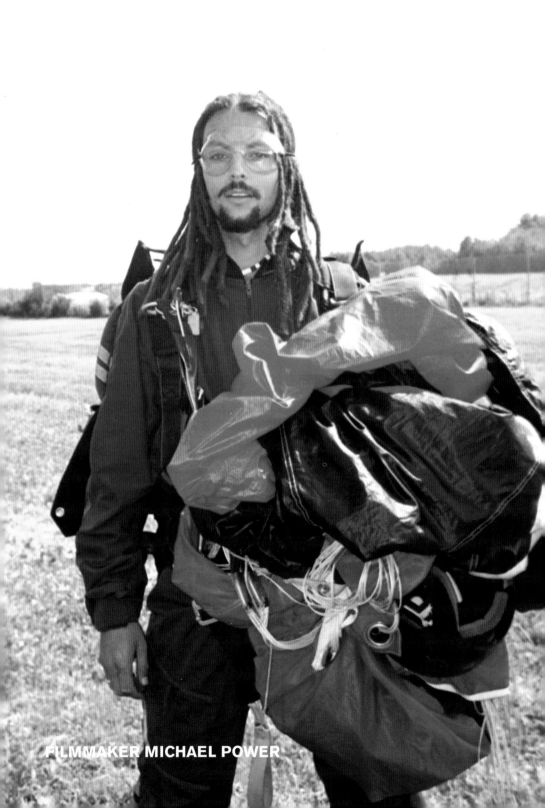

FILMMAKER MICHAEL POWER

"I HAVE DEVELOPED QUITE AN APPETITE FOR SUCH MAJESTIC CONTRADICTIONS"

My life's journey began in Brussels, Belgium, in the summer of 1970. My heritage is a mixture of Eastern European and British. My parents met during the Glenn Miller days of postwar Berlin. My mother was a nurse and my father a British soldier. Though my father lacked the bubblegum allure of the American GI, I think his old fashioned charm and British sense of humour compensated enough for my mother to leave what was left of her family behind, to start a longwinded journey around the world with him and later her two children. I being the youngest. The little DEVIL.

"Childhood: Objects strongly to any form of discipline... in particular to having his hair cut."
–George Power: Father

It is difficult to write honestly and sincerely about oneself, so last week I petitioned my friends, family, acquaintances and business associates via email, to write about the things they both love and hate in me. Some of the responses are what one would expect of friends and others have yet again led me to re-examine myself (and whom I'm calling friends these days).

"Skiny: A complicated, well-read, inventive artist with a soul, showing at times an explosive temper, wanting to do and see it all! A real romantic with many unrelated talents... toiling without rest day and night till the mission is accomplished. Job done! Will play with the same degree of enthusiasm. A warm-hearted man of the world, who has been there and done it all. At ease with kings and paupers alike, one cannot fail to like him."
–George Power

Well, to be honest, pops, there are those that do not care for my brand of ideas, humour or company. I do not know why I have been blessed with the curse of not caring about how I am perceived—it has stood me well in my travels and in my line of work; The film industry.

"I like that you carry yourself like ousted nobility

on the lam. I hate that you carry yourself like ousted nobility on the lam."

–Ethan: co-writer

"Education: A terrible student, attended schools in many countries–seldom in class. In spite of this lack of interest, somehow develops a special gift for writing and a love for objects of art and grace."

–George Power

School wasn't really for me. To be honest, it takes quite a genius to manage not to learn anything until the absolute last year at school. I was strong-armed into learning by an English teacher, a MR Sanders. I had progressed through 13 years of school without ever learning what an adjective was. Bravo, you 'idiotic' booby! I must also admit that education would have taken away too much of my focus on my very lucrative drugs trade. By twenty, I was running to catch up and dove straight into Nietzsche, Marx and many of the other things I was told would be bad for me. Thank you, Mr Saunders, you bastard.

Now my life's dilemma is not being able to conclude whether the unexamined life is not worth living or whether ignorance is bliss.

Moving along. I came very close to spending the following ten years of my life in prison when I became the target of a major investigation into my criminal affairs. I had graduated quickly from weekend party supplies to wholesale importation from Holland and spent most of my time in the company of two very undesirable Turkish characters and a Bavarian pimp named Uli. I was living in a small village in the German Alps at the time and driving a Porsche whose origins were not easily explained to the folks. I was offered a start-up kit into the German pimping scene in the form of a young lady named Marion–I declined, as I could not turn my back on my romantic ideals or face the mullet haircut; selling ladies by the pound wasn't for me. This period of my life is something I'm not proud of, as I am now dealing face to face with the consequences of many friends and lovers fighting drug addiction. But then again, I did get an amazing street-level degree in economics. After the police became involved, and many close to me were sent away to prison, coupled with the fact that the drugs were no longer making me giggle and were starting to make me psychotically paranoid, I decided I wanted my mind back.

I assume I have been asked to write this for my achievements as a filmmaker, yet I feel it important to tell you the A to Z story (note: directors that call themselves filmmakers are those that have not yet made any money). It might make you laugh. I want to introduce you to my life, my friends, and my family. The company I keep can best define my character. If my friends were cars, I would have a garage like Jay Leno–a fantastic collection of rare exotics. It is my life's work, and the only thing that has paid me a healthy dividend. Here are what some of them have to say about the things they love and hate about me.

"I love the fact that u swagger around as if you're hung like a watneys shire horse and we all know you're not.

I hate the fact that despite your being hung more like a racing pigeon,

U still get laid more than me.

Oh yes, and you're a cunt."

–Adrian Panengarth: art dealer/professional public school boy

My only defence, dear Adrian, is to say that any man's penis would look like a light switch in your shadow–and your mother has never complained about the berth nor length of my charms…

Sense of humour and provocation is such an important part of my life, my art and living in London for the past twelve years has taught me how to tango. It has become the basis of my thinking and my work.

"Its harder than you might think to bottle Skiny up in a few lines and infuse the page with 'Eau de Skiny'…..'Odour de Skiny' perhaps. I first met him a few years ago in a friend's apartment in London. A conversation with Skiny is like armed combat and anything goes… his standard approach is to bombard you from a great height in an unashamedly provocative manner. It doesn't matter who you are, what you are–you're still going to get it, so stop struggling, lie back and take your medicine like a good kid. And that's what makes him a great filmmaker–he provokes, disgusts and shocks in equal measure, and leaves you no choice but to question

your own views on everything–taboos...what are they? Skiny likes to work on the other side of the fence–in the really big pasture...the one that's completely empty except for a wiry little guy with dreads yelling at a rattlesnake."

–Adrian Panengarth

"The good thing about Skiny is, he speaks his mind. The bad thing about Skiny is, he speaks his mind."

–Visko Hatfield: photographer and father of two

"Skiny enjoys taking on impossible challenges and generally making life as difficult as possible for himself. He hates anything one might consider normal and must definitely be a sexual deviant of some description, based on his cinematic obsession with ultra-violence mixed with twisted, dark, perverted sexual activity. He is stunning looking, although not in the slightest bit conventionally handsome. His face lights up when you talk about crazy ideas, films or women, but he glazes over if you talk about almost anything else. He has very little patience and likes to shock people. Skiny is very, very cool–he's narcissistic, ambivalent to mainstream society and has a healthy disregard for authority. I would imagine that everyone who has ever met Skiny remembers him. I only ever see him when he's trying to get money out of me to sponsor his latest preposterous project. He's cheeky as fuck. All good, even the bad bits."

–Daniel Barton: Head of Marketing and Communications–Diesel Group UK

Though raised Catholic, I cannot explain how I managed to avoid the sexual perversions expected of a good little god-fearing boy. I have, since the age of eleven, been an uber-romantic and fight to remain that way.

Anyway, I was now living in Munich, and with drugs no longer an option I was compelled to join the work force. I wasn't qualified to do anything and my lifestyle was very seriously in jeopardy. I took a job as a shop assistant with someone who later transformed himself into one half of the pop sensation Milli Vanilli–Fabrice. Me and that prick flirted our way onto many a young ladies' credit card, as we were both heavily inspired by the 15% commission we were making. Unbelievably,

overnight, he learned to speak English and sing. Lita, the Portuguese shop girl and I were left behind in his wake to fend for ourselves. Hee hee–he died.

Shortly thereafter, I was approached by a woman in the shop for a position as an assistant at German Vogue. I thought to myself, though I have absolutely no qualifications or interest in fashion whatsoever, this is going to be a fantastic way of getting myself in the company of many a beautiful woman. I was fired shortly thereafter. Being the idealist and seeking out my newfound sensitive side (grounded in the philosophies of an array of women's magazines), I refused to box up some fur coats after a shoot and was asked to relinquish my position. Life's coincidence led me into the path of a very quick moving train–Katharine Hamnett. One drunken night, I ended up in a hotel room in one of Munich's most prestigious hotels. I imagine these three ladies invited me back there as I always look like I have drugs on me. This was the start of my second chapter. Katharine encouraged me to move to London and become a freelance wardrobe stylist. With her unconditional encouragement and a little faith, it was only a matter of time before I was trusted to create the look for famous people and photographers. She became my Lord Henry Wotton (Dorian Grey ref. you idiots). Eddie Monsoon, the fashion photographer was one of the first people I befriended and he has replied to my calling…

"On the good side, you are a wonderful, caring, decent human being who would give all to help a friend. On the down side, how do you get to sleep with all those good girls and why can't I?"

–Eddie Monsoon: Fashion Photographer

Dirty old prick. In my defense, I haven't slept with half as many girls as I'm accused of. Hand on my heart, I can say that I would trade all the women for one good one. I could now delve into my romantic life and affairs but this would be a book in itself (and probably far more amusing than the journey of my life). Though I am defined by what I do for a living (and, unfortunately, the way I look), I feel that my loves have been, and will always be, most important to me. They are also my Achilles heel. I have loved to the point of madness. I feel it

is the only love worth having. A lot of the responses I received from friends mention women. These people know me.

What is it Johnny Morales loves/likes about you?
"You're the cheeky, misunderstood visionary. Likes the fact that you value his opinion.
What is it that Johnny Morales dislikes/hates about you?
"The drama/the girls. Dislikes the fact that you expect him to explain all this in an email the night before."
(J.S.M disclaimer. Skiny can not be explained in a single email)
–Johnny Morales: artist, father of one

What is it that Amber Graafland loves/likes about you?
"The sincere enthusiasm, optimism and excitement with which you embrace everything that life throws at you."
What is it that Amber Graafland hates/dislikes about you?
"The fact that for someone who is so perceptive in every way you have a complete blind spot when it comes to women and I hate to think that they take advantage of your good nature!"
–Amber Graafland: Fashion Editor of The Mirror/Mother of one

What is it that Ben Pundole Loves about you?
"The exasperating comedy, the infectious school-boy antics, the intelligent, insightful conversation, being well-read and well-travelled, the unabashed approach to women, the frisbee arm."
What is it that Ben Pundole dislikes about you?
"The wallowing in self pity about the downfalls with women, the lack of karma."
–Ben Pundole: nightclub entrepreneur

There isn't much I haven't done. I've climbed mountains, raced cars, played polo, tied fireworks to my penis (which I received a screen credit for in the "Jackass" movie), sailed boats, pierced a mouse's ears, explored subway tunnels, tried (unsuccessfully) to get killed, 'Merengued' with 350 lbs. Haitian prostitutes, hunted, fished, swam, bungeed, fought, drank… It's difficult to list. It would be easier to list all the things I haven't done. All these experiences, and

the aforementioned women, sit somewhere inside me waiting to be born in the form of a moment, a breath, thrust into the parameters of a film. Most filmmakers I meet are a bore, as are most of the films I see. I think to represent life, as a director does, it is an advantage to have tasted what one is selling. I've been guzzling.

There are certain events in my life that have left deep impressions. The murder of my closest friend, the actress Kadamba Simmons four years ago; the drunken (and foolish) impromptu marriage to Tara Palmer Tompkinson, Prince Charles' goddaughter; my immense heartbreaks, which leave me in bed for weeks on end not being able to eat nor sleep. In return for this tortured life, I have found the voice, the calling to make work that provokes people into thinking about their own beliefs. I didn't chose this. It has chosen me, and I am prepared to suffer all hardship in exchange for a forum, a platform.

You may have noticed that I have not considered structure or content as of yet. Sometimes the rantings of a lunatic can be enlightening. I thought, perhaps, if I just allow myself to ramble you will truly get a picture of who I am–and that's the point isn't it. I am not ashamed. Perhaps you'd prefer the same old rubbish. It doesn't take that much imagination or courage to make myself into a Vincent Gallo.

Death, violence and sex have always been a very valid part of the arts. Though I myself am not in the least bit dark, I find that these subject matters are what inspire me most. I truly am not setting out to exploit…well actually that is a lie. Yes, I am setting out to exploit something–human nature's curiosity. Yet, I feel as though I am staging a car accident and calling people in to see it, and only when I have their attention, I execute a well thought out philosophical attack.

I spent almost eight years as a stylist, and soon grew tired of telling pop stars that they didn't look fat in things and telling models that they needed to fatten up. I no longer wanted to be a part of that machine. Instead I decided to make a documentary ("KINGS & TOYS") about graffiti. I spent four years travelling around the world, raising money and filming "writers", and it was through them that I personalised my approach to art and its creation. I learned that

to be pure you have to be prepared to work hard, risk all, and be prepared to walk away from something you have given life to in exchange for the experience of the creation.

I avoided the "phat/ yo muthafucka" approach, and instead set off to make a film which might explain to my 86-year-old Irish grandmother why the buses and streets of London are covered in little scrawls. The film took me four years to complete, bankrupted me, left me heavily in debt and made me homeless. It was worth every penny. My grandmother understands, and I have left my mark.

The success of the documentary opened many doors and soon I found myself traipsing around SoHo with a showreel in tow, lunching at the Ivy with producers and making television commercials and music videos to sell the soulless ideas and products of others. Though the money was good, after two years I walked away and reset the focus on the lens. I went from earning five grand a day to earning 50 quid ($75) a day working in a bakery or selling bread on a market stall in London's oldest food market. I was happy, yet my mother was now really starting to worry about where her 30-year-old son was going to end up. During this time I was still moonlighting in my old lifestyle, and involved myself with an infamous woman that got me much unwanted press attention as the leeching market boy that would go to $3000 a head charity dinners with flour matted hair and 20 bucks in my pocket. I have developed quite an appetite for such majestic contradictions.

This episode, as we shall call it, left another very deep impression, or scar—depending on how you want to look at it—on me. I got a peek behind the magician's curtain and saw the machinery that makes the press work. I got grandma's secret fucking recipe, and I'm going to make it my life's work to tell everyone that one can no longer base one's perceptions of the world on our daily diet of newspapers and television. The challenge will be to find an engaging way of doing it. Ironically, I will be using all the techniques currently being employed by the media to get your much-desired attentions. I must apologize for the use of bad language just now, as I'm sure my mother will not be impressed.

The last few years have been spent earning money writing as a journalist, raising sponsorship monies for racecars, brokering deals and many other things. I've eaten a lot of pot noodles, often run out of toothpaste and bought cigarettes with a kilo of pennies, and have walked to meetings in Manhattan from Brooklyn in the hard driven snow of winter and the blistering heat of summer. My friend Eddie, from whom we heard previously, has the right approach—"you cannot fail if you never give up."

What I love/like about Skiny?
"His ability to make any story sound fantastic—even taking a walk to the shops can become a Robert Louis Stephenson-esque adventure. Just when you think that no way in hell can his bullshit be true, you spend five minutes in his company only to come away feeling like you've just run through the rabbit hole, having taken the blue pill! He has the drive and ambition like no one I have ever met—no matter how many times he has been knocked back, pegged down, restricted, told no way, heartbroken—he always bounces back with a smile on his face and fireworks up his arse."

What I hate about Skiny?
"His ability to run into a stream of baaaad luck, and to lead me down the garden path on every occasion— can I say no?–NO!–You baaastard."
–Mathew Woolf: DOP and trusted right hand man

What is it (if anything) that you like or love about me?
"Intelligence. Honesty. Straightforwardness. Vulnerability. Empathy. Fun. Dreams. Naivety. Edge. Self belief. 2. What is it (if anything) you really hate or dislike about me? Habits that undersell you and present yourself as an uncouth yob, rather than the intelligent and sensitive man you are."
–Duncan Quinn: my Lawyer

I consider myself blessed in that I have found a way to work which is unique, and delivers some very interesting results. Much has to be said of fumbling about in the dark. No pun intended.

My father started his career selling sweaters on market stalls around London in the early '60s that would disintegrate in the wash. His journey has inspired me as he is now a self-made man with an amazing family, properties and a black diplomatic passport. I too will end up somewhere interesting and I strive for the same things he did. I want to be the Nietzschean ubermensch. A great husband, a great father, a great friend, a great director—in that order.

I will be making my first feature film this year and a second next year in the UK. I might mention I am currently residing in the Big Apple. Again it was a woman that got me here—and that is all I have to thank her for… As I was saying, I am finally positioned to do the thing I have been put on this earth to do: Make films and make love.

In closing I will leave you with my adorable nieces…

What she likes about you?
"He is very sweet. He is very funny. He is crazy. He is a lot like a kid. He likes to have fun. He loves to improvise. His hair. His style of writing."
What she doesn't like?
"When he gets mad, he goes a little overboard. He barely visits his family (nieces). Don't like his taste of shoes."
Kelly's thoughts: (age 10)

What she likes about you?
"You are silly. Crazy. Nice. Funny. Cool."
What she doesn't like?
"Your hair. Doesn't spend much time with us. His job. They way he is when he gets mad."
Katelin's thoughts: (age 7)

What she likes about you?
"You are funny and silly. The way he loves his nieces."
What she doesn't like?
"The name Skiny. She likes "Michael" and everyone who says differently gets corrected!"
Kylie's thoughts: (age 4)

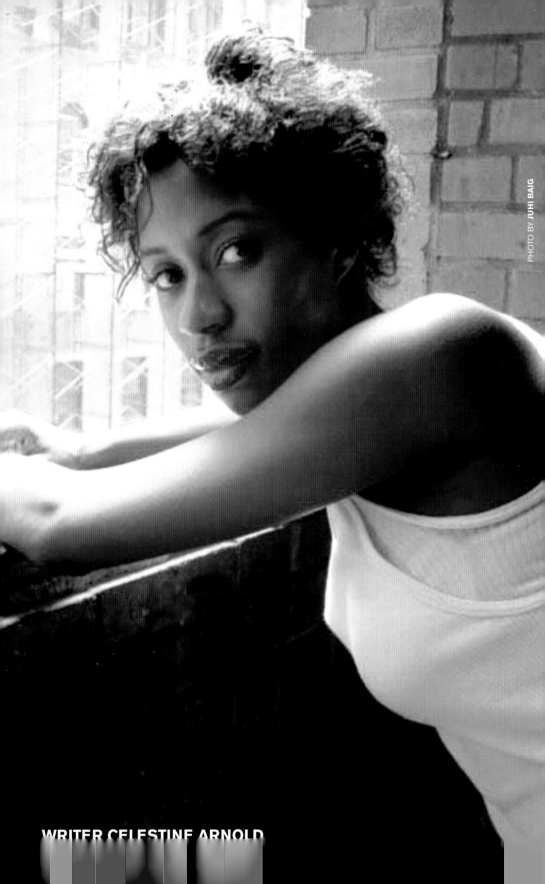

WRITER CELESTINE ARNOLD

"I HAVE BEEN CHARGED WITH THE FELONY OF 'ACTING WHITE' ON MANY OCCASIONS"

It is easy to be confused by society's expectations and definitions. The silly stereotypes of humanity still linger heavily above the heads of our culture. When Caucasians possess the inflections of the street, they are questioned and probed—saddled with the label "wigger," just another misguided soul affecting the sounds of inner city life. If I indulged strictly in hip hop, and spoke in heavy Ebonics, the world would accept me with open arms. Instead, I enunciate with the casual precision of a WASP—the tones of a girl raised in an affluent suburb. I speak to watch a white woman ease the clutch on her purse as the sound echoes her own. I speak to see my black contemporaries recoil in confusion. My lexicon is a frequent topic of conversation. To my amusement and disgust, people often ask if I am from the UK. I am a conundrum, and a challenge to all that we, as a nation, have built into our perceptions. I am a well-spoken, well-educated, young black American woman.

My parents relocated to the suburbs as soon as my older sister was born, determined to raise their children beyond their memories of the ghetto. Grade school was spent with my sister, and we were the only brown faces out of 800. I rocked my Wave Nouveau haircut with pride. In the coatroom, my Eight Ball jacket hung side by side with the L.L. Bean backpacks and J. Crew monogrammed sweaters.

There was no awkwardness yet. The preconceived notions of parents had yet to corrode the childhood innocence of my classmates. I was special because I was an Afro-American. I was beautiful—an exotic delicacy in a continuum of white faces. I knew that I would never desire to be anything but kinky and brown, to eat yams and try desperately not to get my hair wet at pool parties. It was an integral part of who I was and will forever more be.

That first taste of racism still lingers bitterly, ready to spark and ignite into resentment. My

best friend, Jenny Breslin, was having her birthday at a country club, a place I passed every day without thinking of the reason I had never been inside its massive doors. My mother was on the telephone with Jenny's father immediately after reading the pink invitation with balloons floating across the front. I stood in the kitchen listening to my mother berate Mr. Breslin for planning the party at a location where I would not be allowed to step on the grounds. With her chin up, she told me I would not be attending, for the simple reason that I was black. At that moment, I could not comprehend such an injustice. I had yet to learn the hard lessons of racism that many of my urban peers knew all too well. I stayed home, trying to pretend it didn't matter.

Neither was my beautiful brown skin considered an asset when it came to my first kiss. As my hormones raged, I came to see that, while I was an incredible ally for Dungeons & Dragons, I was not a viable sexual outlet simply because I was not white. There were no boys—no young suitors to whisper of budding beauty. The guys I went to school with were too young to resist being cowed by the pressures of society, to stray from the formula of a field hockey player with a last name like Gibson or Gallagher. With my thick lips, I stood on the sidelines, thoughts of gross inadequacies to dance with me at semi-formals.

Puberty brought me rebellion. I left my private school to go where students mingled in a noticeably diverse environment. I wanted to see beyond the world of school uniforms—to peek into the options which public school can offer. There, I discovered a passion for the electric guitar's power, the heavy stroke of the three-chord riff. I fell in love with punk rock, and the ripping-down of a visible status quo. Avail, Fugazi, The Red Aunts and the boys of Seven Seconds kept me alive through the day. I dyed my hair blue, green, white, wore my leather jacket with a skull on the back and let my hair dread, burying myself in Maya Angelou, X and Dubois. I never once thought that by exploring the intangible essence of my personality, I may also have been betraying my race.

No longer was I the only black face. There were about 15 others glaring back at me, sticking together as if for protection. Many had moved to the district recently, still carrying the Ebonics of the city with them. They were chastised by the teachers, mocked by the students, and all their anger came out at me. I was the enemy: the literal Uncle Tom. No matter how many times I approached their lunch table, my desire to belong clearly evident, I was turned away. Antipathy was the only response to my presence. I was a symbol of all that they despised, and even worse, I was one of them. In my junior year, I was jumped by three of my sistahs, on the basement floor of my high school. As they punched my face and ripped my oversized t-shirt, I remember thinking that there was power in their actions. I remember feeling as though they had stripped me bare—revoking my right to be an African American. I was a coward. I changed schools.

I have been charged with the felony of "acting white" on numerous occasions. The source never adheres to racial constraints. During my adolescence, I found myself crushed with sensations of inadequacy, as if I was not living up to an expectation—as if I was a disappointment to my race. It took me a long time to understand that the accusations, as well as my reaction, were based in absurdity. Blackness is not defined by the way you speak, or what you choose to wear. It is an essence—intangible and constant, ethereal and beyond the boundaries of human stereotyping.

The years after high school were spent reconnecting my pride to black society. The demand to alter that which I inherently am had been replaced with the compulsion to let go of everyone else's definitions. Now I find myself amused when a comment is made regarding my speech or aesthetic preferences. I feel a thrill at possibly destroying a stereotype. While I admit to taking pleasure in these moments of human fallibility, part of me always feels a bit of disappointment. Each incident serves as a reminder that we have such a long way to go to topple these walls of manufactured prejudice

ORIGINALLY PUBLISHED IN TRACE #40, 2002

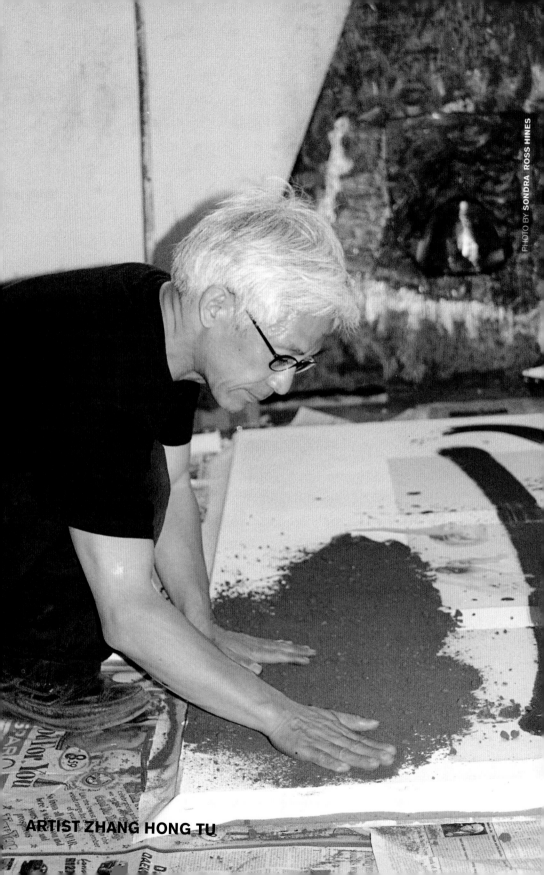

ARTIST ZHANG HONG TU

"I DON'T WANT TO DO ANYTHING PURE"

It's a good idea to start by talking about "The Last Banquet", a symbol of my early cross-cultural work. I painted it in 1989, right after the June 4 Tiananmen Square massacre in Beijing. Before that event, I considered myself more of an American artist. My past life in China was sort of a nightmare, especially during the Cultural revolution.

The Cultural Revolution was the turning point. I trusted Mao. I thought that what Mao said in his "Red" book was really romantic; really idealistic about the future of China and the world. But after one year of watching people die on the street and fight each other, everybody said the same thing, "I'm on Mao's side... I'm on Chairman Mao's side."

When I had the chance to move to America in 1982, I wanted to do something pure, something without a political message. But after the student demonstration in Tiananmen Square, I became concerned about what was happening in China. I couldn't do anything at that time; I couldn't concentrate on my work, my art. I felt I had to do something to support the student movement in China. I started using Mao's image, playing with his image, to express my feelings and ideas about modern Chinese history. I did the "Last Banquet, Acupuncture Chart of Mao"; I did 12 different Mao images using different daily life materials. I used soy sauce, corn and dirt to surround Mao's image. I dealt with the high and low, the east and the west, my past life experience and my present life experience.

I was so excited when I traveled to South Africa for CrossPathCulture's Cross+Overs Workshop and Exhibition. While in South Africa, I went to visit Soweto and Kliptown, and I felt as if I was back home in the Chinese countryside. I grew up in Beijing, but I spent a lot of time in the countryside. During the Cultural Revolution, I was sent there for three years. The skin color was different, but the living conditions, people's attitudes, the relationship between common people and nature were the same.

This trip to South Africa taught me one very important thing: you have to catch every opportunity to learn something new. You are not limited by what you learn, but everyone is limited by their education. As you travel to different countries you can change your mind, you can change your attitude to the world—to the people.

I don't think anything is pure. There is no pure European culture, no pure American culture, no pure Chinese culture, and even no pure African culture. Nowadays I don't want to do anything pure... I don't think anything is pure.

TRANSLATION BY CANNON HERSEY
ORIGINALLY PUBLISHED IN TRACE #44, 2003

Transcultural Intelligence Timeline

5,000,000 BC	100,000 BC	4000 BC	100 BC
Movement of the body, head, arms, hands or face; expressive of an idea or emotion	The faculty or power by oral communication	The record of past events, especially in connection with the human race	The act or practice of bringing one's wants or business into public notice
gestural language	human speech	history	advertising (outdoor)

Becoming Mass Media (Audience=50,000)

Invented ■ Mass Audience ▨ Invented ■ Mass Audience ▨

1609 1833

1895 1932

newspapers: 224 years

radio: 37 years

1928 1948

1990 1994

television: 20 years

internet: 4 years

The number of interracial marriages has leaped to almost 1,000% since 1967. In its U.S. markets

Polish, Korean and the West Indian dialect Twi—with its advertising and promotions. The

1561	1762	1938	2004

To deal in buying or selling merchandise	The act or practice of bringing one's wants to business into public notice	Mechanically portioned loaf made from dough of flour or meal, and milk or water, and baked	Capacity for understanding made possible by the work of the world's first truly transcultural agency.
marketing	advertising (print)	sliced bread	true intelligence

Population 3,000,000

30,000,000 B.C. - Genus Homo 1860 - London 1886 - Paris

1895 - New York 1922 - Tokyo 2004

- Montreal
- Madrid
- Ibadan
- Surabaya
- Harbin
- Pyongyang
- Jiddah
- Bandung
- Cape Town
- Addis Ababa
- Luanda
- Amman
- Bandung
- Changchu
- Curitiba
- Kabul
- Kanpur
- Naples
- San Diego
- Xian

alone, AT&T reaches at least thirty different cultures in twenty different languages—including

population of ethnic Americans is increasing seven times as fast as that of non-ethnic Americans.

Catalyzing the Transcultural U.S.

(Includes data from 2003 and estimated 2004)

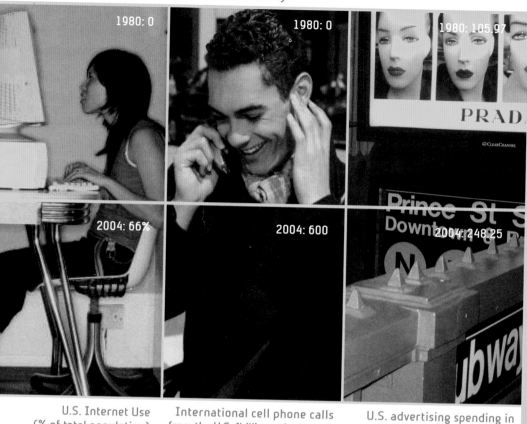

| 1980: 0 | 1980: 0 | 1980: 105.97 |
| 2004: 66% | 2004: 600 | 2004: 248.25 |

U.S. Internet Use (% of total population) | International cell phone calls from the U.S. (billions of minutes) | U.S. advertising spending in all media (billions of dollars)

Worlds Largest Cities

Baghdad, Iraq	Beijing, China	Istanbul, Turkey	Beijing, China
Xian, China	Istanbul, Turkey	Beijing, China	London, UK
Istanbul, Turkey	Agra, India	Esfahan, Iran	Guangzhou, China
Kyoto, Japan	Cairo, Egypt	London, UK	Istanbul, China
Hangzhou, China	Osaka, Japan	Paris, France	Paris, France
900 AD	1600	1700	1800

Number of U.S. households with online access: 1999: 39 million; 2000: 44 million; 2001: 51 million;

the number of Hispanics grew 9.8%—nearly four times that of the general population. 54% of multira-

(Includes data from 2003 and estimated 2004)

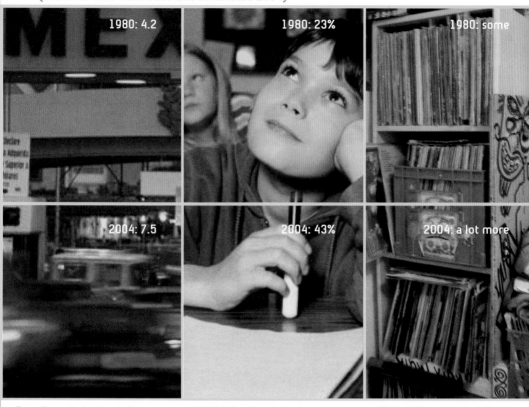

1980: 4.2

1980: 23%

1980: some

2004: 7.5

2004: 43%

2004: a lot more

Immigrants to the U.S.
(millions)

U.S. high school students
studying a foreign language

"World" and "ethnic"
influences in U.S. pop music

World's Largest Urban Agglomerations

London, UK	Tokyo, Japan	Tokyo, Japan – 28,025,000
New York, USA	New York, USA	Mexico City, Mexico – 18,131,000
Paris, France	Shanghai, China	Mumbai, India – 18,042,000
Berlin, Germany	Mexico City, Mexico	São Paulo, Brazil – 17,150,000
Chicago, USA	Sao Paulo, Brazil	New York City, USA – 16,626,000
1900	1975	2004

2002: 56 million; 2003: 60 million; 2004: 62 million. In just two years, from April, 2000 to July, 2002,

cials are under age 25, while 42% are under age 18, according to 2000 Census data.

Underpinning Transculturalism: The Global Effect

	Then	Now
Volume of world export of goods	1950: $311 billion	$8,938 billion
Number of transnational companies	1970: 7,000	67,000
Daily turnover in foreign exchange markets	1970s: approx. 10-20 billion	Since 2000: approx. 1.2 trillion
Non-cell phone lines linked globally	1960: 89 million	1.1 trillion
US films in the European market (% of total)	1987: 56	75
Number of democratic governments	1985: 44	121

(Includes data from 2003 and estimated 2004)

Top Ten Web Sites – Unique Visitors per month (in millions), August 2003	
1. AOL Time Warner Network (proprietary and world wide web)	111,117
2. MSN – Microsoft Sites	110,673
3. Yahoo! Sites	108,240
4. Ebay	63,608
5. Google Sites	54,709
6. Terra Lycos	51,880
7. About/Primedia	42,680
8. Amazon Sites	35,494
9. Gator Network	34,263
10. Symantec	28,524

The number of interracial couples increased four times from 1990 to 2000, making multiracial

in 1999 on targeting African Americans, representing less than 1% of the $215.2 billion in total

identities more common among every subsequent generation. U.S. advertisers spent $1.1 billion

U.S. advertising revenue. This is a huge increase—112%—in the category since 1995.

The New Transculturals

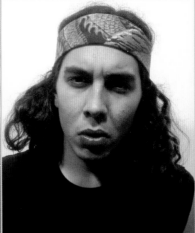

Name:
Jehanne-Marine Buffiere

Age:
22

Occupation:
Student at the American
University in Paris

Background:
French

Music:
Eclectico-ethnico-mixed! Hihi, I
don't really know how to call it

Brands:
EKJO, a young Korean fashion
designer in Paris

Friends:
Raphaelle, Frank, Sonia, Aude,
Thi hien, Berengere, Assaba

Heroes:
My parents

Point of view:
Don't hesitate, go and travel,
the world is big

Name:
Lance de los Reyes

Age:
24

Occupation:
Artist/Crator
Full-time member of "God Army"

Background:
Greek Sicilian/Filipino

Music:
Black Heart Procession, Palace
Brother

Brands:
Militant

Friends:
God's Army

Heroes:
Shepard Fairey

Point of view:
I believe in a deranged move-
ment of our senses to under-
stand how we feel

Name:
Hilary Sophia Sopczak

Age:
24

Occupation:
Full-time artist, part-time
jokester

Background:
Native American, Irish
West Indian, Polish

Music:
Jazzy, funky, fun, uplifting a
sometimes sad

Brands:
Just one on my wrist

Friends:
All kinds, all over. I just smi
thinking of them.

Heroes:
Anyone who's had to overcor

Point of view:
A husband is living proof tha
woman can take a joke

The number of black-white interracial marriages in Alabama have more than tripled

is estimated that by 2010, one-third of the U.S. population will be composed of African

Name:
...sha Panza

...:

...upation:
...king in the editorial depart-
...t of a fiction publisher

...ground:
...ian, Syrian, Italian

...ic:
...ove by The Association is
...epeat in my CD player

...ds:
...'s, Lucky, anything
...fortable
...nds:
...o you sane (but not always
...r)
...es:
...a/Dad

...t of view:
...y day someone teaches me
...ething new and unexpected

Name:
Scott Shannon

Age:
29

Occupation:
Freelance designer/artist
videographer/entrepreneur

Background:
Irish/Italian 3rd generation

Music:
Misfits, Promise Ring,Dead
Kennedys, TMBG, R Kelly

Brands:
Gucci and Helmut Lang
New Balance, Champion
Friends:
All comers

Heroes:
Bruce Nauman
Charles Bukowski
Point of View:
Protect yourself, help others,
our leaders tend not to be
humanitarians

Name:
KET

Age:
?

Occupation:
Entrepreneur, marketer, artist,
publisher

Background:
Cuban and Ecuadorian
Music:
Old salsa, reggae, hip hop,
Antibalas, mix tapes, System of
a Down

Brands:
Azzure, Indigo red, Penguin,
guayaveras, e-play, Francis
Hendy, Actual, writers bench
Friends:
Chris, Kleo, Luis, Eliezer,
Charlie
Heroes:
Malcolm X, Assata Shakur,
Noam Chomsky, Siddhartha
Gautama
Point of View:
Walk slow, think fast, build
schools, create a legacy

from 297 in 1990, to 1,000 in 2000, or about 2.5% of the married couples in the state. It

American, Hispanic-American, Asian-American and Native-American populations.

The New Transculturals

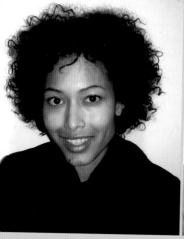
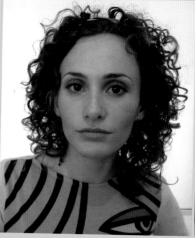

Name:
Noemi

Age:
?

Occupation:
Model and mom

Background:
Cuban and Mexican

Music:
A little bit of everything, salsa,
country, banda, cumbia

Brands:
Not tested on animals and
organic

Friends:

Heroes:
Hillary Clinton, Arundhati Roy
Anita Hill, Ghandi

Point of view:
Too complex for words but
basically try to be yourself

Name:
Kathleen Taboada

Age:
22

Occupation:
Fashion designer/Audio Tech

Background:
Spanish/Ecuadorian

Music:
The funk baby, since '80,
and of course, DJ Korn

Brands:
Katlogik

Friends:
Till the end

Heroes:
Salvador Dalí
Antonio Gaudi

Point of view:
Do you!

Name:
Georgia

Age:
4

Occupation:
Student

Background:
Swiss/Vietnamese
African/Native American

Music:
Missy Elliott! I like the new on

Brands:
Duckies!!! The duckies in my
bathroom

Friends:
Natasha and Elizabeth

Heroes:
My Grandfather

Point of view:
I like [the world] because...
'cause I like it

The growth rate for African Americans purchasing new cars has been twelve times that of

already have the majority in Texas, California and Florida, as well as in Chicago and New York

Name:
Chaelechi Nnadi

Age:
32

Occupation:
Video Editor

Background:
Mother is Swiss, Father
is Nigerian

Music:
tech-house, hip hop—"anything
with a hyphen"

Brands:
Adidas, Supermalt, Apple
Computers, Nivea Lotion

Friends:
Chris, Kleo, Luis, Eliezer,
Charlie

Heroes:
Muhammad Ali, James Baldwin,
Brian Clough

Point of View:
"Try to be good"

Name:
Jessica Seepersaud

Age:
26

Occupation:
Art buyer, casting/producer,
actor

Background:
Puerto Rican, Guyanese

Music: New Order, The Cure,
Elefant, Prince, Stevie Wonder,
Teena Marie, New Edition, Actual
Proof

Brands:
Chanel, Marc Jacobs, Minnetonka,
Morningside, Polaroid, Apple

Friends:
My girls, Stephanie and Julia are
my family, blessed to have them

Heroes:
My abuelita, my mooma, Serena
Muniz—people that know the
struggle really inspires me

Point of view:
Follow your heart and run, run, run

Name:
Amy Hastanan

Age:
21

Occupation:
Travel Writer

Background:
Thai/Puerto Rican

Music:
Lauryn Hill, Nina Simone
Erykah Badu

Brands:
Agent Provocateur

Friends:
Jacqueline
.

Heroes:

Point of view:
Life isn't about finding yourself
it's about creating yourself

non-African American auto purchasers over the last decade. So-called "minority" groups

city. Of the $3 billon sales in rap music each year, $2 billion is purchased by whites.

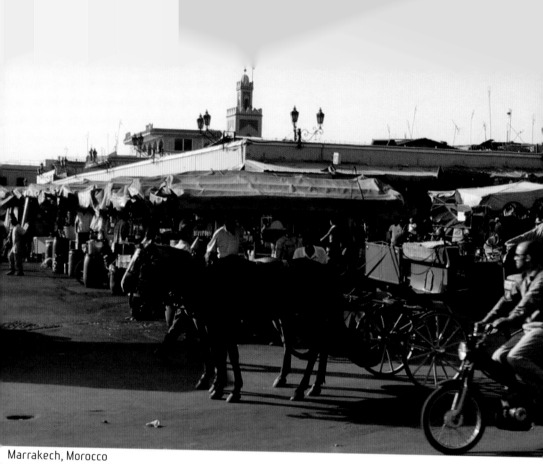

Marrakech, Morocco

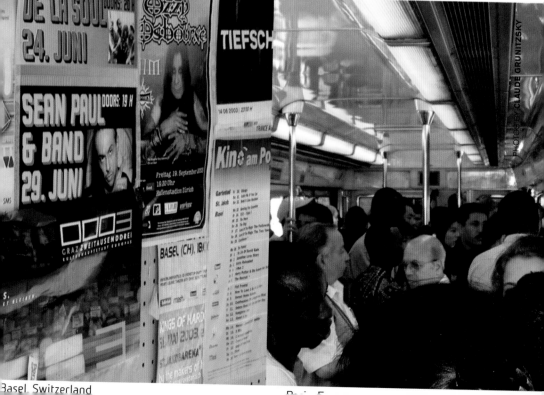

Basel, Switzerland

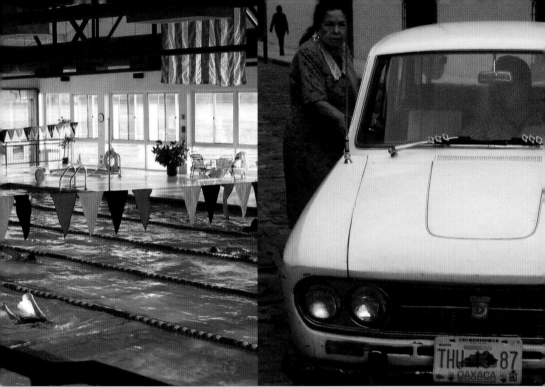

New York, USA

Oaxaca, Mexico

Port Antonio, Jamaica

Then Now

Automotive

Cereal

Alcohol

beyond outmoded categories.... c. 2004

Everyone lives in the same world—and more and more people know it. Today, the nature of the world is a little bit clearer, because Census 2000 was the first in which Americans could identify themselves as belonging to more than one race. What Census 2000 shows is what transculturals of all backgrounds already knew:

· The number of interracial couples increased four times from 1990 to 2000, making multiracial identities more common among every subsequent generation.

· 4.2% of children under 18 identified as multiracial, as compared with 1.9 of adults.

· One in twelve black children under the age of 18 was reported as belonging to more than one race.

· Ethnic Americans—African Americans, Asian- and Pacific-Americans and Hispanic Americans—make up 25% of the U.S. population. If current trends prevail, this figure will be 33% by 2010, and 53% by 2040.

· One in twelve black children under the age of 18 was reported as belonging to more than one race.

· Spending power among so-called "minority groups" is expected to exceed $2 trillion by 2007—$853.8 billion for African Americans, $459.9 billion for Asian-Americans and $946.1 billion for Hispanics.

· Ethnic Americans are increasing in population seven times faster than non-ethnic Americans

The growth rate for African Americans purchasing new cars has been twelve times that of non-

of TV programming must be European in origin (including 40% French). South Korean regulations

TRANSCULTURALISM = RELATIONSHIPS BASED ON SHARED VALUES, AFFINITIES AND ALLEGIANCES, A RAPPORT BEYOND NATIONAL, RELIGIOUS AND SO-CALLED RACIAL BOUNDARIES....

11-year-old Tamika is German-Chinese-Jamaican. She lives in Port Antonio, Jamaica, and loves practicing her magic tricks.

African American auto purchasers over the last decade. French regulations require that at least 60%

require that foreign TV programming be limited to no more than 20 % of all over-the-air broadcasts.

"Just as a subway train is not destroyed by the painting on the side of it, the effect of my

paintings are not destroyed by their removal or appropriation"—BRETT COOK-DIZNEY, pg. 170

CONTRIBUTORS

Graham Brown-Martin is TRACE magazine's U.K. editor as well as the editor and publisher of AMMO CITY (an alternative online network). His career has spanned the design, film, music, television and technology industries. He is currently based in central London.

Daniel Peddle was born in rural North Carolina and spent his childhood drawing in the woods. He studied Anthropology at the University of North Carolina and went to Graduate Film School at New York University's Tisch School of the Arts. In addition to making documentary films, he works as a fine artist and casting director in NYC.

Anicée Gaddis has been the Executive Editor of TRACE magazine since 2001. A native of Atlanta, Georgia, with a stint in Paris, she spent her pre-TRACE days writing for Jalouse, the New York Times, aRude and Platform. Her favorite pastime is tooling around the streets of New York with a pair of good headphones and some decent music.

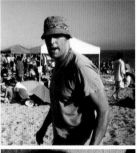

Marc Lecureuil was born in the "erotic" year in Paris, France. There, he attended an experimental Media School, Novocom, which triggered his interest in photography. But it's his traveling experiences that ultimately defined the direction of his work. Marc's images compose a kaleidoscope reflecting the multiple faces of our cultural identities, offering to the viewer a very instinctive and subjective glimpse at communities in our world.

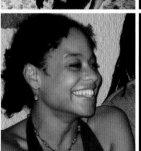

Aina Hunter is a reporter for Scene, an alternative weekly in Cleveland. She wrote most of "Transman" while still a student at Columbia Journalism School. She really misses New York!

CONTRIBUTORS

Edda Hansen is a graduate of London's Central Saint Martin's School of Arts who specializes in design and illustration. She works with Soo Hong under the company name illdesigners. Their contact details are on the website: www.illdesigners.com

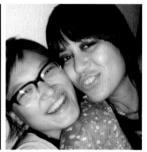

Debbie Rigaud is a Manhattan-born writer who has contributed to Seventeen, Essence, TRACE, Entertainment Weekly and The Haitian Times. To commemorate Haiti's bicentennial, she is currently producing a documentary about Haitian-Americans.

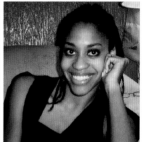

Nicolas Hidiroglou is a longtime TRACE contributor, from Black Girls Rule 2000 to Ai Tominaga Fall 2003. He's mastered elegance and grace, and as a result, also contributes regularly to fashion magazines Citizen K, The Face and L'Officiel.

Tom Terrell is a music journalist and photographer living in Ft. Greene, Brooklyn. A regular contributor to Vibe, Global Rhythm, TRACE, Essence and BET.com, he has over 45 album liner notes to his credit. His photographs have been published in Jazziz and Global Rhythm.

Alex Barnes is a native New Yorker currently working as a freelance writer and associate producer for Festival Productions Inc., where he has worked on the Newport Jazz Festival, JVC Jazz Festival, the Verizon Music Festival and the Vodafone Jazz Festival in Japan. He is currently developing ideas for an outdoor music festival on the Brooklyn waterfront.

CONTRIBUTORS

Rajiah Williams is a native Washingtonian. With a Korean-American mother and an African-American father, she feels particularly connected with the transculturalism movement. Before graduating from Barnard College (Columbia University) in 2002, she completed internships and freelanced for CNN, BET and Fairchild Publications. She now works at TRUE Agency, the world's first transcultural advertising agency. From working in television to fashion to advertising, Rajiah is always ready for a new challenge.

Mari Stockler is a Brazilian artist from São Paulo now living in Rio de Janeiro. Her solo exhibitions include "Did You See It?" and "Meninas do Brasil", which is a critically acclaimed photography book published by Cosac & Naify.

CC McGurr is French.

Amy Andrieux, a Howard University alumni, is the current Managing Editor at TRACE. As a lover of art, literature and politics, her efforts reside in the preservation of true cultural aesthetics for global healing. Amy hopes to assist the youth in bringing that peace into fruition.

Damien Brachet is a French-Hakka Eurasian born in Paris. He is also a self-described "audiovisual freeloader between East and West: fashion whore and indie film art director in Singapore, promos producer and party boy in HK, TV pilot churner turned internet AD in Taipei, Lomo event promoter in the South East, now back in Paris". Other achievements include: best costume at "1,001 Nights" charity ball in Shangri-La HK; best costume at Hard Candy toga party in Taipei; best costume at KMT electoral Halloween party in Taipei.

CONTRIBUTORS

Peter Lucas is a freelance writer and editor currently living in New York. He has written for Dazed & Confused and TRACE, and edited at The New York Times Magazine and the BBC. Specializing in arts- and culture-related work, he says his essays on London and New York here were inspired simply by "observations and wanderings" in the two cities.

Jamel Shabazz is known for capturing the styles shown off on the streets of New York in the early days of hip hop. He documented the emergence of a vital street culture, and published these photographs in his hugely influential book "Back in the Days". His work has also been exhibited in the Brooklyn Museum of Art, at Adidas Originals in Berlin and by TRACE at the Galerie OFR in Paris' "True Signs" show. His most recent book, "The Last Sunday in June", documents Gay Pride Day in New York's West Village.

Alix Sharkey lives in Paris and is a freelance journalist specializing in fashion, media and subculture for the Guardian, Observer, Independent and Sunday Telegraph. A former editor of i-D, his freelance work has appeared in Vogue, Tatler and Arena. He is currently a contributing editor of British GQ, menswear correspondent for The Independent, and a visiting lecturer on the Fashion Journalism MA course at London's Central St Martin's School of Art. For pocket money, Alix has been known to model for Yohji Yamamoto.

Omar Dubois is a true transculturalist, having resided in four continents. "Even without my permission, it seeps out of every blessed pen I've pressed against pulp. It denotes a state of mind that is as agile, as it is embracing. This gumbo of a book could not have come at a better time. This world of ours needs to feast its eyes on more than its own reflection!"

Patrick Neate is a Whitbread Award-winning novelist (for "Twelve Bar Blues"). Most recently he has published "Where You're At: Notes from the Frontline of a Hip Hop Planet" in the U.K. to great critical acclaim. He is also a prolific and respected music journalist and divides his time between London and elsewhere.

CONTRIBUTORS

Stephen Greco is editor-at-large of TRACE magazine and a co-creative director of True Intelligence. A former editor of Interview magazine, and a founder and the editorial director of Platform.net, for years the web's leading global youth culture portal, Greco is also the author of The Sperm Engine (Green Candy Press, 2003).

Steve Mascatello was born in 1979 and raised in McLean, Virginia. He currently resides in New York City and loves his parents very, very much.

Alex Tehrani was born and raised in California. He found his photography passion in high school and has since traveled the world extensively making pictures. He has shot for magazines including Dazed & Confused, Rolling Stone, TRACE, Flaunt. He is also responsible for some Adidas, Kodak, Coca-Cola and Outward Bound ad campaigns. He got married in the north of Iran at the Caspian Sea this past summer. (He ate sacrificed sheep balls.) Alex lives between New York and California.

Erik Ian Schaetzke. The son of a biker and a ballerina. Born in Ohio, raised in NY. Lives with his wife and son, Hudson, in LA (for now). Prefers it behind the camera.

Richard Wayner has been the CEO and publisher of TRACE Magazine since February 2002. A lifelong traveler, he rode a motorcycle cross country en route to Stanford Business School, where he graduated with an MBA in 1994. He also studied in Paris, France, at the Institut d'Etudes Politiques. He spent seven years at Goldman Sachs, where he developed his business interests in multiculturalism and urban youth. As president of TRUE Agency, Richard focuses on business development and strategy.

CONTRIBUTORS

Angela Cravens is a writer living in New York. Angela, who now works for TRACE, is a graduate of UC Berkeley, where she studied literature and creative writing. Other cities she has called home include: Stockholm, Sweden; Leucadia, CA; Los Angeles; and Cuernavaca, Mexico.

Frenel Morris (pictured here with Jamaican legend U-Roy) is an illustrator, photographer, graphic designer, bagel boy and all-around hustler from the Lower East Side of NYC, by way of Paterson "Silk City", New Jersey. His company, The Double Penny Collection, will be launching its premiere clothing line, Gordan Gatrelle, in spring of 2004.

Claude Grunitzky, the Chairman and Editor-in-Chief of TRACE magazine and Chairman of TRUE Agency, has unparalleled experience in publishing a magazine and creating youth-oriented marketing programs on both sides of the Atlantic. TRACE magazine, which is based in New York City and printed in Italy, relies on satellite offices in London and Paris, as well as on a global network of first rate writers and photographers. TRACE is devoted to "Transcultural Styles and Ideas." Additionally, Grunitzky is a frequent contributor to some of the world's leading magazines, newspapers, television networks, radio stations, websites, advertising agencies and academic institutions; as well as an advisor to marketers and retailers in the fields of music, fashion, culture, media and art. TRACE fuses aggressive reporting, arresting visuals and savvy promotion to support an editorial vision that is unafraid to question the trendiest breakthroughs in global youth culture. Last year, Grunitzky and business partners, Richard Wayner and Olivier Laouchez, completed a multimillion dollar financing led by Goldman Sachs Group. As a result, the TRACE brand is now being leveraged globally across various magazine and television platforms, with various editions of TRACE around the world. TRACE recently purchased 80% of France's leading Afro-Caribbean cable and satellite network, MCM Africa, which has been rebranded and reformatted as TRACE TV. In April 2002, Grunitzky and business partners, Richard Wayner and Christopher Davis, launched TRUE Agency, a specialized advertising and marketing shop partnered with Omnicom's TBWA\Chiat\Day, which became the African American agency of record for Nissan in July 2002, with sizeable and increasing billings.

"I find myself thinking of the W.E.B. DuBois idea of double consciousness as the

"in but not of" thrusts his pelvis against the "of but not in."—PATRICK NEATE, pg. 142

"Fumbling through elaborate handshakes, I slowly realized that what I had

presumed was a group of gay boys were actually girls!"—DANIEL PEDDLE, pg. 124

"Lately, we've been feeling the need to get closer to nature and all things

natural, to the analog, to basic human sensations."—BADBC, pg. 170

"As Iraqi troops were barricading the outskirts of Kuwait City and taking my father hostage,

my mother and I were in utter oblivion—on holiday in London."—MEBRAK TAREKE, pg. 216